The Innovativ.
of Materials
in Architecture and
Landscape Architecture

MW00813590

The Innovative Use
of Materials
in Architecture and
Landscape Architecture

History, Theory and Performance

CAREN YGLESIAS

McFarland & Company, Inc., Publishers

Jefferson, North Carolina

Library of Congress Cataloguing-in-Publication Data

Yglesias, Caren.
The innovative use of materials in architecture and landscape architecture:
history, theory and performance / Caren Yglesias.
p. cm.
Includes bibliographical references and index.

ISBN 978-0-7864-7080-8 (softcover : acid free paper) ∞
ISBN 978-1-4766-1464-9 (ebook)

1. Building materials. 2. Sustainable construction.
I. Title.
TA403.6.Y49 2014 691—dc23 2013051364

British Library cataloguing data are available

On the cover: woven steel fence at the Desert Botanical Garden
(designer, Steve Martino, Landscape Architect)

Manufactured in the United States of America

*McFarland & Company, Inc., Publishers
Box 611, Jefferson, North Carolina 28640
www.mcfarlandpub.com*

For my wonderful sisters,
Colette Silver and Cathy Ensor,
women of character and kindness

Table of Contents

Acknowledgments

This book has benefited from the help of many people. Brook Hendricks, librarian at the American Society of Landscape Architects, provided assistance during the early research phase, for which I am most grateful. Several offices opened their doors and their files in support of this work, for which I am most grateful. In particular, I thank Eric Blasen of Blasen Landscape Architecture, Dennis Carmichael of EDAW (now AECOM), James A. Lord and Roderick Wyllie of SurfaceDesign, Ken Smith of Ken Smith Workshop, Robert Bedell, Hallie Boyce, Daneil Mazone, Richard Roark, David Rubin (now of Land Collective), Lucinda Sanders and Jean Weston of OLIN, and Nate Trevathan of Michael Van Valkenburgh and Associates, Inc.

My gratitude extends to Kory Kreiseder, who read every word of an early draft, which benefited from her keen and discriminating understanding of design. Jane Hutton, assistant professor of landscape architecture, who teaches design and materials at Harvard University's Graduate School of Design, read a later draft and offered many helpful suggestions and insights, spurring improvement—thank you. Several scholars and practitioners took time from their busy schedules to read sections of the developing manuscript and to provide strategic comments. I am most grateful for your help: Dr. Franca Trubiano, architect and assistant professor at Penn Design, University of Pennsylvania, and author and editor of the recent book, *Design and Construction of High-Performance Homes: Building Envelopes, Renewable Energies and Integrated Practice*; landscape architect Roger Courtney, FASLA, principal at AECOM; and landscape architect Jack Sullivan, FASLA, former head of the University of Maryland's graduate program in landscape architecture, who provided inspiration and support for this work as well as all of my various activities. I am also indebted to Ralph Bennett, AIA, architect and principal at Bennett Frank McCarthy Architects and professor emeritus at the University of Maryland's school of architecture, who continues to advocate for and to teach the critical issues of sustainability—thank you for providing detailed commentary that greatly improved the clarity of my understanding of the current and future issues of design, education and sustainability.

This work had the benefit of many conversations with Jason Holstine, for which I am grateful. As president of Amicus Green Building Center, the only complete showroom and supplier for exclusively green products in the Washington metropolitan area since 2005, he helps designers bring their sustainable ideals to reality.

My thanks are likewise extended to the many people who helped obtain images or provided them *gratis*, including Charles Anderson, Elizabeth Asawa, Christine Bolghand, Chris Brown, Dixi Carrillo, Jennifer Clark, Matthew Coogan, Sahar Coston-Hardy, Paul Crosby,

Topher Delaney, Anne Evans, Elizabeth Felicella, Tom Fox, Robin Ganser, David Graham, Jared Green, Stephanie Hardman, George Hazelrigg, Becky Hoerr, D. A. Horchner, Todd Kohli, Tamara Kool, Tom Lamb, Micah Lipscomb, David Lloyd, James A. Lord, Kris Lucius, Steve Martino, John D. McDonald, Kelty McKinnon, Yvi Nguyen, Annie O'Neill, Sarah Peck, Kevin Robert Perry, Winnie Poon, Alissa Preibe, Rody Santamarina, Hardy Stecker, Jeri Stedt, James Haig Streeter, Keith Swann, Bill Timmerman, Nate Trevathan, Alan Ward, Steve Watt, Brett Weidl and Roderick Wyllie.

My complete appreciation and love extends to my husband John, who has shared and supported every moment of my work—and life—with humor and patience.

Preface

This book is about the materials used in architecture and landscape architecture. It offers both the fundamental technical information and the substance for critically thinking about these materials to those who are interested in them and the built environment, and to those who teach and take materials and methods of construction courses. Appropriate terminology is introduced and defined to establish a base of familiarity and enable designers to consider a material with sufficient accuracy for their work, and to aid comprehension when consulting specialists are involved. Understanding the technical properties of materials used today for building requires knowing the context within which they exist. To this end, the history of the use and development of each material is reviewed. Appreciating materials benefits from theoretical inquiry, sometimes directed by the intrinsic characteristics of a material and how it performs. All aspects of investigation are linked, and they overlap and blend into a comprehensive whole. Technological developments occur throughout history; thinking evolves and affects performance; inventors alter inherent properties once considered immutable. Ultimately, the innovative use of materials in design comes from designers asking new questions of significance today, particularly about using materials sustainably. For designers, understanding materials opens possibilities of working in innovative ways that take advantage of these materials' innate capabilities. This book does not present novel, trendy or extreme projects that carry no transcendent lesson. Sometimes the more innovative approach is to reclaim sound practices that have been supplanted by technological systems. Using "old" materials to address "new" questions requires understanding the technical capacities and theoretical capabilities of materials.

Design students and practitioners of the productive arts—architecture, landscape architecture and urban design—work in overlapping fields (with mutual concerns for durability, for instance, especially when the materials are exposed to public use and the forces of nature). For all, design is not about composing forms in abstraction, but is rather a cooperative investigation of forms and the materials used to realize the physical aspects of the design. Vocabularies of edges, thicknesses, corners and surface textures are predicated on the particular substance of a material with firm technical properties and varying qualities available for ingenious manipulation. Depending on the choices, materials can connect a project to its specific location and general region when compatible, which has the added benefit of a project contributing to the sense of place.

The overriding premise is that decisions about form cannot be separated from an understanding of materials. Design students and many designers often lack the training and experience of working with materials in construction—honing judgments about stone or wood,

for instance—that becomes second nature to the stonemason or carpenter. With this experience, they may observe the way a craftsman can "tell" if they are working with or against a material because they understand its consistent performative characteristics (Yglesias 2012b: 100). So, too, the people who use the built design can intuitively feel the harmony between well-considered form and well-chosen and well-crafted materials. In the end, it is the responsibility of the designer to understand materials well enough to allow their design intentions to be realized for practical use and emotional satisfaction. This does not mean that the design must express the conditions of its construction, but the best material must be matched to the designed purpose.

Materials are physical. They are available to our senses through perception. Materials are seen, touched, even smelled and tasted. Social anthropologist Tim Ingold, in an essay titled "Materials Against Materiality," observes that materials are the real stuff of the world. He argues that turning materials into materiality favors anthropologic interpretations of cultures based on recovered artifacts, but that this is an illusion. Ingold also urges designers to avoid distracting critiques of materials as embodiments of mental representations in material culture studies of social consumerism (2011: 19–32). More productive engagements call for designers to study physical materials seriously. Ingold suggests ways to regard a material primarily as a *substance* retaining its generative force in design, in which part of the inherent character continues as "active constitutes of a world-in-formation" (Ingold 2011: 28). He refers to David Pye, a theorist of design, who distinguishes between the *properties* and the *qualities* of a material. A material's *properties* are its internal, constant and structural form, behavior patterns and related tendencies that exist absent human involvement. Once identified, the properties may be evaluated as advantages or disadvantages when a material is considered for human purpose. Objectively determined are properties of density, ductility, type of strength and thermal action. A material's *qualities* are the capabilities of a material to be transformed in response to the subjective human imagination and for human purpose (Pye 1971: 45–47). For example, a property of a material may allow it to soften when heated and harden when cooled, and a quality of a material may allow its surface to be manipulated as artistic expression. The physical properties of materials may be measured, analyzed and tested, so that industry standards may be set and performative behaviors predicted. The metaphysical qualities are beyond measurement and rely rather on judgment. In the end, all aspects of materials are part of the human regard of the physical world as it is and for what it means.

The construction industry is a major consumer of raw and recycled materials, and of the energy used for processing and production. Responding to environmental issues, the sustainable or "green" industry has arisen to define healthier and more responsible building practices. This has in turn prompted serious interest in the relationship between design and informed decisions about the use of materials, especially those that are nonrenewable and those that have high recycled content. Design professionals are increasingly required to comply with guidelines that encourage certain practices defined as sustainable; yet something is lost when materials are specified as "good" or "bad" depending on whether they are likely to be awarded LEED Certification credits. What makes a material "good" also depends on the historical and cultural associations at the time of construction for the people who will use it, as well as for future generations.

Sustainable design principles consider the life-cycle assessment (LCA) as the true cost or embodied energy of design decisions that affect the natural resources used for materials.

These costs start with harvesting materials, removing them from their sources; then manu-facturing, in which they are transformed by human and mechanical action in processes of refinement with by-products and waste; transportation from the source for processing and then to the site; construction, with determined assembly and disassembly techniques, oper-ations or use; maintenance; and ultimately a stage of recovery, in which the material is regarded as waste and added to the landfill or incinerated, or repurposed by reuse, recycling or down-cycling. The energy involved and the impact on the environment are bound together with the goals of sustainability when added to the responsible consumption of natural resources. This way of working is no longer a secondary consideration, but is integral to every material choice and application, and information on this subject is woven throughout the text.

This book uses two terms that require definition: nature and sustainable. I think Ralph Waldo Emerson had the best definition of "nature" as "not me." Under this definition, some scholars say nature no longer exists. There is no territory unexplored; no natural wilderness unexamined; no air or water unaffected. In this book, nature is the physical world that exists apart from the cultural world of people with ideas, needs, desires, memories and understand-ings, and who make artificial artifacts out of "raw" or undeveloped materials, which many interpret as natural resources. The polarized regard of nature versus culture, or people as distinct from the natural world, has lead in part to the current ecological crisis. People cannot survive unassisted, and achieving a desired level of comfort and convenience has supported attitudes of exploitation, the consequences of which are only now fully emerging. Continued human health, safety and welfare depend on a more balanced and sustainable approach toward the consumption of nonrenewable natural resources.

Usually construction industry and design books on materials include concrete, wood, metals, glass and plastics. This leaves out the more traditional materials of stone and brick and ignores the advantages of ceramic surfaces for exterior applications. Vegetation as a mate-rial for green roofs and green walls is a relatively new option for exterior skins. Also worth considering are the ancient elements of change that can function as building materials. These are the materials that helped philosophers discuss the composition of the physical world, and their presence brings forth associations bound to the essence of humanity. The approach taken here is to include all materials available for design: *found* materials are stone and earth, which are usable in mechanically unprocessed states; *manufactured* materials start with sand, ore, clay and crude oil, and include compositions of concrete, metals, brick, ceramics, glass and plastics; *grown* materials are trees for wood and plants for vegetated roofs and walls; and the *transformative* materials are fire, water and air, which are both distinct materials in their own right and mediums for the transformation of other materials.

Although the chapters may be read in any order, the book is organized to allow the information about each material to unfold and to prepare the reader for the next chapter. The relevant influential scholars are introduced in sequence. My approach to each material follows a consistent outline. Each material is introduced by defining its properties and asking about the source of its appeal. The popular use and misuse of words is reviewed, as well as their etymology where helpful. The biophysical quantitative properties of the material's molecular and crystalline structures are briefly reviewed in a technical section. The next sec-tion traces the material's origin and use in history as first recorded in Pliny the Elder's *Natural History* and through the architectural treatises of first-century Roman architect Vitruvius and Renaissance architect Leon Battista Alberti, both of whom wrote about design principles

and the role of materials, along with pertinent observations by the material philosopher Lucretius. Much of the current understanding of materials is aided by considering the phenomenology of Gaston Bachelard and Maurice Merleau-Ponty. Histories lead to theories because principles transcend particular applications. If to theorize is to step back and examine in a detached way, then the cultural position of a material is bound up with associations, meanings and values, and it can be linked to metaphors that influence thought. I suggest a theoretical approach—a way of thinking—for each material that provides a framework for understanding why people respond to different materials in different ways.

Once this foundation is laid, the reader is positioned to consider what constitutes innovation for each material. Like language, in which definitions evolve based on use, a material's performative aspects cannot be limited to "how to" instructions, but rather evolve from automatic practices that suggest potential directions. Taking a lesson from high-performing ecological systems, innovative designs do not seek the extraordinary, but the sustainably practical, which is a performative definition of the beautiful that I consider appropriate today. The conclusion of each chapter asks what it is for a designer to work *in* this material so that others may work *with* this material.

Edited lists of online resources are included, delineating governmental and trade industry research and development programs, especially as they relate to sustainability evaluations, with websites for further research. Brief notes are added, often taken from the mission statements of the organizations. A few proprietary products that might be of interest to the reader are also included. For all materials, the National Institute of Building Sciences has a program called "The Whole Building Design Guide" that provides integrated information about design techniques and technologies. Its link provides access to databases appropriate to the planning and construction phases (see http://wbdg.org).

In illustrating these chapters, images have been chosen to clarify points, bearing in mind that most readers have easy access to project photographs on the Internet. Because this book is neither a firm profile nor a collection of case study analyses, the information about the illustrated project is usually included only in the citation. The images are credited as noted or are in the public domain.

As a practicing architect and perpetual student, I see no conflict between practical and theoretical inquiry. They are companions in design—like form and materials—without which neither would carry purpose or meaning.

Chapter 1

Concrete

How can a single material be so appreciated for its performative abilities and yet so generally disliked for its plain appearance? Ubiquitous concrete does the hard work of the constructed world, but when we see something made of concrete, a feeling of disappointment often emerges, causing us to lament that brick or stone were apparently unaffordable. Concrete is a material discriminated against for domestic use, neatly dividing typical residential and commercial building types, and even the frequent label of cities as "concrete jungles" highlights how the material of concrete influences the way we think of dense urban development as being apart from the natural world.

Concrete is a mixture of stone, sand, water and binder. The word "concrete" is defined as "united, composite, opposite to abstract" (OED), and comes from the Latin word *concrēscere*, as in "to grow together." It shares its etymological roots with words such as "increase" and "accrue." The alchemical nature of concrete stems from its inclusion of all four elements of matter: earth (stone, sand, lime and clay); water (for the hydration process that activates the chemical binding action); fire (in the heat given off during curing); and air (the content of which is carefully controlled to improve workability and to reduce weight).

Concrete is a material with numerous properties and is chiefly valued for its structural strength, durability and relatively low cost. Concrete structures retain stability in a fire, but are subject to failure during earthquakes because concrete has low ductile properties that make it unable to bend without breaking. It resists wind forces, inhibits acoustic transmission, and provides thermal mass that benefits passive radiant heating. Concrete is used for both internal structural frames and external surfaces whose appearance depends on the formwork used and the finishing treatment.

Concrete is a material whose final state depends on the proportional mix of its constituent parts. Strong in compression but weak in tension, concrete acquires tensile and sheer strength with added reinforcement. Its low strength-to-weight ratio makes it a massive and heavy material to use in construction, but also stable as long as it bears on structurally sound soil substratum or bedrock. Properly mixed and installed, concrete is exceptionally resistant to degradation. Made of inert components, it does not rot, corrode, decay, or attract insects or rodents. As a result, it is particularly well suited for constructed projects in contact with the earth and its moisture. Exposed concrete normally has a roughly 100 year life span, although this varies depending on the degree of exposure and level of maintenance. All concrete work occasionally needs maintenance to fill open cracks, to clean surfaces of accumulated organic matter, and to seal or re-seal expansion joints. Depending on the formula, finished concrete work is water-resistant, but not completely waterproof. Some concrete

FIGURE 1. MERIDIAN HILL PARK, WASHINGTON, D.C. (1915–1936). JOHN J. EARLEY, ROSSLYN, VIRGINIA. (Courtesy Magenta Livengood.) The innovative and patented cast-in-place and pre-cast concrete techniques used mixes with stone pebble aggregate that were sorted by color and size. The result was intended to have a similar appearance as cut stone panels, railings and orna-ment, but it cost less. The stairs flow down the hill in a way that is well suited to the material of concrete. In 1994, this park was the first in the country to be recognized as a National Historic Landmark.

mixes harden under water because the silica and alumina inclusions react with the lime, allowing the dehydration process to occur even when wet (Newby 2001: 12).

As the world's most common manufactured building material, nothing is consumed more by volume except water. One reason for concrete's popularity is that it is made of mostly locally found base materials. All building materials have the potential to be more sustainable, with a lower carbon footprint, if their source is close to their installation site. For concrete, qualifications of sustainability also depend on improving cement and reinforcing steel production, which are two components of concrete that give off significant amounts of carbon dioxide emissions in manufacturing. Another advantage is that in all parts of the world, relatively unskilled labor working at room temperature can make concrete, although more skilled labor is required to make and to use wood or metal formwork. The formwork is necessary because concrete is a moldable material.

In spite of concrete's many positive attributes and advantages in construction, it is also cold and hard to the touch and typically has a dull gray color. Appreciating concrete as a material may begin with its advantages in construction, but designers remain challenged to find ways to increase its social acceptance.

Properties of Concrete

Concrete is a composite material made up of a binder (cement and water) and fillers (inert aggregates and admixtures) that are exposed to each other in a chemical reaction of crystallization that releases heat. The amount of water determines the workability of the concrete as the liquid hardens into a solid. The pace of hydration, known as setting or curing, establishes the early and ultimate strength of the concrete. The quality of the cement paste "largely determines the character of the concrete" (Brady et al. 2002: 264). The binder or paste is made of water plus calcareous materials of lime and silica, of which the most common mixture (tricalcium aluminates and silicates) is one of eight types of Portland cement, to be discussed later in this chapter. The active ingredient in cement is lime, made by burning and grinding calcite limestone (the remains of shelled marine animals) or marble as calcium carbonate, along with iron and alumina derived from clay or shale (Bell 2006: 53). The process heats these materials at extremely high temperatures of 2,700°F, forcing them to lose bound water and carbon dioxide in a calcination phase. Then dicalcium silicate is formed, and subsequently tricalcium silicate in the cooling phase, and finally aluminates, aluminoferrite or gypsum are added, resulting in marble-sized pieces called clinker (Allen and Iano 2009).

Fossil fuels are usually burned in order to obtain temperatures high enough for cement production, causing carbon dioxide to be released into the atmosphere. Mixtures with less cement or substitutions will lessen the environmental impact of concrete production. This single industrial activity contributes 5 percent of all human-produced greenhouse gases (Calkins 2009: 103–5, 192). Instead of water, air may be added to improve workability and thermal insulating properties, or to make it lighter, but it must be tamped out of the surfaces to eliminate gaps where rainwater can be caught and then expand when frozen, which will spall and chip away adjacent concrete.

Common concrete fillers are aggregates, usually a combination of fine sand, rough gravel and crushed stone, graded by size and color. The density and type of the aggregate gives concrete its compressive strength, surface texture and other performative properties. There are four general kinds of concrete, depending on the type of aggregate: ultra-lightweight concrete has aggregate of vermiculite, perlite or ceramic spheres; lightweight concrete has expanded clay, shale or slate, or crushed brick aggregate; normal weight concrete has crushed limestone, sand, river gravel, or crushed recycled concrete aggregate; and heavy weight concrete has steel or iron shot or pellet aggregate, and is used for structures that provide shielding against nuclear radiation.

Admixtures or superplasticizers are chemicals that change the concrete content and hydration process in several ways, including facilitating concrete installation in otherwise unsuitable weather (below 38°F or above 90°F) (McMorrough 2006: 208; Bell 2006: 57–58). Concrete must set before freezing occurs, which forces the water in the mix to expand by as much as 9 percent. Concrete must also set before it gives off heat too rapidly, as that causes the exterior surface to harden more quickly than the interior, inhibiting even curing. Chemicals that accelerate curing can cause shrinkage and discoloration, and those that retard curing may cause "creep," the term used for the slight deformation of a material due to long-term stress. Modern fillers such as fly ash, obtained as a by-product of coal-burning industrial processes, can also be added to improve workability (Bell 2006: 57–58).

After the design is complete, cast-in-place concrete construction sequences begin with field workers who make forms either out of wood, which are usually used on a one-time basis

(unless a plant-based oil releasing agent is applied), or out of steel or plastic, which are designed to be reused. In parts of the country with stable sub-soils, foundations can be formed either with earth cut and shaped or with reinforced biodegradable fabric that does not need to be removed. Workers place the liquid concrete delivered in premeasured mixes and consolidate it using vibration and tamping equipment to remove air pockets. Then they wait. Curing times can be retarded by spraying, fogging, applying saturated coverings or covering the concrete with plastic sheets to control the rate of evaporation. The process can also be accelerated by adding heat or steam. During the entire construction sequence, the concrete is inspected and tested for current and projected strength. Placed concrete hardens in seven days, with full designed strength achieved after twenty-eight days, although it continues to gain strength indefinitely. Some applications could use a more sustainable mix with less cement if a longer curing period of fifty-six days is specified and allowed by building code (Calkins 2009: 115–16). Like a pastry chef making a cake, concrete's state cannot be altered after the chemical reactions are initiated in mixing and solidified in baking.

Exposed concrete moves. It generally shrinks a sixteenth of an inch per ten feet of length during curing, and once cured, it expands and contracts depending on the ambient temperature (Sovinski 2009: 62–63). Therefore, allowances must be made for concrete to move without failure. To this end, four kinds of joints may be employed: construction, control, expansion and isolation. Construction joints allow successive vertical pours. Given the weight of concrete, its liquid state, and the inclusion of heavier pebble and stone aggregate, only a portion of concrete walls can be poured at one time, and the depth of the "lift" depends on the type of form. Reinforcing must be placed so as to span concrete portions poured at different times. Lift depths range from about twelve inches for residential construction to several feet for heavy construction. In this case, proper pouring equipment does not allow the mix to fall into the formwork, which would prevent even aggregate distribution.

The other three types of joints allow movement once the concrete has set. Control joints allow concrete slabs to shrink by cracking at the joint and not somewhere that is unsightly or unsafe, and should be a minimum of one quarter of the slab depth. The joints can be either hand-tooled in the poured wet concrete or saw-cut once hardened. Expansion joints allow room for continual expansion and contraction due to exposure to temperature changes. These joints must be debris-free and watertight, with gaps filled with foam, fiber or felt backer rods, and a pliable sealant added to the outer surface, which must be occasionally replaced when it deteriorates (chiefly because of UV light exposure). Where reinforcing bridges the gap, it must be wrapped so that it slips along with the concrete movement. The fourth kind of joint is called an isolation joint because it separates the concrete from other elements and materials, such as between walls and floors, or between concrete and metal (Sovinski 2009: 62–67; Bell 2006: 58–59). The performative capability of concrete over time depends on appreciating the relationship between concrete as a monolithic material and these vital joints that significantly contribute to its continued performance.

In order for concrete to have tensile strength, reinforcement is placed within the empty form so that it binds with the liquid concrete. Metals such as steel reinforcing bars (also called rebars) are commonly used and most guidelines recommend at least three inches of concrete surrounding the metal to protect it from rusting due to exposure (Arnold 2003: 52). The most common reason for concrete failure in construction is "attributed to insufficient concrete cover and not settlement or a lack of reinforcement" (Deplazes 2010: 64). New research on alternate reinforcing materials such as bamboo, recycled glass fibers and

carbon fibers is under way, and these are likely to be accepted substitutes in the near future (Newby 2001: 11). Biodegradable reinforcement has the added advantage of allowing easier concrete recycling when crushed into aggregate without the laborious and expensive step of removing the steel reinforcing. Slabs are reinforced with steel mesh (welded wire, fabric, WWR).

The final consideration for cast-in-place concrete installation greatly depends on the weather. Air temperature, humidity, wind speed, and the temperature of the materials and formwork affect the ultimate quality of the concrete. Finished concrete, during its first year, is also vulnerable to de-icing chemicals that contain magnesium chloride, calcium chloride, sodium chloride and calcium magnesium acetate. They can mount an attack on the hardened cement paste component, decomposing it and allowing it to wash away, leaving loose stone aggregate and crumbly concrete. Eventually the steel reinforcement may be exposed to moisture and air, further speeding deterioration.

Concrete in History

Three centuries before recorded history began, Macedonians, Assyrians and Babylonians worked with bituminous materials for mortar and with gypsum for plaster (Draffin 1943: 14). Egyptians used gypsum and lime cement mortars for the Pyramid of Cheops (c. 2560 BCE) and other structures, and, perhaps even more impressive, they used waterproof hydraulic cement to line cisterns, canals and aqueducts. Other peoples used similar materials to waterproof rain-collecting basins in the desert. The Greeks used a lime-magnesia mortar that hardened by evaporation, forming calcium carbonate. From the second century BCE, mosaics in Pompeii were set in lime mortar cementious beds and public baths had unreinforced vaulted concrete roofs (Palley 2010: 24–25).

Roman construction practices were recorded by the first-century BCE architect and engineer Marcus Pollio Vitruvius, who wrote a theoretical and technical treatise titled *The Ten Books on Architecture*, which is the earliest surviving complete account of architecture from classical antiquity. The second chapter on building materials describes the types of sand, proportions of lime, different stones that have withstood the test of time, and the use of pozzolan, a volcanic rock also known as Pompeian pumice and named for the town Pouzzol, near Vesuvius. This type of concrete produced "astonishing results" (II.VI.1). When pozzolan was added to the mix, the lightweight concrete poured over brick tile formwork provided strength with less weight for vault construction, and this innovation is credited as the great Roman contribution to architecture (Fitchen 1986: 106). Vitruvius also gave an account of concrete for two types of terrazzo flooring. *Ruderatione* was made of rough stones for rudimentary rubble paving, and *ērudiō* was a process of finishing that brought concrete to a high polish (VII.I).

Little is known of the use of concrete between Roman times and the late Middle Ages. The technology of cement production was generally lost, and waterproofing mixtures were not lime based. Building guilds protected their secrets as proprietary information. Eventually, an exception occurred in the work of Joseph Moxon, an aspiring English printer, who in 1677 wrote the first book published as a serial. Written for tradesmen, *Mechanick Exercises: Or the Doctrine of Handy-Works* described the tools, materials and techniques used for the construction trades. He accounted for two types of burned lime—one "soft" for interior plastering, and the other "hard" for buildings and waterproof exterior coatings. The lime

FIGURE 2. PANTHEON, ROME (C. 118–128 CE). COMMISSIONED BY HADRIAN, ARCHITECT UNKNOWN. This building is a superior example of a pure architectural form—a sphere on a drum—and of the extraordinary construction expertise required to build a lasting structure with unreinforced cast-in-place concrete. Six mix types of concrete were used with lighter formulas that substituted tufa and volcanic pumice for stone aggregate as the structure rose to its coffered ceiling.

was ground from millstone, flints and shells, and mixed with sand following Vitruvius' recommendations, but adjusted for climate. Moxon noted that this waterproof mortar was used to line water courses, cisterns and fish ponds. Additives included hog grease, fig and lime juice, linseed oil, ox blood, and egg whites, with tensile strength reinforced by the addition of ox or cow hair (Moxon 1703: 241–45).

Many advances have occurred since the eighteenth century. Concrete for underwater construction advanced when John Smeaton rebuilt the third Eddystone Lighthouse off the coast of Cornwall in southwest England from 1755 to 1759, after conducting extensive research on hydraulic lime cement mortar mixtures that harden under water. Shortages of building stone in England prompted the development of hydraulic lime cements (hydraulic cement render) for waterproof stucco, patented in 1779. Also, the appearance of poorly made or irregularly colored brick was improved with a veneer of stucco, often scored to give the appearance of stonework. In 1812, Frenchman J.L. Vicat experimented with the compositions

of lime, silica and alumina required for hydraulic cement. In America, the Erie Canal, constructed in 1818, used natural cement from rock deposits in Madison County, New York. Ten years later, similar dolostone rock was found in Rosendale, Ulster County, in New York and was used for the Delaware and Hudson Canal, although this cement had slower drying times and did not replace Portland cement for common construction use. Cement materials were also found in Indiana, Kentucky and the Lehigh Valley in Pennsylvania. Two other extraordinary modern concrete structures, the Hoover Dam and Grand Cooley Dam, were completed in 1936 and together consumed over fifteen million cubic yards of concrete.

No development in concrete during modern times would have been possible without parallel developments in metal reinforcing. From the early nineteenth century, wrought-iron bars and then cast steel proved to be suitable additions to concrete because they both have a compatible coefficient of thermal expansion, and the cement paste protected the metal from corrosion. By the end of the nineteenth century, iron-reinforced concrete allowed the construction of long span bridges, such as Joseph Monier's bridge at the castle of Chazelet in France, completed in 1875.

Concrete production also benefited from standardized and consistently high-quality cement. Joseph Aspdin patented a formula for limestone-based cement in 1824 that he called Portland because it resembled the fine building stone obtained from the Isle of Portland. Its further refinement became the industry standard, and it is the most widely used cement in the world. Later in the nineteenth century, the French, Swiss, Germans, Russians and Americans developed natural cements that set faster than lime-based mortars.

François Hennebique was a French engineer who pioneered reinforced concrete as a construction system, patenting his method in 1892. He concluded that reinforcing was

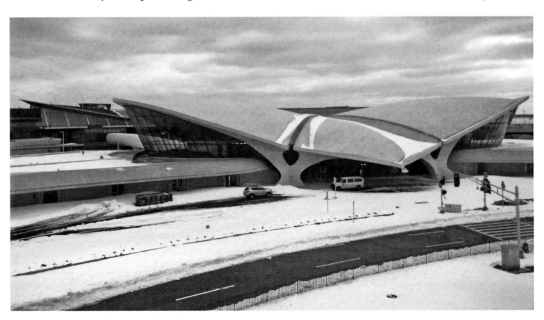

FIGURE 3. TWA FLIGHT CENTER, JOHN F. KENNEDY INTERNATIONAL AIRPORT, NEW YORK (1956–1962). SAARINEN AND ASSOCIATES, ARCHITECTS, HAMDEN, CONNECTICUT. Saarinen captured a sense of flight in the flowing forms of the concrete roof shell. The large and clear-span interior spaces have proved to be ideal for changing terminal services. This building was placed on the National Register of Historic Places in 2005.

required only where the concrete was under tensile pressure. In the next ten years, over 7,000 structures were built throughout Europe using the "System Hennebique" (Billington 1985: 149, 150).

In the 1920s, pre-stressed concrete was developed by Eugene Freyssinet in France. Pre-stressed concrete has reinforcing cables cast in the concrete and clamped at the beam ends, equalizing tensile and compressive stresses, which allows greater loads and longer spans with thinner and lighter concrete elements. This innovation was the precursor to developing methods to calculate the structural forces of reinforced concrete formed into hyperbolic paraboloids, which were used for large curved roof shapes to cover stadiums, airplane hangars and cathedrals. The continuous roof vaults provided large interior spaces with clear spans, also ideal for warehouses and factories.

Beyond the structural advantages of reinforced concrete, cultural institutions appreciated the fireproof property of concrete, especially where large groups of people gathered, such as the Royal English Opera House in London (built in 1888), as well as high-rise apartment and office buildings. These building types were made possible when Elisha Graves Otis patented his design for elevator brakes in 1853.

Theories of Concrete

The various possible mixtures for concrete and its lack of an inherent form belie hasty proposals for a theory of concrete as a material. Some writers even claim that "concrete is not a material, it is a process" (Forty 2006: 35). Its initial fluidity requires formwork to shape it for use as either structure or surface, or both. But it is this very fluidity that defines the character of concrete. *The unique fundamental character of concrete is that it begins as a liquid sharing the gravity-seeking property of water, and then becomes a solid.*

Often the surface appearance of concrete does not reveal its inner structural workings (Deplazes 2010: 56). Designers who want an association with heaviness may prefer rough concrete surfaces, as compared to an appearance of weightlessness enhanced by concrete that has a smooth and polished surface. Regardless of the surface finish, however, concrete does not allow incremental thinking because, unlike materials such as brick or stone, decisions are not made at the scale of the hand. The thinking is larger, more flowing, and only limited by the formwork employed in its construction. Any theory of concrete therefore, is based on construction decisions that take into account how the material may be used to build.

It is not a coincidence that recent exceptional concrete structures have been designed by architects who are also structural engineers or who well understand engineering the transfer of weight. From Frank Lloyd Wright's Unity Temple built in 1906 to tall buildings with gravity-defying cantilevers, designers must possess both vision and a technical understanding of concrete. For typical designs, architects, landscape architects and structural engineers work together to determine the correct and efficient concrete mix based on required strength, the desired final form and appearance, and the formwork used to achieve it. Recognizing that a structure's weight transfers down to the earth, precise calculations locate the concrete massing and rebar placement to counteract dead loads (inert weight of the building and permanent equipment), dynamic loads (snow and wind), and live loads (furnishings and occupants). Thinking through concrete combines architectural and engineering activities because designing forms that flow depends on knowing how weight behaves in conjunction with gravity.

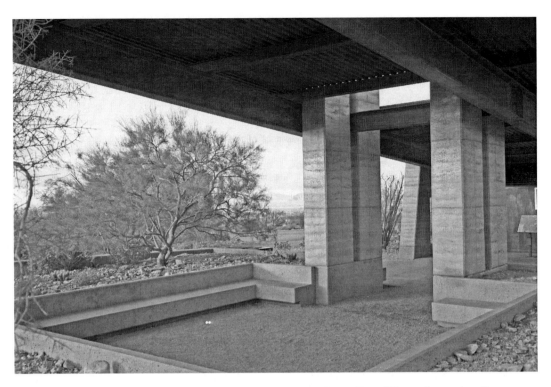

FIGURE 4. McDOWELL SONORAN PRESERVE TRAILHEAD, LOST DOG WASH, OUTDOOR CLASS-
ROOM, SCOTTSDALE, ARIZONA (2006). WEDDLE GILMORE ARCHITECTS, SCOTTSDALE, ARIZONA,
AND FLOOR ASSOCIATES, INC., PHOENIX, ARIZONA, LANDSCAPE ARCHITECTS. (© Bill Timmer-
man.) Pre-cast concrete benches serve as retaining walls, and their form and smooth surfaces
invite sitting. The finish contrasts with the rammed-earth columns and rugged landscape of the
Sonoran desert. The building incorporates many sustainable elements, including photovoltaic
cells, composting toilets, grey water systems, and rainwater conservation and harvesting for irri-
gation.

Beyond form, if the surface texture of the concrete to be exposed was not determined
by the mix or formwork design, then once the forms are removed, the surface can be treated
with techniques of extraction or the imposition of inscription (Mori 2002: 83). For example,
John J. Earley used chemical extraction at Meridian Hill Park in Washington, D.C., where
the "green" concrete was wire-brushed with Muriatic acid removing surface cement, and
then washed with water (Cron 1977). (See Figure 1.) Other possible alterations can be per-
formed by hand-manipulated equipment, such as broom-brushing, bush-hammering, sand-
blasting and water-blasting. Inscriptions can be cut into the surface to provide traction or
to improve rainwater run-off. Poorly installed concrete walkways eventually heave and these
protruding edges can be ground smooth so long as the steel reinforcing is not exposed and
retains sufficient cover. Some landscape architects also work with artists who add objects to
the concrete's finished surface before it sets. Inorganic objects remain permanently and
organic materials wear away, leaving indentations. The images can contribute unique expres-
sions of culture in public projects, enhancing a sense of place.

Concrete can be either formed in a factory as a pre-cast element or cast-in-place on the
construction site. These are two vastly different approaches to the way concrete is used as a
material, and require different thinking. Pre-cast concrete elements are typically made for

FIGURE 5. MOUNT TABOR MIDDLE SCHOOL RAIN GARDEN, PORTLAND, OREGON (2006). KEVIN ROBERT PERRY, CITY OF PORTLAND, OREGON. (Courtesy Kevin Robert Perry.) The striated finish of the concrete water basin captures the idea of water when dry as well as directing the flow in the rain.

architectural exterior enclosures or as structural components. Factory fabrication allows a higher degree of control and enhanced engineered properties. As pre-cast concrete elements, the methods of assembly and joinery become critical issues. Regularized panels can be installed in rhythmic patterns, creating a sense of unity, but the size of the elements is limited by road widths when transported for installation.

Compare this to concrete that is cast-in-place on site, which allows larger and more monolithic forms. The difference is that pre-casting is a *discrete* process that makes distinct pieces, whereas casting in place is a *concrete* process that makes a flowing and continuous mass. A further distinction is that casting in place has the potential to reveal concrete's ability to respond to local conditions in construction. Any solidified sense of flow and movement that demonstrates concrete's original liquid state is part of thinking in this material.

Innovative Applications

Innovative improvements for concrete are developing on two fronts: improved industrial production and better components that alter concrete's intrinsic properties. Methods for obtaining and refining constitute materials are gradually improving, as are more sustain-

able energy sources. Changes that increase the strength-to-weight ratio for instance, are easily appreciated if the added cost is warranted, and especially if the embodied energy total is lowered. Qualitative innovations include making concrete porous or translucent, or allowing it to self-repair surface cracks, or to bend, and resist seismic forces. These will enhance the durability of concrete, lengthening its useful life. Researchers and innovators are also investigating methods to improve concrete's sustainable attributes by testing applications for repurposing existing concrete. Specific areas for innovation include those listed below.

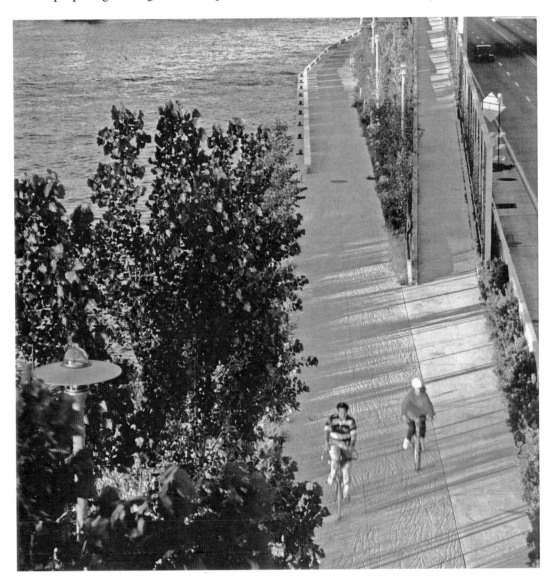

FIGURE 6. ALLEGHENY RIVERFRONT PARK, PITTSBURGH, PENNSYLVANIA (1993–2001). MICHAEL VAN VALKENBURGH ASSOCIATES, INC., LANDSCAPE ARCHITECTS, P.C., CAMBRIDGE/NEW YORK. (Photograph by Annie O'Neill. Courtesy Michael Van Valkenburgh Associates.) Artists Ann Hamilton and Michael Mercil pressed native reeds into the curing concrete surface, referencing the river ecology and providing a textured surface. The result is reminiscent of winter trees silhouetted against a clear sky.

FIGURE 7. OLYMPIC SCULPTURE PARK, SEATTLE ART MUSEUM, SEATTLE, WASHINGTON (2007). WEISS/MANFREDI, ARCHITECTS, NEW YORK. (Photograph by Brett Weidl. Courtesy Hoerr Schaudt Landscape Architects.) Staggered pre-cast concrete panels cover gabion retaining walls. Their overlapping assembly and sloped position take advantage of its form, allowing the thickness of the concrete to be minimized. The wall extends to a highway embankment, where the pattern is especially interesting at night when car headlights cast a bright light on the panels otherwise in shadow, and the illuminated edges follow the passing movement.

Better Concrete

Scientists recognize that increasing concrete's strength requires more carefully selected and more tightly packed stone aggregate with a designed density that fills the voids on a microscopic scale. In the 1980s, high-strength concrete (HSC), now called high-performance concrete (HPC), was devised as a new type of engineered concrete. This concrete uses techniques of nanotechnology to increase material performance by a thousand fold through packing equally sized aggregate into uniform patterns. Since the 1990s, ultra-high-performance concrete (UHPC) has allowed concrete to compete with steel for strength, and even to surpass it for its strength-to-weight ratio with improved tensile ductility and macroporosity (Ulm 2006: 219–21). The life cycle of the finished product is expected to be two or three times longer than that of regular concrete in exposed applications, and UHPC can be recycled two or three times in new concrete mixes before being ground up and downgraded into road drainage base aggregate (Calkins 2009: 113).

Rather than packing aggregate closer, pervious concrete opens it up, making it an ideal material for parking lot surfaces. Maintaining compressive strength, concrete is formed with up to 39 percent void space that allows rainwater to seep through constructed surfaces at a rate of up to fifty gallons per minute, rather than running off into storm drains or eroding

the land. The benefits of this type of concrete include avoiding concentrating stormwater, which can overwhelm waste and stormwater systems, and permitting rainwater to infiltrate the ground below the paving to recharge aquifers. Beyond the ecological benefit, and in spite of the additional maintenance to keep the joints free of accumulated debris, the higher initial cost is offset because property owners in some municipalities are eligible to receive mitigation discounts from surcharge fees for stormwater run-off from impervious surfaces, which are new regulations intended to reduce the negative environmental impact caused by unsustainable design practices.

Concrete that transmits light is now being made as engineered pre-cast panels with embedded fiber-optic cables. Products such as LiTraCon® were invented in 2001 by Hungarian architect Áron Losonczi, who is developing its capabilities to meet building envelope energy requirements (Van Hampton 2006). Concrete that insulates consists of aggregate additions such as perlite, and it is usually used for lightweight concrete applications like long-span roofs. Concrete that self-consolidates or self-compacts usually requires higher cement content, and research is being done on more sustainable alternatives. This expense and increased carbon footprint can be avoided with a bacteria-based strain that can tolerate the high pH level of concrete. This superplasticizer increases workability while reducing the amount of needed water, thereby eliminating the need for vibrating the concrete to eliminate the air pockets. This is a benefit for situations with difficult pouring conditions, in which vibration equipment cannot be used.

There are two approaches to repair cracked concrete. The conventional method injects epoxy cement grout, a sodium silicate solution, which fills interior gaps caused by settlement or shifting and restores the integral strength. An alternate method under investigation is self-healing concrete, in which bacteria or bio-minerals are added to the mix as dormant spores. Their calcium lactate "food" is encapsulated in tiny ceramic shells that crack with movement. The damaged concrete allows water to seep into hair-line surface fractures, activating released bacteria forming calcite or limestone, while at the same time oxygen is generated, which prevents the exposed reinforcement from rusting. The concrete is "healed" because the open cracks close, with this new filler preventing further damage from the weather.

Better Cement

Real innovation that addresses the environmental impact of concrete use will come with improved cement production. Cement requires extremely high temperatures to process the binder and releases one ton of carbon dioxide emissions for every ton of cement produced. Alternate cementing materials such as epoxy and sulfur may reduce greenhouse gas emissions generated by manufacturing because lower temperatures can be fueled with biomass materials, but they are not yet accepted by building codes. Geopolymers, which are synthetic aluminosilicate materials made with water-soluble alkali metal silicates and fly ash, may replace some or all of the typical crushed calcium carbonate stone, and these are also under investigation.

Sustainable alternatives use industrial by-products that would otherwise be disposed of in landfills. These include hydraulic cement (a type of slag cement) and pozzolan additives such as fly ash and silica fume. Molten slag, which is granulated and ground blast furnace slag (GGBFS) produced in steel mills, makes a cement powder and can replace up to 50 per-

cent of the Portland cement used in common applications and up to 80 percent in more massive structures. Fly ash is a by-product of coal-fired power plants that can be captured prior to its release into the atmosphere. It contains silicon dioxide and calcium oxide (King 2005). (ASTM C 618: Class F and Class C, which has some self-cementing properties.) Silica fume is a by-product of silicon and ferro-silicon metal production in electric-powered arc furnaces that is captured as smoke before release (ASTM C 1240). It increases the ability of concrete to withstand de-icing chemicals by reducing the permeability of chloride ions.

Air-cleaning concrete, such as Novacem's carbon negative cement, replaces calcium carbonates with magnesium silicates that absorb and store carbon dioxide, making it carbon negative at a ratio of one-tenth ton of carbon dioxide absorbed for every ton produced (Rosenwald 2011: 55). Another product called Eco-cement absorbs carbon dioxide from the ambient air during hardening, while another company called Calera mixes carbon dioxide emissions with salty seawater to make carbonates for cement.

Better Forms

Instead of using wood, metal or plastic forms that are either treated as disposable or have a limited life span, research is being conducted on polyethylene fabric with reusable reinforcing (Calkins 2009: 128–29).

Better Reinforcing

Steel used for reinforcement has a very high embedded energy cost due to the extreme temperatures required for production. Research on substitutes such as ceramic polymers and carbon fibers, polyvinyl-alcohol fibers and synthetic fibers is ongoing. Improvements that increase durability include Teflon-coated rebars that enhance corrosion resistance, and some projects find that stainless-steel rebars are cost effective.

Recycling and Repurposing Concrete

Recycling concrete from previously demolished projects impacts the environment because it avoids extracting and transporting "virgin" materials for manufacturing, and also saves on landfill waste disposal. According to the Concrete Joint Sustainability Initiative, one hundred and forty million tons of concrete are recycled in the United States annually. Post-consumer concrete can be repurposed in three ways. First, after determining the composition of the existing concrete and its intended use, a mobile recycling plant is brought to the site. Preparation activities include removing the steel reinforcing and any wood and dirt clinging to the concrete fragments. Different types of crushing methods produce different sized concrete chunks. Some are suitable to add as aggregate to new concrete mixes, and up to 20 percent of most new mixes can have recycled concrete as aggregate (CSI, Executive Summary). The second approach uses crushed aggregate as base drainage material instead of gravel for porous granular road setting beds, under concrete slabs cast on grade, or as retaining wall backfill. Concrete aggregate base or fill performs like loose stone rubble, holding air space in voids that occasionally fill with rainwater and handle freeze/thaw cycles that would otherwise threaten the integrity of the primary material. One problem with concrete aggregate backfill is that it has a higher pH factor than gravel, thereby limiting nearby plant

FIGURE 8. ORANGE COUNTY GREAT PARK, CALIFORNIA (PHASE ONE, 2010–2013). WORKSHOP: KEN SMITH LANDSCAPE ARCHITECT, NEW YORK. (© Tom Lamb/Lamb Studio.) Approximately 600 acres of concrete runway paving from the existing airport was repurposed for several uses on site, including fragments stabilizing earthen mounds.

selection to those that can thrive in alkaline soil. A third approach comes from a commitment to build in ways that repurpose as many materials found on site as possible. Doing so reduces the carbon footprint of the new construction by avoiding the consumption of new materials, reducing the need for transportation of materials to and from the site, and lessening the waste stream. For instance, existing concrete slabs can be broken into pieces and reinstalled as stepping stones and dry-laid type walls. The slab size is usually limited by the capacity of the removal equipment. Pieces broken along existing expansion joint locations will yield fragments that have sharper edges. Added labor is frequently needed to cut and seal the exposed steel rebar to prevent staining.

 Concrete is a mixed material composed in manufacturing and formed in construction. Its ability to make fluid shapes with strength, durability and permanence from common and economic base materials allows its relatively universal application, but the great energy consumption of some of its constitute parts demands that more sustainable alternatives be found for its responsible production. Designers who appreciate the plastic quality of concrete, with its ability to make flowing forms, have found inspiration in matching shapes with the flow of weight and gravitational forces of nature. Such designs allow concrete to fit harmoniously with the land, allowing each "to grow together."

Resources

Federal Agencies, Technical Societies and Associations

ASTM International—American Society for Testing and Materials, http://www.astm.org.

U.S. Department of Transportation, Federal Highway Administration, http://www.fhwa. dot.gov.

U.S. Environmental Protection Agency Comprehensive Procurement Guidelines, see for a link to construction products including cement fillers, http://epa.gov/epawaste/conserve/ tools/cpg.

U.S. Green Building Council (USGBC) is the developer of the LEED (Leadership in Energy and Environmental Design) rating system, http://www.usgbc.org.

Research on the Sustainable Production of Concrete and Cement

Athena Sustainable Materials Institute, Canada, and the U.S. Geological Survey publish research and calculations, see the Athena Environmental Impact Estimator for life cycle assessment and the environmental impact of concrete and cement in construction, http:// www.athenasmi.org.

Consumption calculations of global concrete and cement, now and anticipated, see the World Resources Institute (WRI) and World Business Council for Sustainable Development, Cement Sustainability Initiative, http://wbcsdcement.org.

Danish Technology Institute, link to Concrete Centre, see for articles on green concrete research, http://www.dti.dk.

EcoSmart Foundation, a not-for-profit Canadian corporation, brings ecological and economic practices together, http://ecosmart.ca.

Global Cleantech 100 conducts an annual review judging the top international 100 private companies researching and developing clean technologies, http://www.cleantech.com.

Green Building provides best practices guidelines and an online directory for projects of all scales, http://www.greenbuilding.com.

Lafarge, the world's largest construction company, lists over 500 different concrete formulations. For example, Thermedia™ is an insulating concrete with very lightweight aggregates that are 40 percent less dense than traditional aggregates, reducing the thermal conductivity by two-thirds; Agilia® is a self-placing and self-leveling concrete; Artevia® has surface coatings that make it resistant to wear; and Extensia® allows fast setting so formwork can be removed in four rather than twenty-four hours, facilitating construction schedules. See http://www.lafarge.com.

Portland Cement Association, http://www.cement.org and http://concretethinker.org.

Concrete Components

Coal Ash—American Coal Ash Association, http://acaa-usa.org; for current information on EPA regulatory proposals; see Citizens for Recycling First, http://www.recyclingfirst. org.

Fly Ash—Naval Facilities Engineering Service Center (NFESC), formerly the Naval Civil Engineering Laboratory (NCEL), is conducting tests on high-volume fly ash (HVFA),

looking at the long-term costs and benefits (including ecological) for waterfront and ocean facilities construction and operations, environmental impacts, and amphibious and exploratory systems. See publications available online, as well as http://flyash.com.

Pervious Concrete, http://www.perviouspavement.org.

Self-Healing Concrete—The International Conference on Self-Healing Materials (ICSHM) and Self Healing of Cement Based Materials (RILEM) follows research at the Delft University of Technology, Netherlands, and the University of Michigan, where engineers are developing bendable engineered cement composite (ECC).

Silica Fume Association, http://www.silicafume.org.

Slag Cement Association, http://slagcement.org; and the National Slag Association, http://nationalslag.org.

Chapter 2

Fire

Architects and especially urban designers fear fire, and with good reason. Architecture in its most fundamental definition provides protective shelter, but this enclosure quickly becomes a cage when people are trying to escape from smoke and fire. However, landscape architects embrace the ecological advantages of a controlled burn, much as Virgil in his book *Georgics* once praised the purified field (I.84). In either case, intense or tamed, out of control or intentional, fire as a material is dynamic, prompting human response to its presence or absence.

The definition of fire is both scientific and cultural. The *Oxford English Dictionary* defines it as a "natural agency or active principle operative in combustion; popularly conceived as a substance visible in the form of flame or the ruddy glow of incandescence." In the poetic imagination, fire provides a spark of insight that enflames or inspires an ingenious idea. Fan this metaphorical flame with various "fuels" or supports, such as hard work, experience, disciplined techniques, opportunities for expression and a bit of good luck, and positive results are likely. In reality and the imagination, when improperly contained, fire burns out of control, consuming oxygen and matter until exhausted, leaving behind only refuse and waste.

Material engineers and manufacturers are accustomed to thinking of fire as applied heat, an agent of change that transforms raw minerals into usable materials. Examples include concrete's hydration process, which gains strength while giving off heat, or manufacturing techniques that require extremely high temperatures to melt ore (separating and purifying it into distinct metals), or to bake pliable clay shapes (making sturdy brick and glazes that give ceramic surfaces permanent finishes), or to liquefy sand into a glass object that retains its shape when cooled. Artifacts made of worked metal, pottery and glass are the objects that survive for centuries, as do cement, concrete, plaster and brick to a lesser extent (Amato 1997: 15–34). Nevertheless, fire seems an unlikely "natural agency" to include with the usual list of available construction building materials, and it is not included in technical guides or material handbooks, and yet it may be the single most misunderstood material available today to the innovative design imagination. Beyond fire's role as heat in manufacturing or as a naturally occurring phenomenon, or as a symbolic representation of the active and masculine force in Chinese culture, for instance, the material of fire in its designed form is part of the full aesthetic experience, with powerful associations in human nature and purpose. Fire as energy "injects life, processes, and transformations into the inanimate world of matter, and thus into the world of architecture" (Fernández-Galiano 2000: 4).

Fire is regarded in contemporary culture with feelings ranging from popular appreci-

FIGURE 9. UNION STREET RESIDENCE, SAN FRANCISCO (2008). TOPHER DELANEY, LANDSCAPE ARTIST, SAN FRANCISCO. (**Photograph by Marcus Hanschen. Courtesy Topher Delaney.**) **A contemplative landscape designed around a distinctive *Magnolia grandiflora* with many contrasts: between the organic form and the enclosing walls, between ancient traditions of consuming wood as fuel for fires and a respectful relationship held at a safe distance, and between filling the space with the age of the tree and the fleeting presence of flame.**

ation of the profession of firefighting (especially since the tragedy of 9/11) to an association of fire with health pathologies such as manic depressive illness and artistic temperament. The Dark Ages refer to the ten centuries of intellectual darkness, superstition, and social and economic regression in Europe relieved by the creative fires of the Renaissance. What else do the words "You're fired!" mean but that you are released just like a bullet fired from a gun? So, too, fire as a material in design is manifested in its dichotomous attracting and releasing qualities. Destructive and purifying, fire is violent and frees people from darkness.

Properties of Fire

Some scholars consider fire less a material substance and more a process of combustion (Toulmin and Goodman 1982: 20). The inherent properties of fire produce heat and light that take various physical forms depending on the fuel and the container. Technically, fire is composed of the elements that allow it be active in combustion. The equation of components adds flammable or combustible materials, plus an oxidizer, plus heat above the flashpoint of the material that turns it into fuel, to equal the chain reaction of fire. It has no

inherent form except the general dynamic shape made by the gases rising from the burning fuel. The light that fire produces is part of its releasing activity.

Beyond the appearance of fire, scientists interested in understanding all the properties of fire investigated whether it has weight. Voltaire's eighteenth-century experiment to determine the weight of fire produced inconclusive results, mostly because the wrong question was being asked. Whatever the transformation of the fuel material, the composition of the air itself changed, making an accurate measurement of the weight of fire impossible at that time. Later in the century, the American Benjamin Thompson (known as Count Rumford) experimented with ways to measure the heat generated by friction, identifying molecular motion as a by-product of fire.

Understanding fire as a dynamic material means its properties include both its physical composition and its considerable effect. The devastation and social impact of urban fires prompted city officials to change legislated regulations in response to its threat. Under Benjamin Franklin in the 1730s, Philadelphia was the first American municipality to form volunteer fire brigades. Cities added high-pressure water-main system infrastructure to supply fresh water and to service public hydrants, but truly effective multi-departmental responses to fires began only after the National Bureau of Standards, formed in 1901 and known as the National Institute of Standards and Technology after 1988, standardized fire-fighting equipment. Cities also adopted building codes that limited exterior building material choices to those that are noncombustible and mandated fireproofing to protect interior steel structures. Zoning regulations established building to street set-backs and minimum distances between buildings so as to inhibit spreading fires (McMorrough 2006: 116–19). An early example is London after the Great Fire of 1666, where streets were widened and noncombustible stone, brick and stucco replaced combustible wood and thatch for exterior finish materials. In the United States, insurance companies prompted the founding of the National Fire Protection Association in 1896, which lobbied to limit building heights and to create land use–based zoning, especially restricting the location of factories within cities. As urban populations grew, public safety also depended on artificially lighting the main streets, and so providing and maintaining gas street lamps in the nineteenth century and electric street lamps in the twentieth century became part of the government's service and remains a significant operating expense. LED light fixtures (light-emitting diode, a semiconductor light source) were originally developed in the 1960s as indicator lights. In the twenty-first century, they are preferred because they provide better light with less trespass and are more cost-effective to operate, lasting up to 100,000 hours depending on the installation situation. The disadvantage is that even these light fixture types eventually fail and they contain lead and arsenic, which can leach into the soil if improperly disposed of in landfills.

From the late nineteenth century, building codes required egress halls and stair enclosures to be made of assemblies that protect people from fire, smoke and combustion gases for at least two hours, giving them time to evacuate the building. Fire-rated interior demising partition walls are required between dwelling units. To this end, the American Society for Testing and Materials (ASTM) was formed in 1898 to test materials and rate their combustibility. Today, this organization reviews 12,000 standards for 135 countries. To further protect human life and property, active systems were also developed, with standpipes and water sprinklers typically mandated for commercial buildings and places of assembly, although some residential districts now require them as well. Water-less Halon gas systems

are used in museums and computer facilities, where extinguishing water is even more damaging than flame and smoke.

In the landscape, one mission of the National Park Service is to prevent unwanted wildland and forest fires that consume over a million acres of land annually, cost billions, and add significant amounts of carbon dioxide to the atmosphere. For example, the carbon footprint of the California forest fire of 2008 produced 231 tons of CO^2 emissions (Berners-Lee 2011: 261–62), about 4 percent of the total output for the country for the entire year (www.climatecentral.org). Today, most places in the United States prohibit open fires or restrict them to specially prepared areas for Fourth of July celebrations. Since the 1720s, families in New Orleans have built up to thirty-foot-high wood structures along the Mississippi River (now along the levees) for Christmas Eve bonfires. This tradition started as way to encourage people to clear driftwood and debris before the spring snow melt swelled the river. In 2012, 110 permits were granted for the bonfires and tour companies offered river cruises to enjoy the spectacle. In Japan, it is a crime to start a fire (Lyons 1985: 3), while in Italy, the town of Taggia hosts annual fireworks festivals, which feature massive bonfires in city squares and hand-held "bambu" rockets directed at merry-makers (fortunately with surprisingly few injuries). Symbolically, fire can be part of political demonstrations of free speech (in which draft cards were burned during the Vietnam War era, for instance, or American flags or "dangerous" books are burned in protest).

On a global scale, the most significant fire is the sun, although the "fire" is actually the thermonuclear fusion of hydrogen nuclei into helium and not an event of combustion. Sunlight embeds solar energy in other materials. This latent energy accumulates in inert materials such as stone and masonry, whose thermal mass allows heat to be released as radiant energy, and in trees, whose wood can be burned as fuel at our convenience. Fire's combustion processes satisfy many human purposes so long as it is controlled.

Fire in History

The origin of fire, for some, is considered a sexualized act of rubbing of two sticks together, producing a spark. Others speculate that humans first saw fire in volcanic eruptions or as a result of lightning strikes that sometimes caused wildfires. Either way, archaeologists argue about the location and date of the earliest evidence of the human use of fire. Recovered charred wood remains have been found in the Zhouhoudian Cave in China dating from 700,000 BCE, as well as at Gesher Benot Ya'agov in Israel dating from 790,000 years ago. Evidence of domestic fires used for cooking, warmth and light has been dated from the Middle Paleolithic period (c. 200,000–400,000 years ago). In ancient Greek cities, fire was carried from the sacred hearth guarded by Vestal Virgins of the "mother" city to light a fire on a new colony's sacred hearth, which made that place the town's focus (Rykwert 1976: 39, 59). This is loosely reenacted as part of the modern Olympic Games, when a torch is carried from Olympia, Greece, to the host city, and the games are ceremoniously ended when the flame is extinguished.

Empedocles was a fifth-century BCE Greek natural philosopher, poet, prophet and material physicist. He wrote two poems, "On the Nature of Things" and "Purification," of which considerable fragments survive. These works are the earliest records that explore the four elements of matter—fire, water, air and earth—as a way to comprehend the physical

world. He argued that there were two cosmic forces of love or attraction (combination) and strife or repulsion (separation), and this explained the behavior of materials. This philosophical system is the basis for understanding the cautious relationship between fire and human activity that burns fire to clean, to clarify and to illuminate.

A century later, Aristotle developed his philosophy about the matter of the world and its relationships in a theory he called "the four causes" in his book *Metaphysics*. The material cause of fire, in the form of heat and light, was a final cause of purpose that asked an "in aid of what" question (Δ.2). Hence, fire has properties coinciding with definitions based on what it is and what it does. For people, this means that fire as heat cooks food and provides warmth, and fire as light provides security and illuminates the darkness. The accoutrements and operations of dwelling and the critical placement of fire-related elements therefore extend from the cooking pot that does not melt on the noncombustible hearth to the illuminating lamp.

Vitruvius, influenced by Epicurean philosophy known through Lucretius, wrote that physical fire supports the formation of human society and the origins of architecture. Dwelling began in a clearing in the forest. Surrounded by combustible trees and brush, land was cleared and leveled to make a place for a small, safe fire, where people could gather around its thermal space (Leatherbarrow 2004: 114–15). This hearth became a social place, a place of community and of rite and ritual. In Vitruvius' account, this deliberate assembly of people prompted the invention of language (II.I.1). Civilization was encouraged because, as he said, "to supply heat, the mighty sun is ready, and the invention of fire makes life more secure" (VIII.Introduction).

A century later, natural philosopher and historian Pliny the Elder praised and appreciated the finishing power of fire. He remarked on the fiery transformation of sand into glass, or how stone could be tempered into iron or smelted into copper. Fire purifies gold and burns limestone crushed for concrete. Through multiple burns, wood turns into charcoal, valued for heating interior spaces with portable braziers (and not fireplaces) especially useful for places of social gatherings and symposiums (also described by Vitruvius, VII.IV.4). Fire had medicinal powers, as the ash/lye's base composition counteracts the acids of an upset stomach. Pliny concluded his analysis by saying, "Fire is a vast, violent element of Nature, and it is a moot point as to whether its essence is more destructive or creative" (XXXVI.200–201).

In 1450, Renaissance architect and writer Leon Battista Alberti wrote in his treatise *On the Art of Building in Ten Books* that the roof and walls were the origin of architecture and not fire, but that the hearth was the original architectural element (I.2). Thus the domestic fire became the centralized place to gather for warmth and safety. The hearth fire made small and portable became the torch carried by hand that provided illumination in ways that safely extended daytime activities into night.

The transforming capability of fire is the reason for its place in myths about human invention. Devices that controlled fire allowed people to live in colder climates and to see in the dark. According to Greek mythology, this way of life was made possible because of a crime. Prometheus stole two things from the gods, who feared the independence primitive mortals would now achieve, thinking it would produce only misery: he stole the gift of skill in the arts and the gift of fire that allowed this skill to be used. Mortals had made things before this theft but lacked inventiveness, and now culture, art and literacy were possible. The penalty for this crime was horrific. Prometheus was chained to a mountain where Zeus's

eagle ate his liver—the principal human organ associated with fire—every day for thirteen generations. Every night Prometheus healed in the darkness only to be tortured again the next day. Zeus also punished mortals for receiving these gifts by sending Pandora with her box of evil, despair and all other vices, with only the virtue of hope to ease this new condition. The French phenomenologist Gaston Bachelard associates the myth of Prometheus with a lesson of respect (1964). Respect for fire, usually a painful lesson learned only from direct experience, is the lesson that fire consumes what it touches, releasing its powers of transformation.

Before mechanical heating systems were developed, the skill of craft and the power of fire were united in the masonry fireplace, hearth and chimney. These were difficult to build well, and much literature comments on drafty rooms poorly heated by smoking fireplaces, making them almost uninhabitable. The domestic dependence on heat from a fireplace lessened in the mid–eighteenth century with the development of Benjamin Franklin's wood-burning metal stove that was inserted into existing masonry fireplaces, although his invention came to mean any free-standing stove. By the mid–nineteenth century, manufactured heating equipment and ducted distribution systems were available from New York City and mail-order catalogs. American landscape architect and writer on domestic architecture Andrew Jackson Downing advised that while these systems were more efficient and produced more comfortable and safer heat, homebuilders were still to include a "cherry, open fireplace" in the newly named "living room" for its "genial expression of *soul* in its ruddy-blaze, and the wealth of home associations that surround its time-honored hearth." He also urged home-builders to prominently display factory-fabricated terra cotta chimney tops as an expression of the domestic building type (Downing 1968: 480–81). Today, the association of fire with the hearth, dwelling and social gatherings is mostly gone in developer-built housing, replaced by flat-screen televisions and relatively invisible, and certainly more efficient, mechanical heating and air-moving equipment (unfortunately usually powered by nonrenewable fossil fuels). Further, the wasteful over-reliance on artificial lighting and unnecessarily high light levels has become the expected norm. This is a particular area where more sustainable practices recommend reducing building energy loads by making access to daylight a more integral part of the design.

Theories of Fire

Bachelard considered the role of the four agents of change and wrote that fire "alone is subject and object" (1964: 111). As a subject, it causes a *rising* or elevation in our ability to transform materials, technically enhancing the safety and convenience of our activities, while causing a *falling* in the consummation of what must be transformed in order for this to happen. As an object, fire exists as we exist—that is, as a living body that consumes, radiates warmth, produces waste, dies and grows cold—and for this reason it can never be free of metaphorical associations. *Thinking of fire as a balance between these two conditions—a physical and dynamic reality with consequences and a substance desired by people for warmth and light—is the theoretical basis for its innovative use as a building material.*

Used for human purpose, the transformative fire purifies by separating and isolating materials, enhancing worth. This is a violent act of extreme heat, requiring careful control but producing valuable results. All combustion processes require energy, and sustainable

FIGURE 10. COURT SQUARE PRESS COURTYARD, BOSTON (2006). LANDWORKS STUDIO, INC., BOSTON, MASSACHUSETTS. (Courtesy Landworks Studio, Inc.) Similar to a campfire experience, people gather on the lighted wood and Lexan benches in this public park that the designers envisioned as an illuminated bamboo forest.

practices insist that the embodied energy of such manufacturing events be included when evaluating the carbon footprint of an object. Thus it is impossible for materials used in construction to have zero-net energy design, but it is possible to use products of the highest possible quality so that frequent replacement is less likely. Once made, transported and installed, their efficient operation can approach zero-net energy with on-site power generation compensating for continual energy demands.

People consume energy for heat and light. Those who live in more developed cultures use more power-driven technical devices, and those who live in climates with extreme surface air temperatures require more energy to adjust ambient interior room temperatures for human comfort and convenience. Until non–fossil fuel energy sources are more practically available on a regional scale, populations in these places and with these needs will consume a disproportionate share of energy resources. Unfortunately, increasing engineering efficiency of mechanical equipment only perpetuates attitudes of unconscious overconsumption. Fire as light is also out of balance. Since the invention of electricity and the efficient manufacturing of lamps and light fixtures, as well as false assumptions of abundant cheap energy, people have developed unreasonable expectations of artificial lighting levels.

Devices for artificial lighting have evolved over time. In order to make fire portable, lamps or torches were devised and gradually improved. Early lamps consisted of a handful of reeds soaked in fuel and ignited, yielding little light and lots of smoke. The Chinese collected natural gas in skins for lamps. In the West, oil lamps were invented in 1783 in Switzer-

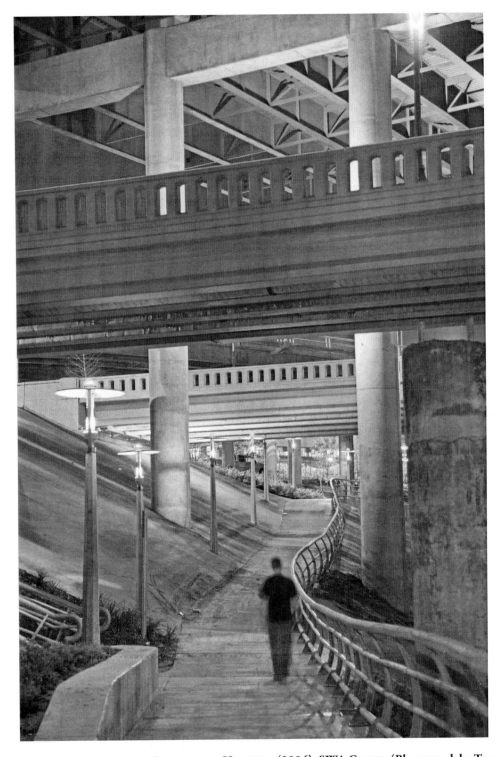

FIGURE 11. BUFFALO BAYOU PROMENADE, HOUSTON (2006). SWA GROUP. (Photograph by Tom Fox. Courtesy SWA Group.) Artificial LED light fixtures illuminate the path, increasing a sense of safety at night. The concentrated lighting design avoids excessive spill.

land, gas lamps in 1792, and coal gas lamps were invented in England in 1804. German experimenters in 1853 developed kerosene made from coal for lamp fuel. Whale oil lamps were used from the mid–1700s to early 1800s, and many whales were killed for their blubber. Beeswax candles with openly woven cotton wicks provided smokeless light, but they were expensive. Like laying a fire, these various fuels and light fixtures required attention and caused many fires when neglected. Electricity was the significant breakthrough in artificial lighting. Sir Humphrey Davy invented the first electric carbon arc lamp in 1801, and Michael Faraday's experiments in electricity in 1831 led to the electric lightbulb. Thomas Edison installed the first electric street lamps in Menlo Park, New Jersey, in 1879. Today, building codes require artificial lighting at every exterior door and for all stairs and ramps, and it is prudent for designers to light paths and other significant grade changes where people expect to move safely both day and night.

Fire can be used politically, as destructive expressions of protest or victorious conquest. It is used socially because its thermal properties encourage people to gather. Following Vitruvius, nineteenth-century German architect, historian and theorist Gottfried Semper posited that architecture began as a protective enclosure surrounding the fire and hearth (about which see the following chapter) (Semper 1993: 102). It is also geographical because its artificial replication allows us to increase the extent of occupiable territories, and it is certainly temporal because it extends human daylight productivity into night. Thus tamed for

FIGURE 12. COLUMBUS CIRCLE, NEW YORK CITY (2001–2005). OLIN, PHILADELPHIA AND LOS ANGELES. (Photograph by David Graham, © OLIN.) In a city as dense as Manhattan, public space that reduces the overwhelming scale to one of intimacy is valued. Surrounded by fountains in the summer that turn into an amphitheater in the winter, the local community has a place to gather both day and night.

human purpose, fire as a material used in design is open to innovative use in its employment, especially in the power of fire as light.

Innovative Applications

Artificial lighting supplements natural daylight and substitutes for it at night. Because energy consumption estimates for artificial light in a typical office building are about 30 percent of the total energy use, plus about 20 percent for the required additional cooling load needed to offset the heat given off by the light fixtures, designers are embracing techniques of design that use daylight to the greatest possible extent. Factors such as site location and orientation, building mass, window-to-wall ratio, glazing type, space purpose, and the color of interior finishes and furnishing materials affect interior daylight performance. Thin buildings (with 40 feet or less between exterior walls) with high ceilings (twelve feet is ideal) and large windows allow daylight to penetrate fully into the room depth, minimizing the need for artificial lighting during the day. Roof apertures such as skylights; windows above eye level called clerestory windows; large, open central spaces such as courtyards or atria with skylights; and even small, unoccupied light shafts bring daylight into buildings that have such deep floor plates that daylight cannot reach into the full interior. In addition to avoiding the overuse of artificial light and the heat generated by artificial light fixtures, rooms with daylight also benefit their occupants, who appreciate experiencing the dynamic qualities of natural light as it changes throughout the day.

In general, light fixtures are designed not to be noticed; however, designs that conceal the light source limit the perceptible qualities of fire as light. Unlike fire, artificial light fixtures cannot offer perceptible experiences of heat, sound or smell to the senses, but when make visible, they offer a sense of orientation and direction. Instinctive decisions to approach or retreat are human responses to environmental stimuli, and this instinct is most reliable when the potential threat can be seen clearly. Artificial light has the ability to both provide general illumination and direct attention, and it is in this role that it supports human sentiment. Just as a chandelier in a dining room centers the space over the table, a center light enhances a feeling of coming together and of focus in a room meant for conferences. Successful lighting in a more supporting or secondary role is usually evaluated for efficient illumination, matching light levels to specific activities, limiting glare from direct sunlight with shading devices, and providing electronic controls that reduce waste. Innovative light fixtures that are more efficient, "smart" (responsive to human interaction) and playful have the potential to make the qualities of light integral to interior design (Brownell 2006: 204–16). Fiber-optic cable technology allows daylight to be transported to interior rooms that cannot risk sparks from conventional electrical devices, such as testing laboratories with non-oxygen or all-oxygen atmospheres, and to illuminate rooms without mechanical devices. Existing buildings being upgraded for more sustainable operations might consider adding bundles of fiber-optic cables rather than inserting light wells (with numerous associated structural complications) to bring natural daylight to interior spaces. In the landscape, minimizing artificial light spill reduces excessive light pollution and is a goal of sustainably designed projects that support the "night skies" movement (Thompson and Sorvig 2008).

In a similar fashion, buildings with south-facing windows can take advantage of thermal heat gain with absorbing floor and wall materials, and find that the radiant properties of fire

FIGURE 13. FLW SOLAR HEMICYCLE, RESIDENCE OF KATHERINE AND HERBERT JACOBS, MIDDLE-
TOWN, WISCONSIN (1944). FRANK LLOYD WRIGHT, TALIESIN, WISCONSIN. This house employed
many design elements recommended today for sustainable design: careful siting for passive radi-
ant solar heating and natural cooling, with a concrete slab and limestone walls that absorb day-
light and radiate heat at night; earthen berms to the south, west and north that divert cold winter
winds; a fourteen-foot-high south-facing glass wall that allows winter sunlight to enter, with
large roof overhang to shade the sunlight during the summer; and cross ventilation flowing from
windows on the lower level to the north-facing clerestory windows on the upper level. This house
was designated a National Historic Landmark Building in 2003.

provide comfortable and free heat at night. George Washington understood this principle
well and his kitchen garden's brick walls have a southern exposure, thereby extending the
growing season, a significant advantage for this self-sufficient farm. (See Figure 21.)

To question what innovative use is possible with a material such as fire requires designers
to look to the past as much as to the future. The fear of harm has prompted mechanical sub-
stitutions, but something has been lost because fire's qualities also benefit people viscerally.
Before electricity, most buildings were mean shelters with few openings to the outside, and
they were drafty with inefficient heat or unbearably smoky (Gissen 2009: 44–57). Depending
on the abundance of firewood, many people considered warm food a luxury. Today, sustain-
able architecture takes advantage of passive heating and daylight in its design, which lowers
operating costs and raises occupant satisfaction.

In Arlington National Cemetery in Virginia, President John F. Kennedy's gravesite is
marked with an eternal flame. Nothing less seemed adequate to a nation in mourning over
his assassination. People are drawn to the gravesite for many reasons, and once there, their

eyes focus on the flame. The orienting power of fire is inescapable. We are drawn to it because, like Prometheus, we appreciate its performative and transformative capabilities. Fire used inventively forms matter. Luis Fernández-Galiano observes that "the relation between form, matter, and energy [is] the capacity of matter to accumulate energy as *in-formation*, and the need for matter to receive energy to maintain its *con-formation*" (2000: 62). The potential accumulation and use of that energy, as daylight or thermal radiation, is free and eternal (and, in most places, abundant). For people, sustainable design means not only less wasteful and more responsible use of nonrenewable natural resources but also more consideration of dwelling within communities that are focused on their physical and emotional well-being.

Resources

Federal Agencies, Technical Societies and Associations

American Solar Energy Society advances research, education and policy for solar professionals and advocates, http://www.ases.org.
International Association of Lighting Designers, http://www.iald.org.
Solar Energy Industries Association is a national trade association of member companies that research, manufacture, distribute, finance and build solar projects domestically and internationally, http://www.seia.org.
U.S. Department of Energy, National Renewable Energy Laboratory, National Center for Photovoltaics (NCPV); for technology innovations in research, development, deployment and outreach, see http://www.nrel.gov/ncpv.
U.S. Fire Administration is the leading federal agency for fire data collection, public fire education, fire research and fire service training, http://www.usfa.fema.gov.

Research on the Sustainable Practices of Daylighting

Lighting Research Center of Rensselaer Polytechnic Institute develops lighting technologies and applications and monitors energy use, with design concerns ranging from health to vision, http://www.lrc.rpi.edu.
Natural Daylight: Sustainable Architecture and Building Magazine, http://sabmagazine.com.
Whole Building Design Guide, a program of the National Institute of Building Sciences, offers online courses and Federal Energy Management Program courses, http://wbdg.org.

Solar Energy

Solar Electric Power Association is an education nonprofit that helps utility companies integrate solar power into their energy supply portfolios, http://solarelectricpower.org.
Solar Rating & Certification Corporation develops and implements national rating standards and certification programs for solar energy equipment, http://www.solar-rating.org.

Chapter 3

Metals

Cold, hard and thin, but with great strength (especially in tension), metal and the fire required for its production are inextricably united. When metal is formed into a basin, fire's transformative power is contained and becomes available for human purpose. Gaston Bachelard explains fire's relationship to metal in a designer's imagination when he observes that "metal is the reward of a dream of brutal power, the very dream of *excessive fire*" (1964: 182). Metals need extreme heat to convert mixed ores into pure and distinct metals that are formed and cooled into permanent shapes. This makes metals a manufactured material, unlike the other materials that could be taken and made into building material without the use of fire, such as wood, stone, earthen mud, woven thatch, hides and wool (Amato 1997: 28). The required industrial processes both give refined metals a very high embodied energy and produce toxic by-products. The heavy weight of metal components means high transportation costs for getting fabricated elements from the factory to the site. The maximum possible size is also limited by the means of transportation. Once on the construction site, specialized skills are needed for assembly, with either hot connections that are welded or cold fastening connections with nuts, bolts, washers and rivets. Nevertheless, once this sequence is complete, metal endures.

The Stone Age, the prehistoric period that lasted over three million years, ended with the development of metalworking. The first pure metal elements were found in streambeds or came from shallow mines, and they were identified in recognizable states, often by color. Gold and silver were easily identified in a relatively pure state. Lead could be separated from silver through heating. Copper was found in malachite and tin in cassiterite. Once found and extracted, ores were purified into single elemental metals by processes of physically crushing and separating the valued metal from the waste (also called tailings), by chemical leaching (in which solutions allowed the waste to dissolve), or by heating.

Metal alloys are formed when refined pure metal elements are combined. Bronze is an alloy made by melting tin and copper, which in a pure state is too soft for useful tools, over a carbon-producing wood-fueled fire that reaches the needed temperature of 1,083°C. By 1200 BCE, coal was used for fuel in blast-like furnaces that produced higher temperatures in excess of 1,500°C, which allowed the Iron Age to begin. Today, ores are mined in large-scale operations that extract them with great environmental damage to the air, soil and waterways, and metal production carries a high carbon footprint because of the extreme temperatures needed for refining.

"About three-quarters of all elements available can be classified as metals, and about half of these are of at least some industrial or commercial importance" (Brady et al. 2002:

593). As a material, formed metals have distinct advantages over other materials (see Figure 14). They are not bulky and have a superior strength-to-weight ratio, making metals the ideal material for jewelry, bells and other musical instruments, weapons, tools, and construction. In spite of the durability of this material, even metalwork eventually fails due to fatigue, rust or obsolescence. Fortunately, unlike other materials, "the potential for nearly endless recycling may be the most sustainable characteristic of metals" (Calkins 2009: 362–66).

Aluminum is the most common recycled material at 57 percent, and new steel can have between 25 and 100 percent recycled content. Refrigerators, for instance, can have up to one hundred pounds of steel that is suitable for recycling (U.S. EPA). Specialty scrapyards want copper and brass. Even tiny bits of precious metals are almost always recycled. Building metal parts are more likely to be recycled when constructed assemblies are fastened with cold connections that can be unscrewed or unbolted, making the quality of the metal fasteners important, too. And this process can be repeated indefinitely without down-cycling, unlike wood's reductive process, which can never be reversed and reformed into a tree or solid lumber once shredded or chipped. Designers who specify materials with a high recycled content are practicing sustainable construction methods. Further, working with engineers to specify the most efficient alloy mix for structural steel, for instance, ensures the most sustainable use of metal materials.

The ability of metals to combine for various purposes with different qualities is due to their crystalline solid structure (Brady et al. 2002: 594). New engineering techniques force the separation and alignment of metal alloys on a molecular level, producing, for example, steel with such capabilities as self-protective coating generation and internal monitors that detect stress, strain and cracks (Addington and Schodek 2005: 41–44).

Properties of Metals

Metals are strong and tough, stable, ductile, resistant to fatigue, poor insulators, and conductors of heat and electricity. As ores, metals have great compressive strength. Once purified, metals do not revert back to their original composition except, to some extent, if ferrous metals are allowed to rust. They also do not react to other materials and take on new qualities. Depending on the blending mix, properties of strength, workability, ductility and brittleness are balanced for the projected purpose. Metals have the capacity to return to their original shape after some deformation by temporary pressure, and they can do this repeatedly, to a certain point, without fatigue or breakage. This energy storage or "memory" allows a paper clip to bend and hold, or a mattress spring to deflect and still support a body. On a molecular level, different metals have more "free" electrons. These allow metal to conduct electricity and heat, but they also make metals vulnerable to degradation in installations exposed to the weather. Corrosion results when two unlike metals touch with oxygen and moisture present. Bimetallic corrosion occurs when the galvanic action of the more noble (more resistant to oxidation and corrosion in moist air) metal gives off ions, causing the less noble (also called active or base) metal to corrode. Different metals also expand and contract at different rates—they have different coefficients of thermal expansion—and this can cause stress and even result in failure.

Metal types are generally divided into two broad categories: ferrous metals, which contain iron, and nonferrous, which do not. Nonferrous metals are further divided into light

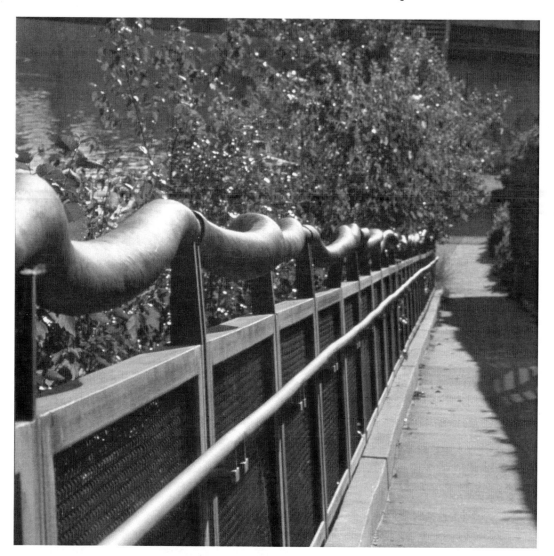

FIGURE 15. ALLEGHENY RIVERFRONT PARK, PITTSBURGH, PENNSYLVANIA (1993–2001). MICHAEL
VAN VALKENBURGH ASSOCIATES, INC., LANDSCAPE ARCHITECTS, P.C., CAMBRIDGE/NEW YORK.
(Photograph by Annie O'Neill. Courtesy Michael Van Valkenburgh Associates.) Artists Ann
Hamilton and Michael Mercil sculpted a bronze handrail that flows gradually down the ramp
without abruptly changing angles at the landings.

metals—including aluminum (which is the second most widely used metal in building),
magnesium, titanium and beryllium—and heavy metals—including copper, lead and mer-
cury. Two common alloys are bronze (copper and tin) and brass (copper and zinc). Refractory
metals melt at temperatures above 3,000°C, are mostly toxic and used primarily in industrial
applications. Other metals infrequently used in design are the precious metals that resist
corrosion well, have a high density, and are rare and costly. Of the ferrous metals, iron com-
bined with at least 50 percent carbon makes steel. The presence of iron oxide tends to make
metals rust when exposed to moist air if unprotected.

Metals are formed into desired shapes primarily in two ways. Wrought techniques take

metal elements in a heated and softened state and force it into new shapes. Casting and forging requires the metal to be completely melted so that it can be poured in a liquid state into a mold. Metals in a molten state can also be extruded, rolled or drawn (in which the material is passed through a series of rollers, or pulled into a fine wire or tube) (Bell 2006: 145). These forming techniques allow metals to be stretched into thin planer surfaces or formed into load-bearing structural members that have both tensile and compressive strength, or into malleable wires that are only strong in tension.

Metals can shine. This finish occurs naturally with the noble metals that resist corrosion and need no protective coating. Their shininess reflects light and their natural radiance appeals to human sentiment. Radiant metal finishes are valued in objects ranging from gold wedding bands to chrome-plated detailing on a sports car, although flat black vinyl is the industry's response to more sustainable trim manufacturing. Most metal products require a protective coating when exposed to environmental conditions. Sustainable practices recommend mechanical rather than chemical finishes (Calkins 2009: 361). Factory-applied chemical finishes include applied powder coatings and are preferred over field-applied solvent-based sprays because the toxic process is better controlled and safer for workers, and the results are more durable. Aluminum can be anodized (an electrolytic passivation process), giving it a permanent finish that increases corrosion resistance and surface hardness and also allows better adhesion of colored paints. The additional cost is practical for metal roofs because it is long-lasting and maintenance-free.

Stainless steel needs no coating and does not rust because it is an alloy made primarily of iron, manganese, silicon, carbon and at least 10 percent chromium. This composition reacts with oxygen from water and air to form a film that is a passive and stable barrier, preventing corrosion. It is appreciated for its permanent and maintenance-free shininess, although the surface can pit over time due to the accumulated dirt in atmospheric pollution. Cor-Ten steel has self-sealing properties that allow rust to form a permanent protective coating that inhibits further corrosion. This has significant economic advantages for bridges, for instance, where maintaining the protective coating usually mandates a regular painting schedule. Steel, iron and copper surfaces can also be protected by a galvanizing process, of which the most common hot-dip coating is zinc (Calkins 2009: 358). This makes the metal corrosion-resistant and self-healing because when it is scratched, the coating corrodes a little, protecting it from being tarnished (Lefteri 2004: 126). Zinc coatings are also good for metal roofs located in regions exposed to the salts of sea air.

The effects of weathering on unprotected surfaces are sometimes appreciated for metals such as copper. For example, the greenish patina that accrues on a copper roof as a result of oxidation is valued for its positive association with longevity, rather than serving as an indication of impending material failure. A bronze statue of a patron saint that has long since oxidized into a dark patina sometimes has a polished foot, where people passing by touch it in a gesture of respect, and inadvertently keep dust and loose dirt from accumulating.

Metals in History

Of the eighty-six metals known today, only seven were in use before the thirteenth century. Gold, copper, silver, lead, tin, iron and mercury are known as the Metals of Antiquity, and none were used as a primary material for heavy construction. Their discovery and uses

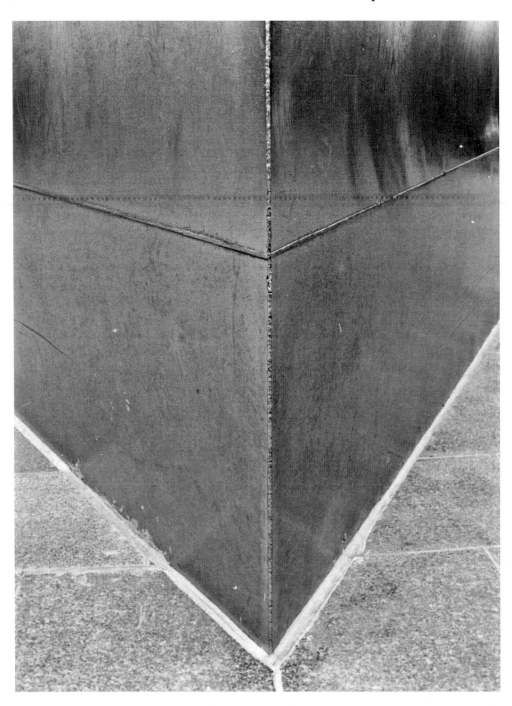

FIGURE 16. GATEWAY ARCH, ST. LOUIS (DESIGNED IN 1947, COMPLETED IN 1965, OPENED IN 1967). SAARINEN AND ASSOCIATES, HAMDEN, CONNECTICUT. (Courtesy National Park Service, Jefferson National Expansion Memorial.) A stainless steel skin was used to cover the inverted and weighted catenary arch. It was welded over carbon steel with a reinforced concrete base and lower core. It is the tallest man-made monument in the United States and the tallest stainless steel monument in the world. This memorial was placed on the National Register of Historic Places and became a National Historic Landmark in 1987.

were described by Lucretius, a Roman poet and natural philosopher who wrote *On the Nature of Things* in 50 BCE, explaining Epicurean philosophy, which was based on understanding physical forces scientifically and not based on superstition or religious influences. Lucretius included commentary on the value of the harder brass and bronze alloys for tools (1904: 5.1270–1328, 6.948–55, 6.1077–88).

Gold jewelry pieces dating from 6000 BCE are the earliest recovered metal artifacts. Copper objects from 4200 BCE had more uses, as the metal was relatively easy to find and could be hammered into useful tools and weapons. Silver was used about two centuries later and was found to be harder than pure gold, although still too soft to use for non-ornamental purposes. Lead was formed into pipes and lined vessels from about 3500 BCE, and the Romans employed it for their water supply and wastewater system. Although the dates for the development of tool-making technology vary with cultures and geographies, the Bronze Age began when methods for smelting tin originated in western Asia. The Chinese cast ceremonial bronze bells and made cannons and swords that were harder than previous weapons and could hold a sharp edge. These refinements changed methods of warfare, and the societies who mastered this metal dominated those who lacked the technology.

The Iron Age followed the Bronze Age, with the use of this metal causing the greatest impact on cultural development. It was the "first metal for the masses" (Amato 1997: 28). Processes for smelting iron date from 1200 BCE. Some scholars consider Japanese samurai swords from the seventh century CE to be the finest metal objects ever made, complimenting the balance of strength, utility and beauty.

Pliny the Elder wrote about humanity's greed and exploitation of the earth's resources, noting the sheer indulgence of mining its depths for riches, as if the earth's surface did not satisfy our needs. He included a section about mercury "always in liquid form," which is "universally poisonous and destroys any container" but is very good for refining gold (XXXIII.99).

Alberti recorded applications of the seven Metals of Antiquity in his chapter on construction. He recommended stabilizing stone joints horizontally with metal cramps in dovetail shapes or vertically with pins. If iron was used, Alberti called for tempering it with white lead, gypsum or liquid pitch to protect it from rusting. He did not consider wood connections to be inferior to iron, but they were to be "anointed with pure wax or oil lees" to protect them from rotting. Brass or bronze lasted longer than either wood or iron, and they were to be protected with coatings of bitumen, oil, liquid pitch or wax (III.11). Stonework was to have gaps filled with soft lead. Alberti, both architect and artist, wrote that important doors on sacred buildings should be made of bronze with bas-relief sculpted panels. He also considered the greatest ornament to any public space to be a bronze statue, and advised that it should be hollow cast work with a "thin skinlike layer," so as to discourage any future temptation to melt the artwork and use the bronze for another purpose (VII.15–17).

Five additional metals came into common use between the thirteenth and nineteenth centuries: arsenic, antimony, bismuth, zinc and platinum. Cobalt, nickel, manganese, molybdenum, tungsten, tellurium, beryllium, chromium, uranium, zirconium and yttrium were isolated and identified during the 1700s. In the nineteenth century, forty-one more metals were discovered, of which only aluminum (in 1825) has played an important role as a material in design. The final nineteen metals discovered in the twentieth century are heavy radioactive metals and are not used in the productive arts (Cramb).

Before the nineteenth century, experimenters used trial-and-error methods to investi-

gate the relationship between various blends, seeking to alter the final properties of alloys that could be made harder or softer, and more rigid or more ductile. Experiments also tried various coatings applied to protect metal from corrosion due to exposure. Modern metallurgical advances began in the nineteenth century, when Englishman Henry Clifton Sorby cut metals into thin films and polished the surfaces to the point that the internal structures were visible. This technique, termed metallography, allowed the metal's internal properties to be identified and linked to distinct technological performance. Various alloys with different properties could now be seen as looking different. Blast furnaces were invented and developed in England by Henry Bessemer later in that century, providing new methods for smelting and purifying iron that allowed the global production of steel to go from a half a million tons in 1870 to 28 million tons in 30 years (Amato 1997: 41–45). Today, metals are used for all scales of design, and the future of metals is being determined in engineering labs where new formulae allow performative-based design to provide the most efficient use of the materials, both newly mined and recycled.

Theories of Metals

An architectural theory of metals is different from a theory of metals based on engineering and technology alone. Technically, after the initial base metal is chosen and other metals are added to make an alloy with the desired qualities, determining the most sustainable fabrication method and installation practice are critical decisions. But the materials for buildings and landscapes are more than a condition of efficient structural frames and sheltering enclosures. *Choosing to use metals may begin with a general longing for hardness and strength and end with an appreciation of thinness, but choosing a specific metal is a more complex theoretical procedure, balancing durable value with the intensity of production.* The investigation of the inherent properties of metals and their implications recognizes that metals are poor insulators and good conductors, which means they take on the ambient temperature of the surroundings and generally feel cold to human touch. On a sunny day a south-facing metal slide in a children's park will burn anyone who touches it, or a car left in the snow will take a while to warm up. One of the biggest mistakes architects make is selecting metal window and exterior door frames with inadequate thermal breaks because exterior temperatures transfer directly through the metal, bypassing adjacent thermal glass and insulated wall assemblies.

The ability of metal to retain its strength even when rolled thin or drawn into a very fine thread is due to the ore's fine molecular grain, which aligns in the fiery process of its production. Once all metals were worked in forges, where the blacksmith pounded the heated metal, particularly iron, into desired shapes. The sound was incredible: metal hammer on worked metal on metal anvil. The rhythmic pounding was one testament to the blacksmith's skill. The result can be said to carry the echo of this violent beating, except that we don't go around knocking on steel beams listening for a resounding ring (Willis 1999: 25–45). Today's architecture doesn't promote this kind of relationship between people and metal, and generally wood handrails and benches are preferred materials for places where bare skin touches surfaces exposed to the weather.

In the mid-nineteenth century, Gottfried Semper wrote a short essay called "The Four Elements of Architecture." In it he defined the first element—the hearth—as the moral

aspect of construction because the hearth and its fire were indications of the first sign of human settlement, with sacred and cultural traditions. The other three elements are the "defenders of the hearth's flame against the three hostile elements of nature"—namely, climate, natural surroundings and social relations, which could all threaten the hearth (Semper 1989: 102). One purpose of architecture was to shelter the flame. To do so, Semper connected thinking about materials used for building with their acts of fabrication: the hearth is molded with a lining of ceramic or metal as a suitable basin for the fire, masonry is piled up to make level terraces and supporting foundation walls emerging from the earth, wood is joined to make structural frames, and textiles are woven into panels enclosing space.

Metals can be used for all of Semper's building elements of basin, platform, frame or enclosure. Nonetheless, they do so in their own way. Steel columns and beams are com-mon structural frames. Retaining walls that are usually made of eight- or twelve-inch-thick masonry or concrete can now be three-quarter-inch-thick Cor-Ten steel (see Figure 17). Copper sheets can make complexly shaped roof surfaces such as domes, or they can be bent into gutters or flashing that cover joints between planes. Thin and lightweight stainless steel panels can be pierced with a laser cutter, providing secure and decorative screens for privacy and some transparency. Pierced metal skins have a great potential to reveal metal's ability to flex and to resonate, responding without failure to nature's dynamic forces. Exposed metal surfaces can vary in character by finish and not just in color. The rusty surface of a ferrous metal may repel touching or a polished surface may attract the eye by its shine. Acoustically, solid metal panels block and divert sound, and thin skins deflect with the wind and reverberate in response to touch. In these ways, metal expresses its muscular character born in fire.

One reason any theory of metals for design is deficient when based on most current uses is that the experience of finished metalwork is removed from its working. Thinking of metals requires a return to the seven Metals of Antiquity and other, more recent metal alloys commonly used in construction in order to link cultural associations with the distinct physical and emotive characteristics of each metal. Bachelard's philosophy was influenced by the early seventeenth-century Lutheran mystic Jakob Böhme's book, *The Three Principles of Divine Essence*, which followed ancient cosmological "sympathies" between divine and terrestrial things that "moved and changed in harmony with seven metallic substances on the earth, seven principal parts of the human body, seven colours and seven days of the week" (Toulmin and Goodfield 1982: 38). His work arguably justified a concept called the Doctrine of Signatures, a nonscientific proposal in which the shape and color of a plant leaf corresponded to specific human body organs, their functions and pathology. These associations are the basis of allegories, metaphors and symbols, referring to distinct metals and their corresponding characters. Because most metal objects can be made of many different metals, unfortunately the choice in design is often based only on surface color. Product catalogs offer finishes in cast iron, bronze, copper, brass or aluminum depending on the desired color of black, brown, red, green, yellow or white. There are further choices of brushed, polished or "distressed" finishes.

The following paragraphs summarize Böhme's "sympathies," attempting to promote a deeper understanding of all of the properties that can better connect each material to the material imagination of the designer. Some qualities are based on ancient myths that link each metal to a specific planet, body organ, day of the week and color. Today, metals can also be distinguished by knowing the embodied energy of those commonly used in construction,

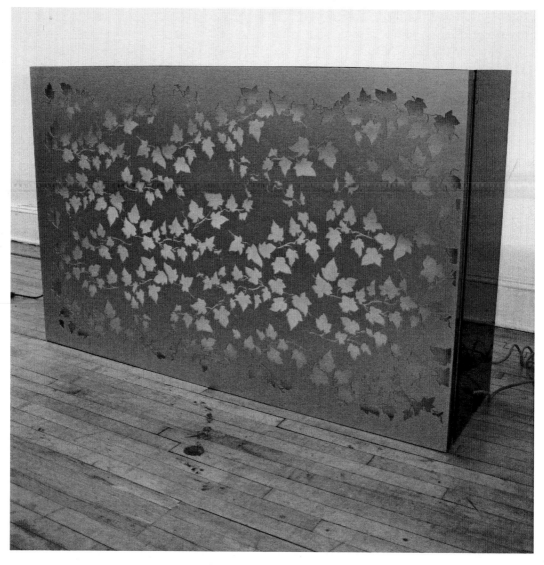

FIGURE 18. 200 WEST STREET GREEN ROOF, RAILING PROTOTYPE, NEW YORK CITY (2012). WORKSHOP: KEN SMITH LANDSCAPE ARCHITECT, NEW YORK. (Courtesy Hardy Specker.) Stainless steel railing panel prototype with cut-outs made with a laser will cover an internally illuminated box structure.

and this data is included as calculated by the Inventory of Carbon and Energy (ICE) as Energy MJ per kg–Carbon kg CO^2 per kg–Density kg/m^3.

Gold | Sun | heart | Sunday | yellow: The ancient Inca called gold the "sweat of the sun." It is the most noble metal used in building and is sometimes applied as a veneer "leaf" coating on exterior structures. It can be beaten or rolled very thin without breaking and does not tarnish because it is the most chemically inert metal, and therefore does not appear to age. It is usually found in a fairly pure state, is stable and has a permanently shiny finish. It is very malleable, allowing thin sheets to retain tensile strength, and requires no finishing or polishing to be highly reflective. Leather-bound books had their titles printed in gold because

the radiant reflected light made the words more legible in candle-lit libraries. The page edges were sometimes coated in gold so that dust would be repelled. Valuable oil paintings often have gold-coated frames, surrounding the image in a golden halo and isolating it from its surroundings. Even though it is precious, gold is found throughout the world, making it the preferred metal for coinage as well as other objects of transcendent value. Crafted or not, gold has intrinsic commercial worth and its value reveals the "heart" of a society.

Silver | Moon | brain | Monday | white: Silver is generally not used in building construction because it is precious and requires maintenance to prevent tarnishing. Pure silver is too soft even for jewelry. Sterling silver is an alloy with 7.5 percent copper added. Beyond the traditional uses of silver for coins, jewelry, silverware, coatings for glass mirrors and photographic processing, silver is finding important applications as a pharmaceutical, as its unique bacteria-fighting quality helps people recover from burns. This quality also makes it a powerful sanitizer for purifying water without chlorine. Industrial uses depend on its superconductivity for electrical circuits, computers and communications, where there is less loss in transmission. Photovoltaic panels and window coatings use silver that reflects up to 70 percent of the solar gain. Silver may not appear as silver, but, as the ancient Inca thought, these "tears of the moon" are the "brains" behind much of our functioning world.

Iron | Mars | gallbladder | Tuesday | iron red | 25–1.91–7870: Cast iron is a metal with low structural strength and low cost. It is often used where metal touches the ground because it is relatively unlikely to corrode so long as a coating is maintained. This made it valued for hinges, handles and other exterior metal elements. England's Victorian era took advantage of new casting techniques for garden furniture, ornamentation and fountains, and these metal objects, usually painted black, became a signature style of public parks. Cast iron objects are cast in sand and the seams of the joined parts are filed smooth before painting or receiving a more permanent factory-applied powder coating. Wrought iron is frequently used for fencing and railings, and the hand-manufacturing process works the twisted square or round bars that are then welded together. This was taken to an extreme in the Art Nouveau style, in which railings and other metalwork had hand-manipulated curves imitating flowing vines. When compared to strong structural steel (20.1–1.37–7800) or stainless steel (56.7–6.15–7850), cast or wrought iron objects usually have more ornamentation, and just as the gallbladder aids digestion, these elements enhance expression.

Mercury | Mercury | lungs | Wednesday | purple: Mercury is the only metal that exists in liquid form at room temperatures. This makes it useful for thermometers, but it is extremely toxic and Congress passed legislation in 2002 phasing out production. Mercury is still used, however, in some chemical compounds. In a gaseous state, mercury is used for mercury-vapor lamps, although "green" construction advocates are calling for manufacturers to retain responsibility for their product's eventual sustainable disposal even after installation and use. Alexander Calder's "Mercury Fountain," designed for the Spanish Pavilion in the 1937 World Exhibition in Paris, was located in the entrance hall opposite Picasso's famous painting "Guernica." Like Picasso's painting, this sculpture was a political statement protesting Franco's siege of the Almadén mercury mines (in operation for 2,500 years) during the Spanish Civil War. Today, the fountain is located in the Fundació Joan Miró in Barcelona and has been encased in glass for safety reasons. Mercury poisoning commonly occurs through vapor inhalation during industrial processing (making fluorescent light bulbs, batteries and explosives) or from eating fish that live in waters contaminated by toxic industrial discharge. OSHA identifies severe respiratory damage as a symptom of acute exposure to mercury vapor.

Tin | Jupiter | liver | Thursday | tin violet or blue: Tin does not easily oxidize in air, making it an especially good material for low sloping roofs that cannot shed rain or snow easily. Today, aluminum (155–8.24–2700) has replaced tin foil, which can be made so thin and so cheaply that it is considered disposable after a single use. The tin content in bronze alloy improves the casting process with lower melting temperatures and makes a harder final product. Tin with 10–15 percent copper makes a low toxic and inexpensive pewter alloy that was used for tools and eating utensils for centuries. Tin is a common additive in the service of other metals, making stronger and more useful alloys, much like the hard-working liver that detoxifies the blood, produces hormones and aids digestion.

Copper | Venus | kidneys | Friday | copper turquoise or green | 42–2.6–8600: Copper is usually formed into sheets or wires for power transmission and electrical wiring. As a metal, the softness of copper found applications ranging from the first pantry sinks, in which dishes were less likely to chip, to covering curved domes. When allowed to patina to a variegated green color, the displayed weathering promotes visual associations with permanence and longevity, an attribute valued by banks and government institutions. Like human kidneys, copper has the ability to balance and regulate change as a metal that displays its usefulness over time.

Lead | Saturn | spleen | Saturday | lead black | 25.21–1.57–11,340: Lead is toxic and can no longer be used where exposed to human touch. In the past, its low melting point, stability and pliable quality allowed it to be poured or forced into open masonry joints to close gaps that would otherwise accumulate water and freeze, forcing the joint to open more. This moldable quality also made it ideal for stained-glass window frames that had to be strong and able to follow irregular shapes. Today, much effort is being expended to remove lead-based paint from older buildings, as it is a neurotoxin. Lead's poor conductivity, density and weight make it good for blocking radiation, but it remains a metal generally unavailable for construction in its pure state. Lead-coated copper roofing offers all the advantages of copper (strong, lightweight and durable) but with run-off staining in gray tones that more closely match light stone and other facing materials. Ancient Romans associated lead poisoning with gout, a disease that manifests itself through spleen and kidney dysfunction. The ability of lead to repair cracks in construction may be compared to the ability of the spleen, which holds about half the body's monocytes (a type of white blood cell) that heal injured tissue.

Precious platinum, gold and silver are generally reserved for shiny adornments; brass and bronze alloys are ideal for objects of value exposed to the weather; and contact between people and lead and mercury must be avoided. These traditional metals, along with aluminum and titanium, are the building materials of practical and imaginative use today. Potential innovations range from the seemingly mundane task of developing more ecologically sustainable extraction methods and more production processes that do not consume nonrenewable resources to a paradigm shift of responsible commitment to building in a longer-lasting way by choosing the correct metal for the desired performance.

Innovative Applications

Most innovations with metals are more sophisticated alloys being developed to improve performance. Structural engineers and industrial designers are also responsible for fascinating applications balancing specific alloys with desired qualities (Lefteri 2004). For designers,

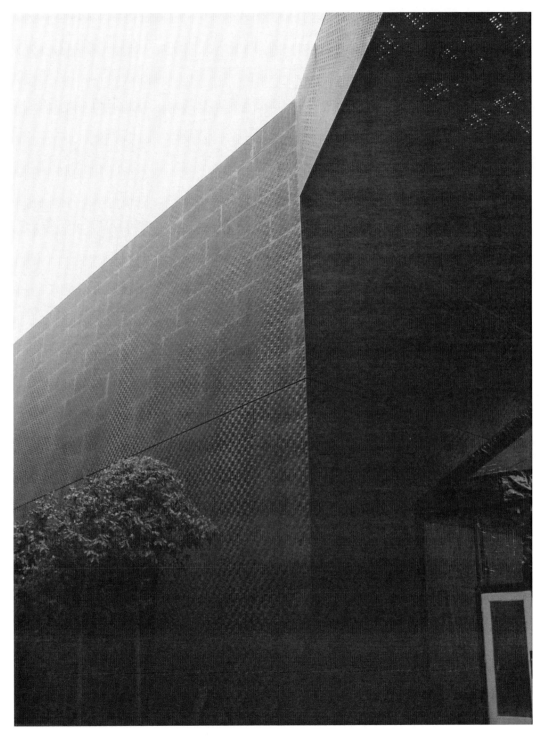

FIGURE 19. M. H. DE YOUNG MEMORIAL MUSEUM, SAN FRANCISCO (2005). HERZOG & DE MEU-RON, BASEL. (Courtesy Magenta Livengood.) Thin oxidized copper panels, variably perforated and dimpled, are used to enclose space to varying degrees and to provide a backdrop to the native eucalyptus trees.

employing sustainable practices, such as choosing to use metal as an exterior skin, is a commitment to long-term thinking. Architects are adding exterior louvered and adjustable sun shades and interior light shelves to buildings to control solar gain and to bounce daylight deep into the building interior. The thin, strong and durable characteristics of metal make it an ideal surface for resisting the rigors of use and exposure while allowing multiple textures and treatments (Leatherbarrow and Mostafavi 2002). Thin metal panels used to sheath buildings can also be permanently embossed with signage and other images. Landscape architects know that public places are more likely to be used if intense sunlight is modulated either by filtering it or by providing full shade with tensile, tent-like structures that are draped or hung with pierced metal scrims made of woven fabric sheets.

An example of introducing a "new" metal to the design material list was the Aluminum Company of America (ALCOA) project called the Forecast Garden, built in Los Angeles from 1957 to 1959. Aluminum, with applications developed in aviation during World War II, was the "most modern of modern building materials" (Treib and Imbert 1997: 87). ALCOA sponsored landscape architect Garrett Eckbo to explore and display the design potential of aluminum for peacetime applications in his own garden in California. New fabrication methods made aluminum an inexpensive, lightweight and durable material able to create architectural elements with high strength and good wear. Although aluminum was not used structurally in this garden, it was used for numerous applications, including a sunbreak mesh screen, a privacy screen that afforded views from one direction while blocking them from another, a curved decorative screen demonstrating possible degrees of enclosure, a free-standing pavilion, and a sculptural fountain. The shiny finish colors ranged from warm yellows to silvery grays. Eckbo found that aluminum, which has low electrical and thermal conductivity, like all metals, shares the disadvantage of becoming too hot in the sun for climbing plants to use as a trellis.

Architects exploring the use of titanium as a building cladding have found that its high strength-to-weight ratio (five times greater than that of steel) and surface tensile strength (twice that of aluminum), coupled with the use of computer-aided design (AutoCAD) tools, allow a new formal vocabulary of curves. The first, the iconic Guggenheim Museum in Bilbao, Spain (1997), designed by Frank Gehry, employed an organic-inspired trunk and branch structural frame type to support overlapping titanium panels. High ductility allows this metal to curve easily and it quickly oxidizes, making a titanium dioxide protective film that is highly resistive to corrosion. Located along the Nevión River, this building's skin gently flexes with the wind flowing from the surrounding mountains to the nearby coast (van Bruggen 1997).

Manufacturing metals is like tempering chocolate. Sequential phases of heating and cooling determine whether the chocolate cools to a liquid or turns into a solid. The type of truffle depends on the flavor of the chocolate, but the material transformation can only be achieved through the tempering process. So, too, some metals are better for frames, skins or ornamentation. Innovation is not manipulating one metal to act like another, but allowing each to realize its full character in the most efficient manner so as to be strong, hard and thin.

There is a contradiction between the long-lasting properties of metal and consumption that relies on the advantage of limitless recycling. The ease of recycling metals does not equate to thinking of metals as a renewable resource, as there is a finite supply of mineral resources. Additional production entails extraction methods that remain environmentally

degrading and manufacturing operations that require energy generated by fuel with efficiencies that have a great range depending on the country (Berners-Lee 2011: 103–4). Industry forecasters are already concerned that supplies of copper, zinc and platinum (used for catalytic converters and hydrogen fuel cells) may not meet future needs, even with improved recycling techniques. Metals are not biodegradable, giving their use the great advantage of durability, but innovation ensuring that demands are met will need to spur development in extraction and processing methods, more efficient designs requiring less metal, and assembly techniques that allow individual piece replacement and recycling. For most equipment, metal objects and components will eventually fail with use or become obsolete, making them more sustainable if designed with cold connections that facilitate disassembly. For example, engineering designs for mechanical heating and cooling equipment are continually improving, with better efficiency of operation and ease of maintenance. Updating existing equipment is more sustainably managed when component parts can be exchanged rather than replacing entire machines, coverings and controls.

Wills from colonial times often bequeathed a cast iron skillet from one generation to the next. Any carbon footprint assigned to that object at its making would surely become nearly nothing with each use, decade after decade. Today, producing aluminum has many times the energy requirement and carbon output when compared to steel, but it weighs significantly less, making it a more sustainable material to transport. Stainless steel also has a significantly greater carbon footprint than steel, but does not require maintenance. When choosing a metal, designers should consider the full economies of each alternative step, take into account the intended use and multiple users, and design assemblies with joinery that will enable recycling. Their choice can also express the cultural associations of practical iron, strong steel, shiny stainless steel, and light aluminum, as well as the display of graceful aging with bronze, brass and copper.

Resources

Federal Agencies, Technical Societies and Associations

American Iron and Steel Institute, http://www.steel.org.
Center for Resource Recovery and Recycling (CR³), http://www.research.gov.
Copper Development Association, http://www.copper.org.
International Council on Mining and Metals (ICMM), http://www1.icmm.com.
International Zinc Association, http://www.zinc.org.
Metal Construction Association (MCA) is working on life cycle assessment calculations for materials and assemblies, http://www.metalconstruction.org.
National Ornamental & Miscellaneous Metals Association, http://nomma.org.
National Science Foundation researchers, along with the Colorado School of Mines and the Worcester Polytechnic Institute, are working to advance science, engineering and education, with the mission of developing improved methods to "separate valuable materials from waste streams and to enable greater use of process effluents in materials processes."

Research on the Sustainable Production of Metals

Inventory of Carbon & Energy (ICE) for embodied energy data, http://perigordvacance.
 typepad.com/files/inventoryofcarbonandenergy.pdf.

The Metal Initiative, http://www.themetalinitiative.com.

The Sustainability Consortium is working with the University of Arkansas and Arizona
 State University to develop improved processing methods, http://www.sustainability
 consortium.org.

Chapter 4

Brick

The *Oxford English Dictionary* describes a person who is a "brick" as "a good fellow, one whom one approves for his genuine good qualities." What if there was a building material with the same qualities? Indeed, Alberti called brick "practical, graceful, solid and reliable" (II.10). Not only does brick have these characteristics, but it is common and has always been so, making the ubiquitous brick "the most ancient of all artificial building materials" (Brady et al. 2002: 138). Because clay is found in abundance in many parts of the world, this material is the very definition of "local." Today, most brick manufacturing plants are located near surface deposits of clay and the final product is transported usually no more than 200 miles (Calkins 2009: 184). Ancient civilizations found that brick production took little skill and that the bricks could be fired at relatively low temperatures fueled by wood in temporary kilns called clamps, which were made of the bricks themselves and sealed with mud, dung or plaster coatings. Builders use bricks because they are inexpensive, strong, durable, fireproof and water-resistant. Sustainable guidelines appreciate that inorganic clay material makes bricks that are nontoxic, have thermal mass valued for passive solar radiant heating, require no maintenance and are endlessly recyclable.

Most designers know the story of American architect Louie Kahn's question when he asked the brick what it wanted, and it said, "I want an arch"—a sophisticated architectural form made of interdependent individual elements that requires a master mason for execution. Other easier-to-build choices include a relatively indestructible wall or floor, fireplace chimney or structural vault. Brick is a highly versatile building material and, at the same time, completely common.

Brickmaking and bricklaying are two separate but related aspects of this material that deserve distinct treatment. Procedures for making bricks followed adobe or mud block techniques, but with the critical addition of fire, which vitrifies the clay blocks into brick. Bricklaying techniques have established terminology and guidelines for constructing level, strong, water-resistant and permanent structures, surfaces and objects. While manufacturing processes with mechanized equipment have changed only recently compared to brick's entire history in construction, the use of brick in design and construction has remained relatively consistent.

The word "brick" has mythical and pragmatic sources. Historian James Campbell says the word "brick" (*sig* in Sumerian) meant both "a building" and "a city," as well as the name of the god of building (Campbell and Pryce 2003: 33). Some etymological historians think the word "brick" came from the fifteenth-century Flemish word meaning to "break." Roman bricks were typically square tiles (one foot square by one and a half inches thick) that were

FIGURE 20. ONDINE GARDEN, DUMBARTON OAKS, WASHINGTON, D.C. (2008). JOHN POND AND NATHANIEL TRENT, MASONS. (Courtesy Magenta Livengood.) Hard-fired brick pavers were dry-laid in an intricate pattern following the elegant design of Beatrix Ferrand in this historic garden. About 10 percent of the bricks were cut by hand during installation.

FIGURE 21. KITCHEN GARDEN, MT. VERNON, ALEXANDRIA, VIRGINIA (1762). GEORGE WASHING-TON. (Courtesy Magenta Livengood.) **The thermal heat that radiates off the south-facing brick wall extended the growing season by a month in the spring and the fall. This improved efficiency helped grow the food to feed the two hundred people who lived there.**

scored on both diagonals to half depth while still "fresh." These shapes fit compactly in a kiln and were an efficient size to transport to the construction site. They were carried four in one hand and broken with a gentle tap when ready to place, leaving the formed and fired edge exposed and the broken edges rough for better bonding with the mortar (Alberti 1991: II.10). This technique provided, as the adage goes, "more crust and less crumb." Early Latin words for this material are closer to "wall-tile" or architectural "terra cotta," which is Latin for "baked earth."

Properties of Brick

Earthy reds, yellows and browns are the colors of clay taken from deposits of inorganic sediments and are often found adjacent to coal seams, which are formed of organic deposits (Heeney 2003: 16). There are two classes of brick: noncalcareous types have clays or shales with sand, feldspar grains and iron compounds, in which the percentage of iron oxide affects the final reddish color, and calcareous types have clay with up to 40 percent calcium carbonate called marls, making yellowish bricks when fired (Brady et al. 2002: 139). Brick colors also change through extending the firing process or adding oxygen or free lime (to make a buff color), magnesium (brown/black) or vanadium (yellow) (Heeney 2003: 16–17). Bricks are

made in many sizes, from flat tiles to much larger utility bricks, but the size is always limited to what can be managed by the bricklayer's hand.

Bricks are distinguished from terra cotta tiles by size and a clay content of at least 75 percent (Heeney 2003: 66–67). Terra cotta tiles are carved or cast, and sometimes glazed rather than molded. Some scholars think that in the past terra cotta roof tiles with tapered curved shapes were formed over a worker's thigh. Bricks should also not be confused with blocks, also called concrete masonry units (CMU) or cinder blocks, or with concrete pavers, both of which have a concrete-like composition. CMUs are too large to be associated with the mason's hand and human scale. Hand-made mud bricks and adobe are composed of mud, straw or other fibrous materials to add tensile strength, have a clay content of less than 30 percent, and will be discussed in the chapter on earth.

The process of making brick begins with mining or "winning" clay from shallow deposits. This was done by hand until 1879, when steam-powered shovels were employed. Preparing the clay, called tempering or pugging, requires screening out stone and other undesired matter and kneading it with water into a usable consistency. During the molding phase, the clay is thrown into reusable wood (often beech) forms that have been dusted with sand so that the compacted "green" brick easily releases after the excess clay has been struck from the top (Heeney 2003: 17). The great advantage of this development was that the resulting uniform bricks were more compact and of a consistent size, requiring less mortar to set level, which allowed a more rhythmic installation operation. The clay material can also be extruded through a die or cut with a wire for flat surfaces and crisp corners. Usually some of the interior clay material is spiked out from larger bricks to leave core holes, making what are known as perforated bricks, thereby reducing the mass and weight, and allowing for more even firing. The core holes also provide grips for the mason's fingers and increase the bonding surface for the mortar. After a period of open air drying, the bricks are restacked to be fired, which fuses the particles together. The bricks then slowly cool. Only about half the bricks that are baked in a nonmechanized vitrification process are usable. Under-fired brick can be used for nonstructural applications and over-fired bricks, called clinkers, can be ground up and added to the next mixture (they are also sometimes used in brickwork as darker accents ornamenting a plain surface).

Bricks are made as three general types: common, pavers and refractory. Brick pavers are fired longer and are harder than common brick. They are at least 2⅜ inches thick for heavy use and 1½ inches thick for pedestrian use. They have an advantage over concrete pavers because the color cannot fade (Calkins 2009: 194). The hardest type is refractory brick, which can tolerate very high temperatures as needed for residential fireplaces and industrial steel plants. Designs that repurpose brick must downgrade the type for the new application.

A rectangular brick has six surfaces, each with distinct names that identify the orientation of the fired side to be exposed when assembled: stretcher, rowlock, soldier, sailor, header and shiner. Window and door sills and free-standing wall caps usually have a rowlock orientation because this position is easily sloped as needed to shed rainwater. If a brick is cut and the unfired surface is exposed to the weather, it will perform poorly, allowing water penetration, and the assembly risks failure, eventually crumbling away. If the cut edge cannot be concealed, custom-shaped bricks should be used. These are also better for designs that require shapes not available with typical brick forms.

Finished bricks are assembled into many kinds of constructions. Like the brick face

FIGURE 22. MUSEO DEL ACERO HORNO (MUSEUM OF STEEL), MONTERREY, MEXICO (2007). SUR-
FACEDESIGN, INC., SAN FRANCISCO, AND HARARI ARQUITECTOS. (Courtesy James A. Lord.)
Refractory bricks from the decommissioned blast furnace were downgraded and repurposed as
a surface paving material.

orientations, bonding patterns have names and are sometimes linked to cultures in which a particular pattern was frequently used, such as Flemish, English and Dutch bond, as well as the more typical running and common bond. Brick coursing patterns reveal much about the internal construction of a wall. Bricks are laid in "courses," which is the horizontal layer or row, and by "wythe," the vertical tier that is one unit thick. Solid brick walls with multiple wythes are woven together with some brick laid along the outside surface, and others are laid short to tie the vertical layers or wythes together. In most bonding patterns, joints are staggered to minimize creeping settlement cracks and to increase the strength of the entire assembly. Ornamental work laid by experienced bricklayers have named patterns, such as "dog-tooth" for brick turned diagonally so that a triangular shape projects from the wall face, or corbelling, in which each brick course projects no more than one inch past the course below it. Ornamental detailing must avoid non-draining pockets that will retain freezing and expanding ice that will gradually damage the brickwork by forcing open joints, eventually allowing brick corners to chip off or for the entire brick to loosen upon impact.

Because nonmechanized brick manufacturing is a slow and labor-intensive process, designs that minimize the number of bricks required for construction were developed. For a free-standing brick wall, a single wythe of brick can be built if curved into a serpentine or crinkle-crankle shape, such as Thomas Jefferson designed for the University of Virginia, making a sound wall that required fewer brick. The thin wall can also be zigzagged so that the corners stabilize the shape; added intermittent structural piers will likewise provide needed support to counteract lateral forces. If laid with openings, the fireproof brick screen allows privacy and air flow. For buildings, brick used in a single wythe as an exterior veneer must rely on a primary supporting structure whose assembly needs air cavities, waterproof sheathing and weep holes to prevent moisture from accumulating inside the wall. Such assemblies use less brick material but forfeit some benefit of thermal mass, and they can have a theatrical appearance when the veneer gets too thin, with flimsy corners, or the brick appears to float with no visible means of support. Steel lintels spanning openings and advanced epoxy glues can hold brick up against gravity, but such applications defy brick's fundamental earthy heritage.

For flat surfaces, herringbone patterns are more durable because of the interlocking pattern. They should be sloped at least 2 percent to direct stormwater to drainage gutters and catch basins, or less if the installation is designed to be permeable (about which see later in this chapter for more information) (Calkins 2009: 194). For free-standing brick walls, horizontal surfaces are capped with solid bricks with minimal mortar joints and are usually set with a slight projection to shed rainwater and protect the wall surface below.

Bricks are assembled with mortar, allowing the mason to create shapes and articulate openings. Mortar should not be confused with cement, which is a binding agent, or concrete, which contains aggregate. In the past, straw was sometimes added to mortared joints to strengthen the bonding properties, and today welded steel wire, often in a ladder-type pattern, is used. Along with the brick size and orientation, the width and placement of the mortar joint determines the appearance and strength of the construction. While the brick will last a very long time if laid level, mortar joints are the key point of potential failure due to moisture penetration, and the mortar may require partial replacement (called re-pointing) about every hundred years. Most joints today are about half inch wide, although more expensive brick material and more labor-intensive coursing tend to have smaller joints. Large expanses of brick walls and floors require control and expansion joints to avoid joint cracking or failure because of temperature changes to the extent that "a 100-foot-long wall can expand

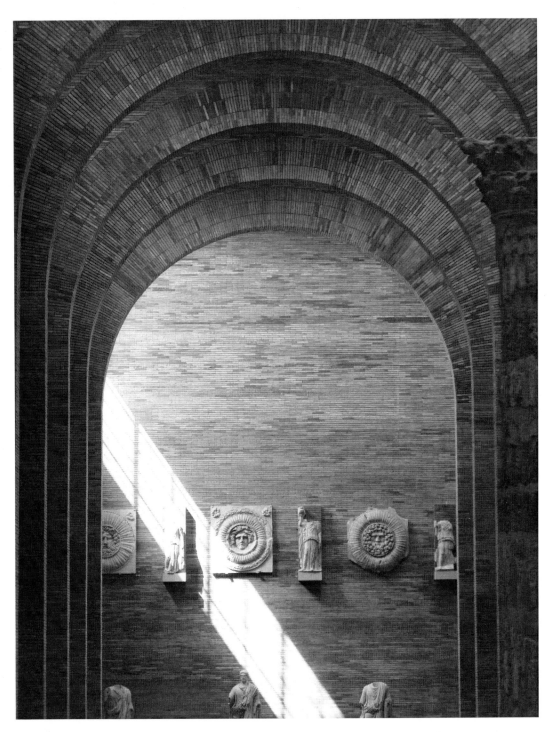

FIGURE 23. NATIONAL MUSEUM OF ROMAN ART, MÉRIDA, SPAIN (1980–1984). JOSÉ RAFAEL MONEO, BARCELONA. (Courtesy Will Collin.) Excavations in the nineteenth century revealed Roman town ruins dating from the first century. The design of the new museum used Roman brick sizes and thin joints as well as construction techniques for the arches, vaults and massive bearing walls that had concrete and rubble infill.

or contract about 0.43 inch for every 100-degree temperature change." Control joints should be located between twenty and thirty-five feet apart and at transition points, and expansion joints should be located every twenty-five to thirty feet (Calkins 2009: 191).

There are three general types of mortar mixes used for exterior masonry wall construction. Site-mixed mortar is made of Portland cement, hydrated lime, sand and water. The three types of this kind of mortar are Type S, which has high tensile strength, is used below or at grade, and has a mix of Portland cement, hydrated lime and sand in the ratio of 2:1:9; Type N, which is the most common and has moderate strength and a mix ratio of 1:1:6; and Type M, which has the highest bond strength and a mix ratio of 3:1:12 (www.cement.org/masonry). Type O, pointing mortar, is a lime-rich mix that is less frequently used. Mortar is also available premixed (with less lime and more additives) and bagged as Mortar Cement and Masonry Cement. Mortar Cement (ASTM C 1329) has the better bond strength and lower permeability that is needed for weather-resistance, seismic load and load-bearing masonry. Masonry Cement (ASTM C 91) is more workable but less water-resistant, with a lower bearing capacity. Masonry on flat surfaces benefits from a low-lime mix that is less likely to leach out, leaving white stains on the brick.

Mortar paste allows the irregular surface of brick to be installed as a perfectly level bed and provides a waterproof seal to unfired concealed surfaces (McMorrough 2006: 196–201). Manipulating the mortar setting bed also allows a brick window sill or wall cap to be laid on a slope that should be greater than 2 percent. As with concrete, the mortar mixture begins wet and develops its binding strength through the hydration process. Like concrete, the temperature and humidity of the air affects the drying rate of the mortar and the ultimate strength. Sometimes on a hot day, a mason will dip a brick in a bucket of water before putting it in place, thereby slowing the mortar cure rate and increasing its ultimate strength. Masons will protect brickwork as it cures from extreme temperatures, excessive dryness or humidity, and wind, following similar procedures as concrete workers.

Some designers add color to the mortar. Byzantine architecture brickwork often had mortar with added brick dust, tinting it red, and the Victorians often added soot to make black mortar. Above all, the mortar joints need to be compacted by a tool making it more water-resistant. The shape of the tooled joint is also important as good joints will shed rainwater and poor joints will have pockets or ledges where water may accumulate and infiltrate the wall assembly. A broken gutter or roof leader may allow rain to wash away nearby mortar over time, although masons can re-point the joints to mitigate the damage.

Prior to industrialized manufacturing processes, brick usually had an uneven appearance due to irregular firing. The constructed walls were often meant to be concealed and builders would apply a lime-based stucco or plaster coating. Sometimes horse hair was added to the coating to increase its tensile strength and inhibit chipping, and to improve the appearance and weather-resistance (Campbell and Pryce 2003: 199). Exterior stucco is a fine mixture of gypsum and pulverized marble dust. Interior plaster is finer and can also be formed into ornamental cornices, medallions and other decorations. Sometimes the smooth exterior surface was scored to allow the underlying brickwork to be "seen" or to imitate more expensive stone construction. In the past, many exterior wood wall assemblies had brick infill to increase their strength, add insulative qualities and improve fire resistance. Below grade, mortar is often used in lieu of a bituminous coating on masonry walls to increase moisture protection in a technique called "parging."

Brickwork can also be a subtractive process. Sculptors working with large forms per-

manently installed at a specific site appreciate the way the brick material references place through earthen material and color. They employ techniques that are several millennia old, similar to the polychrome glazed and carved brick wall panels from the Palace of Darius at Susa in Persia dating from 521–486 BCE and now on permanent display in the Louvre. Artists use brick for bas-relief or fully formed sculptural images by carving "green" or unfired bricks that have been assembled without mortar and are then taken apart, numbered, fired and reassembled on site (Heeney 2003: 9).

Brick in History

Evidence of brick's precursor—clay or mud adobe—has been found dating from at least 10,000 years ago. Much later, from about 5000 BCE, the first technological innovation occurred when earthy material was thrown into a wooden box mold. Early ziggurats in ancient Mesopotamia and Africa were made of abode brick and sometimes included interior chambers. The more significant advancement occurred with fired brick construction dating from 3100 to 2900 BCE, which allowed for more permanent construction because the result was more durable and waterproof (Campbell and Pryce 2003: 13–28).

Greek and Roman cities suffered when wood structures burned and benefited from more permanent brick and stone construction. Pliny the Elder noted that the "Greeks preferred brick walls since these last for ever if built vertically true" (XXXV.172). In Rome, six- or seven-story brick apartment buildings called *insulae* had shops on the street level and dwelling flats above, with decreasing rents as the levels climbed. Many had running water and some sanitation facilities. Sound building construction techniques were not always followed and collapses prompted height limit regulations (Strabo 1923: V.3). Romans also used brick as a structural backer to applied marble or tufa block surfaces.

Vitruvius dedicated individual chapters to brick, sand and lime in his book on materials, and he detailed instructions for stucco in the book on interior decoration. He identified clay types and the best seasons for dehydration, and recommended the length of drying times, size choices and coursing patterns (II.III, II.VIII.1–7). Roman brick construction was highly refined and had extremely narrow joints, often between two or three millimeters. When the Romans built stone walls, their cost could be amortized over 80 years, but brick walls, if plumb (according to Vitruvius), would last indefinitely (II.VIII.8–9).

Alberti's brief advice followed Vitruvius. He suggested clay be dug only in autumn, soaked or macerated throughout the winter to remove softer matter, and then formed into brick in the spring. Comparing brickmaking to breadmaking, Alberti encouraged kneading the raw clay several times and baking the bricks to harden with a finishing glaze. The brick were then to be loosely stacked and air dried, and not used for at least two years. His admiration was summed up as follows: "I would be so bold as to state that there is no building material more suitable than brick, however you wish to employ it" (II.10).

Throughout the centuries, most masonry buildings were built by master masons called the Clerks of the Works, who were in charge of the construction and who formed guilds training workers to ensure consistent quality, providing "how to" guides for making complex forms, and offering a kind of workman's compensation for disability as well as widow's insurance. Further information about their trade identifies white masons as stone workers and red masons as brick workers (Moxon 2009: 237).

FIGURE 24.GREAT WALL OF CHINA, NORTHERN BORDER, CHINA (FROM THE SEVENTH CENTURY BCE, WITH THE MAJORITY OF THE WALL RECONSTRUCTED DURING THE MING DYNASTY [1368–1644], WITH ONGOING REPAIR). (Courtesy Magenta Livengood.) The wall and guardhouse structures were constructed of stone and brick over rammed and tamped earth infill. It became a UNESCO World Heritage Site in 1987.

It was only in the nineteenth century that mechanized pressing and extruding equipment advanced brick production, especially with continuous kilns that allowed unfired brick to roll through the firing phases without manual reloading. These developments coincided with improvements in iron and steel manufacturing for joint reinforcing and frame fabrication, and also with the invention of elevators and braking devices, making multiple-storied buildings feasible in dense cities. Destructive urban fires, beginning with the Great Fire of London in 1666 and another in Chicago in 1871, prompted building code development in both the United Kingdom and the United States that required fireproof materials for all exterior surfaces.

Solid masonry construction is heavy and the first tall buildings had thick foundation walls. Built from 1889 to 1891, the tallest masonry structure in Chicago was the Monadnock Building, designed by architects Daniel Burnham and John W. Root. It has sixteen floors and is 215 feet tall, with ground floor walls that are six feet thick (Campbell and Pryce 2003: 248–50). Brick buildings have become more efficient, using steel or concrete frame structures to support brick veneered wall assemblies. While more automated systems have streamlined brick production, bricklaying is still done by hand, although prefabricated brick panels and glued-on thin brick veneers can be used for less expensive and less durable construction.

Theories of Brick

After mud adobe, brick is certainly the humblest of all building materials. Throughout history and most societies, brick is the most common building material, but it certainly has the greatest use and flexibility. Complex brick structures are possible because of the singular nature of how individual bricks can be assembled into a whole. *The fundamental characteristic of brick remains the same century after century—that is, it is laid by hand, weaving together thick structures that endure. Bricks are sized to fit in the mason's hand and are laid one at a time, and this procedure inextricably links the material to the human body and to a perception of human proportions.* This human-scaled association gives anything made of brick a domestic feeling, which, in addition to its practical advantages, makes it emotionally well-appreciated for housing and usually out of place in airports.

The individual characteristic of brickwork has another advantage in that damaged parts can be repaired without replacing the entire structure. For example, in the past when part of a city's defensive wall was attacked and damaged, that portion alone could be cleared away and rebuilt using the same brick material. Assuming a trial-and-error approach to structural design, if risky constructions failed, the same construction could be attempted again with slight modifications (Winter 2005). Today, unlike concrete, this capability means that a

FIGURE 25. SUMMERHOUSE, U.S. CAPITOL GROUNDS, WASHINGTON, D.C. (1874–1881). FREDER-ICK LAW OLMSTED, SR., NEW YORK. (Courtesy Magenta Livengood.) If the smooth limestone U.S. Capitol building was designed to inspire grand thoughts of democratic ideals, then this brick folly with a freshwater spring grotto was meant to offer emotional and physical relief from the hot summer temperatures, with a cool resting place for legislators and visitors. The textured basket-weave brick walls helped climbing vines attach to the surface.

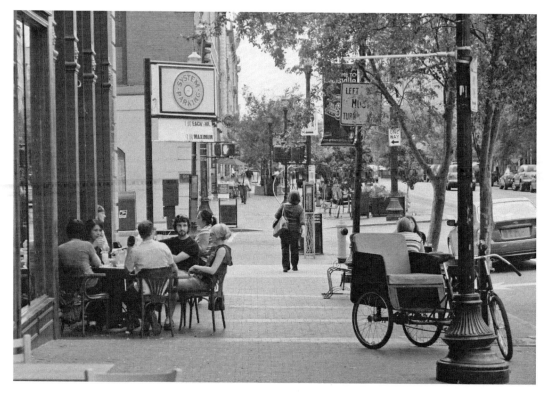

FIGURE 26. WEST MAIN STREET, LOUISVILLE, KENTUCKY (2008). AECOM (FORMERLY EDAW), ALEXANDRIA, VIRGINIA. (Photograph by David Lloyd, © AECOM.) Black brick pavers with a high iron content were used to correspond to the adjacent historic cast-iron facades and ornament.

single cracked brick paver can be replaced without reworking the entire surface, making this material particularly suitable for sustainable building.

Many current books on construction materials for architecture and landscape architecture ignore brick. The otherwise excellent *Materials for Design* by Bell and Rand (2006) and Addington and Schodek's *Smart Materials and Technologies for the Architecture and Design Professions* (2005) include nothing on brick. But brick is not a smart material; it is common and dumb. Nevertheless, designers are smart to use a material that tolerates moisture, is strong and long lasting, is fireproof, and does not decay from water or air, even if it is ubiquitous. While brick production necessitates a relatively high embodied energy, this is offset by its durability and recyclability (Calkins 2009: 179). As societies move toward longer-term thinking and invest in building materials and techniques that last, architects will regain an appreciation of the intimate scale and versatility of brick. So, too, the color of brick, determined by local clay sources, can reinforce a sense of region and place. Blending in rather than shouting for attention is a theoretical position generally holding little attraction for competitive architects designing exotic forms that display signature styles and express contemporary technology. However, native materials and plain construction logic may eventually prevail. Landscape architect Rob Sovinski notes this advantageous link, saying, "brick is *of the earth*, but *shaped by humans*" (1999: 12).

Innovative Applications

Those searching for novelty with brick construction have played, not with the brick unit, but with the mortar pattern and joint type, stretching what are generally considered to be sound construction practices. For instance, brick laid with a vertical stacked bond pattern has the dual disadvantage of making the brick surface more susceptible to stress fractures and creating a "wallpaper" appearance. The weight of brick appreciates distribution over the entire surface, which is facilitated by staggered joints. When the vertical joints align, any settlement or movement will have a ready path to follow along the weaker mortar joint.

Superior brick production has always meant smoother surfaces and a more regular size. When this occurs, less mortar can be used, as thin joints are only possible with well-made brick. Using less mortar is more sustainable because of the embodied energy involved with this cement-like material. Superior mortar may limit the ability of today's brickwork to be recycled in the future because traditional lime mortar is softer, making it easier and more economical to knock off bricks from demolished structures. Innovative architects are changing bricklaying methods by using a form of weaker mortar cement in a mix ratio of 1:1:12. These walls require no expansion joints (usually needed for thermal movement because the joints can expand and compress without cracking) (Campbell and Pryce 2003: 284). While the result is a larger expanse of visually unbroken surface, the risk is that the brickwork will fail if the mortar loses some of its elasticity or the benign climate changes.

More innovative constructions are omitting the mortar altogether for brick paving. Sustainability guidelines and overwhelmed municipal stormwater treatment infrastructure are supporting permeable ground surfaces that reduce sheet flow and encourage rainwater to seep into the ground. Pervious brick paver details require a graded subsurface with gravel drainage layers and usually sand-swept joints. Should uneven settlement occur, the brick paver can be removed, its base altered, and the paver replaced. Sites that are unable to absorb rainwater at the ground level comply with sustainable guidelines if the rainwater is directed to cisterns either for use as graywater inside the building or to supplement piped irrigation systems for the landscape and gardens. One shortcoming of brick pavers is that wheelchair users do not like the bumpy surface, finding it unpleasant and tiring, but locating flush joints along the likely path of travel may address this complaint.

Engineered alternatives to clay-based brick include adjusting content to incorporate industrial by-products and overburden from mining activities. Bricks made with fly ash from coal-fired plants along with lime and gypsum from other industries, make a less durable product that has only a ten-year warrantee and no ASTM standard. Such a product may take less energy to produce—it has about one-fifth the carbon footprint of clay brick and one-third compared to concrete blocks—but it will have to be replaced (and down-cycled as crushed rubble) more quickly, offsetting any early benefit with a higher ultimate environmental cost.

Improved manufacturing equipment and techniques are increasing brick's compressive strength while being fired at lower temperatures, thus saving energy. Stronger bricks mean less breakage during transport and installation, and therefore less waste on the construction site, although waste brick can be chipped and used as drainage material. Brick crushed for backfill does not have the high alkaline content of concrete and does not limit the adjacent plant choice. Most brick manufacturing plants in the United States already use natural gas in lieu of coal as fuel, and some are experimenting with methane gas from landfills.

After the 1906 earthquake and fire in San Francisco, much of the city was rebuilt with fireproof brick buildings, although many wooden residential buildings remain. The Loma Prieta earthquake in 1989 again spurred new advances in retrofitting existing historic masonry structures, addressing brick construction's inherent weakness of stiffness and inability to bend with seismic forces without damage or failure. Clear epoxy fiberglass films can be added to brick surfaces to increase their ability to flex with movement while not altering the historic appearance, although their long-term durability is unknown at this time.

The idea of "appropriate technology" argues for maintaining traditions of brick making and vernacular brickwork in the construction of buildings and landscapes in regions where local labor and clay material still can produce the most cost-effective, comfortable and sustainable shelter (Campbell and Pryce 2003: 296–97). For regions with more choices, brick remains an important building material for the same reasons, but unlike other materials, brick possesses an aesthetic of scale that promotes a feeling of intimacy. Perceiving constructions of brick, we see and feel the human reference inherent in its making and associations of a society made up of individuals. Masonry, whether ancient or modern, is the result of thinking that, in the words of a seventeenth-century building guide, the "bricklayers-Work is an Art Manual, which Joins several Bodies so together, that they adhere like one entire Body" (Moxon 2009: 237).

Resources

Federal Agencies, Technical Societies and Associations

Brick Industry Association provides technical resources about brick and mortars, http://bia.org and http://www.gobrick.com.

Mason Contractors Association of America, http://masoncontractors.org.

Masonry Institute of America, http://masonryinstitute.org.

U.S. Environmental Protection Agency publishes technical information on standards for hazardous air pollutants for product manufacturing, see Brick and Structural Clay Products Manufacturing and Clay Ceramics Manufacturing, http://epa.gov/airtoxics/brick/brickpg.html.

U.S. Geological Survey supplies data on commodity supply for clay and shale, see Minerals Statistics and Information, http://minerals.usgs.gov/minerals.

Research on the Sustainable Production of Brick

International Masonry Institute provides training for sustainable practices, http://imiweb.org.

For sustainable approaches of "appropriate technology" in technologically developing countries, see Laurie Baker's work in India, http://lauriebaker.net.

Chapter 5

Ceramics

Once the technologies for turning clay into molded brick and ornamental terra cotta tile were developed, glazes applied prior to firing were found to improve ceramic objects by making them better able to hold liquids. This enhanced quality meant that houseware pottery containers could hold water and were superior to woven baskets for protecting grains and food from rodents and rot. The most useful ceramics as a material for building purposes are glazed tiles. Ceramic tiles are nonstructural and are not meant to self-support. Their installation as a veneer requires attachment to a primary structure; however, once installed, ceramic surfaces provide a permanent building finish, and they do so while also adding color and decorative ornamentation. The ceramic fragments found in archeological digs testify to their long-lasting character and provide a record of social customs with their painted images.

Strictly speaking, glass is a type of ceramic, but their formations and salvage capabilities differ. Ceramics are formed, fired and finished, yielding a material whose waste cannot be returned to the mix batch. Glass can be formed and reformed many times, either by returning waste to the mix batch or by reheating a finished form to make a new form. Ceramic tiles have a single surface face that is meant to be exposed; glass has two primary surfaces that must be exposed to be transparent. Both can have finished edges, although this is atypical. The applications of ceramics in design are appreciated for properties that are also very different from those of glass. The range of ceramic compounds is vast and its elemental composition is able to be manipulated depending upon the desired performance. As a building material, ceramics are valued because they are hard and stable; resist wear, water, fire and sun damage; and have an appearance that adds color, decoration and visual interest of sufficient durability to withstand rigorous public use and extreme weather (see Figure 27).

The word "ceramic" shares its Greek etymological root with the word "cremate" and alludes to a consummation by fire. The earthy source of the clay material for ceramics means that ceramic artifacts were usually locally made. Once the firing technology was mastered, the pottery could be worked by relatively unskilled labor, although ceramic work has developed to a high artistic level in many cultures. At first, objects were formed by rolling or spinning techniques, and then by coiling long ropes of clay into shapes that were subsequently smoothed. More advanced production techniques made identical objects in repetitive processes by extruding clay through a mold or forcing it into a slip-cast mold. Unglazed pottery has uses as garden pots that breathe and transmit moisture, for instance, but once glazed (and sometimes reglazed), ceramics are capable of many more technical and functional applications.

As a surface veneer material, ceramic tiles are thin and usually flat, and they are mortared in place, making a level skin that is easily cleaned without damage. As a building material, the critical ceramics are durable glazed tiles with designed surfaces of permanent color.

Properties of Ceramics

Primarily composed of clay, ceramics are a polycrystalline material of metallic and non-metallic compounds (Brady et al. 2002: 208). The properties of the material are "based on ionic and/or covalent bonds" (Addington and Schodek 2005: 35). In general, all materials can be characterized by their atomic molecular structure and how their ions bond. Their bonding structure affects their suitability for use as a building material, as well as other properties. A strong ionic bond transfers electrons across the material surface while the covalent bonds share electrons across the surface, making ceramic material both hard and brittle (Addington and Schodek 2005: 42). Because ceramics have both types of bonding characteristics, they are hard enough to withstand great compressive weight, but not tough enough to avoid cracking upon impact. Ceramics have an "almost total absence of ductility. They fail in a brittle fashion" (Brady et al. 2002: 209). Most glazed ceramics appear to have flawless surfaces, but their microscopic imperfections absorb only the first energy of impact and cannot usually absorb it all without failure. Upon impact, cracks open up like fault lines that snap and shatter under pressure, although the tile thickness, edge type and overall form can increase the ability of ceramics to resist impact forces.

Ceramic tiles are brittle because they have low tensile strength. This property means that ceramic objects cannot bend once formed, and this lack of ductility or flexibility is a shortcoming of the material. To improve ductility, shredded ceramic particles have been turned into flexible and fireproof paper and woven fabrics, used, for instance, for the protective clothing of race car drivers and on performance sportswear that blocks UV radiation, among other applications (Lefteri 2003a: 108–13).

Ceramics are the hardest of all the manufactured materials, with a compressive strength that exceeds even that of steel. Ceramics are durable and stiff, and as the most rigid of all manufactured materials, they are well suited to wear-resistant applications such as abrasives and cutting tools (Brady et al. 2002: 209). An example is zirconia, a ceramic product that is used for high-grade cutting tools because it retains its sharp edge at room temperature (Lefteri 2003a: 17). Because ceramics are thermally stable and do not wear due to frictional forces, they are among the best materials for exposure to great temperatures and, even more important, for conditions with large temperature swings. Glass ceramic composite tiles were used on the space shuttle exterior because they could be shaped to conform to the complex curved forms of the exterior shell, and their high melting point was capable of withstanding temperatures from –250°F in deep space to as high as 3,000°F (when entering the earth's atmosphere) (Lefteri 2003a: 20). In addition to resisting heat from surface friction, ceramics are excellent electrical insulators, making them well suited for spark plugs, high-voltage power line insulators and computer components.

The high temperature required to fire glazed pottery also makes ceramics waterproof and fireproof, as well as nonbiodegradable and hygienic. The inorganic and chemically inert composition of ceramics allows surfaces to be automatically anti-static, preventing surface dust accumulation. Chemically inert and nonporous ceramic surfaces do not absorb water

or other materials or chemicals. This property makes them the ideal material for many products, ranging from tableware and plumbing fixtures that must be sanitary to medical prostheses (including dental crowns) that must withstand great pressure and not be susceptible to rejection by the body.

Installed individually, tile work usually has joints with the minimal width dictated by the precision of the tile edge and as needed for placement in the desired pattern. These joints are filled with grout, which is a mortar made with very fine particles and a high water content, often tinted to match the tile color. Sometimes tile joints are sealed with a clear coating to prevent grout discoloration. Depending on the installation location and frequency and type of cleaning product, the sealer may require annual reapplication.

Due to the necessary extremely high firing temperatures, ceramics have very high production embodied energy, even though excess heat is often captured and used as fuel energy. Some manufacturers seeking sustainability credit have found ways to make new tiles more ecofriendly by including repurposed ceramic materials, but this material is almost exclusively made up of pre-consumer manufacturing by-products. All thrifty manufacturers develop ways to use scraps and waste either for their own productions or for another, related industry. Nevertheless, while ceramic tiles are hard to remove without breaking and in a condition suitable for reuse, ceramic and porcelain objects such as bathtubs and toilets can be crushed and the material recycled. This post-consumer approach is likely to be more effective than more sustainable production techniques because it reduces the impact these discarded products have on landfills. And even though ceramics have a very high carbon footprint, their greatest contribution may be the ability to change the way we think about materials. Any manufactured material product that is as durable as ceramics can help shift attitudes about design and construction toward longer-term thinking.

Material engineering methods begin by defining the set of desired performance characteristics and then manipulating the material's molecular properties as needed. In the end, a particular design need may be satisfied by a new composite material that starts as a clay-based ceramic, sand-based glass or polymer-based plastic, and the choice is often determined by the availability of the base materials and the cost.

Ceramics in History

The earliest glazed tile work has been found in the ancient city of Susa, now in Iran, and in the nearby ziggurat of Chogha Zanbil, dating from 1500 to 1250 BCE. Records of Greco-Roman work distinguish *opus vermiculatum*, which are panels made of tiny *tesserae* crafted in studios and then installed, and *opus tessellatum*, which indicates larger pieces of tile installed on site by artists. Pliny the Elder mentions ceramics when identifying Cinyra, son of Agriopa, as the inventor of tiles on the island of Cyprus (VII.195). He says, "Mosaics came into use in Sulla's time ... subsequently mosaics were transferred from ground-level to vaulted ceilings, and these are now made of glass. This is a technical innovation" (XXXVI. 189). Pliny notes that very small *tesserae* were used for mosaic tile panels in the Temple of Fortune at Praeneste, east of Rome, in the second century BCE.

For engineering projects in the first century BCE, Marcus Agrippa had the terra cotta surfaces of hot rooms in Roman baths painted with encaustic coatings (beeswax binder with colored pigment). Agrippa was also responsible for repairs and improvements to Roman

FIGURE 28. NILE MOSAIC, TEMPLE OF FORTUNE, PRAENESTE, ITALY (SECOND CENTURY BCE). A surviving ceramic mosaic tile floor depicts a seascape. The panel is now located in the Palazzo Barbarini, Palestrina.

aqueducts and clay tile sewer pipes, where added waterproofing stemmed water leakage. Vitruvius did not mention decorative ceramics or mosaics in his treatise, only stucco frescos, but he offered detailed construction assemblies that have finished surfaces of clay brick pavers (VII.I.1–7).

Technical advances for ceramic houseware occurred in China from the sixth century onward and European markets received imports starting in the twelfth century. Known as chinaware, the cobalt blue and pure white objects became popular status symbols then and remain so today. The Chinese also developed a form of pottery known as porcelain, which is made of clay, quartz, feldspar and kaolin, and has thinner walls and finer edges than typical ceramic pottery objects. For six centuries European manufacturers attempted to break the Chinese monopoly but were unable to duplicate the manufacturing process. In the early eighteenth century, experimenters in Meissen, later called Saxony, developed lime and silica

mixes for hand-painted porcelain that rivaled the imported Chinese ware (Amato 1997: 36–38). By mid-century, Josiah Wedgwood in England developed a hard-paste porcelain jasperware that was decorated with classical figures and motifs, making it very popular then for consumers enamored with the arts of antiquity.

Many old mosaic floors, walls and dome interiors survive in Europe. Christian churches, Jewish synagogues and Islamic palaces were covered with permanent iconic images conveying the likenesses of important religious figures and narrating stories created from an assemblage of embedded colored glass pieces, semi-precious stones, and glazed ceramics. Mosaic artists needed a large quantity of materials for their work and must have appreciated the predictable supply and color range of manufactured ceramics, as opposed to relying on colored ores that had to be found in crude mines or expensive and rare glass, both of which were usually reserved for jewelry or to ornament small objects. During the Renaissance and later Baroque periods, labor-intensive mosaics were replaced by painted plaster frescoes, although this work was less durable and the artist had to be very skilled in order to work quickly and apply the paint before the plaster completely dried. Still, mosaic work was often appreciated over fresco work because the shiny tiles reflected more natural daylight in dim interiors and matched the jewel colors of stained-glass windows. In the mid–fifteenth century, Alberti described mosaic work as imitating "a picture using stone, glass, or shells of various colors, arranged in an appropriate pattern" (VI.10). He also found that ceramic materials were good for earthenware piping. He described *intarsia* as large panels fixed with a compound of gum, comparing them to *tessarae* mosaics, which are laid with lime and finely ground travertine cement mortar.

Buildings and garden architecture in warm climates frequently included ceramic tile finishes installed over rough concrete to provide cooler surfaces and ornamental variety. An excellent example from the fourteenth century is the Alhambra (see Figure 29). This Moorish palace city near Granada, Spain, is a complex of rooms open to interior gardens, with fountains fed by an intricate system of cisterns and runnels that moved the water in ways that naturally cooled the palace. Washington Irving, the father of American literature, published a book about this place called *Tales of the Alhambra* in 1832 after spending several years there early in his career. This popular book is credited as the first work of historic preservation, as it prompted efforts to save the abandoned palace and gardens from vandalism and ruin. In a letter dated 23 May 1829, Irving described his experience:

> I am nestled in one of the most remarkable, romantic and delicious spots in the world. I breakfast in the Saloon of the Ambassadors, or among the flowers and fountains in the Court of the Lions, and when I am not occupied with my pen, I lounge with my book about these oriental apartments, or stroll about the courts, and gardens, and arcades, by day or night, with no one to interrupt me. It absolutely appears to me like a dream; or as if I am spell-bound in some fairy palace. I wish to enjoy the delights of this place during the hot weather, and to have a complete idea how those knowing Moors enjoyed themselves in their marble halls, cooled by fountains and running streams [1864, vol. 2: 385–86].

Today, ceramic tiles have common uses as interior finishes where surfaces that are waterproof, stain-resistant, cleanable and durable are desired, and as industrial products, but they are unreasonably underappreciated for exterior applications. Designs in climates with multiple freeze/thaw cycles need high-quality detailing and installation methods that ensure that water cannot penetrate joints, expand when frozen and crack the tiles, or cause them to detach over time. If ceramic tile surfaces are installed on concrete—a material with similar

expansion and contraction behaviors—and if the tile work is protected from direct exposure to severe weather by roof overhangs, the work will stand the test of time.

Encaustic tile is especially appropriate for exterior applications because the color comes from different-colored clays pressed together in the unfired tile, and not from tinted glazes. This kind of tile—with a high-gloss or matte finish—is more durable because the color extends through the depth of the tile and is not just a veneer that can scratch or wear away with use. For centuries, durable and decorative floors were made of colored stone, out of which the Cosmati created extraordinarily beautiful pavements for European cathedral floors in the twelfth and thirteenth centuries. Just as artists came to prefer the predictable supply and consistent regularity of colored glass over thinly cut slabs of vein-patterned stone for windows, manufactured ceramic tile offered mosaic artists the same advantage.

In the late eighteenth century, encaustic tile was available from England's Thomas Minton and Sons Tile Company. One exceptional installation in the United States is the Bethesda Terrace Arcade for Central Park in New York. In the 1860s, architect Calvert Vaux worked with artist Jacob Wrey Mould, who used more than 15,000 encaustic tiles for the only place in the world where Minton ceramic tiles are used for a ceiling. Open to the air, this ceramic tile work adds color and patterns with a cleanable surface that has withstood

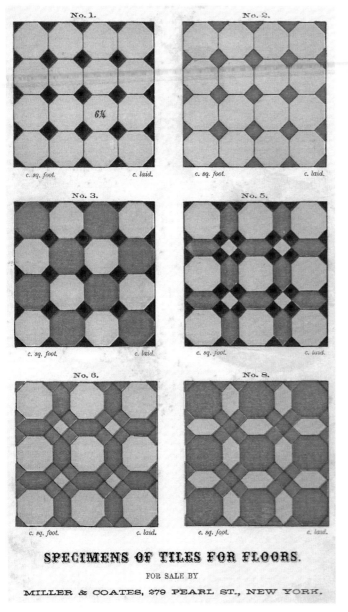

SPECIMENS OF TILES FOR FLOORS.

FOR SALE BY

MILLER & COATES, 279 PEARL ST., NEW YORK.

FIGURE 30. SPECIMENS OF TILES FOR FLOORS (ADVERTISEMENT IN BOOK PUBLISHED IN 1864). (Courtesy Magenta Livengood.) Encaustic Minton tile was imported by Miller & Coates of New York in the nineteenth century. Thomas Minton started the company in 1793, which became the Minton Hollis & Company in 1845, then a part of Royal Doulton from 1968, and a part of Waterford Wedgwood in 2005.

both weather and public use for over 100 years. Tiles such as these are suitable for exterior surfaces exposed to moisture, varying temperature and high traffic, and they may be found in many nineteenth-century vestibules as well as in the corridors of Thomas Ustick Walter's expansion to the U.S. Capitol building, which added flanking wings and the dome, begun in 1851 and completed in 1863.

Theories of Ceramics

Given the extraordinary durability of ceramics as a material, a theory of ceramics is an exercise of conjecturing about permanence as a way of thinking about design, which means that the proposed work can be considered sempiternal. This somewhat intimidating proposition carries the risk that the ceramic design will have only neutral colors in bland patterns. Such banal work may be more likely to be accepted by the varying tastes of the public, and therefore may be more likely to be preserved. Also, the level of commitment to a permanent finish may be unfamiliar and uncomfortable in any consumerist society accustomed to the ease of disposability that prefers to respond to changing opinions with replacement rather than appreciating the fact that tastes evolve. Just as Alberti called for "appropriate patterns" for mosaic work, the concept of propriety or decorum as a design principle applies to ceramic work. Vitruvius cautioned that "the truthful representation of definite things" was more appropriate than "monstrosities" that failed to match subject matter to situation and circumstance (VII.IV.4 and VII.V.3–8). Ceramic work can set an example for designers to appreciate longevity over novelty. The lasting preservation of ceramic tile work also depends on more than the appeal of the surface because the primary structure must also be deemed worthy of preservation.

One such example is Güell Park in Barcelona, designed by Antonio Gaudí and built between 1900 and 1914. Conceived as the entrance and center of a large housing development for 60 houses, the overall scheme failed economically and most of it was not built, although the park was finished and has been saved for public use. Its design followed the guidelines of the Garden City Movement, which called for public parks and markets to be located within the urban fabric. The hillside site had the advantage of spectacular views of the city and sea beyond, but the disadvantage of a relentlessly sunny and hot exposure. The park edge is an undulating concrete bench covered with broken tiles in a method called *trencadís*, which is a local method of making ceramic ornamentation with broken pieces of tile (see Figure 31). In addition to color, the tiles provided a cool seating surface in spite of the orientation. In his diary on 10 August 1878, Gaudí said, "Ornamentation has been, is, and will be polychrome. Nature does not present us with any object in monochrome, totally uniform with respect to colour—not in vegetation, not in geology, not in topography, not in the animal kingdom. Always the contrast of colour is more or less lively, and for this reason we must color wholly or in part every architectural element" (Van Hensbergen 2001: 54–55).

Tiles, like bricks, can be mass-produced, but installed one at a time. This hand-worked method of building is open to artistic expression. Further, some artists embrace the challenge of making permanent art works for public places that are not oversized objects on pedestals, but rather are part of the landscape. The construction procedure guarantees a human-scaled appearance associated with intimacy and individuality. Recently, many architects and landscape architects have been collaborating with artists to enrich blank walls, plain floors and other surfaces in their designs. Some see the future of building design as fighting the urge

FIGURE 32. "FALLEN SKY," PARC DE L'ESTACIÓ DEL NORD, BARCELONA (1991). American artist Beverly Pepper used the *trencadís* technique for this piece that was commissioned as part of a revitalization urban program initiated after Franco's death in 1975. The program's mission was to sanitize the historic city center and to monumentalize the surrounding suburbs through site-specific art installations.

to reduce architectural form to blank planes forced into bizarre forms and made of ambiguous materials of an indeterminate nature. Instead, collaborative designers fully participate in the entire design process, embellishing and contextualizing surfaces with integrated images that communicate visually with the observer. Of course, such permanent art—like all public art—must attempt to serve both present and future users. This suggests a return of the creative process to the fundamentals of academic teaching, in which the artistic concept and its masterful execution allowed a third event—that is, a relationship between building and spectator (Rykwert 2008: 11). Applying ceramic materials to exterior surfaces may be an architectural innovation simply because its purpose as a permanent surface and hand-worked craft receives renewed appreciation.

Innovative Applications

Material engineers are experimenting with various types of ceramic clay mixes in order to alter their inherent performative characteristics. For instance, added fiber increases the tensile strength of ceramics, reducing breakage with heavy use; however, bendable tile is

FIGURE 33. LA CHAPPELLE DU ROSAIRE, DOMINICAN ORDER, VENCE, FRANCE (1948–1951). HENRI MATISSE, NICE. (Courtesy Magenta Livengood.) For the ceramic tile murals, Matisse painted black lines directly on unglazed white tiles, which were then taken to the factory for glazing and returned to the chapel for installation. The tile murals were part of a complete interior in which Matisse designed everything from the colored stained-glass windows to the furnishings to the religious vestments worn by the church priests.

more likely to be made of another material such as plastic. The fundamental properties of ceramics—hard, cool to the touch and permanent—are not enhanced by composites that make it more like other materials. Rather, innovation may come from a renewed desire to use ceramic tile surfaces for their visual and thermal appeal. Many materials have difficulty surviving hot and humid climates: woods rot, metals rust and fibers mold. Surfaces of ceramic tile last.

Innovation is also likely to come from developing enhanced base and glazing materials. Clay ceramics with an added lime base naturally kill micro-organic bacteria, viruses, fungi and mold due to the high alkaline content of the lime. Hygienic properties can also be amplified with coatings that inhibit the growth of germs as well as mold, lichens, moss and fungi. Ceramic tiles can additionally reduce the ability of dirt and grease to adhere to surfaces. This sterilizing effect has applications ranging from reducing the risk of infection in surgical rooms to eliminating contamination in computer component production facilities. Glazing improvements are also increasing the convenience of maintaining ceramic tile surfaces. The hydrophobic property allows rainwater to slide off self-cleaning tile, taking atmospheric dirt along with it. Coatings such as titanium dioxide increase the normal resistive properties of ceramics while reducing air pollution through its absorptive capabilities.

The high embedded energy problem with ceramic tile production is being addressed with products such as Limix, a lime-based ceramic that is not baked but compressed. High-pressure techniques consume less energy than high-temperature methods, and less carbon dioxide is released during manufacturing. The lime base also permits the tile to absorb VOC gases and to clean the air of odors after installation, an action that extends indefinitely.

Other research efforts are experimenting with casting moisture sensors in the tile material, alerting monitoring controls if condensation forms in concealed locations.

Those who speculate about the future of ceramics for the building arts propose that innovation will come in five categories. First, public art that is durable, cleanable, relatively vandal-proof and permanent will enhance civic place image and identity. Second, people will appreciate public spaces for the entertainment value of interactive tiles that react to user presence. Third, certain public spaces may promote increased user safety through the use of "smart" ceramics with embedded electronics that do everything from preventing wi-fi or cell phone transmissions to detecting temperature variations that indicate concealed deterioration within building shell enclosures. Fourth, ceramics that filter and clean air and water already have application in hospitals and health care facilities, and they may find a market in commercial and residential buildings, benefiting people who suffer from airborne allergies. And fifth, ceramic tiles with glazes that self-clean, absorb odors and light, and regulate humidity will provide both convenience and environmental advantages (Sastre and Sos 2009: 19). For the building arts, these enhanced qualities will only increase the long-term benefits of permanent and durable surfaces, and provide a medium for artists to offer their work for public consideration.

Ceramics with thermal, visual and acoustic properties need not be limited to pool patios and ethnic restaurant interior decorations. People with respiratory distress will find formerly toxic interiors "healed" by ceramic tile surfaces that are easy to clean and do not attract dust. Boring public spaces can be enlivened by ceramic mosaic art, or at least made more interesting than innocuous surfaces. After manufacturing procedures are made more sustainable, innovation in the use of ceramics may be more about cultural evolution than technological development.

Resources

Federal Agencies, Technical Societies and Associations

American Ceramic Society, http://ceramics.org.
Ceramics of Italy Tile sponsors competitions for inspired and imaginative architecture using Italian ceramic tiles, http://tilecompetition.com.

Ceramics Today publishes articles on industrial ceramics, http://ceramicstoday.com.

Infotile maintains a question-and-answer forum, http://www.infotile.com/publications.

U.S. Environmental Protection Agency is conducting a research project on reducing production waste, see Mineral and Environmental Sustainability in Ceramic Processing, cfpub.epa.gov/ncer_abstracts/index.cfm/fuseaction/display.abstractsDetail/abstract/7842.

Special Ceramic Tile Products

Air Cleaning Tile—Tau Group S3's Smart Surface Systems clean the VOCs in the air, heat and cool spaces and surfaces such as tabletops, and can have embedded microchips and electronic controls, http://ese3.com.

Antimicrobial Tiles—RAK makes tiles that clean the air and reduce the risk of infection, http://rakceramics.com.

Ceramic Paint—Polymer-based acrylic paint with properties that increase surface durability against UV radiation and high winds, has improved thermal insulation, and is fireproof, breathable and waterproof, http://liquidceramic.com.

Ceramic Paper—3M (formerly the Minnesota Mining and Manufacturing Company) is a conglomerate corporation conducting research in this area, http://www.3m.com/market/industrial/ceramics.

Ceram is a company (formerly the British Refractories Research Association) that provides information about composite ceramics with specific properties, such as piezoelectrics, superconductors, optical and magnetic properties, and biocompatibility, http://www.ceram.com.

Recycled Tile—ECO-LOGIK Plaza Ceramicas contain up to 85 percent recycled glass in their porcelain tile, http://plazatiles.com.

Chapter 6

Glass

The use of glass as a material for buildings exploded in the twentieth century due to many technical improvements making it less costly to manufacture and safer to use, and, as a result, no material has a greater correlation to the architecture of the modern movement. Valued for its transparency over all other characteristics, glass released architecture from its fundamental definition of shelter as a secure, and likely dark, enclosure to one that allowed light to enter. No material seems to capture more contrasting qualities: glass can appear as two surfaces or none, and it can be transparent or translucent, visible or invisible, and enclosing or releasing, with varying degrees of reflection, refraction and transmission of light. Its presence can be articulated or suppressed as surface or edge.

Made by fusing inorganic substances, glass is a material composed of several elements that are worked and reworked in a liquid state that softens when heated or reheated, and then hardens and becomes rigid when cooled. Manufacturing techniques melt, form and cool molten glass into flat sheets that then require grinding and polishing. The finished glass is transported to the site for installation. The transparency of glass depends on the rate of cooling, in which disturbed crystals are allowed to reform, but only to some degree. The more this reformation is prevented, the clearer the glass. This ability to be formed and reformed opens the material to technical manipulation and innovation.

Fundamentally, glass is hard, yet fragile and brittle. Most glass breaks upon impact into many pieces with sharp edges, and the sense of danger from cutting is never far from the human perception of and response to glass. Glass breaks like ceramic tiles, whose tiny surface imperfections likewise make them vulnerable to shattering upon impact. Wind forces strain sheets of glass, too, and structural engineers must calculate these forces for building applications. Even though glass behaves like a rigid material at normal temperatures and like a flexible plastic when worked at elevated temperatures or made very thin, a glass sheet will bend and return to its original shape unless pressed beyond its breaking point. Glass is somewhat insulative and sound-deadening, and it can withstand sudden temperature swings without expanding or contracting. Various innovative glass coatings and laminated assemblies have significantly improved its thermal and acoustic properties (see Figure 34).

The embodied energy of glass is high due to the extremely high temperatures needed for production, although pre-consumer waste can be returned to the mix, and post-consumer glass is 100 percent recyclable. Many manufactured products contain a substantial amount of recycled glass content, making it one of the more sustainable products to use in construction. This is important, because glass breaks. Although well-made glass resists surface scratches, abrasions, weathering and most chemicals, it has low tensile strength and cannot

be repaired to its original condition once cracked or broken. As a non-porous and non-absorptive material, the great advantage is that glass has an "unmatched resistance to deterioration" (Bell 2006: 13). Glass continues to perform as if new throughout its entire life, requiring no maintenance other than an occasional cleaning, and even that is a disappearing requirement. New photocatalytic coatings absorb ultraviolet rays to break down and loosen organic dirt so that the rain washes the windows, eliminating the need for cleaning (McMorrough 2006: 175). Unless broken, glass will last forever, and like ceramic tiles, glass fragments have survived through time and are evidence of the technical and cultural advancement of early societies.

Properties of Glass

The key properties of glass desired for design include transparency, hardness and rigidity at ordinary temperatures. It is does not degrade and resists most chemicals (except hydrofluoric acid). Glass is "an amorphous solid made by fusing silica (silicon dioxide) with a basic oxide" (Brady et al. 2002: 439).

There are three general types of glass used for buildings and related elements: soda-lime, lead and borosilicate. By far, soda-lime glass is the oldest, most economical, and easiest type of glass to fabricate. It is made of 70–75 percent silica sand, which is inorganic grains of mineral matter, with no organic clay content, and "the most common of all materials, and in the combined and uncombined states is estimated to form 60 percent of the earth's crust"; plus 12–18 percent soda, an alkali sodium carbonate that serves as a flux to lower melting temperatures, absorb impurities and prevent fogging; and 5–13 percent alkaline earthen material such as lime or calcium oxide, which is found in limestone, marble, chalk, coral and shells (Brady et al. 2002: 439–40, 838). The lime "renders the glass more viscous at the working temperature, shortens the setting time and improves weathering properties" (PPG Industries 1996–1999—see Resources). About 90 percent of all glass has this composition. Glass that substitutes boron oxide for silica has an increased refractive index and better resistance to damage and thermal shock. Increased iron content makes glass more stable and the edges appear green. Other added compounds affect the color, viscosity and durability of glass, enhancing hardness, mitigating shatter characteristics, reducing thermal conductivity, and filtering ultraviolet light rays.

Lead glass has at least 24 percent lead oxide replacing lime, and is used for products ranging from cut glass stemware with increased brilliance to radiation shielding. Borosilicate glasses provide the durable and heat-resistant material needed for railroad signal lanterns and street light fixtures exposed to extreme temperatures, as well as oven-proof houseware. Introducing crystallization in a ceramification process makes a polycrystalline material called ceramic glass that can withstand the extreme temperatures needed for products ranging from kitchen range cooktops to missile nose cones (Lefteri 2002: 84; Corning 1999: 56–57).

Glass manufacturing begins with mixing the batch. About one quarter of the batch is cullet, which is cleaned and crushed glass recovered from pre-consumer glassmaking waste and/or post-consumer recycled glass objects. The mix is melted at high temperatures that refine and purify it by removing elements that affect its final color, as well as corroding metal particles. The molten glass is then formed and shaped with heating, cooling or warming techniques, or through a combination of techniques. Hot techniques work molten glass

either by blowing air through metal pipes to expand and shape it or by casting in, slumping over or press-bending flat glass sheets over molds as the only way to make predictable, simply curved forms. Cold techniques refine semi-finished glass products capable of being cut, drilled and polished. Warm techniques kiln-fuse glasses with similar coefficients of expansion in controlled conditions, making laminated sheets of glass.

Other manufacturing techniques alter the cooling protocol in a process called annealing, which allows the crystalline structure of the melted silica to only partially realign. The annealed glass has greater strength, transparency and durability. Recently, "smart" glass sheets have been developed that can switch from transparent to opaque by passing an electric current through a liquid crystal film layer between sheets of laminated glass.

Another valuable type of glass is tempered glass, which is made by heat-treating glass until it almost softens and then cooling it quickly and evenly, forcing the exterior surface into a state of compression and the interior into a state of tension (Bell 2006: 15). This makes tempered glass two to four times stronger than annealed glass and capable of withstanding up to 22,000 pounds per square inch of pressure, more resistant to thermal stress and impact, and safer if it breaks. Tempered glass shatters into granular pieces and not sharp shards, and it was developed for automobile windshields, improving occupant survival from accidents. Now windshields are made with tempered laminated glass, further improving the likelihood of survival upon impact. The tempering process slightly distorts the glass reflection and has a very low or even negative coefficient of expansion. Tempered glass also provides the needed strength for glass sheets for building curtain walls, skylights and glass roofs that must resist heavy winds and intense temperatures without movement. Tempered glass is generally required by building codes for applications within eighteen inches of the floor to prevent injury if a person accidentally kicks the glass.

After grinding and polishing, glass can utilize different finishing procedures, such as sand-blasting or acid-etching, that alter the reflectivity qualities or add decorative patterns, but these are less common. Textures can also be made by laying a glass sheet over ceramic, sand, plaster or concrete molded panels and heating the glass as needed to melt into the other material and pick up its surface texture.

The performative characteristics of glass have been enhanced by coatings that are applied during production, films applied post-installation, and designed glass assemblies. Thin tin oxide coatings are blown onto the glass surface in a chemical vapor deposition step during production. The result is called low-emissivity, or Low-E, glass, which suppresses radiative heat flow by blocking solar heat from entering a building in the summer while preventing internal heat from escaping in the winter. While about 8 percent of daylight is reflected off untreated glass surfaces, anti-reflective glass films reduce the reflectivity to 1 percent. Safety glass has transparent celluloid, vinyl or polymer films sandwiched between glass layers that hold the broken shards together upon impact, and these layers can be thickened to make the glass soundproof and bulletproof. Although glass is a dielectric material and does not conduct electricity, electro-optical glass film "heats up" and can melt ice (Addington and Schodek 2005: 156). Other films allow transparent projection surfaces to appear on the glass screen, unaffected by ambient light (Brownell 2006: 149). Thermal and sound insulative capabilities have also been increased with assemblies called insulating glass, sometimes referred to as double-pane or triple-pane glazing. Hermetically sealed air spaces separate glass sheets with a desiccant-filled spacer that absorbs the internal moisture of the air space and prevents condensation from forming (McMorrough 2006: 174). This space is filled with air or gases such

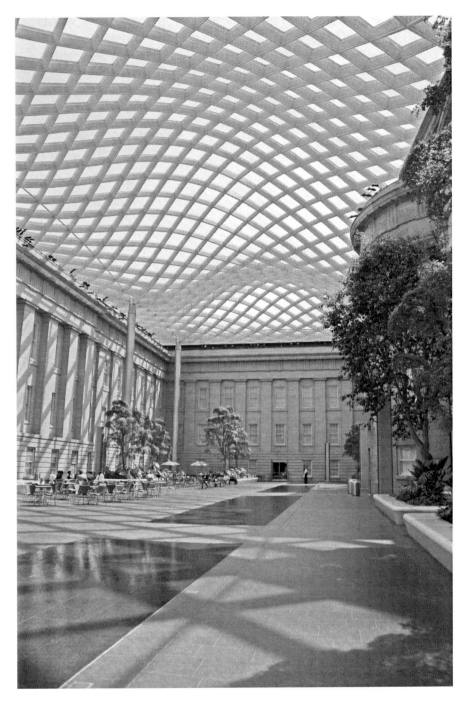

FIGURE 35. THE ROBERT AND ARLENE KOGOD COURTYARD, NATIONAL PORTRAIT GALLERY, WASHINGTON, D.C. (2007). FOSTER + PARTNERS, LONDON. (Courtesy Magenta Livengood.) The undulating roof of 864 glass panels floods a 28,000-square-foot interior public courtyard with daylight. Multiple coatings on the glass prevent the ultraviolet rays from entering and making the space expensive to air condition. The ceiling reflects people and events at night, creating an enlivened atmosphere with images that bounce between the glass and the shallow basins of water.

as argon or sulfur hexafluoride. Window, door and skylight panels with safety glass made with a metal mesh layer can be used in fire-rated enclosures because this prevents the glass broken by heat or impact from falling out of place.

Until recently, glass sheets used for building windows or curtain walls were not self-supporting and required structural frames. Recent innovations have increased the structural capability of glass. Examples include glass mullions and channel glass, which is factory-cast in U-profile channels and installed as interlocking, self-supporting panels that can stand alone without intermediate metal framing. Gaskets and sealants fill narrow seams and allow slight deflection. Thick cast glass of one to two inches can be used as stair treads or glass floor panels, and these can have integral slip-resistant surfaces made during the manufacturing process.

Glass in History

Obsidian is a naturally occurring glass found in the lava flows of volcanic eruptions. The high silica content cools into a hard and brittle rock that was valued for tools with sharp edges. Dating from 3500 to 1500 BCE and found in Egypt, the earliest manmade glass arti-facts were beads used for royal jewelry. Utilitarian objects such as bottles, jars and vases, also found in Egypt, date from 1700 to 1600 BCE. They were made by dipping metal rods with a paste stuck to the end into molten glass and removing the core when cooled, or by wrapping coils of hot glass around a removable clay core (Amato 1997: 31). The earliest surviving glassware bears the name of Pharaoh Thoutmois III (1504–1450 BCE), and glass sculptures of Amenhotep II may be found at the Corning Museum of Glass today. After about 750 BCE, craftsmen in Mesopotamia blew air through iron pipes into a mass of molten glass, making vessels with thin walls of uniform thickness.

Vitruvius does not mention glass as a building material in his treatise. But in the little more than one hundred years between Vitruvius' book and Pliny the Elder's death in 79 CE, glass-blowing and mold-casting production techniques advanced to the point that glass ves-sels became a trading commodity for Rome, with its vast network of merchant shipping. Glass for windows was rare, although it was used in villas in Pompeii and the surrounding region. A 3mm thick bluish-green window pane of cast glass has been excavated from Her-culaneum and is exhibited at the British Museum. The glass color was due to some iron or copper content.

Pliny the Elder had a lot to say about glass. He devoted a section in his chapter on stones, minerals and monuments to glass, even noting a particular river in Syria that scoured and purified sand from its banks as the "sole producer of glass." Pliny described the temporary theater Marcus Scaurus built in 58 BCE and designed for 80,000 people as follows: "the lowest tier of the stage was of marble [columns], the middle one of glass [some say encrusted with glass]—an unheard-of example of extravagance even in later times—and the top one of gilded planks" (XXXVI.114). He continued recounting an apocryphal origin story of Phoenician sailors who put lumps of soda (nitrate or natron, an alkali used in embalming the dead) under their cooking pots on the sand. Once hot and fused with the sand, "an unknown translucent liquid flowed out." Pliny described the manufacturing process of heat-ing, melting and fusing, and then manipulation techniques of blowing, fashioning with a lathe, and some engraving. He concluded by saying that "the most highly prized glass is transparent" (XXXVI.190–99).

Significant developments in glass making did not occur until the eleventh century in present-day Germany, and two centuries later in Venice, which became the foremost producer of glass, holding a monopoly until the early seventeenth century. By 1291, Venetian craftsmen were isolated on the island of Murano both to protect the city from the dangers of the fire needed for glass production and to safeguard the proprietary technology. They developed techniques for blowing a hollow glass sphere and swinging it vertically, using gravity to pull the molten glass into a cylindrical tube, the ends of which were cut off, leaving a tube that was then cut lengthwise and flattened on an iron plate. Known as broad sheet glass, this was used for window panes, and by the mid–fifteenth century, half the houses in Venice had glass windows (Amato 1997: 32). The glass sizes were small. In the seventeenth century, the largest panes were four by six inches; by the eighteenth, they would be about ten by sixteen inches and were set in wooden glazing bars.

In 1450, Alberti recommended that "every consideration must be given to region, weather, use, and comfort," noting that homes with open courts would find it "convenient to have glass windows, balconies, and porticoes" that provide views and "admit sun or breezes, depending on the season" (V.17). More than half a millennium later, this statement describes what is generally expected of windows.

Beyond the distinct advantage of having clear glass for windows, the architectural use of colored or stained glass found application in the late twelfth century. The thick masonry walls of Gothic cathedrals had pointed windows that diverted the weight to either side of large vertical openings. The earliest example is from the 1140s, when Abbot Suger rebuilt the seventh-century royal abbey of Saint-Denis outside of Paris. The large openings were filled with painted glass and colored glass made by adding metal ore elements to the liquid batch. Of the seven Metals of Antiquity, the only metals known as late as the thirteenth century that were available to color glass batches were copper to make green, blue and red, and iron to make green, blue and brown. Other metals were available later in the seventeenth century to color glass, including cobalt for green, blue and pink; nickel for purple and yellow; manganese for purple; and chromium for green, pink and yellow (McMorrough 2006: 174). For the illiterate observer of the medieval era, the stained-glass window images taught the lessons of the church, and likely produced sublime feelings in the spectator, having been touched by heavenly sunlight shining through the work of man, thus "urging us onward from the material to the immaterial" (Suger in Panofsky 1979: 75).

Aside from ecclesiastical architecture, stained glass became a less common art form, and it was not until the Art Nouveau movement in the late nineteenth century (with Louis Comfort Tiffany in America, for example) and the early modern European artists such as Matisse, Chagall and Braque in the twentieth century that interest in this medium returned. Their work uses the power of glass to alter the quality of light, and this practice continues today with art glass sculptures intended to produce special effects (see Figure 36).

The technical advances for making glass came from evolving needs to ease production requirements and enhance performance. In the fourteenth century, a process called lamp-working (also flameworking or torchworking) manipulated molten glass with tools and hand movements without the further use of a furnace. By the mid–sixteenth century, the Crutched Friars in London made crown or bullion glass by blowing a ball that was spun to flatten it into a disk, and then cut into pieces for leaded windows with matched thicknesses. Some panes with the center dimple or bulls-eye were used, and they are still admired today. In England, this method was not replaced for almost three hundred years, until Robert Lucas

Chance introduced new methods for making what is called sheet glass based on a cylinder process, previously described, that used new machinery for grinding and polishing glass. By 1841, his company produced over four thousand feet of glass per week, and a decade later it provided the glass panes for the Crystal Palace in Hyde Park, London, about which more follows.

Polished obsidian was used for the first mirrors, followed by polished stone and metal. Metal-coated flat glass mirrors were mentioned by Pliny, and were generally used for personal grooming. Mirrored glass back plates for candle sconces multiplied the intensity and effect of illumination. Venetians used mercury-tin amalgam for mirror coatings, and modern techniques use silver compounds with additional coatings to prevent tarnishing. The mirrors in the Palace of Versailles (1685) were made of molten glass poured onto a special table, rolled flat and cooled. Rotating iron disks and increasingly fine abrasive sands ground the surface, which was then polished with felt disks.

Techniques for making optical glass began with Galileo, who perfected curved lenses for telescopes, and Sir Isaac Newton, who developed lenses for the microscope in 1668.

Prior to the sixth century, windows typically had wooden shutters to block the wind and secure the room interior. Translucent oiled paper or muslin were used after that until the twelfth century, although thin sheets of translucent alabaster or marble, or even semi-transparent mica, were sometimes used in royal and religious buildings. By the seventeenth century, small window glass panes were joined with lead. The invention of glazing putty in the Netherlands in 1737 changed the structural framing material from metal to wood, making windows more weather- and draft-proof. By the end of the century, window glass was less expensive and commonly used in houses of all sizes and in many commercial buildings in France, Germany and Belgium. Production techniques improved and, by 1895, the Pittsburgh Plate Glass Company was producing twenty million square feet of glass annually.

Not all windows were made of thin glass panes held in frames. The French inventor Gustave Falconnier developed techniques in the 1880s to mass-produce hand-blown, hollow, air-tight glass blocks in oval and hexagonal shapes in a hand-operated split mold. This pressed glass had the advantage of texture and pattern on both sides, was strong, and transmitted daylight in dappled color. Available in clear, aqua, amber, green, blue and opal, architects including Hector Guimard, Auguste Perret and Le Corbusier used the structural glass blocks for thick walls of textured light.

In 1909 in France, Edouard Benedictus patented TripleX, a safety glass with laminated layers that was based on the discoveries of German inventor Otto Schott in the 1880s. This glass satisfied the emerging automobile industry's need for glass that did not break into cutting shards on impact, and by 1929 it became a standard material in all Ford cars.

Beginning in the twentieth century, Belgium inventor Emile Fourcault made sheet glass that was mechanically smoothed with rollers, but still needed grinding and polishing on both sides. Another innovation in production occurred when the Pilkington Brothers, a British company, fully mechanized the process for making plate glass by using rollers to squeeze molten glass into a ribbon, simultaneously grinding it on both sides (twin grinding) before polishing.

Glass sheets were also getting larger. In America in 1903, the machine-drawn cylinder sheet technique made single sheets of glass up to 40 feet long. Large glass sheets meant larger windows that were even more dangerous when broken and required tempered glass that needed expensive cooling chambers and a slower production sequence. In France in 1929,

St.-Gobain developed a hanging technique with air cooling that allowed the automated production of tempered glass.

The development of special coatings improved the performative capabilities of glass. Borosilicate glass was developed in America by Corning Glass, which marketed the new heat-proof glass as Pyrex® in 1915. Their work was based on Schott's experiments with varying the density and refraction of glass by adding barium, phosphoric acid, and boric acid. Corning Glass also developed the mass-production ribbon machine process to make Edison's light bulbs in 1926, lowering the cost of electric light.

The last significant development in the mid–twentieth century was a new production technique that made a very flat surface that could be heat-polished or "smoothed by gravity and surface tension," and required no further grinding or polishing, which was a distinct advantage over plate glass techniques (Corning 1999: 14). Sir Alastair Pilkington made float glass by pouring molten glass at 1,000°C over a long bath of liquid tin, and then feeding the glass through rollers and gradually cooling it to 200°C. This became the most widely used means of producing flat glass.

The development of float glass coincided with the development of a new building type— the skyscraper. Buildings were becoming increasingly taller because of the invention of elevator brakes, cost-effective techniques for making structural steel, and the development of large-capacity heating and cooling mechanical equipment. The development of completely clear, blemish-free, mass-produced large sheets of flat, optically superior transparent glass at affordable costs gave rise to the contemporary appearance associated with ideals of progress and the modern era. Examples of important architecture built in the United States include Mies van der Rohe's Farnsworth House (1946–1951); Chicago's Lake Shore Drive apartment buildings (1951) and Seagram Building (1958) with bronze-toned glass; Philip Johnson's house in Connecticut (1949); Skidmore, Owens and Merrill's Lever House (1952) with green, heat-absorbing glass; and Eero Saarinen's General Motors Technical Center (1949–1955). These elegant glass-clad and carefully proportioned and detailed steel grid structures pushed crystalline form over all other expression, suppressing the appearance of structure, operating systems and ornamentation. Their performative problems only became apparent during the energy crisis in the 1970s, when the cost of heating and cooling glass buildings drew attention and spurred another round of technical advances. These innovations resulted in better-performing building skin glass assemblies, sometimes with qualities that defy the very nature of glass.

Theories of Glass

Transparent, translucent or opaque, glass is a liquid "frozen" in a solid state, "cooled to a rigid condition without crystallizing" (according to ASTM). Premodern glass production processes left "reams" (small waves or folds) and "seeds" (small air bubbles) in glass that was not completely clear or uniformly thick, causing uneven reflections. Consequently, glass had material presence. Light refracted unevenly and chemical impurities left traces as color, but these qualities did not mitigate the great advantage of allowing light, and not air, to pass through walls. Today, technological advances produce glass that is perfectly clear, without blemish or undesired color, and unless it is dirty, there is no material presence. Glass has become invisible. *Thus, the inherent properties of glass, along with its technical capabilities, allow designers to choose the degree of material presence of glass.*

Glass can "reflect, bend, transmit, and absorb light" (Bell 2006: 14). Manipulating these inherent characteristics of reflectance, transmittance and absorbency alters the experience of light through glass. Glass windows and enclosures fracture sensory experience into distinct perceptions. Seeing a view without feeling the touch of the wind, hearing sounds or smelling scents from beyond the immediate area separates the body from the world. This division, along with a sense of security and privacy, defines the experience of the architectural interior as different from outdoors. Walls with windows take on their own dissolution; they enclose and release at the same time.

Glass reflects the spectator, dissolving the space in between, and even itself as a material. The polished surface receives the gaze and, through its invisibility, reflects fleeting glimpses of the "other," much like a mirror. Even with perfectly clear glass, the extent of this view is bounded because most glass panels require a frame. The neutral frame isolates the glass and what may be seen through it from its context (Ortega y Gassett 1986: 24). The frame turns the view into a "picture" and alters the nature of the spectator's gaze. In an essay called "Fear of Glass: The Barcelona Pavilion," the author says that glass allows eternal special currents to flow through space (Quetglas 2001). The eye moves anxiously, as it is bounced back from reflective mirrors only to be freely released by immaterial glass surfaces. Clear glass can dissolve enclosure and containment by its invisibility. As polite observers do not want to leave fingerprints, glass surfaces stand untouched and removed from engagement. Nevertheless, no one can argue against the presence of daylight that is so desirable and appreciated within interior space. It is the way the material quality of glass affects the perception of light that inspires further technical inquiry, along with its great capacity to be manipulated into a more sustainable building envelope both barricading people from the unwelcome forces of nature and providing access.

Innovative Applications

A small early innovation had a lasting impact. One aspect of European colonialism was the importation of plants originally considered exotic, which expanded the diet and garden plant palette. Glass was used to make the Ward's box, an easily transportable and sealed glass box that housed plants in the necessary microclimate to survive long sea voyages. Taken to a larger scale, exotic plants in new climates needed hothouses and conservatories, inspired by the orangeries of Baroque France, to survive and to extend the growing season. Abolishing the glass tax in 1845 in England allowed glass buildings to have wide acceptance, especially among the middle classes, whose houses were taxed if they had more than six glass-paned windows. Combating the long, wet and cold English winter, conservatories were added to houses for so-called winter gardens. Also contributing to the popularity of glass houses was the fall in the price of iron and coal used to fuel stoves, as well as John Claudius Loudon's 1838 invention of the wrought iron sash bar, which allowed a free-standing ridge-and-furrow glazing frame, and his studies of its effect on greenhouse plants (Simo 1988: 112–18). Along with technological developments in gas lamp lighting and steam heat, glass houses could create a heavenly Elysium of perpetual spring, hosting a nature under control.

This technology led to the curved glass shapes of Sir Joseph Paxton's hothouse for the Duke of Devonshire (1836–1841) and Decimus Burton and Richard Turner's Palm House at Kew Gardens (1845–1848), where plant specimens from the globe were first stored and

FIGURE 37. THE PALM HOUSE, KEW ROYAL BOTANIC GARDENS, LONDON (1844–1848). DECIMUS BURTON AND RICHARD TURNER, LONDON. (Courtesy Magenta Livengood.) This important surviving Victorian-era glass-and-iron structure was designed to create a suitable habitat for the exotic palm collection.

displayed. Paxton also designed the Crystal Palace for the 1851 Universal Exhibition in London's Hyde Park, mostly made of cast plate glass using the cylinder process and set between cast iron structural members. Erected in twenty-two weeks and covering nineteen acres, it contained 293,635 panes of glass, which was one third of England's annual production.

Today, technical innovations in glass have enhanced insulative qualities for environmental control and improved structural strength, allowing frameless installations. Glass spun into tiny hollow fibrous strands or filaments has three general applications: glass wool made of soda-lime is spun and blasted with hot air, making fine and lightweight fiberglass used for acoustic and thermal building batt or blanket insulation; insulating glass or fiberglass, which is strong in tension and used to reinforce polymers, especially for automobile shells and boat hulls; and textile or optical fibers—fiber optics—that carry light through flexible tubes without dissipation. This last application was discovered following experiments in the 1840s on how and why light bends when passing through arching water. Further research led to coated glass pipes with reflective interiors that transmit light, and eventually to lasers (Light Amplification by Stimulated Emission of Radiation). "As late as 1965, no light sent into a thousand-meter length of glass fiber drawn from the best glass available would make it to the end," but by the 1970s, scientists at Corning Glass Works developed attenuated fiber-optic cables that were able to carry vast quantities of information (Amato 1997: 109). This also allowed remote lighting of interior rooms where any spark from an electrical circuit could ignite unusual atmospheric gases. NASA embedded fiber optics into spacecraft

interiors so that internal material or structural changes could be detected without disassembly.

"Smart"—as opposed to high-performance—materials have the ability to sense and respond to a changing environment. Recent developments include insulating paint, which has hollow glass beads or microspheres added to the formula, and is used to insulate exposed hot and cold water piping. Another use for hollow glass beads is to coat them with phosphorescent chemical powder that absorbs daylight and then glows at night for road caution paint. Glass-impregnated fabric provides reflectivity for protective clothing that is visible at night and for fashions that glow. In the 1970s, photochromic self-adjusting glass that automatically darkens in daylight was developed and found application in variable transparency eyeglasses (Amato 1997: 172).

In the 1980s, a fusion drawn glass process was used to make liquid crystal display (LCD) glass that needed to be perfect on both sides, very thin and flat. This can be achieved because nothing touches the glass surface in this production technique. For touch screens, a very thin piece of glass became the best coating, providing greater optical clarity and scratch resistance than plastic.

When made with less silicone and more calcium, sodium and phosphorus, biologically inert glass objects interact well with the body's chemistry and can be used for bone, tooth and joint repair and regeneration, as well as actual eyeballs (Lefteri 2002: 45, 91).

For buildings, direction-sensitive mirror panes within layers of insulated glazing units follow the sun, reducing sunshine and glare, and enhance the benefits of daylight (Brownell 2006: 154). Another promising product is Swissflam®, which is an intumescent glazing system in which heat from a fire causes the layers to turn opaque and expand, forming an insulating heat shield, blocking the transmission of radiated and conducted heat, and making a "barrier to smoke, flame and hot toxic gases" (Brownell 2006: 162). For roads, Solar Roadways is a company working with the U.S. Department of Transportation to develop an alternative to asphalt roads. Intelligent glass road assemblies will contain solar photovoltaic panels that supply local consumers and LED warning lights that respond to changing driving conditions, thus increasing safety.

The capability of glass to be completely recoverable finds its first generation of reuse in the industrial plant during production, where waste glass or cullet is less expensive to use than additional raw materials and melts at lower temperatures, reducing the carbon footprint of the batch. The next generations of post-consumer uses are important to continue developing, as glass accounts for 7 percent of the garbage by weight generated in this country, although 90 percent of the glass objects returned for recycling are bottles that are reformed as new bottles and jars (EPA). Other purposes include crushed post-consumer glass used as mulch, which absorbs less moisture than wood chips, reducing irrigation needs. Cullet is also used in asphalt mixes called glassphalt, or as road bed subsurface drainage material. Another approach to repurposing glass is when embedded glass fragments appear and retain their reflective quality in new products. Fabricated surfaces such as DEXterra and IceStone are as durable as granite, with much lower carbon footprints. Products that contain repurposed glass fragments have intellectual appeal precisely because the glass appears as glass, but in a form tamed of its cutting threat.

A visit to the Grand Canyon now offers the experience of walking on air. The clear glass floor of the cantilevered observation skywalk extends over the canyon edge and provides a look down 4,000 feet. Just knowing the structure was engineered with a generous margin

of error, that it complies with building-code requirements, and that it shows no sign of deterioration due to a lack of maintenance does not mean that everyone is willing to take the walk. Perfectly clear and invisible, this glass becomes a felt material even if you can't believe your eyes. Centuries of caution are ingrained on our instincts, engendering respect for sharp edges and the capacity of glass to suddenly break into flying knives. Being near glass means heightened and alert attention; one cannot relax their vigilance. Accepting that an invisible and dangerous material can suspend a body in space requires a thrilling leap of faith.

This is one reason landscape architects seldom use glass even though it is sufficiently safe, strong and durable to survive the normal rigors of public exposure. For architecture, the search for transparency has dematerialized glass. Once this end was achieved, artists and designers have become intrigued by manipulating and distorting glass, giving it presence even as it satisfies the fundamental emotional need for light and the equally important duty to be energy efficient (see Figure 38).

Glass joins the materials examined thus far—metals, brick and ceramics—which are the "ancient trinity of materials that were born of flame" (Amato 1997: 30), but its varied afterlife and potential for contradictory tendencies are unique characteristics.

Resources

Federal Agencies, Technical Societies and Associations

Glass Association of North America, http://glasswebsite.com.
National Glass Association, see for architectural glass, http://www.glass.org.
Pittsburgh Corning is a major supplier for glass block, cellular glass insulation and other glass products, and it also conducts research and development advancing glass technologies, http://pittsburghcorning.com.
PPG Industries (formerly Pittsburgh Plate Glass) manufactures multiple materials, including fiber glass. It also publishes "A Historical Look at Glass," http://glasslinks.com/newsinfo/histppg.htm.
U.S. Environmental Protection Agency, see for information about recycling recovered glass, http://www.epa.gov/osw/conserve/materials/glass.htm.

Research on the Sustainable Production of Glass

eCullet Inc.—recycled glass processing technology, http://ecullet.com/home_1.html.
Recent technical innovations, http://glassonweb.com.

Glass Products

Gorilla® Glass is used for the touchscreen of a billion electronic devices, http://corning-gorillaglass.com.
For hot glass artists, see *Glass Line Magazine*, http://hotglass.com.
Self-cleaning Sunclear® Glass, http://www.ppc.com.

Glass Museums

Corning Museum of Glass in Corning, New York, has an extensive collection of historic glass and exhibitions of the most cutting-edge glass production technologies, http://www.cmog.org.

Glass Pavilion, part of the Toledo Museum of Art in Ohio, contains over 5,000 works of art from ancient to contemporary times. The building has large panels of curved glass designed by SANAA, Ltd., of Tokyo, and it opened in 2006.

Museum of Glass (2002) (architect Arthur Erickson) in Tacoma, Washington, is dedicated to the medium of glass art, http://museumofglass.org.

TOP: FIGURE 14. WESTMINSTER PRESBYTERIAN CHURCH FELLOWSHIP COURTYARD AND MEMO-RIAL COLUMBARIUM, MINNEAPOLIS (2009). COEN + PARTNERS, INC., MINNEAPOLIS, MINNESOTA. (Photograph by Paul Crosby. Courtesy Coen + Partners, Inc.) The perforated copper fence provides an enclosure for private meditation without isolating the place from public view. The pattern resembles the church's stained-glass windows adjusted for the digital program used in production.

ABOVE: FIGURE 17. HORIZON RESIDENCE, VENICE, CALIFORNIA (2005). MARMOL RADZINER, ARCHITECTS AND LANDSCAPE DESIGN, LOS ANGELES. (© John Ellis and Marmol Radziner.) Cor-Ten steel retaining walls provide a thin enclosure for the terraces in this 975-square-foot communal garden shared by four apartments. Taking advantage of the small space, the "floating" platforms surrounded by plants provide places of separation and relative privacy.

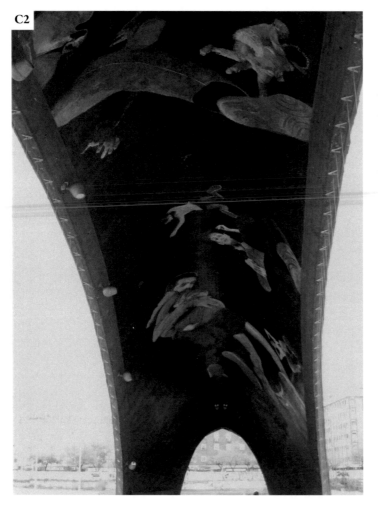

FIGURE 27. CASCARA BRIDGE, MADRID (2007). WEST 8 URBAN DESIGN & LANDSCAPE ARCHITECTURE, ROTTERDAM. (© West 8.) A ceramic tile mural by the Spanish artist Daniel Canogar covers the underside of a concrete bridge, inviting pedestrians to enjoy the crossing.

FIGURE 29. THE ALHAMBRA, GRANADA, SPAIN (FOURTEENTH CENTURY). (Courtesy Cheri Lucas Rowlands.) Ceramic tiles in bright colors and with non-representational images cover the walls that surround the courtyards.

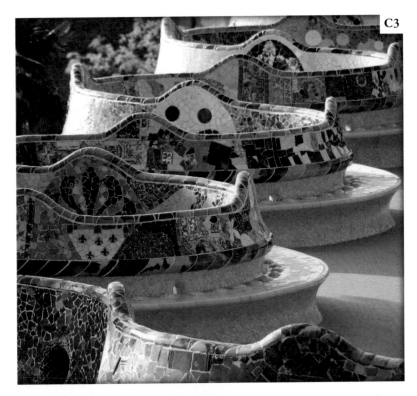

FIGURE 31. GÜELL PARK,
BARCELONA (1900–1914).
ANTONIO GAUDÍ, BARCELONA.
(Courtesy Franz St., Austria.)
The elevated terrace in the
center of the park has a
serpentine-shaped edge with a
continuous railing and bench
covered in broken multicol-
ored ceramic tile in a mosaic
technique called *trencadís*.
This project became a
UNESCO World Heritage Site
in 1984.

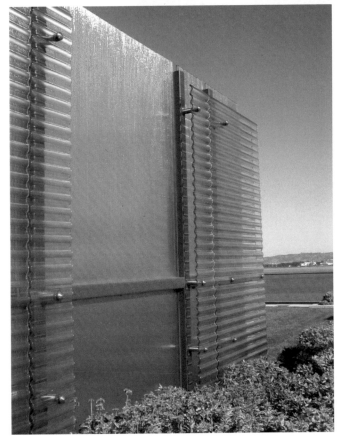

FIGURE 34. GAP
HEADQUARTERS, SAN FRAN-
CISCO (1998–2001). OLIN,
PHILADELPHIA AND LOS
ANGELES. (© OLIN.) Textured
glass walls are layered to con-
ceal the mechanical equipment
and to provide screens that
block the wind and the noise
for people sitting in the roof
garden. Situated next to a
noisy freeway and on the flight
path of San Francisco Interna-
tional Airport, this design pro-
vides acoustic and thermal
benefits.

TOP: FIGURE 36. CHASE CENTER, ROOF GARDEN, SEATTLE (2007). PFS STUDIO, VANCOUVER. (Courtesy PFS Studio.) The ornamental glass abacus screen refers to the bank client, accounting practices and the history of counting.

ABOVE: FIGURE 38. CLOUD TERRACE, DUMBARTON OAKS, WASHINGTON, D.C. (2012, REMOVED 2013). CAO | PERROT STUDIO, LOS ANGELES AND PARIS. (Courtesy Jared Green.) Glass and land-scape artists Andy Cao and Xavier Perrot hung 10,000 Swarovski crystals from suspended hand-sculpted wire-mesh "clouds" that caught the light and were mirrored in a pool. The temporary art installation was designed to heighten the sense of place in the historic Arbor Terrace.

TOP: FIGURE 39. TABLES OF WATER, MEDINA, WASHINGTON (2006). CHARLES ANDERSON | ATEL-
IER PS, SEATTLE. (Courtesy Charles Anderson.) Pools of infinite water, domesticated for pleas-
urable and leisurely contemplation, contrast with the lake surface beyond.

ABOVE: FIGURE 45. WASHINGTON MONUMENT GROUNDS, WASHINGTON, D.C. (2001–2005).
OLIN, PHILADELPHIA AND LOS ANGELES. (Photograph © Peter Mauss/Esto.) White marble
benches provide a cool seat; there is no shade and trees cannot be planted around this iconic
memorial. The National Park Service staff have found that the bench shape organizes the line.

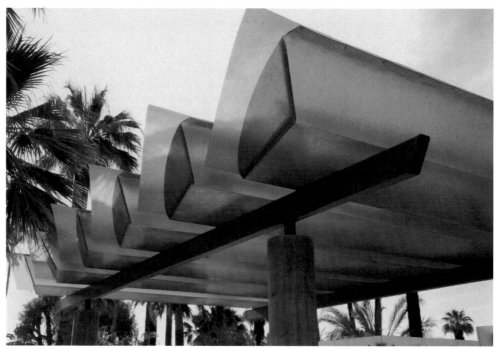

TOP: FIGURE 55. SANTA FE RAILYARD PARK, SANTA FE (2008). WORKSHOP: KEN SMITH LANDSCAPE ARCHITECT, NEW YORK. (Photograph © Peter Mauss/Esto.) Glulam utility poles are of multi-piece construction. The conduit supplying power was concealed inside an interior channel.

ABOVE: FIGURE 72. PRIVATE RESIDENCE, PALM SPRINGS, CALIFORNIA (2012). STEVE MARTINO, PHOENIX, ARIZONA, LANDSCAPE ARCHITECT. (Courtesy Steve Martino.) Hollow fiberglass panels are used repetitively to make a shade bower that glows with warm light in the day. At night internal illumination re-creates the effect.

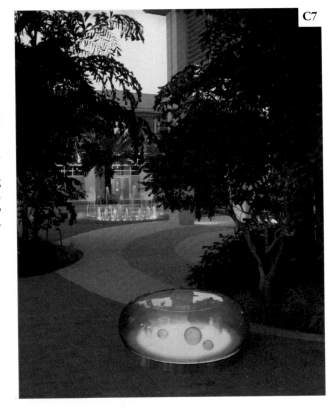

FIGURE 73. CAMANA BAY, GRAND CAYMAN, CAYMAN ISLANDS (2009). OLIN, PHILADELPHIA AND LOS ANGELES. (© OLIN.) Acrylic shells were used for the bubble benches, designed for singles, couples or groups. The plastic is transparent and glows at night, illuminated by LED lights. The benches are located in the shade for more comfortable seating, given the strong sun of this tropical location, and to discourage fading due to ultraviolet radiation.

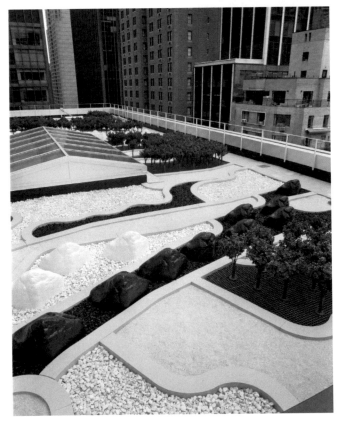

FIGURE 74. MUSEUM OF MODERN ART ROOF GARDEN, NEW YORK CITY (2005). WORKSHOP: KEN SMITH LANDSCAPE ARCHITECT, NEW YORK. (Photograph © Peter Mauss/Esto.) No water + no weight + no life + no visitors = plastic. The program's single purpose was to design a garden appealing to the view of adjacent high-rise apartment dwellers. The landscape design had no choice but to be plastic, with most products ordered off the Internet (Smith 2004).

TOP: FIGURE 76. GREEN ROOF DEMONSTRATION PROJECT, ASLA HEADQUARTERS, WASHINGTON, D.C. (2004). MICHAEL VAN VALKENBURGH ASSOCIATES, INC., LANDSCAPE ARCHITECTS, P.C., CAMBRIDGE/NEW YORK. (Courtesy American Society of Landscape Architects.) The extensive roof system was planted on a tipped structure over the mechanical equipment and showing the subsurface layers. The new stair structure supports an intensive green roof.

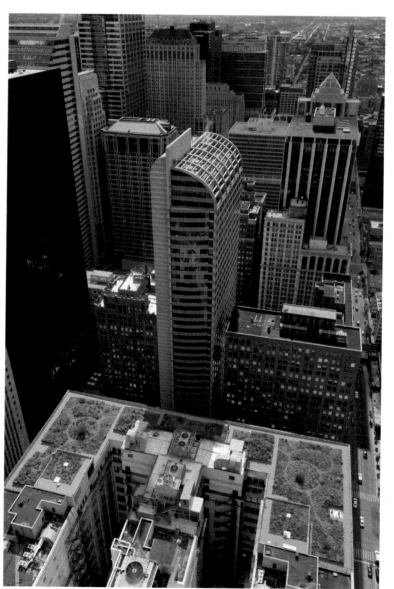

LEFT: FIGURE 78. CITY HALL ROOFTOP GARDEN PILOT PROJECT, CHICAGO (2001). CONSERVATION DESIGN FORUM, ELMHURST, ILLINOIS. (Courtesy Chicago Architecture Foundation.) Because of varying structural capacities on this existing building, all three types of green roofs were installed. An intensive assembly was installed over the support columns, semi-intensive plantings were possible over former skylight framing, and extensive ground cover was planted over the remaining 20,300-square-foot roof.

Chapter 7

Water

> Let us not neglect what we may see with our own eyes: water tends downward of its
> nature; it never permits air below itself; it resents being mixed with any body lighter
> or heavier than itself; it seeps into every cavity of any container into which it is poured;
> the greater the force with which you constrain it, the more obstinately it struggles and
> resists; nor does it rest until it has achieved that repose for which it strives with all its
> might; only when it has found its level is it content; it despises association with anything
> else; its upper surface is always absolutely level with its rim and outer edges [Alberti
> 1991: X.3].

This single sentence summarizes the properties of water, with its certain and consistent behavior that defines its materiality and how it may be considered a material of use in design. This primordial substance exists without human involvement and yet it has come to be considered a natural resource available for human consumption, often with little awareness of the slow pace of freshwater replenishment. Taking water for granted belies the fact that all life on earth completely depends upon water for survival. Our bodies are 70 percent water, and water covers over 70 percent of the planet's surface. Throughout history and in all cultures, no settlement could be located far from sources of freshwater. Abundant supplies negated any concern for conservation or avoiding waste, and most societies used moving water to wash away industrial waste as well as human waste and trash. This attitude persists in many parts of the world even today, with the unfortunate consequence of making unsanitary drinking water one of the leading causes of childhood deaths. Matching access to this vital resource with human needs in a more sustainable way requires developing technologies to reduce transmission leakage and clean the contaminants of human activity, not to mention practicing responsible consumption. How this is done will define key social issues in the twenty-first century.

Some scholars suggest redrawing state/country boundaries into watersheds to focus attention on the hydro-geographical conditions that affect life more profoundly than adhering to traditional religious or political differences. Population growth near diminishing supplies will either produce conflict or innovation or else necessitate exorbitant infrastructure investment and perpetual operation. Regardless, the indisputable fact remains that while the total amount of water on this planet in all its forms is constant, decisions about human development at the watershed scale need to evolve toward valuing water's use today without corrupting its availability tomorrow.

In the study of words, there are many references to paradise as a garden—specifically, the fruitful and well-watered Garden of Eden. Such a paradise may, among other connota-

tions, be thought of as a place where every need is easily satisfied. It is a place where we want for nothing, and so, by extension, to be outside paradise is to have needs. The first need we must satisfy in order to survive, beyond breathing air, is thirst. Unlike breathing, which is an automatic reflex, the first thing humanity did, allegorically, was to cup our hands to collect water to drink. This hand-made basin and the water it contained were the creative beginning of employing tools to satisfy physical, intellectual and emotional needs.

Vital to life, people use water for countless purposes. Water is a liquid material that effortlessly flows in response to gravity and risks stagnation when still. Water has indeterminate form and is virtually colorless, odorless and tasteless if uncorrupted; yet it is felt as wet with discernible sensations of temperature. The surface of water is naturally smooth and reflective, a trait water shares with glass. This apparently limited list of attributes is based on sensory perceptions, and it expands when water's interaction with the designed landscape is considered. Here, activities such as absorption, aerobic or anaerobic action (with or without air), dissipation, attenuation, evaporation, filtering, flooding, infiltration, irrigation and percolation reveal how water may be regarded and treated depending on the intervening materials selected for various purposes.

In Genesis, the first book of the Bible, the waters existed before the earth. Water separated from the land, and then water separated the land from the air. All plants and animals live in at least one of these three mediums. Contact with water, as described by religious historian Mircea Eliade in his book *The Sacred and the Profane*, is a medium for the death and rebirth cycle (1987: 130). Through *immersion* physical form is dissolved, and through *emersion* physical presence is regenerated. Immersion is the transformation of one thing plunged deeply into something else—in an act of succumbing. Water as material allows transformation through falling into depth, an act of distancing that then allows emerging in an altered state. These are acts of initiation and purification that point to the materiality of water in its capacity to affect people (see Figure 39).

Properties of Water

A water molecule has two atoms of hydrogen and one of oxygen. At sea level, the consistent boiling point of H_2O is 100°C (212°F) and the melting point is 0°C (32°F). Water is the sole material with the ability to exist in all three physical states of matter in nature at the same temperature—that is, as a vapor or mist, liquid or solid—and it is always in flux, moving among these states. In terms of weather or atmospheric conditions, when water vapor clouds condense to a liquid, the moisture falls as rain. When it moves from vapor to solid without passing through a liquid state, it falls as snow. If water vapor condenses to a liquid and then freezes, it falls as sleet or hail (with specific conditions of updraft, humidity and temperature). In the United States, surface water makes up four-fifths of the water supply, with subsurface aquifers accounting for the other fifth (Brady et al. 2002: 1022).

On average, humans consume drinking water at a rate of one gallon (3.8 L) per day, although the United Nations considers "the minimum daily requirements of clean, safe water for drinking, washing, cleaning, and bathing to be twenty liters per person" (Venkataraman 2009: 303). Nevertheless, freshwater use in many large cities in technologically developed countries exceeds 150 gallons per capita per day due to industrial use and leaking pipes (Brady et al. 2002: 1022). Americans use about 100 gallons of water at home each day, while, accord-

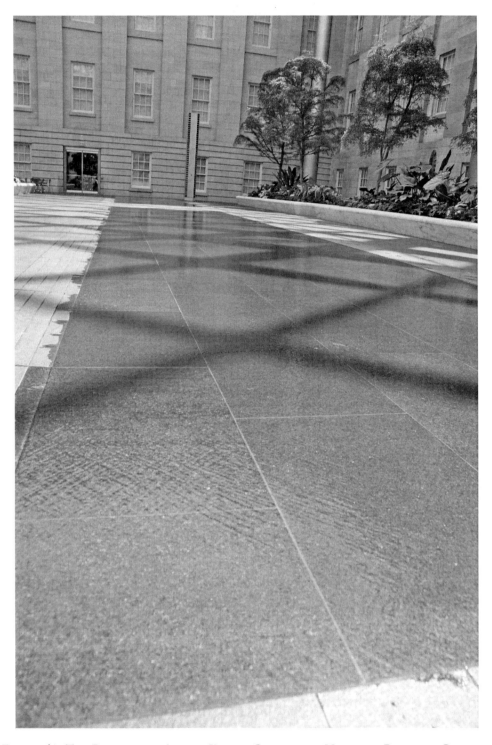

FIGURE 40. THE ROBERT AND ARLENE KOGOD COURTYARD, NATIONAL PORTRAIT GALLERY, WASHINGTON, D.C. (2007). GUSTAFSON GUTHRIE NICHOL, SEATTLE. (Courtesy Magenta Livengood.) The one-quarter-inch-deep water basins animate and dramatize the public space. Children are invited to enjoy the water in this art museum courtyard—an urban beach without the sand.

ing to the United Nations, almost half the world does not have piped domestic water, and one out of eight, or just under 900 million, people lack ready access to clean water, and over 2.7 billion lack access to basic sanitation (UNDP—see Resources).

While no one challenges the fact that water is essential for life, it is important to understand the unique condition that makes this true. Water is the only known nonmetallic substance that expands as it cools and becomes solid. Water expands in volume by about 9 percent when it freezes. While designers may regret this tendency of water to seep into concrete cracks or masonry joints and expand, causing materials to break apart, the very presence of life on earth depends on this performative behavior. If water did not expand in its solid state, then frozen water would sink and no aquatic life could evolve. Actually, no life of any kind would be possible.

Water is the standard of weight by which all other liquids are measured because it is the most stable in volume and the most prevalent material on earth in its liquid state. Freshwater's density equals one gram per cubic centimeter at 38°F (4°C) under specific conditions of pressure. In the past, it was useful to know a material's relative density as compared to water, since this would identify what material would float or sink. The specific gravities of some common building materials include the following: lead (11.38), copper (8.91), aluminum and granite (2.64), plate glass (2.52), limestone (2.16), common brick and ceramic tile (1.92), unreinforced concrete (1.73), earth (1.22), oak (.76), cypress (.54), redwood (.42) and cedar (.36).

The characteristics of water as a building material have a contrasting duality. It is both transparent and reflective under certain light conditions. It is soft to the touch and very hard when moved under pressure, and it feels as hard as concrete upon impact from a distance. It is virtually noncompressible, although the force of expanding steam has been harnessed to drive engines and machinery.

Water is pure, some say impoverished, because it lacks distinctive qualities other than wetness. This purity is easily corrupted because its atomic composition has space between the hydrogen and oxygen molecules, readily allowing other elements to disperse and alter the composition, look and taste of water. This occurs in two possible ways. Colloidal water has other additional elements that combine completely with it. Thus drinking water can take on the taste of foreign elements present in groundwater aquifers, such as mineral salts and industry contaminates. "Hard" water has picked up calcium and magnesium; "soft" water is rainwater or groundwater that has seeped through granite deposits. Non-colloidal water combines with other elements in an impermanent state. For instance, muddy water has suspended particles of soil that will settle or separate from the water if allowed to be still.

In cities, most drinking water is processed in water treatment plants. Graduated levels of technology are employed through phases of coagulation, sedimentation, filtration and disinfection, in which chemicals are added to eliminate contaminants, improve taste and prevent pipe corrosion or tooth decay, and in some cases, the water is exposed to an ultraviolet light phase. Sub-stations test the water and the entire process is more highly regulated than the bottled water industry (Fishman 2011: 354–55; Salzman 2012: 183–85). For uses other than drinking water, for instance, adding polymers lubricates water molecules, making them slippery and permitting the water to be thrown farther under the same pressure from a fire hose. Some municipalities in areas with limited or diminishing supplies of freshwater are building treatment plants that will recycle filtered and treated wastewater into the water supply system. Cultural perceptions about drinking recycled toilet flush and residual phar-

maceuticals can be hard to shake, although the process is known to be safe, with sophisticated testing done continually to detect trace amounts of at least eighty microorganisms, disinfectants and their by-products, organic and inorganic chemicals, and radionuclide contaminants, of which the EPA has identified and determined acceptable levels for human consumption. The ecological consequences of disposed trace drugs on aquatic life have yet to be fully understood.

In some older cities, wastewater systems were built with combined stormwater runoff drainage, which risk being overwhelmed during severe storm events, causing untreated sewage overflow to be discharged into natural waterways. Where a typical water treatment plant cannot be used because the location lacks a freshwater supply or the community rejects the use of recycled sewer water, more expensive infrastructure, such as a desalination plant, is built. Untreated seawater has too much salt to satisfy thirst. Desalination technology removes salt and minerals, typically using a multistage flash distillation process that heats seawater under pressure. This requires energy and produces heat and brine. Sustainable practices also acknowledge that ocean intakes disrupt aquatic ecologies, and this limits acceptable plant locations.

Paved roads and sidewalks were considered great improvements over the typical muddy or dusty conditions of streets. Engineering the control of stormwater also helped prevent seasonal flooding and generally improved the status of a town, attracting further social and cultural development. Unfortunately, as cities became denser, one unforeseen consequence of converting the ground from an absorptive to an impervious surface was that intense storms could overwhelm drainage systems, causing one of the very situations they were designed to prevent. Mitigating stormwater today remains a management proposition that has shifted its approach to providing more unpaved vegetated ground to support tree health, which is ecologically desirable for a vibrant tree canopy, and to constructing more pervious materials, thus reducing the amount of rainwater directed to the treatment systems.

Water in History

Aristotle considered Thales of Miletus (sixth century BCE) to be the first Western philosopher who thought water was the material principle of all things. Water as the originating and fundamental substance is the basis for creation myths because it is "the indispensable agent of germination and growth" (Toulmin and Goodfield 1982: 48). Throughout recorded history, agriculture was possible only with water management techniques for irrigation and drainage. Even today, food production consumes two-thirds of all freshwater. Discoveries of Egyptian waterworks from 2500 BCE show wells supplied by horizontal tunnels that moved water to populated areas without losing much to evaporation. Nearby hot and arid regions developed a system of qanats from 1000 BCE, which are gently sloping tunnels connecting the water table aquifers at mountain foothills to dry plains under cultivation. The tunnels had periodic well-like shafts used for construction and maintenance as well as to supply light and air. Water was then distributed in canals and collected in cisterns for drinking and irrigating gardens and farms.

Vitruvius devoted an entire book in his treatise to water (VIII). He determined that it was the architect's duty to find freshwater supplies by knowing where to dig wells and how to determine water quality, to build aqueducts and underground channels to move it, and

to design basins and cisterns to store it. Finding sub-surface water depended on the close observation of the dawn's mist and an understanding of the soil type, topography and orientation. He described leveling instruments required to build waterways with carefully controlled slopes to enable movement without mechanical means.

Drinking water and food have always sustained life, but using water to wash and cleanse the body has a different history. Freshwater was used to supply public baths, which were an integral part of life in Rome, and Vitruvius included their description in a chapter on public infrastructure construction (V.X.1–5). Public baths were elaborate complexes with tepid, hot and cold bathing chambers built with vaulted roofs and covered with decorative mosaic tiles. Ruins excavated in Pompeii are evidence of engineering proficiency and the role of baths in civic life. The body relaxes when disrobed and submerged in water, and the therapeutic value of soaking in warm water—an almost embryonic recreation—is generally undisputed.

In Rome, domestic water consumption was satisfied in two ways. Atrium house forms had sloping roofs that diverted rainwater through an opening (a *compluvium*) into a courtyard floor basin (an *impluvium*), which was connected to an underground cistern. This method was preferred because rainwater filtered by air was considered more wholesome. This water was also free, meaning that the household consumption did not have to rely on piped municipal water, the other source of freshwater. Rome had a two-pipe freshwater distribution system, with the upper pipe connected to private homes and taxed, and the lower pipe connected to public fountains and baths (which were free). The upper pipe would run dry during times of drought, but the city fountains would have water a little longer. By the end of the first century CE, Rome had one million inhabitants who relied on nine major aqueducts extending over a total combined distance of two hundred and fifty miles, supplying one hundred gallons per capita into the city annually (Illich 1985: 36).

Pliny the Elder's account of water gives technical information on building wells and waterways. Most pipes were made of clay and were about ten feet long, two inches thick, and of varying diameters. One end was slipped into the next, with the joints caulked with quicklime and oil. The pipes were to slope at least one quarter of an inch per foot, with air vents every 240 feet. Lead pipes were used for vertical risers where equalizing water pressure forced the water up (XXXI.48–58). Pliny also detailed three methods of desalinating seawater: wringing the water out of fleece skins attached to ship hulls, submerging hollow containers in which water is filtered by osmosis, and filtering through clay (XXXI.70). He noted, "We are bound to admit that all earth's powers are due to the gift of water" (XXXI.3).

Alberti followed Vitruvius again and identified "four operations concerning water: finding, channeling, selecting, and storing" (X.3). He also referred to Celsus, whose first-century CE treatise *De medicina* (II.18.12) ranks water quality from the most desirable rainwater to spring water, river water, well water, water from melted snow or ice, and lastly lake water (X.6). According to Alberti, rainwater was the purest and softest, depending upon the time of day and season. He gave detailed instructions for the construction of canals, cisterns and filtering basins. Water management was a municipal concern, "since a city requires a large amount of water not only for drinking but also for washing, for gardens, tanners and fullers, and drains, and—this is very important—in case of a sudden outbreak of fire" (X.6).

Throughout history, technological development to move and contain water started with digging wells and tunnels and building aqueducts, canals and runnels with pumps and locks to adjust levels mechanically. Supply and demand were balanced with building reser-

voirs, retention basins and cisterns, and flooding caverns. Industrializing cities developed their waterfronts with ports, polders and piers. Seaports can link distant cultures geographically, and once local agricultural and manufacturing production exceeds demand, the excess can be traded for profit and to raise taxes to support, in part, further civic infrastructure projects (Mayer 2003).

Theories of Water

Thinking of water as a building material is often restricted to its behavioral properties and to what it does for people. *A theory of water need not be limited to use, but can be a way of thinking about formlessness and flow.* Free of inherent form, water is a material that seeks containment, spreading and filling its surroundings. Water does not resist obstructions but flows around them, guided by gravity, or is temporarily absorbed and then released by other materials. Further, people have an inherent attraction to transparent water that appears pure and unspoiled and safe to drink, and they automatically reject and avoid unclear water that appears contaminated. As a liquid material, water is formless and flowing; as a concept, we value its transparency, purity and clarity.

Gaston Bachelard writes about the poetic qualities of water (1983: 126–30, 159–85). He notes a curious cultural perception that water is given a gender. Rivers, lakes and streams radiate purity, as they generally have less turbulent air disturbing their clear surfaces of limpid water. These bodies of water move more slowly and satisfy domestic needs. This he called feminine. Water's dual nature allows Bachelard's sea to be masculine, with a capacity for violence through which its fury and rage challenge domestication and call men to adventure. As the character Ishmael described in *Moby Dick*, if we sets our feet in motion, we tend to walk downhill, often following in the path washed clear by the rain. This leads to a stream, a city and its seaport, and then the open sea. A desire to explore and to be on the sea is a desire to diminish the distance water creates. It is to venture toward the horizon, collapsing space and braving the unknown.

Water has "nearly unlimited ability to carry metaphors" (Illich 1985: 24, 25). Still water reflects with a mirror-like condition that cannot be penetrated. It can reflect the sky and takes on its apparent blue color, although most bodies of water appear green due to algae and other living organisms. Reflective water duplicates the appearance of objects along the water's edge, displaying a balance of symmetry, which appeals to people on a very deep level. It is generally unsettling when something expected to be symmetrical is not; conversely, harmony and a sense of peace are found in the cosmic order of horizontal symmetry made visible in reflected images. This is a device employed frequently in monumental landscape and architecture design. However, one must be sure that the object is worth this effect (Steinberg 2001). Luis Barragan's water gardens and Tadao Ando's Church of Water are worth it.

Metaphors of liquidity allow Bachelard to link water and dreams. Dreams occur in a pre-conscience, fluid state. The significance of dreams (and water) can depend on something as superficial as a spray, or as unfathomable as deep water, or as inexhaustible as vast water. Looking at water encourages a dreamlike reverie, a kind of gazing that most people appreciate. Bachelard argues that dreams make waking life manageable, just as water makes life possible. Waters that flow are an indication of direction with a clear sense of "coming from" and "going to," and this helps our bodies to be oriented in space. Movement has this power. Another

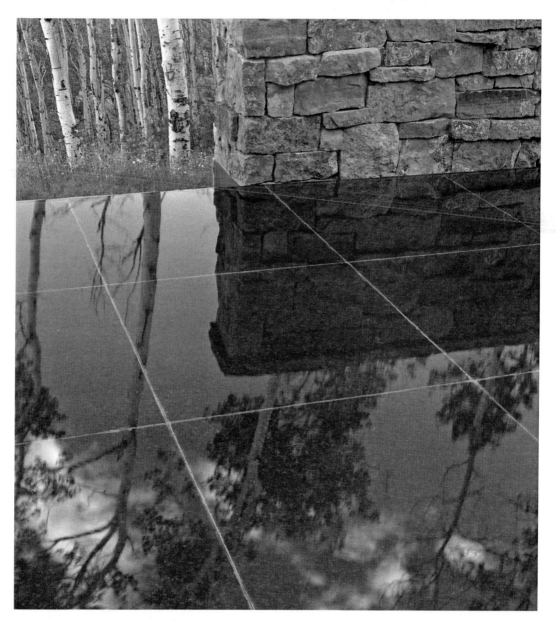

FIGURE 41. WOODY CREEK GARDEN, PITKEN COUNTY, COLORADO (2007). DESIGN WORKSHOP, INC., ASPEN. (Courtesy D. A. Horchner/Design Workshop.) This project uses water to reflect clouds and the sky on its still surface.

type of movement between the watery realm of dreams and being awake and aware of physical experience is similarly carried forward in cycles of the flow of time.

Water's ability to carry metaphor based on its flowing liquidity subject to gravity does not easily admit "unnatural" engineered manipulations. A sense of authenticity is challenged when landscapes have water springing from hilltops as if they came from mountain streams, as may be seen at the Renaissance garden of Villa D'Este. Conversely, "Capability" Brown's placid lakes appear limitless because they are formed with concealed sources, edges and out-

falls. This design contributes to the composition of a picturesque scene of repose and serenity.

Water is often referred to by its ecological function. Freshwater springs feed runs and falls, streams, brooks, ponds and lakes. These in turn feed rivers that are moving bodies of water. Brackish lagoons, wetlands and estuaries are collected bodies of water with seasonal influx or gentle tidal action. Seas and oceans are vast bodies of water where salts and other chemicals do not evaporate and therefore accumulate. All are supplied by rainwater and melting glaciers.

According to the National Snow and Ice Data Center, glaciers and ice sheets contain 75 percent of the planet's freshwater and are melting at alarming rates that exceed historic trends. By the end of the twenty-first century, rising global temperatures will melt most glaciers, affecting sea levels and coastal communities and destroying habitats. The rest of the freshwater supply is in aquifers, many of which are draining more rapidly than natural groundwater recharge rates.

The idea of water being a circular system, moving in changing states through the atmosphere and falling as precipitation or rain to the earth, where plants transpire and ocean waters evaporate, is a metaphor dating from the mid–eighteenth century (Illich 1985: 42–45). This evapotranspiration process summarizes naturally occurring hydrological cycles. Increasing atmospheric water vapor is the primary greenhouse gas affecting climate change. In a positive, self-reinforcing feedback loop, increasing cloud cover responds to and amplifies the effects of other greenhouse gases (carbon dioxide, methane, nitrous oxide and ozone). This will only continue to intensify storm events until fossil fuel burning, deforestation and unsustainable farming practices are reversed.

Innovative Applications

Even though the amount of water in all its forms does not change, its suitability and availability for human purpose is subject to many decisions, all of them local (Fishman 2011: 300–1). Preventing massive leakage, which is endemic with aging municipal systems, and instilling conservation practices for daily use are places in which to start sustainable practices. Public perception has to change from thinking of water as virtually free and therefore valueless to fairly reflecting the true cost of freshwater supply, treatment and waste disposal. This in turn can inform decisions about where to develop land for irrigated farms and other human activities. Operators of extravagant water consumers, such as golf courses and swimming pools, can determine if the expense is warranted. The ecological consequences of building dams, diverting rivers and draining aquifers is better understood today, and yet denying development in areas that would benefit from this extensive infrastructure is seen as limiting progress. Unfortunately, it is only when the full costs are known that land development can be tailored to practical and sustainable access to freshwater.

Watershed regions in Australia, China and the Middle East are developing strategies to ensure the availability of water supplies needed to support current and projected populations and industry, but this seldom includes strategies of retreat or the abandonment of existing facilities, no matter how impractical continued operations may be. Exponentially increasing population growth, global climate change and the subsequent impact of super-storms on coastal development may force governments to reevaluate their resource allocations

to support sustainable growth more vigorously, and to penalize rebuilding in areas sensitive to the forces of nature. Sea level rise will also disable existing municipal storm and sanitary sewer infrastructure facilities that service coastal communities. Individual home owners with affected wells and septic fields, and significantly higher insurance rates and local property taxes, may have to abandon their waterfront properties. Reestablishing wetlands, dunes and ecological buffer zones will protect inland communities and turn private properties back into public amenities.

Water in architecture follows the ways it is used in landscape architecture. Beyond the practical provisions for drinking and bathing, and setting aside industrial requirements, water is a material in design associated with emotion. The seven-and-a-half-acre site of the Franklin Delano Roosevelt Memorial in Washington, D.C. (1997), was designed by landscape architect Lawrence Halprin in collaboration with artists George Segal, Robert Graham and Leonard Baskin. Water is used as a design material, with 100,000 gallons cycling every minute over granite walls and basins in ways that suggest distinct conditions and elicit corresponding emotional responses. "I made it a narrative," Halprin explains, "and wanted people to learn about Roosevelt through all the senses, not just sight." He continues: "Water in my work is never an abstraction. It is not glass. I use it as something that has emotional and experiential weight" (Dillon 1998: 32, 34, 38). In this design, water is used symbolically, as is appropriate for a memorial, and is not meant for drinking, swimming, bathing or waste disposal.

Architecture has to service many needs and use water in many ways. Buildings provide comfortable and convenient shelter from the unwelcome forces of nature. They need to be waterproof and block stormwater as well as provide for other occupant needs. After roads, buildings occupy the most surface area of cities. Their impervious roofs have an opportunity to act as rain collectors, just like those of the ancient Romans. Because most cities have zoning ordinances that permit buildings in dense areas to occupy sites fully, there is often no land available to absorb rainwater. Thus concentrated, rainwater can be either piped directly to the stormwater disposal system or held by green roofs slowing the disbursement, thereby lessening the initial impact of severe storms. Roof gardens, like all landscapes, require maintenance, including irrigation (at least until the plants are established). Alternatively, rainwater can be harvested by tying cisterns to a network of secondary pipes that supply toilets and irrigate gardens, a building's biggest consumers. Separating source and use requires more initial investment and more operating control, but may be appropriate in areas with scarce freshwater supplies.

"Given that our cities are designed to impair rather than sustain natural hydrological cycles, these developments will have serious consequences for the environment" (Hardwicke 2009: 95). Approaches to urbanization, new or newly densified, should include protecting existing hydrological waterways and embracing strategies of self-support and long-term thinking that, when coupled with accurate pricing for water consumption for different levels of quality, will ensure access to safe drinking water for current and projected populations. Zero Net Water is an approach to building in which the design of a closed-loop mechanical system balances rainwater supplies and occupant use. This sustainable approach acknowledges that potable water is not necessary for many dwelling activities and uses methods of capturing and storing rainwater, recirculating filtered water, and segregating needs to satisfy all demand (Berkebile et al. 2010: 30–34). This approach may be more appropriate for development in areas without infrastructure, or regions that will grow without expanding treatment facility capacities.

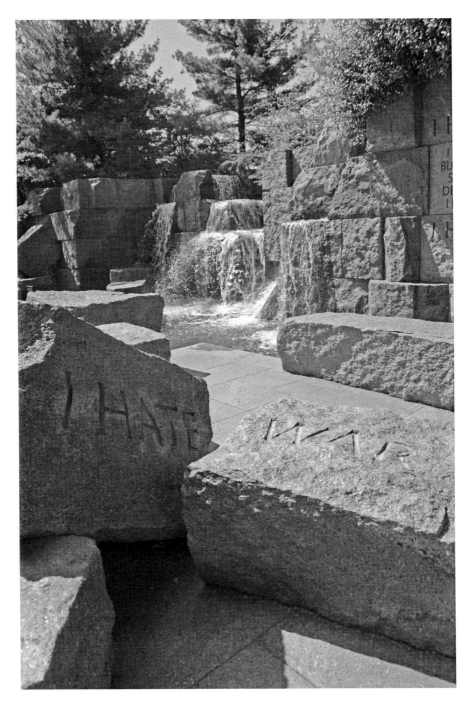

FIGURE 42. FRANKLIN DELANO ROOSEVELT MEMORIAL, ROOM III, WASHINGTON, D.C. (WINNING DESIGN SELECTED IN 1974, DEDICATION IN 1997). LAWRENCE HALPRIN & ASSOCIATES, SAN FRANCISCO. (Courtesy Magenta Livengood.) The monument is divided into four parts representing the four terms of Roosevelt's presidency. Room I is a calm yet foreboding introduction; Room II is based on the bleakness of the Great Depression; Room III has dramatic and violent waterfalls mechanically churning against gravity, representing the turmoil of war; and Room IV is expansive, a place for resolution and gathering with a spirit of optimism.

Other innovations in freshwater supply management include, for instance, Pur's Purifications Powder, which makes drinkable water from polluted water, killing the bacteria and separating sedimentation and dirt. Also, there are new types of containers with ultraviolet light devices that disinfect water-borne pathogens of bacteria, viruses and protozoa. These products provide fresh drinking water at a household scale and are independent of municipal infrastructure investment. Access to drinking water requires balancing supply and demand with management techniques appropriate to local conditions.

Human comfort inside buildings is affected by temperature and humidity. Work is being done on innovative designs for desiccant systems that remove moisture from the air without conventional air-conditioning mechanical systems. For example, teams of architecture, landscape architecture, engineering and natural resources students at the University of Maryland worked on two innovative houses—LEAFHouse and WaterShed—in two of the biennial competitions known as the U.S. Department of Energy Solar Decathlon in 2007 and 2011, respectively. Coming in second place in 2007 and winning in 2011, one component of their innovative designs for both houses was a liquid desiccant waterfall (LDW), a high-functioning dehumidifier that works with the solar thermal array and regenerator system to lower interior humidity by drawing moisture to the liquid desiccant that is then transferred to the air and exhausted. The appealing soft sound of the waterfall coupled with the gratifying knowledge of living with sustainable operations provide a practical and pleasant demonstration of the future direction of thinking of water and air management and human comfort as integrated in sustainable design.

Water is a chameleon material. Human dependence is profound and wasteful attitudes must end, or the increasingly limited access to this resource will alter how life survives. A paradigm shift is needed to change from thinking about freshwater as an infinite resource to viewing it as a renewable resource. Scarcity is not just a problem in developing countries. In the United States, water problems exist because use rates exceed groundwater reserves and prevent aquifer recharge (Calkins 2009: 20). This will eventually affect where people live and work, as well as their access to affordable food. Further, melting polar ice sheets and rising sea levels due to climate change threaten existing coastal development and complicate the complex relationship between water and people. Agricultural needs illustrate this especially well, because farming depends on access to freshwater and is under market pressure to increase productivity through the use of nitrogen and phosphorus fertilizers that run off and pollute water sources. Unlike many other materials discussed in this book, mundane water has no substitute. Building in ways that make apparent the role of water in servicing human activities will draw attention to its vital contribution. Pricing that matches value to cost will help attitudes evolve so that the health of all living creatures will remain secure.

Resources

Federal Agencies, Technical Societies and Associations

American Institute of Hydrology offers certification for professionals, http://aihydrology.org.

American Water Works Association (AWWA) is an international not-for-profit scientific and educational society dedicated to the improvement of drinking water quality and sup-

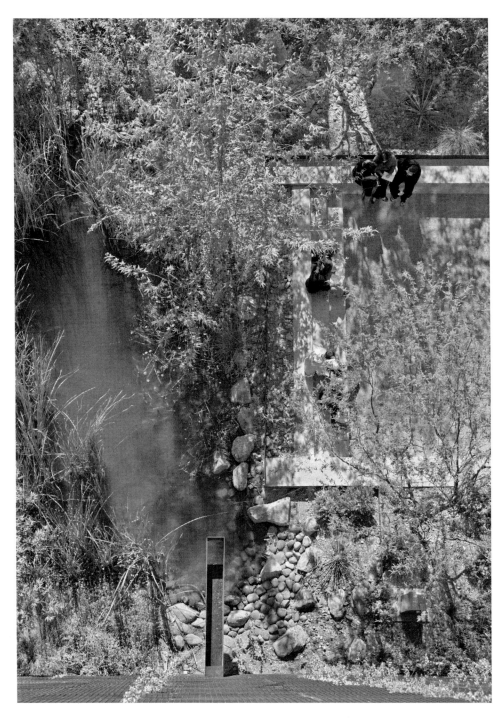

FIGURE 43. UNDERWOOD FAMILY SONORAN LANDSCAPE LABORATORY, COLLEGE OF ARCHITEC-
TURE AND LANDSCAPE ARCHITECTURE, UNIVERSITY OF ARIZONA, TUCSON (2009). TEN EYCK
LANDSCAPE ARCHITECTS, INC., PHOENIX. (© Bill Timmerman.) This high-performance demon-
stration project employs sustainable design practices for water harvesting and reuse that mitigate
desert microclimates, and it also employs techniques for the reduction and redirection of
stormwater runoff for passive and active purposes, essential in arid climates.

ply, and it provides information on water treatment legislation and regulation, http://www.awwa.org.

Clean Water Act (CWA) came from the 1972 Federal Water Pollution Act, which monitored the quality of water discharged into natural bodies of water, and the 1974 Safe Drinking Water Act, which regulates the level of contaminants in drinking water, http://www.epa.gov/lawsregs/laws/cwa and http://www.epa.gov/agriculture/lcwa.html.

Green Biz publishes online e-news, including blogs. Of interest is "10 Rhymes to Remember for Sustainable Water Management" by Jan Dell, Vice President of CH2M Hill, www.greenbiz.com/blog/2010/06/2110-rhymes-remember-sustainable-water-management.

International Desalination Association, http://www.idadesal.org.

National Snow and Ice Data Center (NSIDC) tracks the cryosphere, using the status of snow, ice and permafrost as indicators of climate change, http://nsidc.org.

NSF International is a not-for-profit private organization that certifies water treatment and distribution systems for businesses and private consumers, http://nsf.org.

Organization for Economic Co-operation and Development (OECD) promotes policies between nations as a clearinghouse for government, business and people, http://www.oecd.org.

U.S. Environmental Protection Agency publishes information on irrigation systems and controls, http://www.epa.gov/watersense.

U.S. Environmental Protection Agency publishes a list of contaminants in drinking water, http://water.epa.gov/drink/contaminants/index.cfm.

Water Quality Association (WQA) is an international trade association representing the household, commercial and industrial water quality improvement industry, http://wqa.org.

World Health Organization (WHO) provides the international version of U.S. drinking water standards and monitors disease outbreaks, assesses programs and maintains data on health statistics. It also publishes "Guidelines Drinking-Water Quality," 3rd edition, http://who.int/water_sanitation_health/dwq/gdwq3rev/en.

Research on the Sustainable Management of Water

United Nations Development Programme (UNDP), Water and Ocean Governance, implements programs that provide safe water and basic sanitation to developing countries in sustainable, low-carbon, climate-resilient development pathways, http://www.undp.org/water.

World Business Council for Sustainable Development (WBCSD) was formed in 1992 after that year's Rio Earth Summit. It developed a Global Water Tool© in 2007 as a free tool for companies and organizations to map their water use and assess risks relative to their global operations and supply chains, http://wbcsd.org/home.aspx.

Chapter 8

Stone

What is stone, what is rock? Dictionaries consider them interchangeable terms and use one word to define the other. Jim O'Conner, a geologist, summed it up nicely: "Stone is rock that you pay money for" (Robbins and Welter 2001: 1). When stone is used as a building material, it carries associations of permanence, solidity and stability. Other associations of surface and substance are implied in the children's game "Rock, Paper, Scissors," in which rock crushes scissors, but is defeated by being covered by paper. Revealing rock is an operation of exposure. Rock that has been buried since formation becomes stone through excavation and crafting. The earthy origin of rock carries references of depth still evident in its finished form. The experience of stone-clad interior rooms cannot distance itself from collective memories of ancient cave dwellings. A cave, one of the original dwelling types, is different because it is a found shelter that is carved out, and not assembled in construction. Using stone in a design can convey similar feelings of darkness, coolness, dampness, heaviness and quiet.

Unlike concrete, brick, ceramics and glass, stone is not manufactured but is a material found in nature. Quarried with great difficulty out of mountainsides or stream beds, cut blocks are transported and then worked or dressed (sometimes called dimensioned) as needed for installation. Selecting the right type of stone and turning the raw substance into a building material depends on its predictable and consistent compressive strength, its hardness (which affects durability), and its appearance. Appearance is not just a factor of visual appeal; it has performative consequences. Finer-grained stone generally has a higher compressive strength and deep veining may indicate structural weakness. Secondary considerations are texture, pattern and color, along with finishing options.

Structures meant to last are built of stone. Wells for freshwater, churches and temples, royal palaces, memorials of all types and monumental tombs have been made of stone, even if it was difficult to obtain. The type of stone usually depended on what was locally available and the skill of workmanship evolved with the traditions of the mason's craft. Experience taught builders to find the right type of stone for the appropriate application. Stone masons decided on practical sizes for installation and depended on available technologies for extraction, moving, finishing and placing heavy stone. How the stone was assembled depended on how it was worked, and on the size and type of mortar joint selected. All stonework has joints, and this deliberate piece-by-piece placement is apparent in structures ranging from a farmer's cleared field surrounded by piled-up dry-laid fieldstone walls that have no mortar to Incan masterpieces with surfaces so precisely cut that no mortar was needed. The durability of stone construction made the investment of time and effort worthwhile. A stone mason's

FIGURE 44. M. VICTOR AND FRANCES LEVENTRITT GARDEN AT THE ARNOLD ARBORETUM, HARVARD UNIVERSITY, BOSTON (1998). REED | HILDERBRAND LLC, WATERTOWN, MASSACHU-SETTS. (Photograph by Alan Ward. Courtesy Jeri Reed | Hilderbrand.) Fieldstone retaining walls level the land and refer to New England's history of cleared farm fields edged with dry stone fences.

account of stone's nobility is simple: stone as a material takes the longest to build and lasts the longest once built (McRaven 1989).

Properties of Stone

Stone is the heaviest, most durable, fireproof and decay-resistant of all materials. It resists being built in a flimsy manner and demands visual mass. While a poor insulator, its massiveness effectively blocks wind and external sound. Its same thermal mass amplifies sound, as can be heard when the voices of a few choir boys fill a stone cathedral without acoustic equipment. Stone is thermally stable, making it a good material to absorb the sun's warmth and radiate that heat during the cooler night as part of a passive radiant heating system. Moisture can wick through stone as with all masonry materials. It seems that stone's nearly indistinguishable character from the ground where it was found means that stone cannot truly separate itself from the chill of the air or the moisture of the rain. Perhaps this accounts for why relocated boulders look unsettled when they are not partially buried. They need to "grow" out of the ground and not perch on it.

The classification of natural stone has varying scientific definitions that have identified between one and three hundred types of rock, not to be confused with merchandising trade names (Müller in Mäckler 2004: 42). Classes of stone are generally distinguished by their geological formative processes, reflecting the actions of volcanoes and glaciers, the collision of tectonic plates and the unrelenting force of water, although the classifications are not absolute (Sovinski 2009: 112–15) There are three broad categories:

Igneous, also called *magmatic* or *eruptive*, rock is formed from a molten or partially molten state that solidifies when cooled, causing minerals to crystallize. This group is further divided into intrusive/plutonic (if the cooling takes place within the crust and is more coarsely crystalline) or effusive/volcanic (if the cooling occurs rapidly and outside the earth's

crust). The most common intrusive stone is granite, made of quartz, mica and potassium feldspar, which give granite its range of colors due to its varying structure and chemistry. It comprises around 92 percent of the earth's crust. Granite is further distinguished as oolitic or dolomite, which has greater crushing and tensile strengths (Dernie 2003: 41). Other types of intrusive rock are "glassy, non-crystalline or finely crystalline rocks," such as basalt, which solidified as columns or frothy masses (Campagna 2003: 12, 13; Wolff in Mäckler 2004: 110; Dernie 2003: 40). The types of effusive rock are porphyry, tuff (volcanic, which comes from layers of ash along with pumice), trachyte (which filled in hollow cavities), serpentinite, diorite and gabbro. Intrusive igneous stone is valued for its hardness, strength and monolithic pattern.

Sedimentary rock is aqueous since it is formed from built-up sediments of clay, silt or sand, or from transported fragments deposited in pools of water that were subject to "the actions of water and wind, and by the geological processes of weathering, erosion and sedimentation" (Dernie 2003: 41). Sedimentary rock is further divided into detrial or clastic types, such as limestone (formed of lime-based shells and calcareous skeletons from marine organisms), sandstone (made of weathered deposits of sand), and shale (made from clay). Travertine and onyx are other sedimentary rocks. Sedimentary stone is valued for its tendency to split in sheets, making it easier to cut than other stone types and ideal for building cladding, although it can be porous and absorb moisture, resulting in staining due to the presence of minerals in rainwater.

Metamorphic rock is preexisting igneous and sedimentary rock transformed by crystallization under great heat, or deformation and pressure. Types commonly used in building include some granites, marble and quartzite, and sometime gneiss, mica schist and silicate schist. They are valued for having both properties of hardness and ease of workability, although their suitability for construction depends on climate, weather and exposure of the site.

Rough stone can be cut, or what is called snapped, either at the quarry or at the construction site, and the labor costs for projects are often calculated both ways. The type and quality of cutting results in dimensioned stones that have relatively smooth faces, sharp edges and regular shapes. Undressed stone has rough surfaces, irregular edges and inconsistent shapes.

The three possible techniques for finishing stone surfaces are mechanical, impact or chemical. Mechanical finishing uses natural or synthetic abrasives to make honed finishes that vary from nonreflective matte to shiny high gloss. Impact finishing uses tools such as wire brushes and bush hammers that create a rugged texture and metal tools that incise surfaces or split edges. Power water- and sand-blasting roughs up the texture, as does flamed or thermal treatment. Granite and basalt, not sandstone or limestone, can be torch-burned, expanding the surface and causing particles to flake off. This provides a rough surface that is needed for traction on exterior walking surfaces. Chemical finishing includes acid washing and epoxy treatments. Applied meshes glued to the backs of thinly cut stone tiles increase strength and prevent cracking, and they also make the installation easier. Applied protective treatments of repellents seal porous surfaces, protect walls from graffiti, and can increase the reflectivity of the stone surface (Campagna 2003: 28–31). Cut stone can also be tumbled to round edges and corners.

Decisions about dressing and finishing are linked to choices about joints and mortar, although some stonework joints are not intended to have mortar. Dry-laid stone techniques

are good for retaining walls, where moisture in the soil can readily seep through open joints. Stone retaining walls should be slightly inclined or battered into the hill so that the form resists the lateral thrust of the adjacent land. A stone-lined well, made stronger because of its round shape, fills with groundwater that seeps through open joints and holds water where the stonework has solid joints and is lined with clay. Most stonework is assembled with mortar, and the width and pattern of the joints have a direct relationship to the degree of stone finishing. Mortar beds allow cut stone to be placed level, increasing the ultimate strength of the overall construction, but the mortar should be thought of as a mud-like leveling compound, not glue that attempts to hold poorly cut stone together (McRaven 1989: 47). Some more porous types of granite and marble used for kitchen countertops need to be sealed, and periodically resealed, to prevent staining.

The types of stone used most frequently in construction (Calkins 2009: 236) are as follows:

Limestone (38 percent) is found in locations with glacial deposits, such as Indiana, Kansas and Michigan. It is a sedimentary stone that is heavy, evenly grained with medium to hard workability, and good to excellent strength. Its consistent composition, texture, color and density make it well suited for ornamental carving and exterior building cladding, but it is too porous for exterior surface paving (Sovinski 2009: 117–18). The uniform appearance, flat surfaces and sharp edges that are readily cuttable make this a desirable stone for monumental buildings.

Granite (28 percent) is found in the mountainous states of New England, the Carolinas and Rocky Mountain states. It is an igneous or metamorphic (due to the presence of quartz) rock, heavy and rough, and the hardest stone to work, but it has the highest compressive strength, making it the most durable. It is nearly impervious to weathering, pollution and freeze/thaw cycles. Countries with high-production quarries include Brazil, India, Scandinavia, China, southern African countries, and several countries in North America and the Middle East.

Marble (14 percent) is a metamorphic stone predominately from Italy, Greece, Turkey and Spain, and more recently Mexico (Campagna 2003: 11). Marble is durable, generally has a fine grain and polishes well. Found in uplands and slopes, marble does not weather as well as limestone or granite, a condition accelerated in regions with acid rain. Marbles are grouped as either veined, not veined or breccias (which contain ovular inclusions with a more or less rounded shape). The predominately white color may be too glaring to use in southern locations, but its coolness is appreciated for public benches with no shade, or for northern sites with shorter daylight hours and dreary winters, where there are visual benefits to using bright elements in the landscape (see Figure 45).

Sandstone (13 percent) is found in Ohio and the mid–Atlantic states. It is a sedimentary stone with compounds of quartz, siliceous sand, calcium carbonate and iron oxide, which give it various colors, familiar to East Coast cities with rowhouses known as brownstones. Softer than the other commonly used stones, sandstone is generally found in valleys (Logan 1995: 121). The two types of sandstone are soft sandstone, which is lightweight and easy to work (but has low weight-bearing capacity), and dense sandstone, which has medium weight with medium workability, and medium to high strength. Common flagstone is a type of sandstone that is used for exterior horizontal surfaces. Another type is bluestone, which is sometimes chipped or called "dust," and is a typical pervious setting bed for stone paths.

The less common types of stone used in construction include those listed below:

Travertine from Tivoli, Italy or Turkey is a sedimentary stone that is highly textured with fissures or veining due to sedimentary strata, giving it a distinctive appearance, but it is unsuitable for climates with harsh and freezing temperatures.

Basalt is an intrusive igneous stone, heavy with a non-crystalline fine grain, medium to hard workability, and medium to high strength, and it is valued for its dark colors.

Quartzite is a sedimentary or metamorphic rock derived from quartz sandstone that is hard, resilient and suitable for polishing.

Slate is a metamorphic stone derived from shale (often from Vermont), of medium weight and fine grain that is easy to work, but has low compressive strength. It is water- and ice-resistant. Slate has the advantage of being easily cut into smooth sheets that are good for roof shingles, wall cap coping, and, in the past, classroom blackboards. When used as pavement, the stone size should be small so that the joints can provide traction when wet (Reed 1998: 23).

Shale is a sedimentary stone derived from clay, of medium weight and easy to work, but it has low weight-bearing capacity.

Onyx and *alabaster* can be cut into thin sheets and were sometimes used for windows in important buildings before glass was available. Some contemporary buildings have thin slabs used as translucent screens, in which daylight illuminates the veins and patterns of the stone material.

Stone in History

"The early part of human history—more than 95 per cent of humanity's story as a whole—can indeed be told only in stone, for besides human and animal remains, stone objects are all that survive" (MacGregor 2011: xix). The earliest surviving stone constructions are the upright boulders in places such as Stonehenge. Called *menhirs*, those in Brittany have been dated to around 5000 BCE, and "are almost certainly the earliest of the megalithic monuments" (Tilley 2004: 33). The purpose of these stones and their placement in the landscape cannot be assumed, but scholars think they mark sacred grounds for rituals of fertility (sometimes grouped in alternating anthropomorphic male and female forms) and nature worship. They could also have served as territorial boundaries or as a sort of celestial dating device.

The genesis of stone used for tools and weapons began with a need for more efficient hunting methods as well as better ways to cut meat and scrape animal skins. Harder stones were used to shape softer stones, and those that kept a sharp edge and point, such as flint, were highly valued. The prehistoric Stone Age lasted 3.4 million years and ended when techniques to smelt ore were discovered. Primates that developed into tool-equipped homosapiens did so through their understanding of stone and its capabilities.

In Roman times, Vitruvius wrote about the types of stone and the supplies found in quarries (II.VII.1–3). His key point regarding stone was to be aware of the direct relationship between soft stone that is easier to work, but cannot bear as much weight and is not as durable when exposed to the elements, and hard stone that is more difficult to work, but lasts forever. Vitruvius associated the pockets of air in porous stone as the source of its weak-

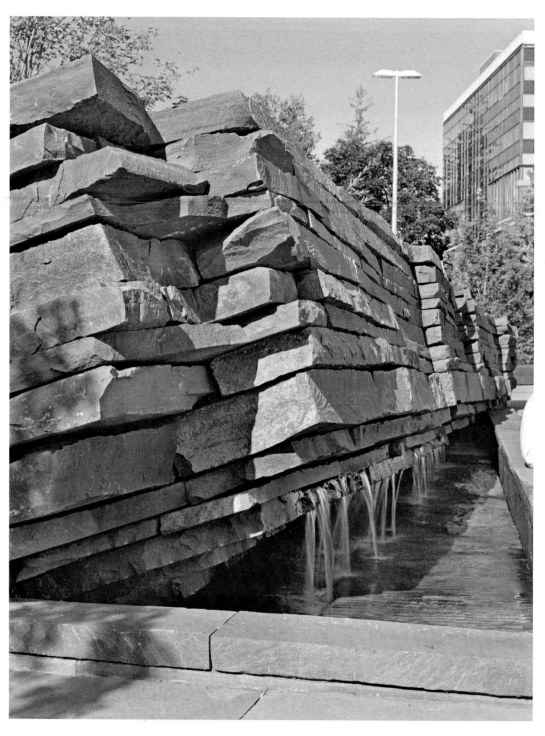

FIGURE 46. BAILEY PLAZA, CORNELL UNIVERSITY, ITHACA, NEW YORK (2004–2007). MICHAEL VAN VALKENBURGH ASSOCIATES, INC., LANDSCAPE ARCHITECTS, P.C., CAMBRIDGE/NEW YORK. (Photograph by Elizabeth Felicella. Courtesy Michael van Valkenburgh Associates.) The campus is surrounded by glacially formed gorges. The plaza used local stone alternating between thermal-flamed Portage bluestone and natural cleft bluestone to achieve an intimate scale with the range of textures and colors. The fountain stone is laid with gaps so that the water can fall into the basin, enhancing a feeling of contemplation and repose.

ness. Stone used for construction was to be cut from the quarry in the summer and left exposed in an open place for two years. How the stone passed the test of nature and time determined where it would be placed, with strong stone reserved for foundations, beautifully veined stone intended for important decorative surfaces, and poor-quality stone broken up for rubble to fill wall cavities.

Pliny the Elder included a chapter entirely about stones and minerals, and the monuments that can be made from them. He said, "Nature ... made mountains for her own benefit, as a kind of structure for holding down the inner parts of the earth, and, at the same time as a means of checking river torrents and wave erosion—that is, to restrain the wildest elements by the hardest material of which she is composed" (XXXVI.1). Pliny's evaluation directed attention to stone's weight and immobility. He marveled that people who were once satisfied to climb mountains now cut them up for personal pleasure, lining domestic interiors with variegated marble surfaces. Pliny berated the audacity of moving stones as a vain display of wealth and power. Stone was and is considered the noblest building material because it was (and continues to be) the most expensive and permanent and required the highest degree of judgment in construction.

In the Renaissance, Alberti wrote about the practice and experience of using stone (II.8–9). He described the best methods of determining its natural qualities by observing the color and veining of each stone as a measure of its structural integrity. Then masons were to test the stone for density by listening for a ring when struck, as this would indicate the presence of interior pockets of air. Finally, masons could test for the durability of the stone when wet by soaking it, and for endurance against the heat of the sun by exposing it to fire. Alberti reminded readers to observe previous stone constructions in particular places, with their specific geographies, climates and weather, before beginning to build in order to determine what stone and building techniques would last.

What lessons from antiquity inform contemporary practice? A drive in the country might provide a sight of cleared fields and pastures where stone walls were constructed a "stone's throw" from where the farmer's plow turned them up. Other discoveries might include a stone chimney standing in a field as the sole surviving element of a wooden farmhouse that burned down or rotted away, or the foundation walls of a barn. These are the stones that masons like to find, as they were the best stones when chosen, and they will continue to serve a new purpose well (McRaven 1989: 16). What is meant by "best?" These are stones that have the most consistent material, with no cracks or fissures, and that were well worked and have survived. When masons work, they look at all the surfaces of a stone before deciding where and how to place it. The front may be selected for the desired appearance, but the unfinished back is also examined for its structural integrity. Individually and painstakingly fit together, costly yet durable, stone lasts, making it a sustainable material if locally found and processed. Using local stone is also a way new construction can fit into an existing historic neighborhood that was built of stone.

Theories of Stone

In the material imagination, when metaphorical mountains are climbed, stone faces are scaled using small imperfections as hand grips. The elevated position allows viewing the activities of the world below, made more predictable and understandable by the sight. This

celestial place of pure air is achieved only by finding an upward path, leaving behind terrestrial limitations, and even the inevitable mortality of life, albeit momentarily. Earth-bound in daily survival, we become airborne through this individual effort, and a fall means hitting "rock bottom." If to ascend a stone mountain is to exercise ambition, to fall or descend is to admit contrition and to feel a sense of humility. Ascent gives us foresight; descent gives us insight. *We touch stone as we climb, and this physically tactile dimension attests to the truth about our desire for permanence and to the capacity of stone as a weighty material to satisfy that desire.*

The great advantage of building in pieces—whether mud brick or quarried stone—is that this additive approach allowed breached defensive walls and structures (damaged by an earthquake, for instance) to be rebuilt only where needed, and for desired expansions to be possible without demolishing the existing construction (Winter 2005). This advantage extended to undamaged work, too. Many finished Egyptian temples were treated as harvest sites of stockpiled materials. Sometimes, a new pharaoh had workers disassemble an existing temple and rebuilt it in a new location with a new dedication. This was, of course, much easier than starting the building process in a quarry. This approach of repurposing materials (minus the theft) also applies to sustainable practices today, as existing buildings, granite road curbs, wharfs, bridges and barn foundations no longer in use can have their stone inven-

FIGURE 47. ATLANTA BOTANICAL GARDEN, ATLANTA, GEORGIA (2009). AECOM, ALEXANDRIA, VIRGINIA. (© AECOM.) Granite curbs were salvaged from an existing road to be demolished. They were repurposed in the garden as dry stacked retaining walls.

toried as building stock for future projects. This is usually done by salvage operators who seek local buyers, if possible, before the stone is moved. Internet websites make this information more readily discoverable, but architects and landscape architects have to look for available materials, engineers have to work with code reviewers and inspectors to verify the structural capability of the recovered stone, and the contractor procurement staff has to manage the temporary storage of this massive and heavy material. If any material warrants being repurposed, it is the most durable and long-lasting stone, since subsequent generations of use partially compensate for the embodied energy initially expended to extract, dress and transport the stone from the quarry. Signs of weathering or wear due to use, and sometimes attached moss and lichen, are appreciated evidence of aging that transfers with the stone in ways that are impossible for new materials.

Stone construction also carries a feeling of place when local stone is used locally. This parallels the ongoing argument debated for several centuries about the role of native versus exotic plants as adding an element of "art" to design. While some reason that local materials and methods of construction are commonplace and cannot ever claim to be unique, as is generally considered important for a work of art, others claim that a sense of placelessness results from ignoring the local in favor of the imported. Using local building materials and methods of construction allow new construction to "look like here." Those interested in displaying novelty are at odds with a desire to fit in authentically.

For surfaces formed by nature and not by design, naturally occurring stone patterns rival only beautifully grained wood for supporting meditative reflection similar to gazing at a flowing stream or a small fire. Early twentieth-century architect Victor Horta valued stone's rich variety and randomly flowing appearance as a self-ornamenting surface exploring "the same ambiguity between surface and dream-like depth" (Dernie 2003: 13). Seeing the interior veins of stone is like a microscopic view of its inherent character, revealing internal structure and composition. The variations are not random, though, and consistent enough for various stones to have distinct names.

Innovative Applications

What are the possible innovative uses of the material with the longest history of permanent construction? Clearly stone has associations of strength, permanence, history and investment. Possible finishes range from so refined that it looks almost like a manufactured material with flawless surfaces, precise joinery and a predictable appearance to so rough that a stacked wall does not need mortar to hold it together. Constructing in stone carries a ritual of manufacture that begins with discernment and continues by following educated experience, through which the strength of a particular type of stone is matched to its degree of dressing and a corresponding installation pattern and joint width. Selecting the type of stone for a particular application reveals the mason's deep understanding of stone's performative capabilities, coupling limestone with smooth surfaces, sharp corners and geometrically even joints; granite with heavy block-bearing weight; elegant marble with extraordinarily beautiful veining; or dutiful sandstone with cohesive textures that may even hold fossilized records of the past.

Practices attempting to be innovative tend to flip traditional methods of working stone, making the heavy light, the stable fluctuate, the solid translucent, or the hand-worked mech-

FIGURE 48. CAMANA BAY, GRAND CAYMAN, CAYMAN ISLANDS (UNDER CONSTRUCTION). OLIN, PHILADELPHIA AND LOS ANGELES. (© OLIN.) Local coralstone, a loosely compacted limestone, was collected and sent to a manufacturing plant to be used as the aggregate content in precast unit pavers. The original color was darkened to improve the albedo effect and to be varied enough to reduce glare. The color and pattern helps the new construction blend into the local landscape.

anized. Stone blocks can transfer weight and each course can corbel out about an inch, distorting planer surfaces, but large steel-supported cantilevers that defy gravity and suspend stone are illogical. Hidden steel reinforcing allows normally weak stacked stone to have vertical joints or undulating horizontal joints, but this appears unsettled and prone to cracking. As discussed in the previous chapter, cutting tools can slice stone so thinly that it becomes like stained-glass windows, allowing daylight to transmit through solid walls. Steel gabion cages containing stone rubble can replace conventionally built stone walls, making retaining and secure screen walls with free drainage and air flow, but the best procedure is to hand place any stone that is going to be seen.

Current construction practices generally favor installing engineered assemblies rather than building simply with thick materials. For example, composite wood glulams are used in lieu of solid timber, and thin stone veneer panels can be hung from structural concrete frames absent all associations of weight and mass. While this saves old trees and requires less stone, the ability of the materials to age well diminishes. The worn stone cathedral step shows evidence of having been walked on by thousands of the faithful over centuries, and

FIGURE 49. REST ROOMS, GEORGE "DOC" CAVALLIERE PARK, SCOTTSDALE, ARIZONA (2012). WEDDLE GILMORE ARCHITECTS, SCOTTSDALE, ARIZONA, AND FLOOR ASSOCIATES, INC., PHOENIX, ARIZONA, LANDSCAPE ARCHITECTS. (© Bill Timmerman.) **Local stone was placed piece by piece in steel gabion cages that were used for building enclosures and retaining walls. Their color blends with the surroundings, and the construction technique requires no maintenance.**

thick stone is better able to withstand atmospheric pollutions such a surphuric acid, generated by burning wood, coal or oil, which eat away its surfaces (Wolff in Mäckler 2004: 111).

Sustainable practices mandate restricting choices to locally quarried rock and specifying minimal processing. The impact of mining and overburden spoils or waste on habitats, along with the ecological consequences of dredging riverbanks for sand and gravel, are "the primary environmental stressors of stone" (Calkins 2009: 235–37). Unfortunately, common practices of shipping quarried granite from the United States and Germany to China as ballast to be cut into cobblestones and then shipping it back need to recognize the high life-cycle assessment cost in transportation, even if the labor cost is lower. Recycling stone depends on the inventories of available "used" stone that can be repurposed for new building elements or used for retaining or seat walls in the landscape. Salvage yard operators and construction site managers need to coordinate delivery and storage of this stone. It can also be downcycled for new applications such as drainage rubble, or it can be crushed and become part of the concrete or asphalt mix content.

If sustainable guidelines dictate conservation practices, and the demands of sound stone construction procedures have their own narrow parameters, then the innovative use of stone seems rather limited. Like all innovation, the best direction may not be doing more with less

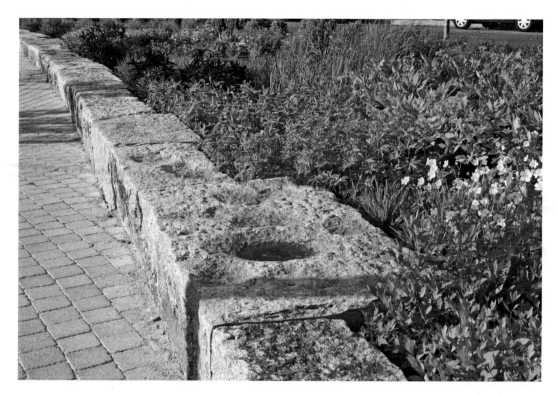

FIGURE 50. WHARF DISTRICT PARK, BOSTON (2008). AECOM (FORMERLY EDAW, VIRGINIA) AND COPLEY WOLFF DESIGN GROUP. (Photograph by Dixi Carrillo, © AECOM.) Granite stock-piled from a waterfront redevelopment that was part of the Big Dig was salvaged and reused as seats and retaining walls. The front and top surfaces were aligned and the stone sides were cut for a tight, mortared fit. Once installed, the sharp front top edge was sanded round for more comfortable use.

in increasingly complicated and failure-prone assemblies, but rather taking advantage of a material's inherent capabilities to address new problems. In the case of stone, this means using stone for projects meant to last. Coastal development that must withstand occasional extreme storms may find that stonework survives such rigorous conditions. Using computer-aided design and robotic cutting machinery that makes three-dimensional forms using Rhino 3-D modeling software allows designers to propose flowing stone shapes for many applications, from comfortable benches in public places to retaining walls that protect shorelines from storm surges (Dernie 2003: 47).

Stone constructions have the capacity to demonstrate stillness in a way no other material can. They remain as they have been placed long after other building materials have burned up, rotted away, fallen over or broken. Stone's weight and the difficulty involved in finding, extracting, finishing, transporting and installing it are all factors that insist on a deliberate and unambiguous design. One does not design in stone by accident. Nevertheless, portraying its stony properties by contrasting weight with lightness, threatening its strength with the fragility of gravity-defying joinery, or turning it into a veneered wallpaper all belie its inherent character. Stone's weighty and heavy silence is patiently present amid the activity of life. Its presence lasts. Like Pliny's mountains—part sky and part earth—stone can be worked to build lasting monuments with heroic effort. The immobility of stone is its greatest asset,

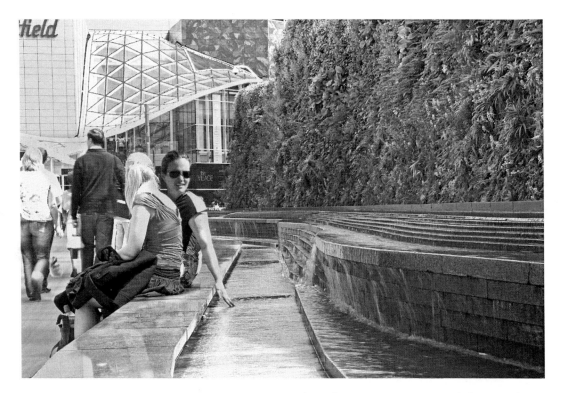

FIGURE 51. WESTFIELD SHOPPING CENTRE, LONDON (2008). AECOM, U.S. WEST. (Photograph by James Haig Streeter, © AECOM.) Rhino 3-D modeling software was used to draw the design for the granite fountain and seat wall with curving forms. Computer Numerical Control (CNC) machining technology was used to fabricate the stone directly from the software models.

and this characteristic has the greatest potential to create what people long for—lasting connections to the fundamental forces of nature.

Resources

Federal Agencies, Technical Societies and Associations

American Geological Institute, a nonprofit federation of geoscientific and professional associations, http://www.agiweb.org.

Building Stone Institute, http://www.buildingstoneinstitute.org.

Geological Society of America is a 125-year-old organization that provides information on geological sciences and social impact, http://geosociety.org.

Marble Institute of America publishes fact sheets for life-cycle data on granite, limestone, marble and sandstone, http://marble-institute.com.

Mineralogical Society of America is dedicated to the advancement of mineralogy, crystallography, geochemistry and petrology, promoting their use in other sciences, industry and the arts, http://minsocam.org.

National Building Granite Quarries Association, Inc., http://nbgqa.com.

Natural Stone Council supports sustainable initiatives for the innovative production of natural stone products, specifically accounting for durability and reclaimed applications, http://www.naturalstonecouncil.org.

Society for Sedimentary Geology (formerly the Society of Economic Paleontologists and Mineralogists) provides online publications, http://sepm.org.

U.S. Geological Survey (USGS) has maps, imagery and publications, including historic and current maps that show topography, and aerial and satellite photographs, http://usgs.gov. Another program under the National Cooperative Geologic Mapping Program is the National Geologic Map Database, which provides geologic survey maps online by state, http://ncgmp.usgs.gov.

Research on the Sustainable Processing of Stone

Building Materials Reuse Association supports designers, contractors and government agencies, http://bmra.org.

Construction & Demolition Recycling Association (CDRA) promotes the safe and economical recycling of more than 325 million tons of construction waste, including concrete, asphalt, asphalt shingles, gypsum wallboard, wood and metals, http://www.cdrecycling.org.

Online Green Building information; especially technologies, suppliers and related costs for foundations, floors and wall applications in various materials, http://sustainablesources.com.

"Stone Quarries and Beyond" is an online article about the history of quarries and stone workers, and it includes a list of quarries and stone supply by type and by state, compiled by Peggy B. Perazzo and George Perazzo, http://quarriesandbeyond.org.

Chapter 9

Wood

Seeing a beautiful object made out of wood, with smooth surfaces, rich, glowing colors, and gentle variations in the grain pattern, prompts an intuitive desire to touch, to run your hand over its soft form, and to appreciate the craftsmanship of fine joinery and finishing. Appealing for these reasons, most cultures also appreciate wood for its practical use in construction. Wood has a single source—trees—and this inextricable link requires that the materiality of wood be tied to an understanding of trees, living organisms that grow without reason and have many practical purposes.

The definition of a tree begins with its size. A tree is a single erect stem plant at least three inches in diameter at four and a half feet above the ground, and it is at least twelve feet tall (Brady et al. 2002: 1042). Exceptions to this definition are based on locations near tree limits, where extreme temperatures result in shorter growing cycles and slower-growing and stunted trees. Trees are classified as broad-leaved hardwoods that produce nuts or fruit and are generally deciduous, or as softwoods or conifers with needles that are generally evergreen. Of the 10,000 estimated tree species in the world, and over 1,000 in the United States alone, about 50 hardwoods and 30 softwoods are commercially viable (Reeb 1997). Generally, slow-growing hardwoods are better suited for finished surfaces and furniture exposed to hard use or the weather, and softwoods work well for interior structural framing that is protected from moisture.

A forest or wood is a group of trees in an unfenced place outdoors, neither domesticated nor cultivated. The words "forest" and "foreign" have a common etymological root that refers to places elsewhere. In 1791, English landscape writer William Gilpin commented on the four types of forests that he characterized from wild to refined (1988: 338–41). Gilpin said the wildest are woods that are a wilderness untouched by humans. Second, a copse, from the Latin *colpāre* (meaning "to cut"), is a thicket of brush and small trees between the forest interior and adjoining cultivated land. Here the type of tree species usually does not matter to people, because the wood will be burned for heating or cooking. Third, a glen is a clearing where trees give way to water bodies, making a naturally occurring gap in the otherwise dense tree canopy. Finally, Gilpin considered the open grove to be a small, planted wood or a domesticated landscape that is often associated with sacred places and burial sites for important people, such as Rousseau's first grave. This sequence—from the wilderness that is completely indifferent to human presence to the forest edge, to the clearing, to the highly designed grove—follows a progression of dependence in which nature is identified in increasingly anthropomorphic terms. In using wood in design for human purpose, the type of tree matters.

Forest —> Copse —> Glen —> Grove

FIGURE 52. ILE DES PEUPLIERS, ERMONONVILLE, FRANCE (1778). (Courtesy Yvette Gauthier.) Rousseau's first grave was on an island, with the marker surrounded by poplar trees. His remains were moved to the Pantheon in Paris in 1794 in honor of his contribution to the ideals of the French Revolution.

Properties of Wood

A tree is a living organism made up of air and earthy elements. Technically, "wood is an organic chemical compound composed of approximately 49 percent carbon, 44 percent oxygen, six percent hydrogen and one percent ash" (Brady et al. 2002: 1042). The sun's energy is stored in trees through photosynthesis. Since most of the world still burns wood for fuel, the embodied solar energy may be thought of as waiting in wood to be released as fire, producing heat and light. The dynamic quality of wood as a building material comes from the sap that flows within the tree. Understanding the fluid retention factor of wood leads to either successful or disastrous use in building.

Wood has a cellulose structure (C6-H10-O5) in long-chain, carbon-based molecules that make the wood fibrous, and this accounts for its strength and flexibility in tension. The cellulose fibers are held together with lignin, giving wood compressive strength. This rare advantage of combined tensile and compressive structural capability has made wood an ideal building material, and this asset can be enhanced with proper milling. Wood is many times stronger when cut with the grain (growth rings) than against it. Compared to other building materials, wood is lighter for its strength than concrete or steel, with a greater strength-to-

FIGURE 53. CURRAN HOUSE COURTYARD, SAN FRANCISCO (2005). ANDREA COCHRAN LANDSCAPE ARCHITECTS, SAN FRANCISCO. (**Courtesy Magenta Livengood.) Reclaimed cypress was used for the solid wood benches. They express a sense of solidity that invites approach.**

weight ratio, but it has limited spanning capacity. Wood bends because of its tensile properties and this allowable deflection is the main reason a wood floor is more comfortable for people than a floor made of rigid concrete or masonry. The Modulus of Elasticity is the calculation of bending based on dead and live loads, determining the maximum allowable length and support spacing for specific grades of wood species. Deflection is not consciously felt, but the cumulative effect is apparent in a sore back after a day of walking around a shopping mall or museum.

Wood has a long tradition in construction because trees are plentiful in most climates. Wood is generally easier to work than other building materials, and this allows relatively unskilled laborers to learn and to build, especially when following traditional methods of material preparation and joinery. Locally found, wood is considered a sustainable building material because it is a renewable resource, although there are significant differences (and corresponding ecological implications) between wood harvested from old-growth and second-growth forests and that taken from commercial tree plantations. Logging natural woodlands disturbs wildlife and habitats, and clear-cutting procedures cause soil erosion. There is also considerable waste because the target trees are surrounded by other plants that are destroyed and usually end up as wood chips turned into a base material for disposable paper products. Forest preservationists urge manufacturers to use alternative sources of cellulose, preferring plants such as hemp as a non-timber fiber crop. On the other hand, sus-

Cultivated trees vs. Wilderness

FIGURE 54. COLUMBUS CIRCLE, NEW YORK CITY (2001–2005). OLIN, PHILADELPHIA AND LOS ANGELES. (© OLIN.) The Brazilian Ipê wood bench offers a porch-like feeling to city dwellers who usually have little private outdoor space.

tainably managed tree plantations produce commodity-grade timber on agricultural farms with a 20-year growing cycle. They can preserve riparian buffers for wildlife corridors and protect sensitive habitats. However, trees grow differently on plantations because single-species monoculture ecologies have less plant competition for nutrients and light, unlike biodiverse forest habitats. Further, some consider plantation wood to have reduced properties, like a loosely knit sweater, such as less decay resistance and structural strength due to its rapid growth. Possible compensations include adding preservative treatments and adjusting engineering and building code standards. Nevertheless, in spite of global reforestation and farming programs, current forest consumption exceeds replacement.

Concentrating on exterior applications, wood surfaces require persistent maintenance if the original appearance is to be preserved. Unprotected wood weathers to a gray color very quickly as the softer parts of the wood deteriorate, leaving a rough texture (although this is not a signal of impending failure). Protecting the wood from weathering depends on three things. First, the wood must be protected from adverse climate conditions in which heat, moisture and wind can cause leaching, hydrolysis and swelling. Second, wood that is exposed to ultraviolet light ages in a process called photo-degradation and requires more

extensive protection and maintenance procedures than wood projects installed in unexposed locations. Finally, the skill of the fabrication and finishing affects the longevity of objects made of wood (Feist 1983: 185–86). While wood may weather without significant performative deterioration because the harder fibers remain unaffected, serious decay occurs when wood objects are poorly finished. As an organic material, wood can provide food for fungi (mildew) and mold spores (which are everywhere) to the point that any constructed wood object that traps moisture beneath an impenetrable surface will rot (Carlsen 2008: 201). Properly crafted, the organic life of a tree may be extended as a wooden thing, but eventually, through either neglect, fire or excessive dryness, this afterlife will likely come to an end.

Wood in History *Wood is less permanent*

Some ancient Greeks built their temples out of wood and then gradually replaced each element with more permanent cut stone as circumstances allowed (Rykwert 1996: 174–76). Surviving stone temples, civic buildings, theaters and monuments display joinery and ornament that reflect wooden construction techniques. Other common early structures combined earthen pits and compacted foundations, timber-framed walls and roofs, and surface enclosures made of skins or woven fabrics.

Vitruvius described uses for wood from elm, beech, cypress, hornbeam, cedar, juniper, poplar, willow and linden trees. He also wrote that wood was to be cut in the early autumn, when the living energies of the tree were less robust (II.IX.1). He recommended cutting the outer sapwood part of the tree first and then letting the liquid drain. He also compared many types of the trees for their distinct proportions of air, earth, fire and water. These proportions guided matching tree types to intended purpose. For instance, fir is relatively lightweight, making it suitable for straight and strong open framework; oak is better for underground construction, where it is in contact with earth's moisture; alder is good for underwater pilings; and larch is better able to be near hearths and fireplaces without burning. Wood from larch trees was also used for pilings because it grew very tall and straight, and its heartwood was rot-resistant (Carlsen 2008: 317).

Another early account of wood comes from Pliny the Elder, who said that "trees and forests were thought of as her [the earth's] ultimate gift to mankind" (XII.1). Because "trees were the temples of the gods," Pliny associated particular wood species with individual gods, saying "the Italian holm-oak is sacred to Jupiter, the laurel to Apollo, the olive to Minerva, the myrtle to Venus, and the poplar to Hercules" (XII.3). Wood's usefulness in construction depended on understanding the hidden qualities of a tree in order to determine its internal integrity. According to Pliny, a way to test for hidden knots or twists was to "put your ear to one end of a beam ... however great its length, you can hear even the tapping of a pen at the other end since the sound travels along passages that run straight through the wood" (XVI.184).

Alberti described the influence of the moon on every living organism. He advised about when and how to cut and dry particular trees, and called for air-drying wood for three years. Alberti also reviewed various possible applications for wood, including carving boards, panels for painting, pictures, interior doors, furniture and building construction (II.4). His descriptions illustrate his position distinguishing between architecture as a profession (in which architects design and make drawings) and construction (in which craftsmen and manual laborers build the project according to the plans).

More recently, Michael O'Brien, in an article titled "The Five Ages of Wood," traces the history of wood construction from its technically primitive beginning to current practices, following this progression:

Shaping: Whole logs are joined with rough connections.

Joining: Whole logs are trimmed into squared timber and the framing has tight joints.

Commodifying: Trees are reduced to standardized parts and dimensioned lumber may be reliably ordered. This was done after the 1830s, coinciding with the availability of machine-made nails that permitted lighter and faster construction.

Transforming: Wood is disassembled and reassembled with waste, wood by-products and adhesives, making new "raw" materials. Instead of using large timber members for long spans and heavy loads, thin multi-ply sheets are glued into plywood and multi-piece "sticks" are formed into glued laminated timber pieces called glulams, which can be used for beams and posts. Redwood, red cedar and Alaskan cedar are the best wood species for glulams, with Douglas fir, hem-fir, western hemlock and southern pine offering a less expensive alternative (Winterbottom 2000: 30) (see Figure 55).

Reconstituting: Wood fiber on a cellular level is remade into composite materials with recycled content, and then cast, extruded, or molded into shapes and products. For instance, engineered or plastic lumber can withstand exterior exposure with little maintenance. Interior cabinetry can be made with processed by-products, including sunflower seed hulls or sorghum straw. Medium-density fiberboard (MDF) is sometimes made of discarded wheat stalks and is called wheatboard. Complying with sustainable guidelines, these composite materials are now made without the bonding resin urea-formaldehyde, which produces toxic off-gases.

The history of wood for building purposes begins with inherent botanical capabilities and continues with developing more productive or disease-resistant strains of tree species, and then evolves into more technological wood manipulation techniques.

Theories of Wood

Methods and reasons for converting trees into finished wood objects reflect the practical and emotive associations people have with the material. Societies with primitive technologies used logs and often retained the tree bark on timber, assembling the pieces using simple mortise-and-tenon (or hole-and-peg) joints. When done today, this less processed approach yields results that appear closer to nature and express an innate human desire to return to the idealized (and illusionary) simplicity, honesty and authenticity of the natural world, a romantic theme found in some urban public parks. For instance, in an attempt to counteract the intensity of dense city life and often overwhelming advancement of digital technologies, many designed landscapes, including Central Park, incorporate rustic wood structures. American parkways have wooden bridges, fences and signage, as do national parks, which also have log shelters, all expressing in their rough wooden construction a kind of relaxation only found close to nature.

However, wood working that is highly refined reflects a desire to distance humanity from nature through craft. Assuming the proper selection, preparation and finishing of wood, superior workmanship is evidence of skill and of continual care. Projects that aim to display a high state of refinement may use wood because, unlike manipulating manufactured mate-

FIGURE 56. RUSTIC BRIDGE, CENTRAL PARK, NEW YORK CITY (OPENED IN 1859, REBUILT AS NEEDED). (Courtesy Magenta Livengood.) Rough wood logs from fallen trees salvaged in the park are used for repairing or replacing rustic structures. They are found in the wilder areas and support a feeling of being in the country.

rials, controlling a living material requires a great degree of ingenuity and respect for its dynamic character.

Wood worked as a building material demonstrates the attitude people have chosen that reflects how we appreciate nature's "ultimate gift." *The vitality and generative energy of wood, along with a metaphor of rootedness, a requirement for nourishment to grow and an acknowledgment that it will eventually die, are ways to think about this material.* The relationship between people and nature is continually challenged with questions of preserving old-growth woods, managing forests, harvesting lumber and exploiting renewable natural resources. While cultures may no longer link oak trees to Jupiter (whether a god or celestial planet) or use wood where concrete or steel can meet greater structural demands, when we chose to use wood, sustainable practices require attention to the selection, treatment, fabrication and finishing of the right species for the project.

Selecting

Designers can look to past applications in matching wood type to crafted object. For instance, the type of wood used for barrel construction is matched to the particular liquid to be stored. Vinegar and beer are cured in white oak, cypress or western red cedar barrels, while whiskey uses white oak because of the high presence of tyloses, and wine is aged in redwood, oak or fir casts (Bond and Hamner n.d.: 7). In the past, ship decks were made of

FIGURE 57. THE GAMBLE HOUSE, PASADENA, CALIFORNIA (1908). GREENE & GREENE, PASADENA, CALIFORNIA. (Courtesy Magenta Livengood.) Seventeen species of wood were used for highly crafted architectural elements.

South American teak; Maine had tall, straight and slow-growing pine that was ideal for ship masks; and rock-hard lignum vitae from Brazil, with its oily, self-lubricating moisture, was ideal for pulleys and gears (Carlsen 2008: 280).

In general, the pattern and density of the wood grain determines its suitability for its intended purpose. All species used for construction are tested and identified according to their structural strength, serviceability and appearance, and graded accordingly. Lumber grades are divided into select and common. The highest select grade is wood that has no knots or blemishes, the lengths of which are spliced together so the joints are less visible, with finished surfaces that are suitable for clear stains. The lower select level is intended to be painted, and it has finger-joints. Common grades from highest to lowest are identified as construction, standard, utility and economy. The higher grades cost more, but do not produce as much waste because fewer imperfections need to be cut out, while the lower grades will have considerable waste if the construction is to achieve the designed structural performance. Selecting the right grade for the intended purpose at the lowest cost and producing the least waste is one aspect of sustainable practice. Another aspect is choosing the right wood for the structural framing (harder woods can span further between supports, often decreasing the overall amount of wood required).

Selecting the proper species also requires balancing individual wood characteristics, cost, likely use and maintenance. Balsa wood has the highest strength-to-weight ratio and is the most buoyant. Birch retains its bacteria-killing organisms and is the best wood for

FIGURE 58. POPE-LEIGHEY HOUSE, ALEXANDRIA, VIRGINIA (1939). FRANK LLOYD WRIGHT, TAL-IESIN, WISCONSIN. (Courtesy Magenta Livengood.) The original cypress siding survives even though the house has been disassembled and relocated. The original wood beams for the roof cantilevers have been replaced with steel.

toothpicks. Pine, fir and poplar are strong and good for rough carpentry if the wood does not contain too many knots. The densest woods, such as walnut, sycamore, beech, maple, ash, cherry and oak, are good for highly finished woodwork that remains exposed and is handled frequently (Lefteri 2003b: 16–26).

Some tree species produce chemicals called extractives that serve as natural preservatives against decay. The heartwoods of cedar, redwood, bald cypress, black walnut and black locust are naturally decay-resistant making them good for exterior use because they have short fibers, lots of lignin, and lower densities (which cause less swelling and shrinking), and they tend not to rot (Winterbottom 2000: 23–24). Heartwoods of redwood, eastern red cedar and bald cypress are naturally termite-resistant, and they are acceptable in an *untreated* state for landscape applications and building construction according to some residential building codes (International Residential Code 2033, §R319.1, R320.3, R323.1.7). Frank Lloyd Wright used Louisiana "tidewater" cypress siding for many of his Usonian houses in southern locations, as well as his own home in Spring Green, Wisconsin, and called it the eternal wood.

Woods that do not require chemical treatment are better for people with environmental sensitivities. In 2004, the U.S. Consumer Product Safety Commission released a study that concluded children had an increased risk of developing cancer when exposed to wood preserved with chromate copper arsenate (CCA), used for play structures and decks. The EPA has since prohibited the use of this treatment, although other forms of inorganic arsenate are still used. This lumber is sold with warning labels advising consumers to avoid touching

the wood with bare skin or burning scraps for firewood. The labels also warn about chemicals that can leach from wood with arsenate into adjacent soils, and the danger of eating plants grown in raised beds framed with this wood. Further, wood treated with preservatives cannot be repurposed as filler or bedding chips, and so it eventually becomes waste adding to landfills.

Seasoning

Most wood requires treatment or seasoning once cut. Common, unseasoned lumber has a moisture content of between 15 and 19 percent. Kiln drying can reduce the moisture content to as little as 6 percent. An alternative but slower process is to air-dry wood. Wood tends to shrink by 1 percent in size for every 4 percent of its moisture content, which accounts for the difference between green wood and dry wood dimensions. If the wood is not properly dried, it will continue to change dimensions by checking, twisting, splitting or cupping. Also, the wood must be sufficiently dry before it is sealed with paint or another weather-protective coating. If the moisture content is too high when sealed, then the moisture already present in the wood cannot escape and interior rotting will occur. Building codes require that all wood in contact with masonry have pressure treating by injecting chemicals under pressure in a kiln in a process invented by Dr. Karl Wolman in the 1940s. The pressure rating depends on the intended use, with the lowest rating for above-ground applications, followed by applications with ground contact and masonry foundations, and the highest rating required for wood exposed to saltwater.

Joining

Proper wood joining begins by recognizing that surfaces that follow the grain are fundamentally different from the cut-end surface. Detailing that exposes the end grain can allow water to penetrate, resulting in swelling, shrinking and movement. Mitered joints connect and conceal the end grains. Unfortunately, while this kind of joint is tight initially, over time the joint can open up if exposed to rain, snow and temperature changes. Further, any exposed horizontal wood surfaces, such as window sills and post caps, should be thought of as little roofs and should slope at least 7 percent to allow rainwater to shed away.

Wood can be cut into very thin sheets and glued to less expensive wood species in a technique known as veneering. As a surface, the veneered appearance may fool the eye, but usually the joinery reveals the superficial condition. If wood is to be used as pretentious wallpaper, then a piece of solid wood for the joint can at least keep it from looking cheap.

Wood exposed to the weather requires special fastening and connecting devices. Coated, galvanized steel or stainless steel cold fastenings are recommended because they will not rust. Where wood touches copper or aluminum, fasteners made of the same metal should be used.

Finishing

Translucent and lightly pigmented treatments allow the quality of wood grain to be expressed, highlighting the naturally occurring irregularities of wood as a material. Polishing that produces a high degree of reflection may show more care, or it may make the wood look

artificial, such as wood surfaces smothered by a coat of polyurethane. A matte finish with a soft sheen may be more appealing and allow the patina of use to show in subtle wear patterns. Selected for care and maintenance, the intent is to preserve the wood in a way that recognizes that a little life is left in the material.

Unless naturally decay-resistant species are chosen, wood that is exposed to direct sunlight will last fifteen to twenty years if maintained, but only three to five years if left unprotected. There are several approaches to protecting wood from weathering, including applying film-forming paints, stains or penetrating preservatives, or coats of water repellents or chemical treatments. Varnishes are used for wooden boats and require annual maintenance, while lacquers can be used for interior products (Feist 1983: 190–92). Designers should test choices in the proposed situation before specifying a product, remembering that visual appearance is the chief source of wood's tactile appeal. Attention is also needed to ensure that the finishing treatment uses an environmentally friendly product that does not produce toxic off-gases, or volatile organic compounds (VOCs).

Substituting

Some wood objects cannot fulfill their purpose if they are made out of alternative materials. For instance, musical instruments such as violins, guitars, drums and pianos lose all ability to resonate without the dynamic character of wood. Alternative materials for sporting equipment, on the other hand, have mixed results. Wooden tennis rackets and golf clubs are no longer used in competition, but if metal baseball bats were allowed in the major league games, larger ball parks would be required and pitchers would need to wear more protective gear. Substituting for wooden pool cues likewise changes the game. Wooden roller coasters, called woodies, have their dedicated followers because it is the moving and flexing that makes the ride more fun than rigid steel construction allows (Carlsen 2008: 116–84, 313–48). In landscape construction, the high maintenance required for wood has made PVC plastic substitutes an attractive alternative in spite of PVC's typical shiny white appearance, its propensity to chip upon impact with no hope of repair, and, most importantly, its unsustainable manufacture and disposal.

Selecting, treating, fabricating and finishing wood have developed far enough to allow the use of cheaper or more abundant wood species. Nevertheless, the idea of using wood as a construction material is still based on an appreciation of its organic character, flexibility and the display of skill in its making and care in its maintenance. This makes wood a material that reflects a culture.

Innovative Applications

The seemingly endless variety and availability of wood is now being tempered with sustainable practices that recommend some tree species not be used. According to the Rainforest Relief Guidelines, "Avoiding Wood from Endangered Forests," and supported by the Friends of the Earth guide as well as the Convention on International Trade in Endangered Species of Wild Fauna and Flora (CITES) Appendices, tree species to be avoided in particular come from rainforests. From tropical climates, these include cedar (Spanish), which is endangered; ipê (Ironwood); teak (Borneo), also endangered; mahogany (African, American or

Honduras); and wenge, also endangered. From temperate climates, tree species to be avoided include cypress (Patagonian or Fitzroy), also endangered; redwood; and western red cedar.

Suggested alternatives for sustainable construction should first use repurposed post-consumer wood, starting with reclaimed or salvaged wood from existing buildings, bridges and trestles, often made with heavy Douglas fir timber framing with thick redwood plank decking. Also worth considering are the newly available submerged cypress and pine sinker logs recovered from river and lake bottoms, where pre–1900 logging of old-growth forests had some logs sink during their transport from forest to mill. However, environmentalists are concerned about the impact of removing these logs because the extraction disturbs aquatic habitats and requires heavy equipment that may disrupt adjacent sensitive wetlands. Second, if new wood must be used, designers should require second-growth wood that is certified by the Forest Stewardship Council (FSC) or wood from managed tree plantations. Third, one should specify engineered wood products, particularly with high waste and recycled content. Finally, trees with natural rot-resistance should be used to minimize the need for chemical preservatives and finishes. The trees should be either native or at least grown and

FIGURE 59. TAHARI COURTYARDS, MILLBURN, NEW JERSEY (2002–2003). MICHAEL VAN VALKEN-BURGH ASSOCIATES, INC., LANDSCAPE ARCHITECTS, P.C., CAMBRIDGE/NEW YORK. (Courtesy Michael Van Valkenburgh Associates.) A "river" of locally harvested black locust planks are set in moss to make a path through the interior courtyard of an office building.

FIGURE 60. U.S. CENSUS BUREAU HEADQUARTERS, SUITLAND, MARYLAND (2004–2007). SKID-MORE, OWINGS & MERRILL, LLP, WASHINGTON, D.C. (Photograph © Eduard Hueber/arch-photo.) The FSC-certified, marine-grade white oak *brise soleil* was used for shade fins on the first federal government office building to achieve a LEED® Gold Certification rating.

harvested within five hundred miles of the installation site. For example, in the mid–Atlantic region, suitable wood species to use for exterior applications include the following:

Bald cypress (*Taxodium distichum*): An extremely durable and decay- and rot-resistant tree.

Black locust (*Robinia pseudoacacia*): Often regarded as a weed volunteer tree, and many current technical guides do not include it in lists of wood building species, although traditionally it was used for fence posts and ship building. The wood is naturally decay- and rot-resistant, and it is available in three grades. It is considered to be a renewable resource (actually, it is invasive) due to its underground stem propagation habit.

Eastern red cedar (*Juniperus virginiana*): A decay-resistant and fast-growing tree, but a weaker wood that necessitates the use of shorter pieces, avoiding long structural spans. Cedar split shakes and sawn shingles are used for roofing materials; cedar planks are used for siding.

Eastern white oak (*Quercus alba*): A decay-resistant tree that is plentiful and inexpensive.

Why work in wood today when there are many easier, and often cheaper, alternatives? Why risk the potential for rot and decay, and assume responsibility for continual maintenance? Wood is a renewable living material with various types, capabilities and suitable applications. Our entire bodies respond to this living material. Our eyes see the beauty in the grain patterns, our hands long to touch the smooth surface, our feet appreciate the deflecting floor, and our backs are engaged sitting on a wood bench. This intimate relationship between the body and the material prompts approach and encourages occupation. So long as the cut ends are concealed and the surface is protected from ultraviolet light and absorbing moisture, wood is a material that balances the human need to be close to nature and to distance ourselves from its primitive condition.

Resources

Federal Agencies, Technical Societies and Associations

American Forest & Paper Association has technical guidelines and an engineer-staffed help desk, http://afandpa.org.

American Wood Council provides a Directory of Wood Products Industry Associations, http://awc.org.

American Wood Protection Association (formerly the American Wood-Preservers' Association) develops and maintains an international Book of Standards for wood protection, http://awpa.com.

APA—The Engineered Wood Association (formerly the American Plywood Association) has information about glued laminated timber (glulams) and other assembled wood products, http://www.apawood.org.

Forest Product Laboratory has hundreds of thousands of tree species samples and information about forest-destroying invasive insects, http://www.fpl.fs.fed.us.

Forest Stewardship Council (FSC) promotes environmentally sound, socially beneficial and economically prosperous management of the world's forests, http://us.fsc.org.

Mercer Museum in Doylestown, Pennsylvania, has extensive collections of pre-industrial wooden artifacts and woodworking tools, http://www.mercermuseum.org.

National Association of State Foresters provides information about forest management and assistance with lobbying efforts on the state and federal levels, http://stateforesters.org.

Natural Resources Defense Council is an environmental action group involved with all issues of sustainability, including forest certification, http://nrdc.org.

U.S. Environmental Protection Agency, National Service Center for Environmental Publications, provides a free download for the Building for Environmental and Economic Sustainability Technical Manual and User Guide (BEES 4.0), prepared by Barbara C. Lippiatt. It offers information of life-cycle assessment (LCA) tools and is available on several websites.

U.S. Forest Service manages 193 million acres of public lands and grasslands. It identifies seven goals in its Strategic Plan for Fiscal Years 2007–2012, including sustainable natural resource management, http://www.fs.fed.us.

Woodworking Industry Information has articles and an informed online discussion chat room, http://woodweb.com.

Research on the Sustainable Harvesting of Wood

CitiLog, located in New Jersey, is an example of a company dedicated to providing information and services for up-cycling trees and repurposing wood. It defines up-cycling as taking fallen trees, trees removed for construction or wood saved from demolished buildings and processing the material into useful products, saving the wood from landfills, being cut for firewood or ground up for mulch, http://citilogs.com.

Convention on International Trade in Endangered Species of Wild Fauna and Flora has links to a species database and appendices that list the current status of each species, http://cites.org.

Rainforest Relief is an advocacy organization dedicated to exposing and challenging rainforest consumption by monitoring the sustainable and unsustainable use of endangered woods as well as listing sources for certified and reclaimed wood throughout the country, http://rainforestrelief.org.

Chapter 10

Earth

Earth, soil, dirt or ground: the material implications of these often interchangeably used words reflect their varying cultural perspectives. Earth is the planet formed millions of years ago from colliding particles of solids, liquids and gases. The earth in turn is the source of all elemental physical material that most people regard as natural resources, including trees to be harvested, stone to be quarried, ores to be mined, and other matter extracted for manufacturing into concrete, brick, ceramics, glass and plastics. The planet has a relatively smooth form and moves by revolving, a motion that is too subtle to feel but becomes apparent in the passing of day to night. Soil profiles divide the thin upper surface of the earth into layers. The uppermost layer is the topsoil, humus, and is made up of organic matter such as decaying leaves, sticks and dead wild animals. This soil layer is the critical growing medium for plants. Below the topsoil is a second layer of loose and weathered stones and some organic matter. Below that is a third layer made up of solid rock. Dirt, a term often negatively associated with "dirty," implies contamination, and various cultures have accepted expectations of what is considered clean or unclean. Ground is associated with the idea of being grounded—that is, firmly planted in a stable and reliable fashion. Fundamentally, the earth is the only home to humans and all other known life forms, and the ability of its renewable resources to support continued survival depends on living in harmony and balance with nature. These definitions reflect physical realities as well as cultural perceptions, and thinking of earth as a building material has a similar range.

The human-earth relationship starts when we are children. Digging in the dirt is imaginative play, local and free, with a medium easily moved and mounded. Full-scale earthen construction carries similar characteristics of being local and relatively free but labor-intensive to work, in need of minimal processing and transporting, and endlessly recyclable. Because earthen materials are not manufactured, they are nonpolluting and any carbon footprint comes from making the formwork and additives needed for certain types of construction. Earthen buildings—as over one-third of the world's population knows because they live and work there—have thermal mass making them warm in the winter and cool in the summer's heat, and they are durable and sound-absorbing (Elizabeth and Adams 2005: 88, 152). Less sustainable practices begin when the earth as found must have its composition adjusted to amend it for agriculture or to stabilize it for construction. Throughout history, people have built earthen structures with unfired brick or adobe, which allowed relatively unskilled labor to construct secure shelters that shut out wind and rain.

Depending on the region, cultures have myths about the origins of dwelling and vernacular architecture. The hut, cave and tent are the three original dwelling types that are

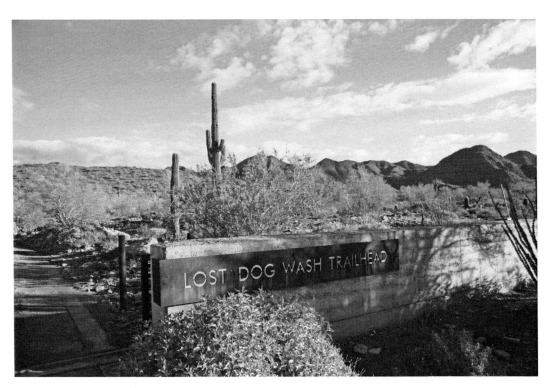

FIGURE 61. McDowell Sonoran Preserve, Lost Dog Wash Trailhead Sign, Scottsdale, Arizona (2006). Weddle Gilmore Architects, Scottsdale, Arizona, and Floor Associates, Inc., Phoenix, Arizona, Landscape Architects. (Photograph © Bill Timmerman.) The rammed-earth wall takes advantage of local soils, and the colors and textures blend with the surrounding desert landscape.

linked to traditional building materials and human activity. Earthen materials are formed into shelters by molding and piling up adobe for farmers in arid regions whose planted fields and investment in irrigation systems required them to settle in one place. Farmers in regions with forests used wood, for permanent shelters made with posts and beam structures. Hunters found rocky outcroppings and caves for temporary shelter. Nomadic tribes and wandering shepherds cut, trimmed and joined wood, making framed tents draped with fabric or skins for portable shelter (Yglesias 2012a: 125–34). For premodern societies, taking advantage of local resources was critical to survival. Today, the amount of new construction required to support the increasing global population suggests reconsidering local materials, especially earth.

The etymological root of the word "earth" comes from "ero," linked to "eros." In Homer's *Iliad*, Eros was the Greek god of love and sexual desire, and was worshiped as a fertility god. According to Hesiod, Gaia (Earth) gave birth to Uranus (Heaven or Sky), who became an equal and covered her. Together, they gave birth to Eros, an active earth. Roman myths turned Eros into Cupid, who shot golden arrows made with dove feathers into unsuspecting hearts, prompting attraction, or leaden arrows with owl feathers, rendering one indifferent. Cupid also became a symbol of everlasting life after death—a bodily recycling with images of renewal that reflect healthy earth cycles. These lessons of Cupid recognize that the natural resources of the earth are limited, but so long as biological life cycles, especially those of

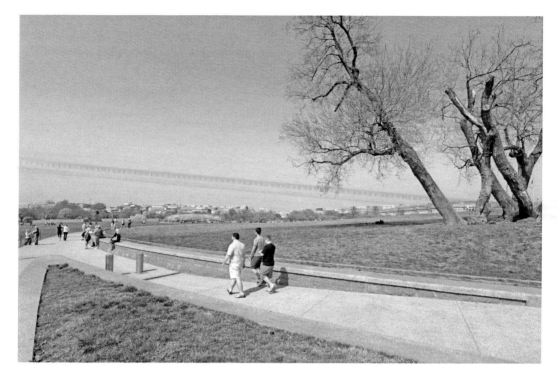

FIGURE 62. WASHINGTON MONUMENT GROUNDS, WASHINGTON, D.C. (2001–2005). OLIN, PHILADELPHIA AND LOS ANGELES. (© OLIN.) The grounds were redesigned to comply with new Department of Homeland Security post–9/11 security measures, employing the idea of the ha-ha, "these walls succeed in safe guarding against automobiles entering the site and also provide seating without distracting from one's view" (OLIN website). The ramps were laid out to provide handicapped accessibility and the seat walls increase user comfort in a historic landscape that has no benches.

forests, are protected and more sustainable practices are employed for materials that must be consumed, the bounty of the earth will remain.

Properties of Earth

"The ideal soil has about 45 percent mineral solids, 5 percent organic matter solids, and 25 percent each water and air" (Hopper 2007: 646). Soil is classified by the mineral content of gravel, sand, silt and clay according to the particle size distribution from coarse to fine in a procedure called grading, as well as its plasticity or workability, compactibility and cohesion (Calkins 2009: 145). ASTM D 2487 classifies soils by type. The presence of organic matter such as peat usually means that the soil should not be used for constructing shelter. Another soil type is loam, which is good farming soil because it has more nutrients than sand and better drainage than silt, and it is easier to till than clay. It can also be used to coat the inside of a house, where it will control the humidity. As prairie settlers discovered, houses made of sod had problems with insects, and any organic matter included in the earthen mix of mineral solids used for a building may attract similar problems.

In order to build, land is cleared of vegetation and the earth's surface is cut. Cut earth

reveals layers of different types of soils called horizons or lifts, and each "is a template with tendencies" (Logan 1995: 125). These slowly changing layers were formed by impact, shifting forces, seismic activity and erosion. Foundations for structures start as trenches or holes that must be dug to the frost line, where the moisture in the ground is too deep to expand or contract with the freeze/thaw cycle. The foundation must rest on earth that is capable of supporting the weight of the projected structure. Structural engineers need to be familiar with the region and its soils, and, if so, generally assume the bearing capacity to be 2,000 pounds per square foot. If the region is unfamiliar, a geotechnical soil conditions report can be done based on taking core samples of the earth. Builders prefer working on "virgin" soil that has never been disturbed because filled earth contains more air unless it is compacted in layers with mechanical tamping equipment.

Typical soil has a sufficient constitution to carry the weight of most construction. When the soils at the level of the foundation base contain too much clay or water, or have insufficient bearing capacity, several options are available. Deeper holes (called piles) or trenches can be dug, the ground can be mechanically compacted to reduce the air content, or the earth can be removed and replaced with suitable structural soil, usually crushed or decomposed granite. Ground that has less air and is too compacted will not allow rainwater and air to infiltrate the ground and reach plant roots, which eventually kills the trees. This can happen when a shady park is turned into a playground if a suitable groundcover has not been added to prevent compaction.

When soil is removed, it can considered a base material similar to all matter that is removed for building—that is, it is raw in its undefined capacity to become something useful to people. It is in this sense that ground-up limestone, sand and stone make concrete, minerals and ores are refined into metal, clay is formed into brick and ceramics, sand into glass, rock into stone, and oil into plastic. Earth can be used for rammed-earth construction if the air and water are compressed sufficiently, or the soils can be bagged and assembled. Adjusting the proportion of elements is done for green roofs and other places where structural soils may be needed.

Construction with earth as a material employs techniques of mechanical compaction that reduce the air content, add fibers or mineral reinforcement, or insert chemical binders such as cement, lime or asphalt emulsions, and, more recently, industrial by-products (Calkins 2009: 148). Unless the ground has been contaminated with chemicals and toxic waste or has unusual concentrations of heavy metals, earthen structures are generally nontoxic to people and teeming with many forms of life, from bacteria and fungi to earthworms. Also, earthen structures are fireproof, resistant to seismic activity and inexpensive.

Earth's varied composition means that its perfection is determined only when matching it to the desired use. This determination governs everything from where to plant the vegetable garden to where to locate a building. Soil types support different plant species depending on the acidic to alkaline range, with most plants preferring the middle. The difference occurs "when chemical reactions release hydrogen ions into the soil, [and] it becomes more acid. The more acid in the soil solution, the more iron compounds become soluble," affecting the soil profile (Logan 1995: 181). Thus earth transforms the chemistry, biology and physics of life.

Ecological threats to the earth include soil erosion due to commercial forestry and agriculture, mining and resource extraction, and dredging accumulated sedimentation in fresh waterways (Calkins 2009: 15). Environmental concerns extend to the overprocessing of large

commercial farming practices that do not allow the soil to recover and to heal itself, and that try to compensate with unsustainably produced fertilizers that cause polluted run-off. Urban soils tend to be more compacted and have less capacity for holding air and water, and this affects plant growth rates and causes stormwater management problems.

Fertile soils form over multiple cyclic events, and contain mineral accretions and wind-blown silts that are high in calcium and other bases. The root masses of plants are fertilized with matter that attracts microflora, altering the earth's composition by allowing air and water to flow freely. Anything that disturbs this process of renewing mineral and organic nutrients, air exchange and the capillary action of water will diminish the symbiotic pro-ductivity of soil in ways that cannot be easily restored (Logan 1995: 28–29).

Earth in History

The loaf-shaped, hand-molded mud brick adobe walls of Jericho dating from 8300 BCE are the earliest surviving earthen structures, and their craftsmanship suggests even ear-lier origins (Elizabeth and Adams 2005: 90). Jericho is considered to be the oldest surviving known city, with many layers of settlement accrued over centuries. The uncovered palimpsest of excavations reveal abode walls on stone foundations for housing, government and defensive structures. Adobe was the first building material and its structures had an advantage because they could be endlessly rebuilt, repaired or expanded (Winter 2005).

Beyond its use for building structures, earth has been a medium of creative and cultural expression for centuries. Earth mounds were places of sacred rituals, sometimes with buried sacrificial victims. Some earthworks are evidence of advanced social communities because they were places for civic ceremonies. Some scholars think they reflect how societies "wor-shiped gods, buried their dead, remembered their ancestors, and respected their leaders" (Milner 2004: jacket). All are evidence of social and economic organizations that were suffi-ciently stable to undertake large-scale, communal public work projects. Once made, "the mere presence of a mound—a prominent landmark built through sustained collective effort—may have been enough to draw people back to a traditional meeting place imbued with social and perhaps super-natural significance" (Milner 2004: 49–50).

In Pliny the Elder's *Natural History*, earth is discussed in the book on the universe and the world in the section on astronomy. Here he marveled at how "earth is kind, gentle, indul-gent, always a servant to man's needs," acknowledging humanity's complete dependence (II.155). But Pliny was also scornful of what humans do to the earth, saying, "We penetrate her inmost parts, digging into her veins of gold and silver and deposits of copper and lead ... we drag out Earth's entrails; we seek a jewel to wear on a finger. How many hands are worn by toil so that one knuckle may shine!" (II.158). This paradoxical relationship between dependence and exploitation remains an issue exacerbated by technological advances that facilitate natural resource extraction and environmental degradation. Pliny's caution is to take only what we need; today's caution is to take only what can be regenerated.

In addition to using earth as a building material and for agriculture, earth has been shaped for other purposes. For instance, land was cut for defensive trenches and hills that were partially flattened to provide a barrier called a ha-ha. Commonly found in England, a ha-ha or sunk fence is a landform that regrades the land to one side so that physical access by animals and people is prevented while preserving visual continuity as seen from the other

direction. The history of the ha-ha can be traced to Roman defensive earthworks, and the concept finds application today in landscapes designed for security. In the eighteenth century, ha-has were reintroduced by Lancelot "Capability" Brown, who designed landscapes that have come to typify the English picturesque. His avowed successor, Humphry Repton, described this principle of land shaping in 1791:

> A large extent of park in reality, is not necessary, but it is essential in *appearance*, since a bound-
> ary however distinct, always offends the eye in a view from the house. A deception to conceal
> the boundary is so allowable, that even after we have discovered the sunk-fence which unites
> Lawn to Lawn, the mind acquiesces in the fraud, and we are pleased with the effect, so long as
> the cause does not intrude on the sight [Repton, 1994: n.p., but 51].

Permanent levees follow a similar principle, in which occasional floodwaters are contained, but the general appearance of the land is not one of fortification, but of rolling hills. Some embassies and other secure facilities have been designed with land mounds that provide defensive barriers while projecting an image of accessibility. Public parks are also designed with constructed berms and swales whose shapes provide areas with some sense of privacy, with intimate spaces that are partially concealed.

Currently, those interested in sustainable construction are using alternative approaches especially appropriate for self-help housing. The most local of all building materials is being

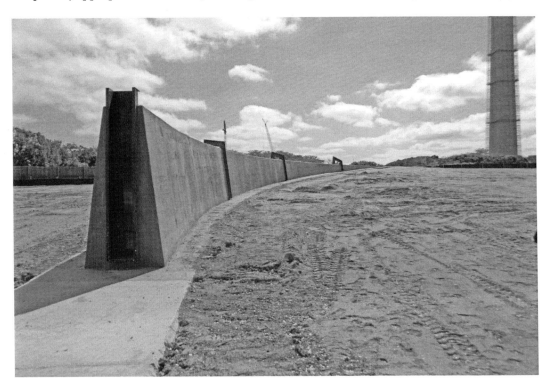

FIGURE 63. POTOMAC PARK LEVEE, WASHINGTON, D.C. (2012—UNDER CONSTRUCTION). OLIN, PHILADELPHIA AND LOS ANGELES. (Courtesy Magenta Livengood.) This levee complies with new post–Katrina FEMA 100-year flood-control requirements. Along with the earth berms and stone-clad concrete walls, 17th Street can be blocked with a post-and-panel system that can be installed with 24 hours' notice. These measures will prevent rising waters from the Potomac River from flooding the Federal Triangle and other critical areas in the district.

FIGURE 64. DERBY ARBORETUM, DERBY, ENGLAND (1839). JOHN CLAUDIUS LOUDON, LONDON. (Courtesy Magenta Livengood.) Derby Arboretum was the first European park designed to be public. The eleven-acre park site was once where the town's open sewers emptied. John Loudon installed nearly a mile of drainpipes below the paths and used the trench dirt to mound up berms that are six to ten feet high. The meandering berms direct the serpentine walks around trees, benches and monuments. The park was designed to host intimate and public gatherings, and this depended on the privacy and openness of the berm-created landscape.

used for adobe bricks, cobs (thick walls built up in layers), rammed earth (compacted between removable formworks), and piled-up earth-filled bags, as well as earth plaster wall finishes and compacted earthen paths and floors. In spite of their long history of successful construction, with many structures surviving intact for many centuries, alternate building techniques using earth as a material face slow acceptance by the regulatory building code compliance industry. A common misconception is that earth is inappropriate for regions with rainy climates or seismic activity. In such locations, earthen structures require masonry or concrete foundations to prevent moisture from wicking up by capillary action and benefit from deep overhanging roofs that protect walls from pounding rain, although washed-away surfaces are easily replaced.

Theories of Earth

Maybe more than the other agents of the poetic imagination—fire, air and water— earth is intimately connected with the study of materials. The maternal associations of matter and materiality are referenced in identifying earth as Mother Earth—that is, the source of

everything biogeochemical. Mircea Eliade writes in a section of *The Sacred and the Profane* called "Terra Mater" that there are many legends that account for our birth from the earth and our desire in death to return to it (1987: 138–44). The womb-to-tomb cycle myth is based on the idea of the earth as fecund and fertile. Anthropologists studying ancient African cultures sometimes face difficulties with autochthony due to competing claims for identifying the original occupiers of a land. American Indian myths say people remain buried in the earth until they "ripen" sufficiently and are able to survive on the surface. Chinese symbolism links the earth with many things, including the feminine, inexhaustible creativity and the square (with the heavens or cosmos above associated with the circle), as well as the color yellow and the tiger. Nevertheless, we do not need myths to appreciate lasting associations with our native land, which explain in part our desire to belong to a place.

The earth is both surface "ground" and "field," clearly what we see and perceive with our other senses, and the metaphysical "world" or geotemporal cosmos within which we live, but being *on* the ground and *in* the world is different from being *of* the earth. The idea of earth as a material may be associated with depth, but how people participate in the idea of earth is not about falling into depth, but rather sinking into it, insulated from shifting winds, fleeting light and shadow, and sudden noises. *Absent other perceptions, the experience of earth brings forth sensations of stability and stillness, and allows centering to occur.*

Martin Heidegger's essay "Building Dwelling Thinking" asks what it is to dwell and how building belongs to dwelling (1971: 145–61). For Heidegger, building is the manner in which mortals dwell on earth. Our presence as builders is an activity of sparing and preserving in what Heidegger calls the fourfold: a unity of sky and divinities above with earth and mortals below. Mortals dwell in an active way by making things present. The example Heidegger used to illustrate what he meant was the bridge that gathers the fourfold in its making. That is why it is not only a thing, but also a thing made present. A place becomes spatially located because a bridge was built there. Heidegger cautioned that this was not an activity pursued in isolation—we must listen. We must listen in our making and in our thinking about the desire to dwell *on* earth and *in* the earth as world.

There is no argument about the human tendency to see only the earth's surface. We often draw superficial conclusions based on the appearance of things. This limitation stands in acute contrast to the wonder we feel in the rare experience of seeing the earth's geologic layers exposed by erosion at the Grand Canyon, for instance, or by deep cuts made through mountains for highway construction. They display the result of millions of years of sedimentation and subtraction.

Gaston Bachelard says that the terrestrial imagination has many examples of "passionate dreaming of the beautiful solids" coming from acts of materialization (2002b: 1). For Bachelard, we may see surface, but we dream about depth. More forcefully, all material elements demand to be imagined in depth. Bachelard talks about a blind sculptor who makes art using his internal vision, which achieves a purer form, revealing the inherent essence more clearly than relying on surface appearance. The material essence of earth is its resistance to force, felt as weight and gravity. Anyone who has dug a ditch understands the will required, the labor expended and the energy necessary to move earth. For Bachelard, the qualities of the earth range from softness to hardness, and that metaphor is extended to life and to how we use earth for human purpose.

The French phenomenologist Maurice Merleau-Ponty wrote about what it means to imagine (1968: 38–43). In his reaction against the Cartesian tradition, he defined the world

as phenomenological and intimately connected the perception of the "real" as the possibility of the same world. The privilege of the senses to read the world as an image, however momentary, and to describe it with language depends on perceptive and reflective acuity. There is simply no other way to cultivate the world of the imagination or our understanding of the deep earth beneath the surface of appearances.

The idea of depth is possible in all material investigations. Thinking about the earth's depth begins with understanding its great mass relative to human size. We are held on the planet's surface by gravitational force, which manifests itself as weight. Gravity is a particular property of the earth because it physically binds us here. And gravity commands a structural accounting of everything that is made as the passive force of dead weight as well as the activities of use as the active force of live weight. People have weight and feel the force as gravity, experienced as resistance to pressure. Even lifting our arms is an act of resisting gravity, a critical act essential to freeing our hands for making. In this sense, the earth's gravity resists our making what we need to survive as a corruption of its natural perfection.

Bachelard claimed the other poetic agents of flowing water, consuming fire and air as wind cause the earth to yield (2002b: 56–79). Through one or more of these agents, materials found in their natural states are transformed and reformed. He described a process of kneading and modeling as form making, a sort of working the material from within (2002b: 56). In activities of corruption and purification, designers seek a balance between accepting a material's inherent properties and changing it for an intended purpose. All materials weather over time. More precisely, metals corrode, plastics become brittle, and many materials deteriorate due to exposure, which sometimes leads to failure but also can reveal temporal depth. In the end, good design is the confident mixing of elements in proportions that deeply unite formal and material beauty.

Earthen materials are, of course, the earth itself. Consequently, the further away cultures are from the land, the less grounded life will seem. Building materials that retain their earthy heritage convey a sense of connection not limited to appearance. The thermal and acoustic properties of thick earthen walls and the absorbent qualities of uncovered ground are felt and perceived as a less technological response to the forces of nature, suggesting that designers find ways to incorporate earth as a material particularly in urban environments. Integrating earthen building materials for smaller structures and soils in all forms, from sandy pits and banks to boulders in gardens, and including wild places with rough terrain in parks will promote sentiments that support dwelling, which is especially desirable in dense cities.

Innovative Applications

Reviving ancient methods of building that use mud and dirt hardly seems to be either innovative or desirable, and yet earthen construction has a place in sustainable design because it is the most ecological way to build. More buildings, including high-rise steel or concrete framed structures, can have exterior skins and non-bearing walls made of adobe. One-foot-thick walls provide superior insulation and acoustic and fire separation, and they also balance indoor humidity while being nontoxic. Windows could be set in deep recesses, providing shade and interior window sill space. The typical adobe mix includes clay (8–15 percent), fine grain sand that is mostly quartz, silt stabilized with cement (10–12 percent), lime or

emulsified asphalt, gravel screened for sizes between one-quarter and three inches across, and amendments to increase tensile strength such as straw, cane or bamboo (Elizabeth and Adams 2005: 99–100). The exterior surface could be sealed with waterproofing stucco; the interior could be coated or not. The result would both satisfy current enclosure energy requirements and at the same time give relief from typical rooms that feel artificial because they are made of drywall, acoustic ceiling panels and wall-to-wall carpeting, and that often have poor indoor air quality, acoustic integrity and a generally thin, hard feeling. Rammed-earth construction has the same potential, but it requires formwork, geopolymer binders and mechanized damping equipment that reduces the air space between particles, improving adhesion and strength and providing a hard, smooth surface.

The relentless search for "green field" building sites unfortunately consumes farmland and forests near cities. The continuing sprawl is contained only by governmental zoning regulations that determine land use patterns and practices. The city of Portland has successfully contained urban sprawl with strict urban growth boundary regulations adopted in 1979 following statewide land conservation policies that were established in 1973. Sprawl is especially threatening to forestland, whose destruction is worrisome because "only 36 percent of the world's primary forests remain as of 2005" (Calkins 2009: 19). Developing ways to build on forested sites without damaging the soil or removing the trees would resolve many competing environmental and social issues. Helical screw piles and pier foundations can be located so as to avoid mature tree roots, and building platforms can be elevated over the forest floor. Construction on the ground can use earthen or dry-stacked stone walls that allow moisture to move. Rather than asphalt, an appropriate substitution is soil-based pavement for walking and biking trails made of compacted mixes of mostly sandy clay soil with about 3 percent cement and only enough water to allow shaping. These trails blend well with adjacent landscapes and are appropriate so long as they have low to moderate use and follow the land contours (Calkins 2009: 168). However, weaving a texture of building and forest into cities is not the current development model for urban planning. Clear cutting the entire site, selling or allowing the topsoil to erode, and building with impervious materials and adding a few trees in tree boxes that are inadequately sized for their healthy growth is more typical. Alternatively, pressures to densify cities can balance land development with conserving and restoring natural systems and making landscapes full of vital ecological actions that produce food and provide habitat.

Much land is already polluted. The Environmental Protection Agency (EPA) estimates there are more than 450,000 brownfields within the United States alone. Hazardous substances (military explosives), organic contaminants (petroleum and chlorinated solvents), inorganic contaminants (metals such as cadmium, nickel, arsenic and lead), and landfill leachates pollute the ground and groundwater. EPA's Office of Superfund Remediation and Technology Innovation is working on various techniques to restore the ecological health of these post-industrial sites, which are often located on valuable property within cities and towns that have developed around them or along nearby streams. On-site bioremediation techniques use various kinds of vegetation whose natural growth systems absorb and degrade pollutants over time. Phytotechnologies are an alternative to conventional clean-up methods that collect, contain and remove contaminated soil for permanent storage elsewhere. More symbiotic approaches are economical and successful, but take time depending upon the contamination. These technologies also provide a lasting way to counteract ongoing environmental polluters, such as using constructed wetlands to reduce the water temperature caused

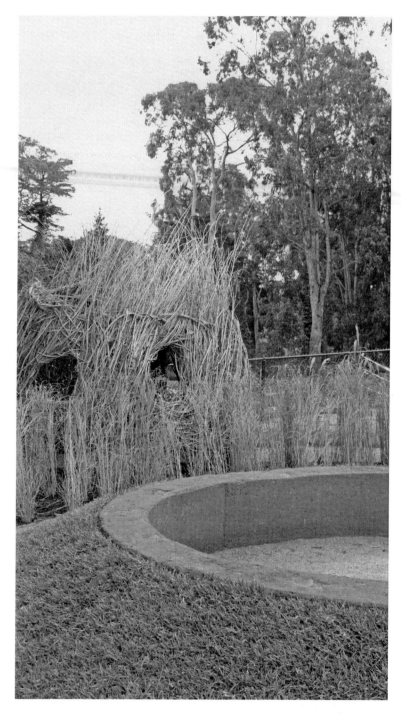

FIGURE 65. COW HOLLOW PLAYGROUND, PRESIDIO, SAN FRANCISCO (2009). SURFACEDESIGN, INC., SAN FRANCISCO. (Courtesy Roderick Wyllie.) Permanent construction is not allowed on the historic Presidio grounds and no footing depth can exceed eighteen inches, making rammed earth a suitable material and construction technique for the seat wall. The earthen wall and sand-colored decomposed granite paving surface unite two materials ideal for kid-friendly durability.

by power plant operations. Restoring contaminated sites also saves farmland and forests from being developed and losing even more land for the supporting infrastructure.

The stable temperature of earth's sub-surface has become a source for clean and renewable energy generation. On a domestic scale, geothermal energy uses a water-filled, piped closed-loop system that extends below the frost line, tapping a consistent ground temperature of 50°F. The piped water circulates to a fan coil unit that blows the treated air throughout the house. This mild temperature starting point requires less energy to achieve the desired temperatures for heat in the winter and for cooling in the summer, and in some cases it can also heat the potable hot water. Federal subsidies are lessening initial costs, but this method remains difficult to install in existing houses due to the drilling equipment. Domestic systems do not generate electricity, but industrial geothermal plants now produce over 3 percent of the power required nationwide, and have the potential to produce all the power needed globally. These larger systems drill up to 300 feet below the surface and run water-filled pipes in a closed loop through hot springs or a hot aquifer, or the water picks up heat from the rock. The heated water converts into electricity by steam-driven turbines or a binary power plant system. The advantages are that it is local; clean because it produces no atmospheric pollution; renewable; low cost for infrastructure, especially when compared to hydroelectric power plants; reliable, especially when compared to solar and wind generation energy; has some potential for mineral recovery, lessening the need for mining; and does not degrade habitats beyond the facility site. The United States produces more geothermal energy than any other country, with over thirty years of experience and with plants primarily located in western states, where hot springs and known sources of sub-surface hot water exist (GEA— see Resources). What are unknown at this time are the effects on the aquifer and the combined consequences of multiple buildings in nearby locations that all have systems changing the sub-surface temperature.

Earthen materials can be used to rearrange the topography, which is significant design tool for landscape architects. Regrading sites can solve problems such as directing surface stormwater, and it can also choreograph movements of ascent and decent. Paths that require climbing effort focus attention on the energetic exertion and slow the pace. Downhill movement quickens the pace, releases effort, and allows the pedestrian's attention to widen. The phenomenology of being in the world depends on the relationship of the body to place, and this is made apparent by what is felt underfoot, alongside and overhead. The body set in motion adds a temporal dimension as a sequence of perceptions unfolds, building up impressions kinesthetically, which then become more firmly anchored in our memory and imagination.

American attitudes toward the earth have evolved over the last three centuries. There was a fundamental shift from Thomas Jefferson's ideal agrarian society to Thoreau's definition of nature as free and wild, and apart from society (which he considered merely civil). Another shift is occurring today with a recognition of the earth as fragile, unbalanced and imperiled, calling for ethical stewardship by environmentalists, green building and sustainable design advocates and rating systems, and what are pejoratively called "doomers" (Meisel 2010: 10–11; Fisk 2010: 9–13; Stein 2010: 9–21). This is profoundly different from the view of the earth as vast and possessing unlimited and inexhaustible natural resources.

Artists sensitive to the environmental movement rejected the idea of art as a framed painting or pedestal-perching sculpture displayed in galleries or museums, and turned to the land as a medium for making in a relatively object-free way (Beardsley 2006). The earthwork

or land art movement from the 1960s used earth and water as mediums for making simple forms, often in remote locations, that enhanced ecological awareness "beyond the reach of the commercial art market" (Weilacher 1999: 12). Working with earth and its inherent properties to be vast and deep, and capable of being cut or mounded up, or displayed in layered horizons of varying compositions that reveal accumulation and displacement, artists are showing designers how to work with earth. Public urban spaces can host refuge wildernesses and refined landscapes, both of which employ earth as a material. Earthen matter paradoxically belongs in cities because that is where the people are. For people to belong to this world, to really dwell, they need dirt for digging as children, soil for growing gardens, and the expressed presence of earth to feel grounded.

Resources

Federal Agencies, Technical Societies and Associations

American Geophysical Union, physical sciences and earth science research and promotion, htpp://sites.agu.org.

American Geosciences Institute, for earth scientists, strives to increase public awareness of the vital role that geosciences play in the consumption of natural resources, http://www.agiweb.org.

Geothermal Energy Association (GEA) has information about all aspects of geothermal energy-generation systems on domestic and industrial scales, http://geo-energy.org.

International Society for Soil Mechanics and Geotechnical Engineering coordinates information about professional development in geotechnical engineering, http://issmge.org.

North American Rammed Earth Builders Association, http://nareba.org.

Portland Cement Association provides technical information about soil cement, http://www.cement.org.

Soil Science Society of America (SSSA) provides information for the field of soil science related to crop production, environmental quality, ecosystem sustainability, bioremediation, waste management, recycling and wise land use, http://www.soils.org.

U.S. Environmental Protection Agency provides information about cleaning up the nation's hazardous waste sites, especially brownfields, with information about the treatment or removal of contaminants, http://www.epa.gov/superfund/remedytech.

U.S. Permafrost Association provides information about soil at or below the freezing point of water for two or more years, http://www.uspermafrost.org.

Research on the Use of Earthen Materials for Sustainable Construction

Cal-Earth, the California Institute of Earth Art and Architecture, is a nonprofit foundation dedicated to advancing environmentally oriented arts and architecture, http://calearth.org.

Earth Materials provides green building information, including sustainable sources and the commercial status (technology, supply and cost) and implementation issues (financing, public acceptance and regulatory compliance) of various earthen materials, http://earth.sustainablesources.com.

Chapter 11

Air

Air is neither empty nor invisible. There persists an unrealistic cultural desire for air to be perfectly clear, implying that it is completely clean. Clear air appears to be both free of particulate matter and free to flow at will, making it an unlikely material for designing solid objects. As "a thing inferred," unless air is contaminated by smoke or dust, it appears as "the transparent solvent of the world" (Knechtel 2010: 19–20). Nevertheless, no substance is more essential to human survival and no medium has a more important role in the behavior of the numerous natural processes that tie together material interactions with earth and water, supporting life in all its forms. In its most fundamental role of supporting human life, the "average person takes about thirty thousand breaths per day" (Logan 2012: 322–23). All living organisms rely on air, whether their habitat is in the atmosphere, on the ground or under water. Today, most people who live in cities in developed post-industrial countries enjoy clean air, while many cities in technologically developing countries have polluted air due either to coal-driven industrial manufacturing emissions or to wood burned for heating and cooking. According to the World Health Organization, acute respiratory infections are a leading cause of death in children under the age of five years worldwide.

The water vapor in clouds, fog and mist makes air visible. The wind caused by differing atmospheric pressures allows air to be felt. Usually unseen are the by-products of the technological era—multiple exhaust gases, vaporized liquid and solid particles called aerosols, mechanical vibrations, jettisoned aircraft fuel, radio and microwaves, cell phone signals, and digitized information—which pass through the air along with substances that have always been airborne, including ultraviolet radiation, spores of fungi and bacteria, and the pollen of the world's flora. Air is the vehicle for climate trends and weather patterns. Rain and snow accumulate and fall through the air, removing fungi and molecular bacteria (which attach to other materials) as well as particulates and gases, temporarily leaving behind fresh scents so that everything seems clean and crisp.

Advanced technical instrumentation has allowed the air to be treated as a commodity by measuring pollutants and ranking the ecological status of airborne emissions. Ratings measure particulate matter larger than 2.5 micrometers (PM 2.5), ground-level ozone (caused by the combustion of fossil fuels), particle pollution, carbon monoxide, sulfur dioxide and nitrogen dioxide. The Air Quality Index (AQI) ranks air quality values from 1 to 100 as good to moderate, with the color codes of green and yellow. Orange alerts mean that the ranking is between 101 and 150, and is considered unhealthy for people with asthma and respiratory diseases. Rankings between 151 and 300 are considered unhealthy or very unhealthy, and are coded red and purple. Maroon indicates hazardous conditions, with rank-

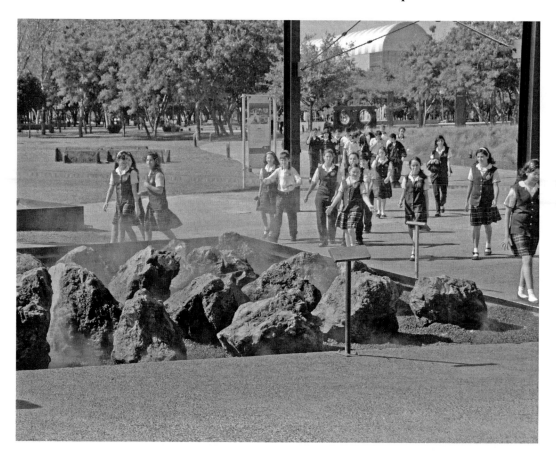

FIGURE 66. MUSEO DEL ACERO HORNO (MUSEUM OF STEEL), MONTERREY, MEXICO (2007). SUR-
FACEDESIGN, INC., SAN FRANCISCO, AND HARARI ARQUITECTO. (Courtesy James A. Lord.) Mist-
ing fountains cool the air, refreshing visitors and reminding them of the hot refinery process
needed to make steel.

ings above 301 to the top score of 500. Some cities in India, China, Mexico and Indonesia
have air pollution levels that are beyond measurement, primarily due to heavy-metal industrial
refinery emissions.

The American Lung Association evaluates the state of the air and concludes that 40
percent of all people living in the United States live in cities with unhealthy levels of air
quality. The top five worst cities are all along the coast of California, where warmer layers
of air are trapped between oceanic upwelling air movement and mountain ranges that trap
atmospheric pollutants in what are called inversions, which allows smog to accumulate.

Wind carries sounds and scents attracting and orienting many living creatures, especially
insects and birds. For people, the sense of smell is the quickest way to evoke a memory. Some
designers choreograph the sequence of experience from beds of fragrant flowers and flowering
shrubs whose scent is carried by the wind to places occupied by people. Richard Neutra, an
Austrian architect who practiced in the United States in the mid–twentieth century, advo-
cated for applying the biological and behavioral sciences to architectural design. He was par-
ticularly sensitive to designing methods that allowed people to be near nature (Neutra 1954).
Neutra designed almost 300 houses, many of which were built in California, where the cli-

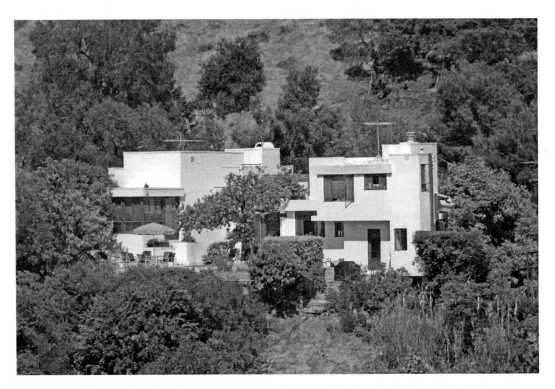

FIGURE 67. LOVELL HEALTH HOUSE, LOS ANGELES (1927–1928). RICHARD NEUTRA, LOS ANGELES. (Courtesy Magenta Livengood.) This was the first steel-frame house in the United States. Neutra conducted extensive research leading to a design that incorporated passive ventilation, among other elements and systems now considered essential for sustainable design.

mate permitted large glass window walls with operable panels set low and close to planting beds exposed to prevailing breezes.

The word "air" shares its etymological root with the word "area," suggesting a connection between air and space. This is one reason why some ancient cities were laid out according to the prevailing wind, as will be discussed later in this chapter. Today, cities have zoning regulations that set street and public space widths and limit building mass and height in an attempt to protect free-flowing air and access to daylight for their inhabitants, and sometimes to preserve views of important sights.

Following the model of a body's circulatory system, urban streets and highways serve as the arteries of movement, with the leftover land often reserved for pocket parks. Many cities have larger parks and undisturbed stream beds as linear parks that are the "lungs of the city" (a term dating from nineteenth-century English urban landscape design), which are also important as habitats for local and migratory birds. To this end, Frederick Law Olmsted designed 1,100 acres of connected parkways and waterways in Boston and Brookline, known as the Emerald Necklace. Today, many cities are converting under-utilized industrial ports to riparian wetlands and waterfront parks that take advantage of prevailing breezes and views of the water.

Pierre L'Enfant's original design for the capital of the United States was physically and visually symbolic. The design for Washington, the District of Columbia, was divided into four quadrants, the center of which was to be a grand plaza next to the Congress House

(now called the Capitol), where people could gather near their lawmakers. Unfortunately, unauthorized revisions to the design moved the building into that central space, but it is thrilling to think of the original intention of an open public space being the heart of the city that was to represent the center of the nation's states united in democracy.

Properties of Air

Air is mostly made up of gaseous elements, of which 78 percent is nitrogen, 21 percent is oxygen, a little less than 1 percent is argon, and about .039 percent is carbon dioxide (Venkataraman 2009: 225). The remaining air is made up trace gases (sulfur compounds and nitrates) and particles of organic and inorganic carbon. The nitrogen is regulated and replaced by bacterial fixation and supports organic decomposition, and oxygen is replenished by plant photosynthesis (Logan 2012: 350). The carbon dioxide is generated primarily by burning fossil fuels, although people exhale it and plants absorb it for the carbon it contains. Unfortunately, over the last two centuries, industrial production has aerosolized elements that were once part of the earth, causing soot, acid rain and other airborne problems to enter the atmosphere (Arbona 2010: 84).

Earth's atmosphere is made up of layers. A ten-mile-thick troposphere layer is closest to the surface, with 75 percent of the air, and this is where weather occurs. Air temperatures in the troposphere vary, with the warmest air closer to the surface and a cooler upper edge. This cold layer forms a trap that prevents water vapor from breaking down into separate oxygen and hydrogen molecules, which could then leave the atmosphere. The cold trap ensures that the amount of water, in all its forms, remains stable. Mt. Everest, the highest mountain on Earth, has 57.8 percent of the atmosphere below its peak, which is about five and a half miles above sea level. Most people need long periods of acclimation and supplemental oxygen to ascend to that height.

The next layer above the troposphere is the stratosphere, which is twenty miles thick and contains 24 percent of the air. This layer contains a very thin, three-millimeter-thick layer of ozone (O_3) that screens all life on earth from the sun's ultraviolet radiation. Ozone depletion and actual holes over the Antarctic and Arctic poles were first observed in 1985. In response, countries have banned ozone-depleting chemicals such as man-made halocarbon refrigerants (CFCs, freons and halons) that were used in air conditioning and cooling units (including refrigerators), as well as aerosol spray propellants emitted from manufactured products. The consequences of a depleted ozone layer include increased cases of skin cancer and cataracts, plant damage and reduced plankton populations.

The outer layers of atmosphere are the mesosphere, which is twenty miles thick; the thermosphere, which is 350 miles thick; and the exosphere, which is 39,600 miles thick. These three layers comprise the remaining 1 percent of the atmospheric molecules, which slowly escape into outer space. The inner atmosphere is replenished by active bacteria cycles that release gases. In total, the earth's atmosphere is 40,000 miles thick, one-sixth the distance to the moon.

In addition to the threat to the ozone layer integrity, the supply of clean air is compromised today primarily because of the ecological consequences of burning fossil fuels and wood-burning fires that add organic and black carbon, reflective sulfates, carbon dioxide and nitrous oxides to the atmosphere. These so-called greenhouse gases trap ultraviolent

solar radiation in a reinforcing cycle that is accelerating the rate of climate change and intensifying severe storm events. Of all the materials used in design, ignoring or aggravating the irreversible damage that unsustainable practices cause to air quality will have the greatest impact. We need to recognize that invisible air may be free, but it is also essential and must be valued.

Managing indoor air quality, thus ensuring human comfort, has been made possible with the development of mechanical heating, ventilating and air conditioning (HVAC) equipment, distribution systems that permit temperature and humidity adjustments, and air exchanges that serve to filter and clean the air. Engineered systems work best when buildings are completely sealed, restricting individual control and access to outdoor air. This approach is the exact opposite of newly mandated sustainable guidelines that reward building designs employing natural ventilation systems comprised of operable windows and air inlets, shafts and outlets that direct air flow without (or at least with minimal) mechanical fans and that require little operating electricity.

Air in History

One of the earliest records of town planning with respect to the air and wind is the account by Vitruvius, who devoted the sixth chapter of his first book to the spatial arrangement of town streets. Here the buildings were considered objects and the streets were the spaces in between, where the movement of air or wind was to be channeled. Hippodamas of Miletus, a Greek architect of the fifth century BCE, introduced a grid system for city planning and laid out Thurii on the Gulf of Tarentum and the harbor town of Piraeous at Athens for Pericles in about 446 BCE (Branch 1978: 64). The grid plans were oriented to take advantage of healthy prevailing winds. Architects built octagonal wind towers based on the four cardinal points of the compass and secondary divisions. Each face was named for a wind with reference to its source, and described with attendant benefits and risks. The ancient port city of Naples, Italy, is an example, with three primary straight streets extending northeast-southwest, and long, thin blocks oriented toward the waterfront.

Vitruvius's "wind is a flowing wave of air with uncertain currents of motion" that comes from mixing heat or fire, and moisture or water (Granger trans., I.VI.2). It is as if fire and water cause the material of air to be formulated as moving wind. Vitruvius believed exposure to the noxious breath of direct wind was unhealthy and oriented building corners to block and dissipate it into gentle breezes. He also described the role of climate, how it affects architectural style, and ways to modify strict architectural geometry to suit particular sites.

In the Mediterranean rim port cities, the wind direction and intensity shifted with the seasons and time of day. Coastal societies with seafaring activities needed people who understood the consequences of wind strength and direction. On land, desert climates had cultures that understood the wind as a means of improving human comfort. These people devised wind towers connected to underground rooms for passive cooling, similar to sustainable techniques recommended today. Since the 1930s, the National Water and Climate Center has published Wind Rose diagrams showing wind speed and direction for most locations in the United States, which is useful for wind-powered alternative energy source design. Specialists note that attention must be paid to the height of the anemometer measurement, as that may affect the ideal location of windmills and turbines for small-scale installations.

Alberti was also concerned with the parameters employed to locate a new town. He noted that "while there is no doubt that any defect of land or water could be remedied by skill and ingenuity, no device of the mind or exertion of the hand may ever improve climate appreciably" (I.3). Pure air that was the least polluted with the smell of slaughtered animals, or from industries such as tanning or soot from burning fires, was the most desirable. He recommended cool and dry climates over hot and humid. Alberti considered unhealthy air to be heavy with moisture, allowing the temperature to fluctuate too rapidly. Window openings facing toward unfavorable winds were to be low and small; windows that received beneficial air were to be large and high (I.12).

The properties of air and its relationship to architecture and the city were issues requiring attention, especially in response to plagues common in dense European cities full of odors, waste and miasma (noxious air emanating from rotting organic matter). One scholar has noted that in France "between the sixteenth and the eighteenth centuries our relationship with air began to change in response to new technologies and measuring tools. All those airs and winds with their distinct characters began to merge into one air, a unified substance

FIGURE 68. ROYAL VICTORIA HOSPITAL, BELFAST, NORTHERN IRELAND (1906). W. HENMAN AND T. COOPER, BIRMINGHAM. (Courtesy John D. McDonald.) The first major public building designed to be mechanically air conditioned had tall ceilings and thin wings, allowing the natural daylight to penetrate deep inside the building and avoiding the need for heat-producing artificial lighting during the day. Small buildings housed the mechanical fans that moved the air through wet hanging strips of fabric to dedicated chambers that circulated the cooler air throughout the building (Banham 1969, 82–83).

that permeated outside and inside, and that could be dirty or clean, toxic or invigorating" (Williamson 2010: 192). World War I introduced airborne chemical weapons of poison tear and mustard gases, as well as lethal agents such as phosgene and chlorine, which were effective killers of men trapped in trenches until gas masks became a common military accoutrement.

The greatest modern change to the relationship between people and air, and then to architecture, occurred with the invention of central air conditioning. At the turn of the twentieth century, large buildings, particularly hospitals, explored ways to circulate fresh air with fans through cooling mediums to interior rooms that were then exhausted cyclically. Willis Carrier formed a company in Newark, New Jersey, to produce equipment that would increase human comfort, regulating temperature, humidity and air movement, and filter particles so that the air was sanitized. Coupled with new developments in electric light fixtures (which give off heat), cooling equipment increased worker productivity and allowed office densities otherwise considered risky. By the 1920s, cinemas were air conditioned, bringing patrons a few hours of relief during scorching summer weekends. The technology of air-conditioning equipment expanded to the residential market in the 1950s, when window air-conditioning units were made like other appliances that came to a home in a box to be plugged into an electrical wall outlet.

Unfortunately, the invention of air conditioning also allowed architects to abandon passive design strategies for hot climates that included orienting the building on the site for the prevailing breezes and insisted on high ceilings and roofs with deep eaves shading exterior walls, and screened open sleeping porches for residences. With mechanical air conditioning, buildings could be bulky with low ceilings and artificial lighting because tempered air was circulated through plenums (the spaces between the suspended ceiling and floor structure above), shafts and ducts from centrally located cooling equipment. Today, sustainable guidelines advise reconsidering engineering solutions that require significant energy, often supplied by nonrenewable fossil-burning power plants, and returning to thin forms and high ceilings, with windows sized and located to capitalize on natural daylight and prevailing breezes as well as passive radiant heating by solar exposure and materials with thermal mass, all shaded by mature deciduous trees.

Industrial processes and incinerators have always exhausted their waste into the air. The polluted emissions of many manufacturing cities make the air perpetually thick and unhealthy to breathe. In the United States, the Clean Air Act of 1970, following the Air Pollution Control Act of 1955, mandated permissible levels of six common pollutants (sulfur dioxide, nitrogen dioxide, lead, carbon monoxide, ozone, and particulate matters), improving the air quality of the nation. The EPA monitors and reports a 63 percent improvement in air quality of aggregate emission of these pollutants from 1980 to 2011. Nevertheless, in most places, news services announce the pollution levels daily, and people with breathing problems are advised to remain indoors.

Theories of Air

Bachelard's air is vertical. He writes in *Air and Dreams* in 1943 about the land-bound perception of physical forms that may be compared to the free air of the imagination, where images are formed, deformed and reformed. This allows the structures of the earth to be

contrasted with the movement of the air, because if there is no movement, there is no matter. For most living organisms, mobility is evidence of life. The constant motion of growth, decay and regeneration is both unavoidable and desirable. Bachelard's vertical air is the medium for the upward motion of the human impulse, the *élan vital* of rising and expanding energy. This is balanced with the downward motion implied in rest as a physical and intellectual falling into depth. Both are needed for life to survive, and they are found in air as an unrestricted ability to breathe freely.

Air moves because of natural convection caused by different densities, air pressures and temperatures that respond to differential solar energy and, to a limited degree, gravitational forces. Warm air is less dense and relatively more buoyant than cooler air, causing warmer air to rise and cooler air to fall. Air flows from areas of high pressure to those of low pressure. The temperature variations of different air masses are slow to mix or stabilize because gases are insulative. Thus, air remains free to circulate. The ancient Greek word for breath is "pneuma," a philosophical life principle that sets air in motion and allows it to hold a capacity for movement. *As a building material, air is felt as a physical substance and its tendency to flow freely can direct design that increases human comfort naturally.*

Bachelard wrote about the wind as the most violent form of circulating air, as its unexpected force cannot be controlled. All we can practically do is prepare to "weather" the storm. Metaphorically, similar mental preparations suggest free associations of change and growth, breaking all that binds creative and productive dreaming to the heavy earth. For example, designers have to work with the forces of nature such as gravity and weight, capillary action of moisture, and the environmental conditions of orientation and exposure. If the atmosphere is the stage for these present but invisible forces, then what is made on earth must negotiate and compensate when designed. Sayings such as "smelling something in the wind" allude to the creative impulse that is alert to opportunities that may not be within one's direct control, guiding design decisions. Bachelard wrote that "to imagine motion we must imagine matter" (1988: 264). Linking motion and matter requires thinking about dynamic forces and design approaches that avoid interpreting "raw" materials as passive, stable, inert, and patiently waiting to be consumed for human purpose.

Jeremy Gilbert-Rolfe is a contemporary philosopher of aesthetics. His essay "Blankness as a Signifier" considers the material of air. He argued that blank areas in a painting refer to the invisible, writing that it is in the areas Cézanne left untouched that airy materiality may be found. It is here—Cézanne called it the envelope—that the painted image is "waiting to be carved out" from imagined space (Gilbert-Rolfe 1999: 113). Departing from the philosophy of John Locke, no "vacant" land considered for construction is an empty *tabula rasa* or blank canvas that is waiting to be filled with built objects. The blankness, invisible to varying degrees, is actually full of what is already there.

The Japanese garden is an example of landscape design that is "form giving way to pure idea" (Gilbert-Rolfe 1999: 122). Here the constructed form privileges the movement of the eye, accompanied by an airy imagination through space in perceptions of duration. A concept of emptiness leaves room for the material imagination in motion.

In the first century BCE, the material philosopher Lucretius proposed an alternate approach to understanding the matter of the world and how objects formed (Greenblatt 2011). Ether was the space—the void—that was full of all matter continually rising and falling, swerving together and apart (Lucretius 1904: I.329–448). Upon impact, matter combined or broke up, forming material solids. Forces of attraction and repulsion were pri-

FIGURE 69. JAPANESE TEA GARDEN, GOLDEN GATE PARK, SAN FRANCISCO (1894). (Courtesy Magenta Livengood.) In Japanese rock gardens, several stones are carefully selected for similar color and type for balance, grouped in odd numbers for rhythm, and oriented or positioned to direct your view. This act of composition promotes harmony with the feeling of space flowing from one group of stones to another. In this oldest public Japanese garden in the United States, stone "islands" are set in a raked "sea" of sand. It is a meditative place because its minimalist design uses few materials in a non-geometric composition, and for the privileged role of the spectator.

mal, everything was in constant flux, and nothing was permanent. Freefall was a cooling off; forceful rising was a heating up. Air was an invisible and active substance.

Innovative Applications

Questions concerning sustainable design and efficient building practices are not new. However, the consequences of energy consumption were seldom a consideration in the past, as most building activities relied on locally available materials and construction techniques, and most operations were made as efficient as current technologies allowed. Compared to today, materials were used more generously, with thicker walls, floors and roofs using massive quantity to compensate for uncertain engineering calculations. Vernacular architecture traditionally also attended to climate and situation, including soil type, topography and the proximity of freshwater. The choice of style only arose when there was a choice—that is,

when a building was meant to be more than comfortable and secure shelter. The wealthy who traveled could express their cosmopolitan breeding with opulent piles in styles foreign to the region. Culture was displayed; power and privilege were expressed. In the garden, exotic plants were introduced and appreciated for their foreignness. New material technologies such as structural metals, large sheets of glass and reinforced concrete, and new building types such as train stations, opera houses and commercial buildings, also called for new ways of designing. Many building types, such as schools, churches and libraries, were conceived of as enlarged houses where the same methods of ventilation, lighting and temperature control were employed, but on a larger scale.

Many people welcomed technological inventions that conditioned the air by adjusting temperature and humidity. Central heating furnaces were available in the United States from the mid–nineteenth century onward and provided a great improvement over the often poorly constructed masonry fireplaces that required nearly constant attention, were often smoky, and failed to heat interiors evenly. Central air conditioning, however, allowed buildings to be built with windowless rooms lacking natural daylight and ventilation. For those who lived in climates with hot and humid summers, people could remain in their homes year round, rather than having middle-class mothers and children depart for residential hotels on lakes and seashores, leaving fathers (and those less fortunate) to suffer while they worked through the summer. The wealthy usually had country homes and could follow the comfortable weather.

Before mechanical air conditioning, the natural convection of moving air was used to cool commercial and institutional building interiors. Ground-level windows were opened before dawn. Fireplaces in the basement were lit to create upward drafts that drew in the cool night air and vented the hot air through roof chimneys or venting copulas. Once the interior spaces were cooled, the fires were extinguished and the windows were shut to keep the daytime hot air from entering the building. For residential buildings, this procedure was accomplished using whole-house fans. Both systems work best in climates where the air cools at night.

The control of the environment was the subject of research for the Olgyay brothers, whose work in the 1950s culminated in the 1963 publication of their book, *Design with Climate*. They presented their data-based analysis of solar and wind factors, arguing for climate-responsive architecture with building orientation and passive systems that fit the region. Air flow was designed in buildings through the use of cavities or unfinished spaces, such as the attic, basement (meant for people), and cellar (meant for storage). These open areas vented accumulated hot air and prevented condensation (along with mold and mildew) from accumulating on surfaces. Passive air-flow systems had inlets and outlets that were covered with metal-screened louvers sized proportionate to the gross area, or else had mechanical fans to draw air through the space. When well designed, walls had inlets located with the prevailing winds in mind. On the exterior, thickly planted shrubs and trees could block or direct the wind (Olgyay 1963: 94–112). Deciduous trees were to be planted on the south side to shade buildings in summer and allow daylight through the leafless canopy in winter. Evergreens effectively block winter winds.

Air cavities are also used to control moisture penetration inside wall assemblies. Usually one to two inches wide, air cavities provide for the differing thermal expansion and contraction of materials due to solar radiation on exterior surfaces, as well as acoustic separation. The air cavity separates the exterior surface material from the inner wall assembly that

includes the insulation and waterproofing membrane. Metal ties are required to connect inner and outer planes of masonry construction spanning the air cavity. The moisture that accumulates in the air space is blocked by the membrane and runs down the cavity space to through-wall flashing at the bottom. During construction, this cavity also allows room for a mason's hand, and to secure and adjust fastening devices.

Interiors that breathe are those with air flow that replaces stale air with fresh air. The materials of numerous furnishings and products increase the need for frequent air exchange. Many factors, from the volatile organic compounds (VOCs) given off by toxic cleaners containing formaldehyde and asbestos to carbon monoxide from improperly vented gas stoves and furnaces, affect indoor air quality. New techniques of construction make heavily insulated buildings that do not leak and have vent-less attics that rely on engineered mechanical systems of air intake and circulation. While these more efficient operations may mean lower operating costs, a sense of air freshness is lost. It may be regained by leaving a window cracked in winter or flushing the interior occasionally at night. Believing in the healthful benefits of fresh air, Benjamin Franklin took daily "air baths" in the fresh early morning air, summer and winter, sitting unclothed while reading and writing. This practice is being revived by some because of its de-stressing health benefits.

The use of air-conditioning systems has expanded the climate range, allowing planned development in formerly hostile environments over the last fifty years. Pressure for inexpensive single-family houses has prompted suburban sprawl on converted farmland, and affordable mechanical systems have allowed cheap construction of poorly insulated envelopes to be built in regions that would otherwise be too uncomfortable for most people to live. Sustainable guidelines encourage the reconsideration of naturally cooling air methods coupled with well-insulated architecture. These methods take advantage of newly available artificial LED light fixtures and smaller, more efficient computers that give off less heat than when first available, reducing the demand for cool air. Sustainable thinking also requires attitudes toward individual expectations of comfort and control to evolve. Extreme weather may necessitate adjusting schedules and production deadlines because equipment is no longer oversized to operate during peak demand times. Once the true and total costs of operating mechanical systems are understood, owners will find that improving existing buildings to operate more efficiently has long-term cost and environmental benefits.

Air-supported structures, also known as air-inflated structures, use differential air pressure to support a fabric enclosure. Large spaces, such as multipurpose sports stadiums and temporary buildings, are covered with a structural fabric and anchored cable system held in tension that does not require interior structural supports. These types of buildings have lower initial and operating costs, but do not last as long as conventional hard-walled structures with fixed or retractable roofs. The interior pressure must be continuously maintained and be sufficient for wind and snow loads. They require more mechanical heating and cooling due to the lower insulative value of the membrane. While multipurpose stadiums are no longer popular in the United States, these types of buildings may have future applications in dense cities that are perpetually polluted, where people in large public spaces would benefit from filtered air.

On a smaller scale, inflated air-filled plastic cells made of ethylene tetrafluoroethylene (ETFE) are becoming popular for "pillow" domes, a geodesic design invented by James Baldwin following the work of Buckminster Fuller. These translucent air pillows, supported by steel frames, transmit natural daylight evenly and were used for the National Aquatics Center

known as the Water Cube for the Beijing Olympics in 2008, and more recently for domes covering artificial biomes at the Eden Project in Cornwall, England.

The National Renewable Energy Laboratory (NREL) has the goal of making land and off-shore wind-generated energy provide about 20 percent of the nation's power needs. Sites are located to avoid avian and bat migratory flyways because the large blade turbines can kill birds. Nevertheless, the considerable transmission loss from generation to consumption may make smaller arrays of spinners and twirlers more practical for serving smaller regions or specific locales. Thinking of air as a renewable natural resource for power generation keeps the material of air in the category of a commodity. For designers, using passive and active air flow as a ventilation system keeps the material in the category of management. For imaginative thinking, using air metaphorically keeps your head in the clouds, where ideas spin and flow freely. Bachelard described it as a "reverie without responsibility" (1988: 185). The responsibility then comes, as the adage goes, with keeping your feet on the ground.

Resources

Federal Agencies, Technical Societies and Associations

American Wind Energy Association, http://www.awea.org.

U.S. Department of Agriculture, Natural Resources Conservation Service, National Water and Climate Center, provides surveys and feedback as well as climate monitoring. It also provides Wind Rose data plots by climate station in each state, http://www.wcc.nrcs.usda.gov.

U.S. Department of Commerce, National Oceanic and Atmospheric Administration, offers weather information and cloud data, http://www.noaa.gov.

U.S. Department of Energy, Energy Efficiency & Renewable Energy, Wind Powered America, provides information on renewable electricity generation, including solar, geothermal, wind and water, http://www.eere.energy.gov.

U.S. Department of Energy, National Renewable Energy Laboratory (NREL), is the primary laboratory for renewable energy and energy efficiency research and development, including fuel production and energy generation, transportation and delivery, and environmental impact, http://www.nrel.gov. Also see for information on wind research, http://www.nrel.gov/wind, and on the National Wind Technology Center, the wind energy technology research facility for land-based and offshore wind energy technologies, http://nwtc.nrel.gov.

U.S. Environmental Protection Agency has programs that monitor indoor air quality (IAQ), http://www.epa.gov/iaq.

Chapter 12

Plastics

Plastics are a material in search of a definition. Dictionaries give a vague suggestion of "plastic" as "characterized by moulding, shaping, modeling, fashioning, or giving form to a yielding material" (OED). An etymological search shows that it shares the same roots as "plasma" and "plaster." Historically, plastic was an adjective meaning "pliable"; it became a noun in the twentieth century as a "synthetic material made from organic compounds." Just as with other composite materials (such as concrete) that are as much a process as a product, some say plastic "does not describe a specific material but how a material acts" (Lefteri 2001: 150). Online research for the word "plastic" brings up almost a trillion websites with topics ranging from plastic surgery to sustainable nanocomposite materials made of bioplastic and layered silicates.

Most plastics are made of organic polymers that are primarily monomer carbon atoms, 30 percent of which are derived from oil and 70 percent from natural gas. Monomers are short chains of molecules. A polymer, from the Greek meaning "many parts," is a long chain of large, loosely packed molecules that make plastic base materials durable and flexible, and they are able to link other molecules, altering their characteristics in a finished state. This allows the notion of plasticity to be associated with the materiality of plastic as an accommodating host material. Certain plastic compositions can be as tough as concrete, hard as metal or stone, strong as steel, moldable as clay, cleanable as ceramics, clear and smooth as glass, light as air and recyclable as wood. Unlike the innate properties of naturally occurring materials, plastics have no distinct organic identity, and their composition and performative character are entirely engineered for targeted qualities.

At the beginning of the twentieth century, scientists in Russia and the United States patented thermal cracking techniques that capture and isolate hydrocarbons by refining waste of crude oil or natural gas production, or from chemical processing. Distilled crude oil is used for much more than refining into gasoline. Petrochemical processes are part of manufacturing many common things, from the pens we hold, the shoes we wear, the chairs we sit on, the keyboards we type on, the glasses we see through, and the non-wrinkleable polyester fabrics we wear to the packaging for the food we eat and the medical supplies we trust. Plastics consume about 8 percent of all applications of distilled crude oil (Bell 2006: 219). According to the American Chemistry Council, about 33 percent of the plastics produced in this country are used for packaging and 20 percent for consumer goods, while the medical supply market consumes less than 10 percent, and buildings and construction activities consume 17 percent. Those who attempt to avoid plastics in all forms, especially disposable plastics designed for a single use, find it nearly impossible.

Plastic as a material possesses many advantages and several fundamental problems. The problems begin with consuming nonrenewable fossil fuels—coal, petroleum and natural gas—that have serious environmental consequences in extraction, pipeline transport and combustion, and will be depleted if current rates continue. Most plastics are durable to the point of being indestructible and are not biodegradable due to the polymer chemical structure, although they photo-degrade with exposure to ultraviolet radiation. Degradation makes plastics brittle and discolored in time.

Most plastic products are designed to serve consumers only once before being treated as disposable. All plastics have a resin identification recycle code, usually cast in the bottom of the object or printed on the label, that identifies the plastic type and expedites sorting for recycling. If used plastics are not recycled, some pose health hazards through the bioaccumulation of toxins in landfills or in the atmosphere when incinerated. The various types of plastics, along with the additives used to prevent photo-degradation and products with combined plastic types, make effective recycling difficult. Research continues on these problems, including using alternate base feedstock materials such as cornstarch and soy as sustainable sources of carbon that also increase the likelihood of less environmentally damaging biodegradation. This research is critical to the future of plastics as a material used in construction because people have become completely dependent upon plastic products.

As long as most plastics are made with nonrenewable resources, the short-term attitudes toward this material will perpetuate the ongoing energy crisis. With the oil peak date identified as 2007, production since then has relied on diminishing supplies of basic raw materials. The energy crisis related to petrochemicals will impact much more than transportation habits (www.peakoil.net). Although the consequences of distinguishing between the growing and declining production phases of the Oil Age depend on the region, the rate of discovering untapped resources and improved efficiencies in production and consumption, it is inevitable that an overreliance on nonrenewable fossil fuels will necessitate a reconsideration of all plastic materials made from petroleum as well as the fuel energy required for production (Gore 2013). Shifting attitudes will affect routine conveniences for individuals, the mentality of disposability and conservation for societies, and the global treatment of energy, its sources and its by-products. Designers will have to respond to the use of materials formerly taken for granted as abundant, relatively inexpensive and perpetually available for maintenance-free operation.

Properties of Plastic

The Society of Plastics Industry's official definition states, "At some stage in its manufacture, every plastic is capable of flowing, under heat and pressure if necessary, into the desired final shape" (www.plasticsindustry.org). Chainlike carbon-based molecular structures form non-crystalline hydrocarbon substances. There are three general types of plastics identified according to their properties: thermoplastics, thermosetting plastics, and thermoplastic elastomers. Thermoplastics can be reformed into new shapes under the influence of multiple heat applications, and are used to make acrylics, nylons, vinyl, plastic bags and celluloid used for hair combs and film, among other purposes. "Thermosetting plastics are shaped only once, and due to their tight molecule nets, they can withstand great temperatures without losing their form." These are commonly used for epoxies, melamine (cabinetry board veneer),

pot handles and artificial resins. Thermoplastic elastomers (TPEs), sometimes called thermoplastic rubbers, are a mix of polymers with electrometric properties, making them "flexible due to their loose molecule nettings" and able to substitute for natural rubber (Van Uffelen 2008: 6). There are six general classes of commercial types of TPEs, with rubber bands being a typical application and membrane roll roofing a common surface for buildings with relatively flat roofs.

Three types of thermoplastics are generally used in design and construction. Polyvinyl chloride (PVC, or uPVC for hard PVC that can simply be called vinyl, recycle code 3) was patented in 1912, is the third most widely produced plastic, and is the most commonly used plastic in construction. It has several advantages: "PVC has the lowest embodied energy of thermoplastics because so much feedstock is chlorine, which uses little energy to extract from brine" (Calkins 2009: 378). It is durable, chemically stable, fire-resistant, waterproof, easily molded, and cheaper to produce than most plastics because it requires less oil or natural gas to make. But PVC products can weaken and become brittle when used in climates with extreme temperatures. Unfortunately, most PVC products are not recycled and the waste stream either enters landfills, where it slowly leaches toxins into the soil, or is incinerated, giving off dioxins and furans, two highly carcinogenic compounds (Freinkel 2011: 86). In and outside the PVC industry, scientists are debating the long-term impact of the findings on PVC toxicity in response to pressure from the industry and consumers who benefit from its many applications. For instance, PVC products have replaced cast iron for sanitary sewer piping and copper for water supply pipes, wrought iron for ornamental railings, wood for exterior wall siding and decks, and metal for light fixtures. As maintenance-free fencing, it is also usually white and shiny, with a reflective surface that can look foreign and artificial in verdant landscapes although recently it has also become available in other, less glaring but likely to fade colors. It is popular in spite of concern over its long-term toxic chemical hazards to people in manufacturing and to the environment upon disposal (especially if burned). Workers in the PVC industry have also developed rare cancers through direct exposure to vinyl chloride monomer (VCM), a key intermediate material for PVC. Those who document sustainable practices recommend avoiding any product made of or containing PVC in all forms (Calkins 2009: 405).

The second common thermoplastic is polycarbonate (PC), which was developed in 1953 and is used for eyewear lenses and as a substitute for glass and window glazing. Compared to glass, its light transmission levels are almost identical, it is highly impact-resistant and cleanable, and it has half the weight of standard architectural glass (Bell 2006: 221). Panels are available in various colors and textures, and with varying degrees of transparency.

The third most common thermoplastic is acrylic, also used as a substitute for glass. Common products such as Plexiglas are used for skylights and screen walls, for instance, because acrylic is stronger than glass and more thermally stable than other plastics.

The properties of plastics are almost unlimited. In general, plastics are highly formable, lightweight, economic, tasteless and odorless, and able to imitate the appearance of other materials. In terms of weathering, plastics are generally waterproof and color-fast, easy to clean, and corrosion-, abrasion- and scratch-resistant, and they will not rot, mold or naturally degrade except when exposed to ultraviolet radiation. Their substitution saves on the consumption of other materials, such as wood, concrete or metal (Calkins 2009: 378). In terms of performative properties, plastics are somewhat chemical- and moisture-resistant, have low thermal and electrical conductivity, are durable, and can be mechanically or chemically recy-

FIGURE 71. EL CAMINO HOSPITAL, MOUNTAIN VIEW, CALIFORNIA (2009). AECOM, U.S. WEST, SAN FRANCISCO. (Photography by David Lloyd, © AECOM.) Emergency rooms are places of high anxiety. Illuminated acrylic panels were used for a screen wall to project a sense of calm and care. They provide a backdrop for plants, which are reminders of growth and life.

cled (if a thermoplastic). Thermoset plastics cannot be recycled, but components can be down-cycled for reuse (Calkins 2009: 384). For exterior applications, plastics can be formulated with added stabilizers so as to be ultraviolet-light-resistant, reducing degradation due to exposure. Plastics can become brittle in extreme temperatures and break, crack or shatter upon impact, unless plasticizers are added to improve flexibility and ductility. Compared to other materials, plastics can be hard, stiff, soft, flexible, slippery and clingy, and strong in compression and tension (depending on the form) (see Figure 72).

In general, plastics have a low fire rating and require protective flame-retardant sealers when used in buildings. Most plastics melt with heat and many produce toxic gases when burned, although "rigid PVC is intumescent, meaning it burns but becomes self-extinguishing, so the fire is not sustained" (Bell 2006: 220). Another disadvantage is that most plastics have a high coefficient of thermal expansion, requiring assembly details to allow for expansion and contraction due to temperature change.

There are five general methods of fabrication. Plastic for solid parts can be formed by compression, rotational (less expensive) or injection (more expensive) molding processes in which polymer pellets (new and recycled) are heated and injected into steel molds, mass-producing objects such as furniture, toilet seats, toys and medical supplies. Second, plastic can be cast as a liquid, making various shapes such as ornamental molding. Third, extrusion processes are well suited for linear elements such as pipes and window frames. Fourth, injection-blow molding works a softened plastic and injects air, forcing the material to fill

the mold, thus making hollow objects such as bottles. Fifth, calendaring methods work the plastic pellets through heated rollers to form a film or sheet that can have embossed patterns if textured rollers are used. In a subsequent thermoforming phase, pliable sheets are stretched by vacuum or pressure onto a mold and cooled, making products from disposable clam-shell food containers to car dashboards (see Figure 73).

Plastic elements can be joined with adhesives, with solvents or by heating that softens contact surfaces slightly, which then melt together and seal when cooled. Finished plastic pieces can be assembled with mechanical fasteners or by snapping together interlocking pieces (Bell 2006: 220–23).

Plastics in History

Unlike other materials that have been used for centuries, plastic was invented and matured as a material in just over 70 years. As young as it is, annual global consumption today is close to six hundred billion pounds, and if present trends hold, it could reach nearly two trillion pounds by 2050 (Freinkel 2011: 7, 232). In the last century, plastic has moved from a descriptive quality to a thing in itself. This is a direct result of the Industrial Revolution and the discovery of practical uses for rubber, a natural polymer. Metal machinery has moving parts. When metal objects rub together, they need rubber gaskets to keep the metal from building up friction and heat, thus causing metal fatigue and failure. Rubber is found in forests as a sap product that slowly drains from wild vines. As demand increased, these vines were domesticated and cultivated in rubber plantations (Freinkel 2011: 16). Natural rubber was used industrially from 1824 to make such things as the rubberized fabric for waterproof Mackintosh raincoats, insulated electrical wiring and vulcanized rubber pneumatic tires for wooden wheels, replacing metal bands. In 1839, Charles Goodyear developed rubber tires that greatly increased rider comfort (Van Uffelen 2008: 6), with air-filled rubber tires patented in 1846 by Robert Thompson and used on automobiles by the end of the century.

Plastics were developed to economically replace the materials used for desirable objects, often made with scarce natural resources, thus making formerly valuable and rare things more readily available to all. For example, plastic synthetic rubber can substitute for natural rubber. Belgium's colonization of the Congo stands as one of the great contemporary tragedies of European imperial greed, for in the late nineteenth century, King Leopold II exploited this part of Africa in search of rubber to supply a new and lucrative market for a material to replace ivory for billiard balls. Fortunes were made, but this enterprise also caused an estimated ten million deaths (Hochschild 1999). Celluloid was developed in 1868 as another possible substitute for ivory billiard balls (Brady et al. 2002: 725). While it unfortunately made noisy billiard balls, it did make excellent hair combs, replacing hand-carved tortoiseshell and saving the lives of many tortoises. Today, melamine formaldehyde compound (MF) is used for plastic objects such as hair combs because it is highly impact- and scratch-resistant, as well as easy to color (Lefteri 2001: 120).

The first man-made synthetic plastic was shown at the 1862 Great International Exhibition in London. The inventor of Parkesine, Alexander Parkes, claimed this new material, made by mixing chloroform and castor oil, would be a substitute for all rubber products. Today, three-quarters of all rubber-like products are made from petroleum.

Another early synthetic material was Bakelite, patented in 1907 by Leo Henry Baeke-

land of New York. It was meant to replace shellac, a naturally occurring amber-colored resin made from the sticky excretions of the female lac beetle, and as difficult and expensive to acquire as natural rubber. This liquid resin was heated under pressure until it took the shape of the mold. It was called a material with a thousand forms. Bakelite has a long list of performative characteristics, including being "electrically resistant, chemically stable, heat-resistant, shatterproof, and impervious to cracking or fading" (Bell 2006: 219). It does not discolor from exposure to sunlight, dampness or sea salt.

Other early significant discoveries in the development of plastic materials include rayon (1891); polyethylene (1933), made from ethylene gas under high pressure, the most widely produced and highest-selling type of plastic, used for water bottles, packaging and garbage bags; polyamide or nylon (1935), an artificial silk used for stockings; Teflon (1938); Velcro (1957); and polyester or Lycra (1950s), used for clothing fabric. Another common plastic is polyurethane (PUR and PU) (1937), used to make foam, coatings and fabrics such as Spandex; polystyrene (PS) (1839, with industrial applications developed in the 1930s), used today for CD and DVD cases, yogurt containers, disposable cutlery or even Styrofoam (recycle code 6); polycarbonate (PC) and polyvinyl chloride (PVC), both previously discussed in this chapter; and polypropylene (PP) (1954), the second most widely produced plastic, used for packaging and labeling (recycle code 5). Polypropylene products generally have polymer degradation due to exposure to heat and ultraviolet radiation, and antioxidants are added to prevent this, which consequently complicates future recycling processes. By the 1960s, plastics were used for vehicle parts, equipment cases, and domestic and industrial products, and today it is difficult to identify any manufactured object that does not contain plastic and have plastic packaging.

Theories of Plastic

The imitative character of plastic, its inexpensive cost and its maintenance-free quality allows ready substitution for most constructed objects, and even living vegetation in landscape design. Landscape architect Martha Schwartz has questioned this attitude in numerous projects, asking about "what one expects from a garden—this mantra that it should be quick, cheap and green. If a garden is a representation of nature, then [plastics allow] a re-representation of nature. [They are] something that won't weigh anything, makes no demands and will not involve having to keep things alive" (Schwartz 2004: 95). Such gardens are "seasonless, durable, and do not depend upon water, soil, temperature, or sunlight. It grows anywhere in the world. Its prefabrication is intended to echo the way facsimiles and the virtual are seen to be replacing what is considered real or authentic" (Schwartz 2004: 115) (see Figure 74).

The 1957 essay by Roland Barthes called "Plastic" coincided with the explosion of applicable uses for plastic materials, many as a result of technological advances researched and developed during the two world wars. Barthes links the transformative character of plastics with the power of alchemy, claiming it gives form without material consequence. It is not a true substance in itself, but a "substantial" attribute that is neutral "in spite of its utilitarian advantage." With plastic, there is an absence of resistance or yielding. Its deceptive appearance is exposed by sound, allowing an argument that plastics lack tone. Since plastics do not have a particular character of their own, they can only offer the idea of a material

attribute, not a quality in itself. He asks the question that cannot be avoided: What is lost when plastic replaces other materials?

Plastics lack the principle of variation unlike materials such as wood or stone, which are grown or found and finished, retaining their naturally occurring properties, or other materials such as glass and ceramics, the manufacturing process of which results in specific qualities reflecting the characteristics of the material. Much like a computer-generated design drawing, the graphic precision of plastic implies a certainty that may or may not be true. An essay draft printed on a word processor appears finished, although the appearance is not reliable evidence of actually being done. Plastic products do not stray from their intended form. It is as if all aspects of manufacturing are suppressed unless designed to be expressed. There is no revelation of ripening from a natural or raw state into a finished object. There are no cut marks, pour joints or unpredictable stains that are not designed intentionally into the final object. There is no evidence of the human hand in the making, or of wear or weathering due to the forces of nature and use.

Barthes' essay concludes that the advantage of the artificial material is that it aims at the common, not the unique. Through its manufacturing necessity and mass-production capability, plastics exchange the rare for the ubiquitous. While there may be a stigma attached to plastic products as inferior to "the real thing," the economical availability of objects made of plastic has meant that more people have access to food that is safe because of plastic packaging, to sterile (anti-bacterial, fungal and viral) medical supplies, and to exterior surfaces that last without attention or care (Freinkel 2011: 81–114). The theoretical resolution of this is unclear, except that as long as plastic imitates other materials, it cannot carry a sense of its own materiality. *If plastic as a synthetic building material is free to form its appearance independent of inherent properties or fabrication techniques, then its theoretical position is essentially and authentically performative.* The paradox is that daily life has become completely dependent upon plastic, however ambiguous.

Innovative Applications

As pervasive as plastics have become in daily life, no one predicted the popularity of bottled water, and few have understood the consequences of that much plastic in landfills or floating in the oceans as trash. One advantage is that the overall reduced weight of plastic bottles is more sustainable to transport, with eight gallons of beer requiring 27 pounds of glass bottles as compared to only five pounds of unbreakable PET plastic (Lefteri 2001: 79). Additionally, the convenience of portable and disposal water and other beverage bottles is indisputable, although the Container Recycling Institute estimates that thirty million plastic bottles are discarded daily. It takes three to four liters of water and one ounce of petroleum to produce every single-liter bottle (Salzman 2012: 186). Made of polyethylene terephthalate (PET, recycle code 1), most people assume that tossing an empty bottle in a blue recycling container guarantees that it will enter the recycling stream, and will save on both the consumption of unprocessed crude oil and landfill space, or at least avoid incineration.

According to the EPA's most recent data (2009), nearly thirty million tons of plastics are disposed of in the U.S. municipal solid waste stream annually, making up over 11 percent of all waste. This data reflects a recovery rate of a little over 7 percent of all generated plastic. Unfortunately, even Northern European countries with the most developed programs sup-

ported by government subsidies for effective recovery recycle only about 30 percent of their plastic. And "a large portion of the used plastic Europe recovers is burned to make heat or electricity, a technology known as waste-to-heat" (Freinkel 2011: 196). Even though post-consumer PET plastic products have numerous secondary markets, this type of plastic is more likely to be down-cycled than recycled. Further complications in recycling are due to the commingled plastic composition of plastic products, meaning that different types of plastics as well as additives cannot be separated by conventional sorting techniques, making recycling practically impossible. The Association of Postconsumer Plastic Recyclers calculates that only 7 percent of all plastics are recycled, as opposed to 23 percent of glass, 34 percent of metals and 55 percent of paper.

Not all plastic products are intended for disposable use. Plastic lumber (generally non-structural applications) and composite lumber (for structural use) is made of such bio-composites as wood waste, cellulose-based fiber fillers like flax and rice hulls, and recycled plastic such as polyethylene. Plastic lumber composed of 100 percent recycled high-density recycled polyethylene (HDPE) is capable of low-structural uses. Composite lumber is commonly substituted for wood for exterior furniture and decks. It has a comparable strength to weak softwoods such as cedar (Elizabeth and Adams 2005: 81). LEED® rating points are awarded for construction waste management and materials with recycled content, and users benefit from the absence of maintenance and durability of plastic objects (Meisel 2010: 57). Taking this thinking further, plastics developed for structural strength rivaling concrete or steel can replace aging infrastructure, such as bridges, with a more sustainable material if attitudes of "short-termism" are replaced by a social willingness to reallocate and reprioritize natural resource consumption (Gore 2013: xxviii, 27–30).

Other innovative uses of plastics include strong and clear polycarbonate solar water purifiers that desalinate brackish water and saltwater, are inexpensive and give people without easy access to freshwater the tools to make water safe to drink. Porous paving systems made of 100 percent recycled HDPE can support load-bearing vehicles and allow vegetation to grow and stormwater to drain in the open joints. Also for landscape applications, crumb rubber from recycled tires can be processed into modular sidewalk paving systems and play-ground surfaces that move without damage in freeze/thaw cycles, and it can also be easily removed for adjacent gradual tree growth (Brownell 2006: 136, 112, 140). Advances in indus-trial design have developed Smart-car body panels made of a polycarbonate/polybutylene terphthalate (PC/PBT) alloy that does not dent with low-impact collisions and is easily replaced and recycled when damaged in high-impact collisions. The panels are corrosion-resistant and colored through the material, making surface scratches invisible (Lefteri 2001: 20–21). Product design applications include plastic laminate for durable and functional countertops in many kitchens dating from the 1950s, only to be surpassed by DuPont's Corian® for durability. For all uses, researchers are investigating self-repairing polymer com-posite products that have chemical triggers and a micro-encapsulated healing agent embed-ded in the plastic mix, making products that last longer with the ability to sense and repair minor stress fractures.

Replacing timber, concrete and steel for heavy construction, technology companies such as Axion International have the mission of "greening tomorrow's infrastructure." They have developed 100 percent post-industrial and post-consumer recycled plastic composite materials that have sufficient compressive and tensile strength to be used for railroad ties, heavy-load bridge panels and structures, deck planking, boardwalks and pilings, and con-

struction road mats. Designed to use conventional assembly techniques familiar to construction workers, these products will not rust, splinter, crumble, rot, warp, absorb moisture or leach toxic chemicals into the environment, and they require virtually no maintenance. They are impervious to infestation by insects, marine borers and other parasites. Their use anticipates a dramatically lower total lifetime cost, conservatively projected to be only 50 years, although the material is then completely recyclable.

One response by manufacturers concerned with the environment and worried about the long-term availability of petroleum for production is to make more sustainable plastic products with plant-based carbon molecule content. Plant-based polymers can be used for cellophane and celluloid plastics as well as rayon and viscose textiles (Freinkel 2011: 210). One disadvantage of this feedstock substitution is that this diverts bio-material grown on limited land and irrigated with limited water resources from the food supply. This matters, as some forecasters predict that up to 90 percent of all current plastic products can be made of bio-based polymers.

In many environmentally conscientious societies, market pressure will insist either on using biodegradable plastics or that manufacturers use single-plastic types for products and packaging that will help recycling efforts. No consumer, if asked, would insist that their laundry detergent container be made of a dark color, especially if they knew that the dye alone greatly decreased the likelihood of successful recycling. Social pressure for government regulations will avoid such senseless market-based motivations.

As people increase their awareness of both the ubiquity and unsustainable attributes of many plastic products, and as the Zero-Net Energy standard for buildings gains momentum, some types of plastics will no longer be manufactured (Berkebile et al. 2010: 18). The Living Building Challenge™ 2.0 maintains a Red List of plastics to be avoided. Banned plastics include chlorinated polyethylene, used for pond and irrigation channel liners that allow the evolution and emission of hydrogen chloride during combustion, and chlorosulfonated polyethylene (CSPE—Hypalon is the Dupont trademark, discontinued in 2009), a rugged synthetic rubber used as a film-forming agent in varnishes, preservatives and adhesives, for roof membranes and insulation, and in wire and cable jackets (lead additives and the toxic gases produced during combustion are the reasons it is banned). HDPE (recycle code 2) and low-density polyethylene (LDPE, recycle code 4) are excluded from this list.

The Montreal Protocol on Substances that Deplete the Ozone Layer, enforced in 1989 with the latest revision in 1999, banned chlorofluorocarbons (freon) (CFCs) and hydrochlorofluorocarbons (HCFCs). Also banned are chloroprene (Neoprene), whose chloroprene base is a known carcinogen; halogenated flame retardants, which allow plastics to meet flammability requirements, although the Stockholm Convention on Persistent Organic Pollutants (POPs) banned all halogenated chemicals in 2001; phthalates, plasticizers added primarily to PVCs to increase flexibility, transparency, durability and longevity that easily leach into the environment and bioaccumulate in people with direct exposure through fatty foods and meats; and polyvinyl chloride (PVC), previously discussed, which degrades into microplastics that concentrate POPs, making them more easily ingested, and off-gases that contribute to indoor air pollution, which affects everyone, especially people with allergies.

Plastic as a material has irrevocably changed the lives of people everywhere. Its benefits are partially negated because it supports a disposable mentality. Further, the consequences of its production remain problematic. In the future, manufacturing procedures will have to address alternate base supplies and production energy sources with their contribution to

FIGURE 75. BLUR BUSINESS HOTEL AND CULTURAL FACILITY, BEIJING, CHINA (2006). STUDIO PEI-ZHU, BEIJING. (Courtesy Magenta Livengood.) Walls made of fiber-reinforced polymer plastic (FRP) hang off a retained existing concrete structure. The semi-transparent panel façade glows at night, providing a beacon-like lantern of subtle attraction that is compatible with the historic district near the Forbidden City.

global warming, perhaps effectively motivated when the price of oil loses its government subsidies. Some types of plastics will be banned if exposure is linked to an increased risk of cancer, or if they present problems with bioaccumulated toxic chemicals in people and ecosystems. Societies will insist that plastic products meant to be disposable are designed for the minimal need of the projected use and thus should be quickly biodegradable in composting landfills, or, as some predict, everyone will have a kitchen appliance that turns discarded plastic, especially packaging, into a new product. Otherwise, plastic products should have multiple uses or be considered permanent. Municipalities may develop more effective mechanical recycling techniques, with scanners that identify different types of plastic for separation and reprocessing.

All plastic products substitute for other materials, and they can often perform better, last longer and cost less. What they actually look like as a material tends to reflect consumer preference and is incidental to how they perform. Designers who employ plastic's capability to have varying degrees of opacity, to incorporate sensors that monitor internal structural integrity or respond to surrounding activities, to glow with soft and colored decorative lights, or to last when exposed to demanding environmental conditions will have made something best made of plastic.

Resources

Federal Agencies, Technical Societies and Associations

American Chemistry Council, plastics division, provides educational resources such as "The History of Plastics and Polymers," http://plastics.americanchemistry.com.

Association of Postconsumer Plastic Recyclers is a trade association that represents companies that acquire, reprocess and sell the output of post-consumer plastic processing, http://www.plasticsrecycling.org.

Environmental Working Group provides information and lobbies for public health and the environment, http://www.ewg.org.

Oxo-biodegradable Plastics Association provides information about the abiotic process that combines with oxygen to initiate plastic decomposition with varying time scales, http://www.biodeg.org.

Peak Oil provides information and strategies about fossil fuel consumption, http://www.oildecline.com.

Rubber Manufacturers Association (RMA) provides information on such topics as scrap tire markets, http://www.rma.org.

Society of Plastics Engineers for technical papers, http://www.4spe.org.

Society of the Plastics Industry, Inc. (SPI), is the plastics industry trade association that provides information about the Resin Identification Code (RIC) system, http://www.plasticsindustry.org/aboutplastics.

U.S. Environmental Protection Agency publishes numerous documents on the rubber and plastics industry.

Research on the Sustainable Use of Plastics

Building Green provides thousands of online articles about plastics and a list of sustainable products (with subscription), http://buildinggreen.com.

Healthy Building Network provides free downloads for documents on building materials and the construction industry, http://healthybuilding.net.

Plastic Products and Alternatives

NatureWorks makes biopolymer materials from plants, not oil, such as polylactic acid (PLA), http://www.natureworksllc.com.

Symphony Environmental Ltd. makes degradable plastic bags and controlled-life plastic technology and it has also developed a process called oxo-biodegradation, http://www.symphonyenvironmental.com/d2w.

Chapter 13

Vegetation

Vegetation is a building material that recently "has been added to the architectural lexicon" (Nouvel in Blanc 2012: 5). While training a plant to grow on built structures has a long history, in less than 20 years the design of green roofs and green walls, generally summarized as landscape over structure, has taken on an expanded role. The difference between vegetation and all other materials is that it is neither found nor manufactured, but is grown and continues to grow once installed on a building. The living plant requires a supportive habitat of soil, nutrients, light and water, and in return it insulates buildings, mitigates stormwater impact and ornaments blank surfaces with verdant gardens. Vegetated materials can also absorb atmospheric pollution, reduce the urban heat island affect and provide a habitat for migratory birds and pollinating bees. The added cost of vegetal materials is offset by reduced mechanical air-conditioning operational demand, and the elevated landscape substitutes to some degree for the land consumed by the building footprint. Using plants as a building material requires two attitude shifts toward sustainable building practices. First, design decisions must evolve toward investing in building materials that have long-term benefits, because plants take time to mature. Second, the operation of buildings can no longer be limited to cleaning, changing filters and flipping thermostats with the seasons. Vegetated materials require continual attention to keep the plants alive and thriving, just as commissioning and monitoring the sophisticated engineering systems is needed for efficient and sustainable operations.

Green roofs and green walls are planted landscapes that are defined by their technical type and by what they do. Unlike most gardens and landscapes, the growing medium is designed and added. Except for the occasional decayed leaf litter and humus-packed gutter that hosts self-seeding plants, landscapes over structures do not form by accident or without effort. Artificial landscape constructions range from individual containers on apartment balconies to raised planter beds on roofs designed for public assembly, to complex structures that support hanging, suspended and climbing vines, to algae that is allowed to grow on exterior surfaces.

On the roof, planted landscapes compete for space with mechanical equipment and solar panel array installations, although raised panels can provide the shade needed for a more diverse palette of plant species, including conifers (Dunnett and Kingsbury 2008: 86–87). Because green roofs are generally seen from taller buildings, the design becomes part of the "borrowed" view, with the landscape fitting into the rooftop world of a city. For new buildings, green roofs provide places for people to enjoy gardens of many types so long as the structural load is sufficient (see Figure 76).

Both vegetal walls and roofs can risk compromising the primary duty of building enclosures as shelter that keeps unwanted weather and uncomfortable climatic elements out. For buildings without green roofs, roof leaks are the source of half of all post-construction insurance claims (Weiler and Scholz-Barth 2009: 275). Green roof failures occur when inexperienced designers and contractors, and distracted owners with inadequate budgets, fail to correctly specify, construct and maintain installations. Wind and water erosion can eliminate plant-growing media, clog drains, and degrade surfaces, exposing insulation.

All building enclosures have openings to allow light and air to infiltrate into the building interior, and these apertures compete for space with solid and vegetated surfaces. The resulting negotiation is an exercise of control and license. Vegetal materials require maintenance that consists of weeding, pruning and trimming to prevent self-strangulation and overloading and unwanted growth over windows or near drainage systems. Plants can act like sails and focus wind loads that can stress the structure. Properly designed and maintained, green roofs and walls are compatible materials for water-tight buildings that take advantage of a planted skin, and they are especially desirable in cities, where people benefit from more landscapes and the wildlife they attract.

Properties of Landscapes Over Structure

Green roofs are generally classified as extensive, intensive or semi-intensive (sometimes termed semi-extensive). Extensive roofs are shallow assemblies, which is often appropriate for new landscapes on existing buildings with limited additional structural capacity. They are usually between three and six inches thick, planted with low-growing hardy succulents (genus sedum), seldom irrigated once the plants are established, and require little maintenance. Of the three planting methods—pre-made vegetation mats, plug plants and sedum shots growing substrate—the more expensive produces immediate results, but all are equally likely to be successful once established. Modular components also allow easier plant replacement. The assemblies weigh between twelve and fifteen pounds per square foot, which is about equal to the gravel-ballasted cover on essentially flat roofs. The EPA estimates the cost of extensive roof systems to be about $10 per square foot (see Figure 77).

Intensive green roofs have a deeper assembly, allowing a more diverse plant palette that adds to the structural load and requires structural engineers to design increased support. Intensive assemblies usually have buried drip or spray irrigation, and they require more maintenance. The cost is about $25 per square foot (U.S. EPA). Semi-intensive roofs are a compromise between the two types, and have a growing medium depth of between four and eight inches (Dunnett and Kingsbury 2008: 1–7). Semi-intensive and extensive green roofs can use capillary mats as their irrigation system, introducing supply water in only a few locations. The annual maintenance of all types of green roofs is between $.75 and $1.50 per square foot (U.S. EPA). Due to the added cost and maintenance, and structural requirements, intensive green roofs are "considered to be less environmentally effective than extensive green roofs" (U.S. DOE, Green Roofs—see Resources).

Green roof designs are generally more practical for roof pitches with slopes of 2:12 (rise/run) or less. As previously mentioned, extensive green roofs have about the same weight as the stone ballast cover on EPDM membrane typically used for relatively flat roofs. (EPDM stands for "ethylene propylene diene monomer," M-class rubber electrometric, ASTM

D-1418.) Special stabilizing sub-structures are required for green roofs on roof slopes that are greater than 2:12, and orientation and wind load must be calculated for each exposure condition.

The depth of the supplied growing medium depends on the capacity of the structure. Structural calculations are based on dead, live and environmental loads. Dead or permanent loads include the weight of the soil when fully saturated, vegetation, paving, and stable structures such as pergolas. Live or dynamic loads include movable objects such as benches and people. Environmental loads are a result of weather events and include wind, rain, and accumulated snow and ice.

The weight of plants and the soil they need cannot be taken for granted. Grass requires a soil depth of 12 inches that weighs about 120 pounds per square foot; shrubs require at least 24 inches of soil that weighs about 240 pounds per square foot; and trees generally need a pit that is ten feet square by five feet deep. It is difficult to calculate the weight of a tree at either the installed size or the projected mature size, and estimates depend on the species. The rule of thumb is 100 pounds per caliper inch for smaller trees less than eight inches, but for larger caliper trees, the weight can be several tons (Weiler and Scholz-Barth 2009: 107–16). Trees selected for green roofs should have their north sides marked in the nursery and be planted with the same orientation, because trees that have grown in response to a particular orientation have less stress when relocated with the same exposure, which is especially important when the new environment is as challenging as a green roof.

The growing medium is usually about 75 percent lightweight granular aggregate and 25 percent organic matter of sandy loam or heavy clay. Green roofs are stressful and hostile environments for plants, with unrelenting sun and wind exposure. The plant choices depend on the soil depth and type, with the hardiest varieties generally favored. For instance, shallow alkaline soils support slower-growing, less competitive plants in temperate climates that will require less irrigation and maintenance, while fast-growing varieties may show quicker results, but require more care.

The typical profile for extensive (shallow) roofs include layers (from the upper surface) of growing media, moisture retention mat, lightweight drainage board, protection fabric, waterproof membrane and the roof assembly with deck, insulation and substrate. Intensive (deep) roof layers include the growing media (usually with buried drip irrigation if the depth is greater than eight inches, or a capillary mat if it is less), protection fabric, drainage gravel, another protection fabric, root barrier, extruded polystyrene, waterproof membrane and the roof assembly with deck, insulation and substrate (Novitski 2008: 4–5). Extruded polystyrene (EP) blocks can be shaped to create topography, and they provide lightweight fill and drainage material under the landscape assembly.

Green walls are generally divided into two types. Green façades have climbing plants or creepers that are rooted in the ground and supported by structures. Living walls, also called vertical gardens, have modular elements of growing media and plants rooted in attached containers. Green walls are often seen as part of the building façade, but they can also serve the opposite purpose as a living screen that conceals unwanted views. Green walls can provide dynamic surfaces that are active habitats for animals and respond to the changing seasons, often bringing the sight and feeling of lush landscapes to places with no open land (Margolis and Robinson 2007: 30). Growing plants vertically requires a structural framework that is attached to a building, with space between the exterior wall and the frame for air cir-

FIGURE 78. PHOENIX CONVENTION CENTER, PHOENIX (2011). TEN EYCK LANDSCAPE ARCHITECTS, PHOENIX. (© Bill Timmerman.) The 1,400-square-foot living wall uses air-conditioning condensate that is UV treated and purified to irrigate the plants. It is also a screen, blocking views of the parking garage at street level.

culation and to keep the plants from damaging the surface. The framework must be made out of long-lasting, maintenance-free materials such as galvanized or stainless steel cables and supports, or the mature plants will be destroyed when rotting frames require replacement.

Green roofs and green walls perform many beneficial functions:

Eco-function: Plants reduce atmospheric pollution by absorbing carbon dioxide and releasing oxygen. They also sequester gaseous pollutants in their foliage. In cities, they filter urban dust and pollutants when rainwater comes into contact with microbes, fungi and bacteria attached to plant roots, depending on what is called residence time, or the rate of water absorption or run-off.

Urban heat island effect: Vegetated surfaces cool the air by plant evapotranspiration cycles, keeping solar heat from radiating back into the atmosphere, especially critical in cities. The EPA website on green roofs states that the surface temperature of a green roof can be even cooler than the ambient temperature of the air. However, "vegetated roofs will only achieve evaporative cooling in the summer if they are watered," although dry landscapes still absorb more solar radiant heat, producing a lower albedo effect, than flat roofs made of dark materials (Dunnett and Kingsbury 2008: 67). The albedo effect, or reflection coefficient, corresponds to the degree of reflecting power of a material color.

Stormwater management: Building roofs are made of impervious materials. In cities, stormwater is usually collected and piped to the wastewater plant and into the managed water supply cycle. This prevents rainwater from replenishing groundwater aquifers or freshwater bodies. During intense storms, sewers can become overwhelmed, causing flooding and overflows of untreated sewage into streams with a blasting capacity or force that erodes the banks and undermines adjacent trees, as well as polluting the waterway. Green roof plant roots intercept and absorb rain, and, once saturated, at least slow and delay stormwater run-off. About 60 percent of the rainwater can be absorbed by green roofs, and this can reduce the run-off by almost 90 percent (Weiler and Scholz-Barth 2009: 20). Some buildings capture stormwater and use it for internal gray water systems, or store it in rain barrels or cisterns to be harvested for irrigation. In areas where the rain is not directed into the wastewater system, green roofs keep the rainwater from being heated by the otherwise exposed roof surface, which affects the temperature of run-off and can eventually have an adverse impact of thermal shock on aquatic life.

Cooling buildings: Green roof assemblies insulate buildings, reducing building temperatures and ambient noise flow. Americans spend about 40 billion dollars annually to air condition buildings, which consumes one-sixth of all generated electricity. This demand can be reduced by up to 75 percent with the installation of a green roof (US DOE, Green Roofs—see Resources). Most non-vegetated roofs experience a 70 degree temperature swing daily; green roofs have almost none. Beyond ongoing operational cost benefits, extensive green roofs can lengthen the life of the building roof.

Habitat creation: Landscapes provide habitats for pollinators, including birds, bees and beneficial insects, increasing the biodiversity of animals (especially in cities). Migratory corridors depend on patches of vegetation; green roofs can provide food and nesting places. Difficulties arise with building glass that either reflects sunlight directly onto plants that cannot thrive under such intense heat or is hard for birds to see and avoid. Terraced buildings with multiple green roofs need exterior walls placed so that they do not concentrate prevalent breezes, intensifying them into destructive winds. Green roofs that are designed to be wild habitats with minimal management must determine if the role of people is to be that of participant, observer or uninvolved. It is equally important to resolve the potentially conflicting expectations of clients regarding the appearance of the landscape and maintenance requirements.

Pleasure parks and productive gardens: Green roofs can provide places for people. Roof gardens offer similar opportunities for passive recreation and to grow food. Intensive roofs with between twelve and eighteen inches of soil depth can grow leaf crops, including edible weeds such as lamb's quarters (*Chenopodium album*), purslane (*Portulaca oleracea*), chickweed (*Stellaria media*) and dandelion (*Taraxacum officinale*). These may become part of a salad harvested and eaten immediately, which provides the greatest nutritional benefit (Weiler and Scholz-Barth 2009: 298). Herbs such as rosemary, thyme, oregano, marjoram and sage thrive with harvesting. Wild strawberry and evergreen huckleberry can be consumed by people and birds. Interest in urban agriculture is increasing as cities become denser and access to community gardens for growing food diminishes (Mougeot 2006).

Some extensive green roofs are called eco-roofs because their purpose is less to provide a verdant garden that requires irrigation during dry seasons, and more to be an active participant in the local ecosystem. Chicago and Portland are examples of cities that provide

zoning incentives for developers to encourage more buildings to include green roof construction for all the benefits listed above. Alpine or rockery-type gardens called brown roofs are being built in European cities, where the medium is sand and rocks and the only plants are wildlife volunteers that spontaneously colonize and are likely to be native species. These biodiverse habitats encourage invertebrates such as earthworms and insects that populate the region (Dunnett and Kingsbury 2008: 9, 22–27).

Plant species for vegetated walls in temperate climates that do not require additional supporting structures and do not damage masonry walls include the Virginia creeper (*Parthenocissus quinquefolia*) and Boston ivy, also known as Japanese creeper (*Parthenocissus tricuspidata*). Creepers with twining growth require trellis-type structures for support. Two flowering vines that generally thrive are the deciduous anemone clematis (*Clematic montana rubens*) and evergreen trumpet honeysuckle (*Lonicera sempervirens*). Vines to be avoided because they are invasive and pest-prone include grapevines and English ivy.

Vegetated Surfaces in History

Pliny the Elder wrote an entire book about vines and viticulture (XIV), which is the art of growing grapes for juice and wine. Some vines were allowed to grow like garlands on trees such as poplars, and others were trained to stay within arm's reach. Flowering vines attracted bees, valued for their honey, and others were appreciated for the wood, of which he claimed none had a longer life. Pliny reviewed practices that had been in place for hundreds of years and remain true today. There persists a relationship between regional climate, the type of soil and water quality, the variety of grape, care of the vine, wine making and storage, and ultimately taste. He appreciated the heightened value of land devoted to cultivating grapes, a situation that also exists today in places such as California (with high land prices and development pressure). Even the problems of intoxication are described in details that would make a frat boy blush. Ever observant of human nature, he quoted the saying, "*In vino veritas.*" Pliny also wondered why people were not content to drink what nature has so amply provided—water.

For a thousand years, some societies in northern European climates built houses with turf on birch-bark roofs that were encouraged to host plants. These types of buildings are similar to the well-insulated earthen and sod buildings built by Kurdish-speaking peoples, with roofs colonized by grasses. Traditional houses in China and Japan also had thatch roofs with greenery (Dunnett and Kingsbury 2008: 14–16). Thatch and grass-covered roofs can be a fire hazard and may not be allowed by fire codes in cities today. Green roofs, however, reduce the risk of fire because the heat load of burning vegetation is much lower when compared to conventional bitumen-covered roofs (Dunnett and Kingsbury 2008: 99).

Throughout history, productive farms and estates in remote locations often had graperies, which are enclosed structures built to force the continual growth of grapes. Kitchen gardens often included fruit trees that were trained on espalier frames supported by walls or designed to be free-standing. At Mt. Vernon, George Washington grew figs along the south-facing brick kitchen garden wall. (See Figure 21.) In 1847, Andrew Jackson Downing claimed this method resulted in a "superior size and beauty of the fruit" and increased production in less space that was more easily controlled (Downing 1981: 34).

Other types of structures that support vegetation include the arbor, bower, pergola and trellis (O'Malley 2010). Many early dictionaries correlate the terms "arbor" and "bower," although the early garden treatise by A.-J. Dézallier d'Argenville, translated into English in 1727, and Webster's dictionary of 1828 made a distinction between them. The arbor is a long arched structure over a path covered with grape or flower vines. The bower is a shaded place to sit that was round or square in plan. The Italian term "pergola" for a garden structure was used by John Evelyn in the late seventeenth century, but it did not come into common usage in America until after the mid–nineteenth century. The trellis covered with climbing roses has long been considered an ornament in any garden. Early American garden writers noted that these structures were likely made of wood, with Philip Miller (1754) recommending fir, Bernard M'Mahon (1806) suggesting pine, and Downing (1851) preferring cedar. Cast iron and metal wire were used if available as well.

In addition to being used for farming specific plants and vines, vegetated structures found purpose in pleasure grounds as either verdant screens or ornamental elements. Using plants on buildings, beyond the practical insulative value, displayed a sentiment of attachment in feelings of domesticity and caring that were well described by Downing in 1841: "The cottage in this country too rarely conveys the idea of comfort and happiness which we wish to attach to such a habitation, and chiefly because so often it stands bleak, solitary, and exposed to every ray of our summer sun, with a scanty robe of foliage to shelter it. How different such edifices, however humble, become when the porch is overhung with climbing plants" (Downing 1991: 325).

In the twentieth century, Stanley Hart White, a landscape architect and professor at the University of Illinois at Urbana–Champaign, is credited with inventing the vertical garden. His patent of 1938 is titled the "Vegetation-Bearing Architectonic Structure and System." The patent description included technical details of the structure, substrate, vegetation and supports for this new garden type. His writings on the subject portrayed this material as part of modern ways of thinking about design, architecture and landscapes, and the social benefits they provide.

Of all types of vegetation material used in landscape design, currently the most controversial is the lawn. From the level, closely cropped turf game court located next to the main house of Italian villas of the Renaissance to rolling sheep pastures that are the basis of the quintessential English picturesque landscape to nineteenth-century malls of public space often called "commons" in early American cities, turf areas covered with grass provide places for recreation and assembly (O'Malley 2010: 403–18). Once lawn grasses could be cut with mechanical mowers that were lightweight, maneuverable, inexpensive and safe to operate, rather than by hand with scythes, and the single-family home became more readily available to middle-class families, a sea of "green carpet" became a popular and desirable landscape ideal. While dust and mud control is appreciated, today the environmental consequences of pesticides and fertilizers that produce toxic by-products in production and damage waterways with run-off, of consuming over half of a typical household's use of freshwater, and of adding to air pollution because of gasoline-powered mowers are all issues of concern. More sustainable recommendations require shifting public expectations from wanting a perfect *tapis vert* to appreciating a dynamic habitat full of a variety of drought-tolerant plants that require no supplemental nutrients and are controlled by low-impact approaches to pest management.

Theories of Vegetation and Buildings

The relationship between architecture and landscape has no greater arena for exploration than where they become united in form and material. Green roofs and green walls have many practical benefits, but they also tap into an uneasiness designers have with the conflict between nature and artifice. Collective memories of the extraordinary effort required to convert wilderness into farmland for cultivation begin with the manual labor to cut trees, clear stumps and field stones, and level the land. For many who are only a generation or two away from a predominantly agricultural society, these are deep cultural intuitions. The persistent march of wildlife to reclaim cleared land is well known to gardeners who weed their gardens, and to observers of rotting wooden country barns overtaken by unrestrained plant growth. It seems counterintuitive to introduce plants (with all their growing activities) to buildings, inviting nature to be near, but only if it acts as designers specify.

Building technologies have allowed design choices that either respond to environmental conditions or ignore them. For instance, steeply sloped roof forms manage rainy or snowy climates and effectively collect and drain stormwater. In other cases, circumstances may encourage architects to design relatively flat roofs. Flat roofs were first made of metal and now are more commonly made of engineered membranes. They fail due to poor installation or maintenance, or unintended uses that add loads not considered in the structural design calculations. The roof integrity is continually threatened by even small cracks that open up over time as exposed materials age; even worse, the cause of the failure is often concealed and becomes apparent only when interior damage appears, which is often long after product warrantees expire. The risk of designing a roof that holds stormwater, and even requires the addition of irrigation water, can discourage applications that also require more initial investment. Nevertheless, most municipalities are convinced that the benefits outweigh the risks if properly constructed, and many have building codes that require green roofs on new commercial buildings.

As a material, green roofs and walls change what is expected of architecture. At first, dynamic plants turn static roofs and walls into an ekoskeleton, with the roof becoming a floor and the walls becoming a supporting scaffold (Margolis and Robinson 2007: 34). Then climbing vines eventually become woody with intertwining stems and roots that become self-supporting. These exterior blankets modulate light and temperature and provide living landscapes for people and animals, but the soft fuzzy surfaces alter the building appearance. Given that these are artificial environments that require continuing care, can these urban landscapes truly be fully functioning ecosystems that perform and are appreciated as much as forests and meadows?

Those who have toured the English countryside may wonder why there was ever a need to build public parks in that country. The first park designed for public use was Derby Arboretum, designed by John Claudius Loudon in 1838 (see Figure 64). It was an eleven-acre park with over one thousand species of trees. In 1845, industrial laborers had a short life, averaging 21 years, and no means of escaping the city to the nearby countryside during their few leisure hours (Simo 1988: 191–205). The park supplied places for relaxation and instruction, allowing people to breathe fresh air and see beautiful flowers. Today, those same human needs remain for urban dwellers, especially in cities with insufficient space for public parks and landscapes.

An example of current work that addresses this need can be seen at the U.S. Department of Agriculture's Administration Building in Washington, D.C., which was built in 1908

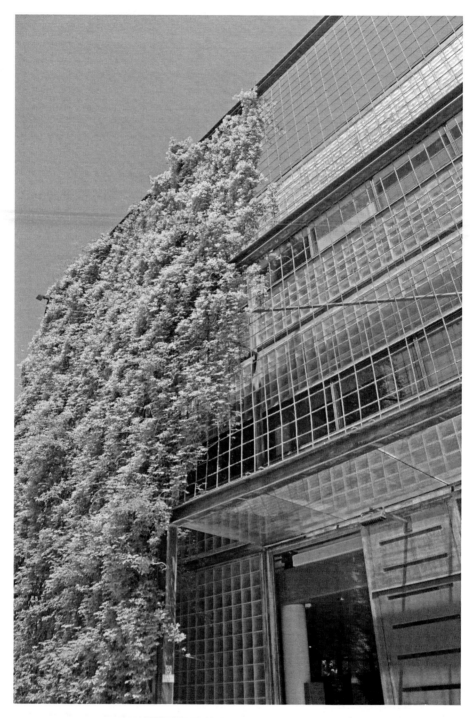

FIGURE 79. EMBASSY OF FINLAND, WASHINGTON, D.C. (1994). MIKKO HEIKKINEN AND MARKKU KOMONEN, ARCHITECTS, HELSINKI, AND OEHME, VAN SWEDEN & ASSOCIATES, LANDSCAPE ARCHITECTS, WASHINGTON, D.C. (Courtesy Magenta Livengood.) This embassy is the first green embassy in the United States, with a LEED Gold Certification awarded in 2010. Its design created quite a stir in the stodgy Washington architectural scene because of the bronze trellis screen attached to the front south-facing façade and covered with evergreen akebia. The vegetation allowed the building to connect to its site along Rock Creek Park, but the appearance of the living wall was a new style for the federal city.

before air-conditioning technology was available. The wing-shaped design allowed better air flow and natural daylighting. In 2006, the courtyards between the wings, once filled with either parking lots or structures for mechanical equipment, had green roofs installed as part of the Greening the Government through Environmental Leadership program (Executive Order 13148). The administrators have found that, besides the ecological benefits, people like looking at the roofs and employee absenteeism is down (personal conversation).

Beyond the practical advantages, vegetation as a material epitomizes the potential for creating connections between people and nature, and between nature and what we make for comfort and convenience as a theory of attachment. Creepers literally attach themselves to their supporting structure and engender human responses, as described by Downing's quotation in the preceding pages. Further, his work also encouraged all home builders to include places that mediate between house and garden for the ways they support dwelling and the contemplation of nature. Some of these elements are attached to the building, such as the porch, terrace and veranda, each of which have different degrees of enclosure and specific materials, and all of which are intended to host climbing vines. Free-standing structures—the arbor, bower and pergola—offer similar opportunities. Sheltered and exposed, surrounded by vegetation, these are places where people cultivate an attachment to the natural world (Yglesias 2012a: 141–53).

Many studies have concluded that people prefer views of plants and landscapes rather than solid walls. Seeing green roofs and vertical gardens, with a necessarily limited constructed version of nature, presents verdant materials that respond to and reveal the dynamic forces of nature. Plants move with the wind and their leaves turn toward the sun. They thrive with adequate rain and struggle with drought. Observing this can provide emotional support, connecting human sentiment to nature and generating the precise feelings that are otherwise often missing in lives consumed by digital technology and bound by virtual social systems. The workers of the Digital Age have exactly the same needs as those of the Industrial Age. The main difference is that green roof and green wall designers are working on fully constructed surfaces and not on *terra firma*.

Patrick Blanc, botanist and vegetal artist, has pioneered the use of vertical gardens from 1994 to the present day, with projects built throughout the world. Drifts of creepers, low-growing plants and shrubs cling to vertical surfaces and provide lush landscapes that are neither superficial nor destructive. He says, "It seems that humans are continually confronted with this duality: how to surround ourselves with plants without letting them propagate freely. And yet it is precisely this form of freedom of the plant world that most fascinates us" (Blanc 2012: 76). Blanc works with the growing patterns of naturally occurring opportunistic plants that take advantage of moist surfaces with access to soil or air plants (such as *tillandsia* of the bromeliad family) that receive nutrients and moisture through their leaves.

Innovative Applications

As a material in its current interpretation, has less than a 20-year history, designers have only just started to accumulate data on the performance of vegetated surfaces and identify problems that require innovative responses. Landscapes over structure are designed individually responding to unique situations of climate, weather, exposure, intended purpose and projected degree of maintenance. Even when a plant palette is tested prior to installation, surprises can occur. For example, the California Academy of Sciences in San Francisco's

FIGURE 80. THE CALIFORNIA ACADEMY OF SCIENCES, SAN FRANCISCO (2008). RENZO PIANO BUILDING WORKSHOP WITH CHONG AND PARTNERS ARCHITECTURE, SWA GROUP, LANDSCAPE ARCHITECTS. (Photograph by Tom Fox. Courtesy SWA Group.) The roof was envisioned as a landscape that was raised from the ground to cover the building, substituting for the displaced habitat.

Golden Gate Park has a planted green roof that is almost 200,000 square feet and has over 1.7 million plants. Head ecologist Paul Kephart spent four years testing plant species in similar conditions prior to installation, but found after installation that some plants did not survive while other volunteers grew well (personal conversation with staff). It was discovered that the coastal location and surrounding parkland attracted migratory birds that seeded the roof with unintended plant species. Weeding will prevent plants with a potential biomass that exceeds acceptable weight for the structure from becoming established. Also, the flexibility of this instructive landscape, which is part of the museum's mission, can tolerate these changes from proposed design to practical reality. As part of his research, Kephart invented the BioTray, a biodegradable, modular planter tray made of organic material that degrades over time as the plant root structure matures (Novitski 2008). This precedent serves as an example of designers and clients coming to a more empathetic understanding of vegetal materials as natural ecological systems with a degree of unpredictability. Evolving attitudes of people toward this building material may be the place of innovation at this time.

Given all the benefits of green roofs and green walls, and government incentives motivated by environmental concerns, many wonder why more progress hasn't been made in covering existing structures with flat roofs in cities. Reasons include the added maintenance, few designers with expertise, fewer contractors with the necessary experience, and owner reluctance to invest in a relatively new technology that may compromise the existing roof waterproofing. Further, the construction methods of installing vegetal material are limited

by seasonal constraints. Water supply and drainage systems require installation and flood testing that cannot be done in below-freezing temperatures. Moreover, during construction heavy materials cannot be stockpiled on structures that have not been designed for the temporary concentrated load. Constrained staging areas further complicate construction procedures on tight urban sites where the building footprint may occupy the entire property. Soil placement cannot be done with the customary earth-moving equipment, requiring more hand labor. The plants, as a living material, need to be procured and cultivated for their planting conditions, transported, and then installed, with proper handling throughout. And sometimes large plants, particularly trees, must be installed while other construction activities are ongoing, and must be protected and watered by hand until the irrigation system is functioning. The soils around the trees cannot be compacted by the weight of stored materials, other activities and construction equipment.

Another vegetal material used for green walls is algae. Buildings with bioreactor flat glass panels on exterior louvers provide a habitat for growing algae that can be used as a renewable biofuel. For example, the HOK and Vanderweil team, using the Living Building Challenge 2.0 guidelines, won the METROPOLIS Next Generation® Design Competition 2011 with a proposal to wrap a building with algae tubes. A GSA office building built in Los Angeles in 1965 was used as a sample project, challenging designers to propose retrofit modifications that would allow it to lower greenhouse gas emissions and to achieve a Zero Environmental Footprint for operations. The bio-inspired approach employed microalgae that produce fuel for the building power supply as it shades the interior and absorbs carbon dioxide.

"Verdant" is a word usually found in Victorian-era garden and landscape descriptions. Applying that word to describe a constructed material surface may be unfamiliar to designers, but the increasing presence of verdant landscapes can only enhance the experience of civic places by people. Green roofs and green walls are building materials installed in artificial growing conditions that remain dynamic and in need of continuing care. Accepting the untamed appearance of vegetated surfaces can challenge architecture to respond and to become more closely aligned with the natural forces that affect people. Further, architecture with sustainably designed systems and ongoing commissioning to ensure operational efficiency will find they, too, need continuing attention. The long-term investment for architecture and landscape means attending not just to design but also to the maintenance operations, which has always been required for living plants and now is clearly beneficial to all building operations.

To date, almost 1,500 projects have been built in the United States, with almost thirty million square feet of vegetation (www.greenroofs.com), and these statistics will increase exponentially as the advantages become better known, and the ability to execute projects, manage expectations and understand the consequences is not only accepted but also becomes an incentive to build in a more sustainable way.

References

Federal and International Agencies, Technical Societies and Associations

German Landscape Research, Development and Construction (FLL), founded in 1975, publishes guidelines and labor instructions, available in English since 2010, see Guideline for Green Roofs, http://www.greenrooftechnology.com/fll-green-roof-guideline.

International Green Roof Association provides information of the economic and ecological advantages of landscape over structures, http://igra-world.com.

U.S .Department of Energy, Energy Efficiency and Renewable Energy, Federal Energy management Program supplies an online summary of green roof research and application, see Green Roofs, http://www1.eere.energy.gov/femp/pdfs/fta_green_roofs.pdf.

U.S. Environmental Protection Agency has several websites of interest: for the heat island effect, http://www.epa.gov/heatisland/mitigation/greenroofs.htm; for stormwater management and the National Pollutant Discharge Elimination System (NPDES), http://www.epa.gov/npdes/stormwater; for working with NASA, http://www.nasa.gov/agency/sustainability/greenroofs.html.

Research on the Sustainable Qualities of Vegetated Structures

Green Roofs for Healthy Cities (GRHC) includes information about the green wall industry and a project database, http://greenroofs.org.

Sustainable Sites Initiative publishes standards for sustainable landscapes, with information on urban trees, advantages of biodiverse plant choices and water issues, http://sustainablesites.org/vegetation.

Vegetated Structure Products

Living retaining wall (LRW) systems, http://furbishco.com/products/smartslope and http://thelivingwallco.com.

Conclusion

The World Resources Institute on Global Warming publishes data on the state of the earth and the continuing impact of unsustainable human activity, generally summarized as global warming. While there is significant and encouraging research and development under way nationally and internationally on more sustainable manufacturing techniques and the better management of materials, it is unclear if the global ecological tipping point has passed. Supporting this concern, the organization reports that last year (2012) 3 percent more carbon emissions were added to the atmosphere. Economic uncertainty has affected domestic research funding levels, and yet doing nothing is not an option. Nations are already suffering the economic consequences of climate change, with more severe droughts and wildfires, and the recovery costs from intensified storms will continue to affect people, especially those in coastal communities further threatened by rising sea levels.

The urgency is compounded by exploding global populations projected to reach 3.8 billion by 2030. The U.S. National Intelligence Council predicts the required food production will generate 29 percent of the global greenhouse gas emissions and consume 70 percent of the freshwater and 38 percent of the land mass. Energy demands will also increase. Currently, 1.3 billion people lack access to electricity and the consumption per capita for those with access is continually increasing. There are serious questions about how food and energy needs will be met in the future. By 2030, the increased demand for food will rise by 35 percent, for water by 40 percent and for energy needs by 50 percent. Urbanization is increasing at a greater rate, and the next 40 years will see as much construction as has been built throughout history. Cities continue to sprawl, replacing farmland and forests. Beyond the role forests have in absorbing carbon dioxide, they contain 80 percent of the world's land biodiversity, but 32.5 million acres are lost annually.

As a society, the "shop and toss" mentality must be left behind. In the United States, previous generations had a legacy of frugality captured in a saying from the Great Depression: "use it up, wear it out, make it do, or do without." Postwar consumption and disposable consumerism has set aside that virtue, and consequently resources are wasted; the air, earth and water are polluted; and nonrenewable resources are depleted. Urban street trees have an average life of three years; big box buildings are designed for five years; durable goods are defined as those that last only three years. The value of design is plagued by short-term thinking, with minimal investment in lasting materials that are easy to repair or repurpose. Designers have often been guided by the only metric of marketplace worth: the cost to the profit-driven businessman. Even appropriate designs are "value engineered" until the project, for all intents and purposes, is value-free.

The building industry is the largest consumer of natural resources for materials and operations. Designers working with materials have three ways to make their projects more sustainable. First, materials chosen for building envelopes need to respond to human use *and* site-specific environmental factors. Second, material choices and design applications need to support passive heating, cooling and daylighting functions, through which sophisticated buildings can achieve zero-net energy once constructed. The third requirement for sustainable design related to materials is for manufacturing and processing industries and power plants to use renewable resources to generate energy. Understanding the embodied energy of a material in a full life-cycle analysis means designers must attend to the extraction methods (with the associated environmental impact), manufacturing processes (with their impact on workers and the community), transportation requirements, installations (with their affect on users and need for maintenance), and the conditions for recycling. This approach will help designers use minimal natural and maximum recycled resources wisely and sustainably.

Materials that are found locally reduce transportation costs and help regions retain distinct identities of place, but they also require people to resist the temptation for the exotic and novel. Materials specified with minimal processing reduce industrial operations and post-construction maintenance as well as the accompanying human and environmental impact of pollution and greenhouse gases from carbon emissions. Designs with simple assemblies allow the easy replacement of broken or obsolete parts that can be recycled rather than thrown "away." Packaging made exclusively of recyclable materials will ensure the safe and convenient delivery and storage of food and medical supplies. The innovative use of materials asks for designers to choose to design with the most appropriate materials used in the most sustainable manner so as to address current issues. Innovation may mean that high-rise office buildings have adobe walls, for instance, which is more environmentally responsive and ecologically sustainable than buildings with the same size shade fins on all four exposures.

The innovative use of materials may well usher in the post-consumerist era. Flexible designs well suited to multiple purposes and made of durable materials will require revising the metrics for evaluating real estate worth, releasing societies from former quantitative measures established in the postwar capitalist boom (Jameson 1982: 113). This will complete the modernist dream of providing beautiful design for everyone in ways that are healthy for both people and the planet (Habermas 1980: 10). This book examines the properties and qualities of materials used in design with the hope that something of their substance may be understood, and that the goals of this dream advance.

Afterword: With Measured Materials in Mind

A book about the history, theory and performance of materials draws its arguments through principles. Questioning why a particular material may be chosen based on its fundamental properties, I believe, leads to using that material in a better, more sustainable way that suits the object being made, resulting in superior design. That may be the goal, but what is superior design and how may it be achieved? Treatises full of principles are not cookbooks, but even great chefs have a solid grounding in the fundamentals of the materials and methods they use. They know that their craft depends upon working with ingredients and understanding how they interact; nothing essential can be excluded and anything extraneous distracts. There is no doubt that outstanding work in any design field is recognizable to most when it occurs, but was this the result of fortuitous caprice, a talented, experienced and hard-working designer, an extraordinarily generous budget, or a visionary client? Critical analysis of built work may or may not comment on the creative process, which ranges from the display of a signature style to so collaborative that authorship (and responsibility) is uncertain. Whatever the procedural model, the cultivated intuition displayed in the methods of an accomplished designer is difficult to translate into guidelines for others to follow. Words such as "art," "authenticity," "artificial," and "artifice" get jumbled up, with their meanings further complicated by the vague role of the designer's intent, acts of expression and limitations of functionalism. Design with measured materials in mind means that the exploratory design process thinks through specific materials that have particular characteristics, including conventional production sizes and other properties that have been presented in this book. This is far more likely to produce favorable results than composing abstract forms first and later assigning a material to them. Still, beyond understanding the materials of design and supported by practical experience only gained in the field, what if the principles of design also had recommended practices that helped architects and landscape architects in their design work? Fortunately, this is not a new desire and others have offered guides that follow, which may inspire or at least serve as a check for work in progress.

From antiquity, Vitruvius outlined three requirements of design: *firmitatis, utilitatis, venustatis* (usually translated as firmness or durability, commodity or convenience, and delight or grace or beauty). Known as the Vitruvian triad, the first is directly related to materials, which must be chosen for their strength, ability to be structurally sound and capacity to endure. The second is related to purpose, where the planning and composition of the site and building allows for various activities to function with convenience. The third is the most

difficult to define because it is usually considered subjective. It covers the appearance of the design, calling for it to be pleasing, elegant and in good taste, with appropriate correspondence between the related parts.

Vitruvius also claimed that architecture had six fundamental principles. These are order, arrangement, proportion or eurhythmy, symmetry, propriety or decorum, and economy or distribution. *Order* is a rational awareness of the fundamental size of building components and how they fit well together. The size of a brick, for instance, or the weight of stone affect how they are used in construction and therefore should be a consideration in design. The agreement between parts and whole either supports a harmonious assembly or diminishes it. *Arrangement* is the imaginative and inventive consideration of the design, investigated through drawing ground and floor plans, elevations and perspectives. These are developed concurrently, and they proceed through stages of refinement, from sketches to completed design drawings to construction drawings. It is only through drawing that designers make choices, and circumventing the process through computer-aided technology risks investigations that are shallow and incomplete, no matter how complicated the result appears. *Proportion* or *eurhythmy* is the semblance with a numerical correspondence between parts. From the time of Pythagoras, geometries based on the Golden Ratio (Golden Section or Golden Mean) were considered to produce visual harmony, much as the proper intervals played on an instrument in tune produces acoustic harmonies. The formula in a line segment is the sum of $a + b$ is to a as a is to b. Also known as the Divine Proportion, designers of all art forms have found this ratio in nature (from seashells to flower petals), and set proportional relationships of 3:4:5 occur in things such as playing cards and medieval manuscript page and text sizes as well as the façades of classical architecture. *Symmetry* at its most basic is a mirror image of one half to the other, either vertically or horizontally. Vitruvius used the human body as an example for a building, noting the balance between the parts and the numerical modular relationship between the length of the foot and overall height. An example using the body is the face, which appears symmetrical from side to side, and the leg, which appears asymmetrical when seen from the side but allows mechanical movement. *Propriety* or *decorum* is the total composition, often termed style, with an agreement among the parts. Vitruvius gave the examples of appropriate references to the gods (today these would be the appropriate associations between design and purpose), and the desirable daylight exposure for rooms with specific activities. *Economy* or *distribution* is the prudent selection of local and available building materials. Also, the class of structure was to fit the status and vocation of the occupant, and the rural or urban location.

From the Renaissance, Alberti's writings described the many aspects of architecture as it should be built rather than recording what had been built following Vitruvius. His work proposed a new humanist theory of art and architecture predicated on three guides. The first was that buildings had types, with relative value necessitating different requirements for domestic and civic architecture, and further elaboration for palaces and religious buildings. Architects were to devote appropriate attention to the degree of ornamentation, for instance, depending on the social value of the project. Second, the lessons of the past mattered, with the Greek column and Roman arch having the greatest influence. Recent excavations of ruins in Rome helped spur this interest, and observing the grace and beauty of ancient monuments provided the basis for a neoclassical revival, which served as a contrast to the gothic style. Finally, the mathematical harmony of Euclidean geometry, with proportional relationships based on whole numbers, and the optical laws of visual perception were

intended to inform decisions about the amount of enclosure and opening, or what was to be solid or void. Spaces feel different when there is a scale relationship between width and depth, as well as height. Exterior elevations with a proportional balance between members look well considered. The early twentieth-century architecture of Adolf Loos is a masterful example of three-dimensional proportional design. For all work, Alberti cautioned about proceeding too quickly to construction, advising that architects patiently allow time for both the materials and the design to cure, and then to build large-scale models of the proposed structure to verify all decisions.

In the early nineteenth century, J. C. Loudon devised what he called the first principle of landscape design: a theory of recognition of art. His concern was that landscape design could not simply be nature improved or in imitation of the naturally occurring. The design had to be recognizable as art. Loudon argued for three guides for design that would allow it to offer what art can offer—that is, to stir the emotions and the mind. First, plant a single tree or shrub in a way that gives it presence. Loudon preferred non-native plants (generally termed exotics). He was working at a time in England when the introduction of foreign species had many botanical advantages, and the design of greenhouses and conservatories had recent benefits of an eliminated tax on glass and his invention of a metal furrow frame design. Scientifically minded and intent on educating the public, Loudon advised labeling all trees, providing information about the name, country of origin and habit of growth. (An example in America is Gray Towers, the home of Gifford Pinchot, first director of the U.S. Forest Service. Pinchot chose a site on a cleared mountaintop in the Poconos with a view of the Delaware River and not in a forest, although he clearly loved trees. He planted nine European copper beeches (*Fagus sylvatica*) in 1920 as single specimen trees around the house, where each had the space to develop to full maturity and are still thriving there today.) Second, use geometry. Pure geometric shapes—circles and squares—are seldom found in nature, and their use for flower beds, borders or masses of a single species of plantlife displays the deliberateness of design, distinguishing it from nature. Finally, keep the finished design polished with strict maintenance. This means matching the design not to an unrealistic intention of the client, who has little commitment to ongoing involvement, but to the likely afterlife of the design, matching expectation to stewardship. Plants grow, and therefore the design is dynamic and matures.

In the mid-nineteenth century, A. J. Downing took French and British theories about design and adapted them for his American audience. He supplied his readers with new definitions of the fundamental rules of unity (consistent style), uniformity (regular geometric forms—in later writings called proportion), symmetry (balanced irregularity), harmony (agreement between the parts) and variety (varied massing and detail appropriate to the scale), but considered expression of purpose to be paramount. A house should be designed with elements that say this is a place for dwelling and is not to be confused with a barn or a school. These elements included the welcoming porch, sheltering roof overhangs and terra cotta chimney-tops that refer to the familial associations of the hearth, all surrounded by pleasure grounds communicating the idea that the occupants are cultivated and above the survival level. Applying this guide to other building types today means that a hospital should express healing and care, perhaps with landscapes and materials that require high maintenance, or an office building should say that this is a place of calm and focus, free of external stress and distraction, and that work can be done here. Metaphors are not just for marketing; they allow associations to move from one place to another. Linking attributes to design decisions stimulates the imagination and enriches the experience.

The movement of the twentieth century called Modernism presented new approaches that evolved in a partial reaction to the destruction of World War II and employed material production techniques developed at that time. Architecture was no longer to be a repetition of previous historic styles. Ornamentation was not to cover the poorly crafted joint or to coat the unadorned surface. Materials were to be honest, with their inherent surface qualities expressed and their joinery displayed. Mass-produced components would bring cleaner, safer and better buildings to all classes of people, thereby connecting architecture with a social agenda. Structural systems separated the frame from the enclosure, allowing non–load bearing partitions to be free to shape space. The vocabulary of building elements included long bands of windows in metal frames, cantilevered structures and flat roofs. Unfortunately, this approach is easily degraded by cheap, poorly crafted construction for banal buildings that depend on elevators, mechanical air conditioning and artificial lighting in ways no longer considered sustainable. The lessons of Le Corbusier's low-cost reinforced-concrete column-grid system called Maison Dom-Ino used for Villa Savoie (1928–1931), Mies van der Rohe's elegant skyscrapers, Frank Lloyd Wright's Usonian houses and Philip Johnson's efforts to direct Modernism into an international style have been superseded by a call for architecture that is more responsive to people and to the environment.

For the twenty-first century, Marco Frascari's *Eleven Exercises in the Art of Architectural Drawing: Slow Food for the Architect's Imagination* (2011) offers methods of drawing that support creative musings about design. If architecture is designed by drawing, then the materials of the drawing tool and drawing surface are an initial material experience. Lines and surfaces are marked and shaded, erased and traced, all with reference to the building material being represented. Further, drawing materials can be chosen to resemble certain characteristics of the building material, complete with sequential assembling procedures. Thus, heavy materials should be drawn thickly with opaque materials, whereas bricks are indicated with individual strokes, glass can be drawn with fine straight lines, spaces left open for insulation can be shown as fluffy, and water can be represented by dropping liquid onto the paper surface that soaks it up. And lines can be built up, corresponding with the associated constructing activities. These create drawings that talk back to the designer during the design process in a dialogue that guides visual thinking. Materials are physical, and drawings that keep their physicality present in the designer's mind will avoid overly abstract representations. Frascari says, "Consequently identifying themselves with the emotions and the materialness of the objects to which they are referring, architects immerse themselves in their drawings' materiality; as a kind of inverted transubstantiation the materiality disappears and the architectural meanings learned through these subjective immersions are then projected through two homologous creations of materialness: the one of the drawings and the one of the building. This quadripartite nature of the architectural project is the delight and the irritation of any sincere architect" (2011: 91).

Appendix: Biographies

Brief biographies of the people who repeatedly appear in this book may be helpful to the reader so long as they are not simply lists of facts that can be readily found online. Therefore, the following has made no attempt at completeness, but rather aims to present aspects of these individuals' work that support their inclusion in a book about materials.

Alberti, Leon Battista (1404–1472), Florentine writer, painter, sculptor, mathematician, and, most famously, architectural theorist and architect. Alberti exemplified the Renaissance ideal of the complete man and his work proposed a new humanist theory of art. Of about forty literary works, *De pictura* or *On Painting* (1435) is important because it was the first systematic study on perspective. The most significant book for architects is *De re Aedificatoria* or *On the Art of Building in Ten Books*. Written in Latin between 1443 and 1452, with only a few small illustrations, and printed in 1486, it was translated into Italian in handwritten manuscript form first and then printed in 1546 with woodcut images. Following Vitruvius in format, Alberti presents ten books on lineaments (form before material), materials, construction, public and private work, ornamentation and restoration. Alberti set up the profession of architecture as a discipline with principles distinguishing it from the practical concerns of construction. The book was first translated into English in 1726.

Bachelard, Gaston (1884–1962), French epistemologist, philosopher of science, and professor at the University of Dijon and the University of Paris. Bachelard's work departed from Cartesian rational accounts of truth as scientifically empirical with the publication of *La Psychanalyse du feu* or *The Psychoanalysis of Fire* (1938), which argued for imagery-based constructs as a more profound account of reality. Now concerned with phenomenology—the study of appearances, perception, sensory experience and consciousness, a philosophical school distinct from aesthetics and language—he argued for connections between thought and feeling, and technology and the imagination. His subsequent books on the substance of the four elements of earth, air, fire and water were written using literary sources to help explain why and how materials matter to people. His work gives force to the descriptive associations people have with the core relationships between the materials that make up the world and reverie and dreaming. Also of interest to designers is his book titled *The Poetics of Space* (1957), which is primarily about the experience of inhabiting interior places and dwelling.

Downing, Andrew Jackson (1815–1852), American horticulturist, pomologist, landscape designer and writer. Born in Newburgh, New York, on the Hudson River, Downing was a self-educated garden and landscape designer who supplied the plants from his family nursery, as well as the designs for country estates along the Hudson now accessible with new rail lines and steamboats from New York City to Albany. Downing is considered the father of American landscape architecture, setting in place expectations for the design of suburbia, the middle ground between cities and rural farms and wilderness, and he is well known for his advocacy of public parks and institutions in cities. Even with significant design commissions, including the design of the Public Grounds at Washington (known now as the Washington Mall), Downing's primary influence occurred through

his writing, of which editing the monthly journal *The Horticulturist* was the best known. Taking advantage of new printing technologies that allowed white-line wood engravings to be included at a moderate cost, thereby remaining affordable to the middle classes who were his target audience, and usually teamed with architect/lithographer Alexander Jackson Davis and engraver Dr. Alexander Anderson, Downing's four books reached a wide audience in America and were recognized in Europe as well. His books were *A Treatise on the Theory and Practice of Landscape Gardening* (1841— revised and expanded in 1844 and 1849), *Cottage Residences* (1842—expanded in 1852), *The Fruits and Fruit Trees of America* (1845—with color plates in 1847), and *The Architecture of Country Houses* (1850), all of which had numerous reprints before and after his death. Downing's contribution was his argument that design should express the proprietor's character and be linked to the natural qualities of the land and to what should be built. His house design exteriors were made of field stone, where available; wood, because it was plentiful in America with large roof overhangs to make it durable; or stucco-covered brick. His advice for productive gardens would yield fresh fruit for ten months of the year in temperate climates, a practice that would be considered ecologically sustainable today.

Loudon, John Claudius (1783–1843), Scottish botanist, landscape architect, inventor, prominent and prolific writer on horticulture and landscape design, and father of English landscape architecture. Born in Scotland and educated at Edinburgh, Loudon lived and worked in London starting in 1803, and then in Bayswater from 1816 in a country house he called the Hermitage. In 1816, he invented and patented a wrought-iron sash bar for curved greenhouse glass construction. Loudon designed Derby Arboretum in 1838, putting his principle of "recognition of art" into practice. Derby Arboretum was the first park in England designed to be public, as opposed to royal gardens that were occasionally opened to the public. Loudon buried sewage drainage pipes under paths in the eleven-acre site and used the excavated dirt to make mounded berms that created areas of relative privacy. Native and non-native trees and shrubs were planted, each with an identifying brick tally noting its country of origin, year of introduction to England, and height in its native country. Among numerous publications, his best known were *The Encyclopaedia of Cottage, Farm, and Villa Architecture and Furniture* (1832–1833), *The Architectural Magazine* (1834–1839), *The Arboretum et Fruiticetum Britannicum* (1838) and *The Suburban Gardener* (1839). Loudon was also responsible for assisting in the dissemination of the landscape principles of Humphry Repton, who employed a "before-and-after" method that showed existing conditions and proposed improvements to estates. Loudon collected, edited and published *The Landscape Gardening and Landscape Architecture of the late Humphry Repton, Esq.* in 1840.

Lucretius (Titus Lucretius Carus) (c. 99–c.55 BCE), Roman poet and material philosopher. The only known surviving poem of Lucretius is the epic *De rerum natura* or *On the Nature of Things*, sometimes translated as *On the Nature of the World*. Most scholars claim it was unfinished at the time of his death and only parts survive. Lost for centuries, it was discovered in 1417 in a monastery by Poggio Bracciolini, who also discovered the treatise by Vitruvius. The didactic poem of 7,400 hexameter lines, written in Latin, is divided into six books and follows some of the ideas of Epicurus, including the controversial correlation of pleasure and virtue. It argues that the world is made up of atom-like particles that combine or split, swerving to make everything physical and metaphysical, all of which is known through the perception of the senses. As a poem, it is full of metaphors and similes that bring to life the otherwise obscure epistemological concepts under discussion. Recent scholarship has accounted for its importance, then and now, as it describes a universe of matter whose behavior does not depend on the gods, and notes how organized religion interferes with life.

Merleau-Ponty, Maurice (1908–1961), French philosopher of phenomenology and philosophical psychology. Merleau-Ponty's major work was the *Phénoménologie de la Perception* or *The Phenomenology of Perception* (1945), which took the position that consciousness is not limited to thought, and thus cannot be separated from the body and its sensations. Experience is the person living in space and in time. Thus, understanding something like a material depends on appreciating how it came to be, what relationship it has to a person and their perception, and it also extends to

appreciating the language associated with that material as a cultural construction of common expression. The relationship between materials and the body is established by the way they are perceived and become present—in a way, each touches the other. For instance, the idea of a wall becomes physically perceptible when made of brick or glass, actualizing our understanding of the concept of separation as it depends upon the distinct properties of that material.

Pliny the Elder (Gaius Plinius Secundus) (23–79 CE), born in Como, now northern Italy, Roman officer and author. Of the seven works he is known to have written, the only surviving text is *Naturalis Historia*, or *Natural History*, completed in 77 CE. It is an encyclopedic account of nature and the works of humanity in the sciences, arts and technology. His observant commentary on the culture and traditions, good or unethical, in practice during the first century provides a thorough study replete with what some estimate to be over 2,000 references to other sources that have not survived. The thirty-seven books cover topics including cosmology, astronomy, meteorology, geography, anthropology, human physiology, zoology, trees, vines, olive and fruit trees, forest trees, botany, agriculture, horticulture, medicine and diseases, magic, water, minerals, metals, earth, stone and jewels. The oldest preserved manuscript dates from the ninth or maybe the eighth century. Much of what is known of Pliny the Elder comes from the letters written by his nephew, Pliny the Younger, who also described the villas near Rome and Pompeii in architectural detail.

Vitruvius (Marcus Vitruvius Pollio) (c. 90–20 BCE; sometimes estimated as c. 80–70 to after 15 BCE), Roman architect and engineer. Vitruvius wrote the oldest surviving and most influential book on architecture from antiquity. *De architectura libri decem* or *Ten Books on Architecture* was completed before 27 BCE and was dedicated to the Emperor Augustus. It explains the education of an architect, siting for buildings and cities, materials (with recommendations for preparation and installation), and construction for public and domestic buildings, theaters and their acoustics, baths, harbors and cities, all aspects of working with water, clocks, and war machines. This treatise has been dated by the references he used, often citing previous authors whose work did not survive and various military battles. Whatever illustrations were part of the original have been lost, although subsequent editions have added images. One important contribution of the book is that it codified the orders—Tuscan, Doric, Ionic and Corinthian—which are the column and entablature construction of Greek and Roman temples. Vitruvius' book was rediscovered in the fifteenth century and translated from Latin into Italian in 1521.

Bibliography

Addington, D. Michelle, and Daniel Schodek. 2005. *Smart Materials and Technologies for the Architecture and Design Professions*. Oxford: Elsevier.

Alberti, Leon Battista. 1991. *On the Art of Building in Ten Books*. Translated by J. Rykwert, N. Leach and R. Tavernor. Cambridge, Mass.: MIT Press.

Allen, Edward, and Joseph Iano. 2009. *Fundamentals of Building Construction*. 5th ed. Hoboken, N.J.: John Wiley & Sons.

Amato, Ivan. 1997. *Stuff: The Material the World Is Made Of*. New York: Basic Books.

Arbona, Javier. 2010. "Dangers in the Air: Aerosol Architecture and its Invisible Landscapes." In *Air*, edited by John Knechtel. Cambridge, Mass.: MIT Press.

Aristotle. 1995. *Metaphysics*, translated by W.D. Ross. In *The Complete Works of Aristotle*, Jonathan Barnes, ed., 2 Vol. Princeton, N.J.: Princeton University Press.

Arnold, Rick. 2003. *Working with Concrete*. Newtown, Conn.: Taunton Press.

Bachelard, Gaston. 1964. *The Psychoanalysis of Fire* (1938). Translated by A.C.M. Ross. Preface by N. Frye. Boston: Beacon.

_____. 1983. *Water and Dreams: An Essay on the Imagination of Matter* (1942). Translated by E.R. Farrell. Dallas: Pegasus Foundation.

_____. 1988. *The Right to Dream* (1970). Translated by J.A. Underwood. Dallas: Dallas Institute Publications.

_____. 2002a. *Air and Dreams: An Essay on the Imagination of Movement* (1943). Translated by E.R. Farrell and C.F. Farrell. Dallas: Dallas Institute Publications.

_____. 2002b. *Earth and Reveries of Will: An Essay on the Imagination of Matter* (1947). Translated by K. Haltman. Dallas: Dallas Institute Publications.

Bahamón, Alejandro, and Maria Camila Sanjinés. 2010. *ReMaterial: From Waste to Architecture*. New York and London: W.W. Norton.

Banham, Reyner. 1969. *The Architecture of the Well-Tempered Environment*. Chicago: University of Chicago Press.

Barthes, Roland. 1972. *Mythologies*. Translated by A. Lavers. New York: Hill and Wang.

Beardsley, John. 2006. *Earthworks and Beyond: Contemporary Art in the Landscape*. New York: Abbeville.

Bell, Victoria Ballard, with Patrick Rand. 2006. *Materials for Design*. New York: Princeton Architectural Press.

Berkebile, Bob, Stephen McDowell, and Laura Lesniewski. 2010. *Flow: The Making of the Omega Center for Sustainable Living*. Foreword by J. Todd. Berkeley, Calif.: ORO Editions.

Berners-Lee, Mike. 2011. *How Bad Are Bananas? The Carbon Footprint of Everything*. Vancouver: Greystone.

Billington, David P. 1985. *The Tower and the Bridge: The New Art of Structural Engineering*. New York: Princeton Architectural Press.

Blanc, Patrick. 2012. *The Vertical Garden: From Nature to the City*. Revised and updated. Translated by G. Bruhn. Preface by J. Nouvel. New York and London: W.W. Norton.

Bond, Brian H., and Peter Hamner. n.d. "Wood Identification for Hardwood and Softwood Species Native to Tennessee." PB1692, University of Tennessee. http://utextension.tennessee.edu/publications/Documents/PB1692.pdf.

Brady, George S., Henry R. Clauser, and John A. Vaccari. 2002. *Materials Handbook*. 15th ed. New York: McGraw-Hill.

Branch, Melville C. 1978. *An Atlas of Rare City Maps: Comparative Urban Design, 1830–1842*. New York: Princeton Architectural Press.

Braungart, Michael, and William McDonough. 2002. *Cradle to Cradle: Remaking the Way We Make Things*. New York: North Point Press.

Brownell, Blaine. 2006. *Transmaterial: A Catalog of Materials that Redefine Our Physical Environment*. New York: Princeton Architectural Press.

Calkins, Meg. 2009. *Materials for Sustainable Sites*. Hoboken, N.J.: John Wiley & Sons.

Campagna, Marco. 2003. *Stone Sampler*. New York and London: W.W. Norton.

Campbell, James W.P., and Will Pryce. 2003. *Brick: A World History*. London: Thames & Hudson.

Carlsen, Spike. 2008. *A Splintered History of Wood*. New York: Collins.

Cement Sustainability Initiative (CSI). 2009. "Recycling Concrete: Executive Summary." Washington, D.C.: World Business Council for Sustainable Development. www.wbcsdcement.org/pdf/CSI-RecyclingConcrete-Summary.pdf.

Cohen, Jean-Louis, and G. Martin Moeller, Jr., eds. 2006. *Liquid Stone: New Architecture in Concrete*. New York: Princeton Architectural Press.

Connelly, Dianne M. 1994. *Traditional Acupuncture: The Law of the Five Elements*. 2nd ed. Columbia, Md.: Traditional Acupuncture Institute.

Corning Museum of Glass. 1999. *Innovations in Glass*. New York: Corning Museum of Glass.

Cramb, Alan W. "A Short History of Metals." http://neon.mems.cmu.edu/cramb/Processing/history.html.

Cron, Frederick W. 1977. *The Man Who Made Concrete Beautiful: A Biography of John Joseph Earley*. Ft. Collins, Colo.: Centennial.

Deplazes, Andrea, ed. 2010. *Constructing Architecture: Materials, Processes, Structures, a Handbook*. Expanded 2nd ed. Basel, Switzerland: Birkhäuser.

Dernie, David. 2003. *New Stone Architecture*. New York: McGraw-Hill.

Dillon, David. 1998. *The Franklin Delano Roosevelt Memorial Designed by Lawrence Halprin*. Washington, D.C.: Spacemaker Press.

Downing, Andrew Jackson. 1968. *The Architecture of Country Houses*. Reprint of 1850 ed. Introduction by G.B. Tatum. New York: Da Capo Press.

———. 1981. *Victorian Cottage Residences*. Reprint of *Cottage Residences* (1842). Preface by A.K. Placzek. New York: Dover.

———. 1991. *A Treatise on the Theory and Practice of Landscape Gardening, Adapted to North America*. Reprint of 4th ed. (1849). Introduction by T. O'Malley. Washington, D.C.: Dumbarton Oaks Research Library and Collection.

Draffin, Jasper O. 1943. "A Brief History of Lime, Cement, Concrete and Reinforced Concrete." *Journal of the Western Society of Engineers* 48, no. 1 (March): 14–47.

Dunnett, Nigel, and Noël Kingsbury. 2008. *Planting Green Roofs and Living Walls*. Revised and updated. Portland and London: Timber Press.

Duran, Sergi Costa, and Julio Fajardo, eds. 2010. *The Sourcebook of Contemporary Green Architecture*. New York: Collins.

Eliade, Mircea. 1962. *The Forge and the Crucible: The Origins and Structures of Alchemy*. 2nd ed. Translated by S. Corrin. Chicago and London: University of Chicago Press.

———. 1987. *The Sacred and the Profane: The Nature of Religion*. Translated by W.R. Trask. San Diego: Harcourt.

Elizabeth, Lynne, and Cassandra Adams, eds. 2005. *Alternative Construction: Contemporary Natural Building Methods*. Hoboken, N.J.: John Wiley & Sons.

Feist, William C. 1983. "Finishing Wood for Exterior Use." Forest Products Laboratory, Forest Service, USDA. www.fpl.fs.fed.us/documnts/pdf1983/feist83c.pdf.

Fernandez, John. 1986. *Material Architecture: Emergent Materials for Innovative Buildings and Ecological Construction*. London: Routledge.

Fernández-Galiano, Luis. 2000. *Fire and Memory: On Architecture and Energy*. Translated by G. Cariño. Cambridge, Mass.: MIT Press.

Fishman, Charles. 2011. *The Big Thirst: The Secret Life and Turbulent Future of Water*. New York: Free Press.

Fisk, Pliny, III. 2010. "The Evolution of an Architecture in Balance." In *The Sourcebook of Contemporary Green Architecture*, edited by Sergi Costa Duran and Julio Fajardo. New York: Collins.

Fitchen, John. 1986. *Building Construction Before Mechanization*. Cambridge, Mass.: MIT Press.

Forty, Adrian. 2006. "A Material Without a History." In *Liquid Stone: New Architecture in Concrete*, edited by Jean-Louis Cohen and G. Martin Moeller, Jr. New York: Princeton Architectural Press.

Foster, Hal, ed. 1983. *The Anti-Aesthetic: Essays on Postmodern Culture*. Seattle: Bay Press.

Frascari, Marco. 2011. *Eleven Exercises in the Art of Architectural Drawing: Slow Food for the Architect's Imagination*. New York: Routledge.

Freinkel, Susan. 2011. *Plastic: A Toxic Love Story*. Boston: Houghton Mifflin Harcourt.

Gerwain, Richard G., Nestor R. Iwankiw, and Farid Alfawakhiri. 2003. *Fire: Facts for Steel Buildings*. American Institute of Steel Construction (AISC). http://www.aisc.org/WorkArea/showcontent.aspx?id=7046.

Gilbert-Rolfe, Jeremy. 1999. *Beauty and the Contemporary Sublime*. New York: Allworth Press.

Gilpin, William. 1988. *Remarks on Forest Scenery*. Reprinted in *The Genius of the Place: The English Landscape Garden, 1620–1820*, edited by John Dixon Hunt and Peter Willis. Cambridge, Mass.: MIT Press.

Gissen, David. 2009. *Subnature: Architecture's Other Environments*. New York: Princeton Architectural Press.

Gleich, Arnim von, Robert U. Ayres, and Stefan Gößling-Reiserman, eds. 2006. *Sustainable Metals Management: Securing Our Future—Steps towards a Closed Loop Economy (Eco-Efficiency in Industry and Science)*. Dordrecht, The Netherlands: Springer.

Gore, Albert. 2013. *The Future: Six Drivers of Global Change*. New York: Random House.

Greenblatt, Stephen. 2011. *The Swerve: How the World Became Modern*. New York: W.W. Norton.

Habermas, Jürgen. 1980. "Modernity—An Incomplete Project." In *The Anti-Aesthetic: Essays on Postmodern Culture*, edited by Hal Foster. Seattle: Bay Press.

Hardwicke, Chris. 2009. "Ravine City." In *Water*, edited by John Knechtel. Cambridge, Mass.: MIT Press.

Heeney, Gwen. 2003. *Brickworks*. London: A & C Black; Philadelphia: University of Pennsylvania Press.

Heidegger, Martin. 1971. *Poetry, Language, Thought*. Translated by A. Hofstadter. New York: Harper Colophon.

Hochschild, Adam. 1999. *King Leopold's Ghost: A Story of Greed, Terror, and Heroism in Colonial Africa*. Boston: Houghton Mifflin.

Hopper, Leonard, ed. 2007. *Landscape Architecture Graphic Standards*. Hoboken, N.J.: John Wiley & Sons.

Illich, Ivan. 1985. *H²O and the Waters of Forgetfulness: An Inquiry into Our Changing Perceptions of Urban Space and the Waters that Cleanse It*. Berkeley, Calif.: Heyday Books.

Ingold, Tim. 2000. *The Perception of the Environment: Essays in Livelihood, Dwelling and Skill*. London: Routledge.

_____. 2011. *Being Alive: Essays on Movement, Knowledge and Description*. London: Routledge.

International Residential Code for One- and Two-Family Dwelling. 2003. Country Club Hills, Ill.: International Code Council.

Irving, Pierre M. 1864. *The Life and Letters of Washington Irving*. 4 vols. New York: G.P. Putnam.

Jameson, Fredric. 1982. "Postmodernism and Consumer Society." In *The Anti-Aesthetic: Essays on Postmodern Culture*, edited by Hal Foster. Seattle: Bay Press.

King, Bruce. 2005. *Making Better Concrete: Guidelines to Using Fly Ash for Higher Quality, Eco-Friendly Structures*. San Rafael, Calif.: Green Building Press.

Kirkwood, Niall. 1999. *The Art of Landscape Detail: Fundamentals, Practices, and Case Studies*. New York: John Wiley & Sons.

Knechtel, John, ed. 2009. *Water*. Cambridge, Mass.: MIT Press.

_____, ed. 2010. *Air*. Cambridge, Mass.: MIT Press.

Leatherbarrow, David. 2004. *Topographical Stories: Studies in Landscape and Architecture*. Philadelphia: University of Pennsylvania.

Leatherbarrow, David, and Mohsen Mostafavi. 2002. *Surface Architecture*. Cambridge, Mass.: MIT Press.

Lefteri, Chris. 2001. *Plastics*. Crans-Pres-Celigny, Switzerland: RotoVision.

_____. 2002. *Glass*. Mies, Switzerland: RotoVision SA.

_____. 2003a. *Ceramics: Materials for Inspirational Design*. Mies, Switzerland: RotoVision SA.

_____. 2003b. *Wood*. Mies, Switzerland: RotoVision.

_____. 2004. *Metals*. Foreword by R. Arad. Mies, Switzerland: RotoVision.

Logan, William Bryant. 1995. *Dirt: The Ecstatic Skin of the Earth*. New York and London: W.W. Norton.

_____. 2012. *Air: The Restless Shaper of the World*. New York and London: W.W. Norton.

Lucretius. 1904. *On the Nature of Things*, translated by J.S. Watson, poetical version by J.M. Good. London: George Bell and Sons.

Lyons, John W. 1985. *Fire*. New York: Scientific American Books.

MacGregor, Neil. 2011. *A History of the World in 100 Objects*. London: Viking.

Mäckler, Christoph, ed. 2004. *Material Stone: Constructions and Technologies for Contemporary Architecture*. Basel, Switzerland: Birkhäuser.

Margolis, Liat, and Alexander Robinson. 2007. *Living Systems: Innovative Materials and Technologies for Landscape Architecture*. Basel, Switzerland: Birkhäuser.

Mayer, Han. 2003. *City and Port: The Transformation of Port Cities: London, Barcelona, New York and Rotterdam*. Dublin: International Books.

McMorrough, Julia. 2006. *Materials, Structures, Standards*. Beverly, Mass.: Rockport.

McRaven, Charles. 1989. *Building with Stone*. Pownal, Vt.: Garden Way.

Meisel, Ari. 2010. *LEED Materials: A Resource Guide to Green Building*. New York: Princeton Architectural Press.

Merleau-Ponty, Maurice. 1968. *The Visible and the Invisible*. Translated by A. Lingis. Edited by C. Lefort. Evanston, Ill.: Northwestern University Press.

_____. 2002. *The Structure of Behavior* (1942). Translated by Alden Fisher. Pittsburgh: Duquesne University Press.

Milner, George. 2004. *The Moundbuilders: Ancient Peoples of Eastern North America*. London: Thames & Hudson.

Mori, Toshiko, ed. 2002. *Immaterial/Ultramaterial: Architecture, Design, and Materials*. New York: George Braziller.

Mougeot, Luc J.A. 2006. *Growing Better Cities: Urban Agriculture for Sustainable Development*. Ottawa: IDRC Books.

Moxon, Joseph. 2009. *Mechanick Exercises: Or the Doctrine of Handy-Works*. Facsimile reprint of 3rd ed. (1703). Introduction by G. Roberts. Dedham, Mass.: Toolemera Press.

Neutra, Richard. 1954. *Survival Through Design*. New York: Oxford University Press.

Newby, Frank. 2001. "The Innovative Uses of Concrete by Engineers and Architects." In *Historic Concrete: Background to Appraisal*, edited by James Sutherland, Dawn Humm, and Mike Chrimes. London: Thomas Telford.

Norgate, T.E., and W.J. Rankin. "The Role of Metals in Sustainable Development." http://www.minerals.csiro.au/sd/CSIRO_Paper_LCA_Sust.pdf.

Novitski, B. J. 2008. "Verdant Surfaces." *GreenSource* (September).

O'Brien, Michael. June, 2000. "The Five Ages of Wood," SWST Conference Address. www.mjobrien.com/Papers/Five_Ages_Wood_OBrien.pdf.

Olgyay, Victor. 1963. *Design with Climate: Bioclimatic Approach to Architectural Regionalism.* Princeton, N.J.: Princeton University Press.

O'Malley, Therese. 2010. *Keywords in American Landscape Design.* Washington, D.C.: Center for Advanced Study in the Visual Arts, National Gallery of Art, in association with Yale University Press.

Ortega y Gassett, José. 1986. "Mediations on the Frame." In *Art of the Edge: European Frames, 1300–1900,* edited by Richard R. Brettell and Steven Starling. Chicago: Art Institute of Chicago.

Palley, Reese. 2010. *Concrete: A Seven-Thousand-Year History.* New York: Quantuck Lane Press.

Panofsky, Erwin, ed. 1979. *Abbot Suger on the Abbey Church of St.-Denis and Its Art Treasures.* Translated and annotated. Princeton, N.J.: Princeton University Press.

Pliny the Elder. 1971. *Natural History.* Translated by H. Rackham. Cambridge, Mass.: Loeb Classical Library, Harvard University Press.

Pye, David. 1971. *The Nature and Art of Workmanship.* Bethel, Conn.: Cambium Press.

Quetglas, Josep. 2001. *Fear of Glass: Mies van der Rohe's Pavilion in Barcelona.* Basel, Switzerland: Birkhäuser.

Ramsey, Charles George, Harold Reeve Sleeper, and John Ray Hoke, eds. 2000. *Architectural Graphic Standards.* 10th ed. Hoboken, N.J.: John Wiley & Sons.

Reeb, James E. 1997. "Scientific Classification of Trees: An Introduction for Wood Workers." www2.ca.uky.edu/agc/pubs/for/for61/for61.pdf.

Reed, David. 1998. *The Art and Craft of Stonescaping.* Ashville, N.C.: Lark.

Repton, Humphry. 1994. *The Red Books for Brandsbury and Glemham Hall.* Introduction by S. Daniels. Washington, D.C.: Dumbarton Oaks Research Library and Collection.

Robbins, Eleanora I., and Myrna H. Welter. 2001. "Building Stones and Geomorphology of Washington, D.C.: The Jim O'Connor Memorial Field Trip." http://www.gswweb.org/oconnor-fieldtrip.pdf.

Rosenwald, Michael. 2011. "Green Cement." *Smithsonian* 42, no. 8: 52–56.

Rykwert, Joseph. 1976. *The Idea of a Town.* London: Faber and Faber.

_____. 1996. *The Dancing Column: On Order in Architecture.* Cambridge, Mass.: MIT Press.

_____. 2008. *The Judicious Eye: Architecture against the Other Arts.* Chicago and London: University of Chicago Press.

Salzman, James. 2012. *Drinking Water: A History.* New York and London: Overlook Duckworth.

Sastre, J., and T. Sos. 2009. "User-Orientated Innovation." www.infotile.com/pdfFile/advicetopic/1404201141044.pdf.

Schama, Simon. 1995. *Landscape and Memory.* Toronto: Random House.

Schwartz, Martha. 2004. *The Vanguard Landscape and Gardens of Martha Schwartz.* Edited by T. Richardson. London: Thames & Hudson.

Semper, Gottfried. 1989. *The Four Elements of Architecture and Other Writings.* Translated by H.F. Mallgrave and W. Herrmann. Introduction by H.F. Mallgrave. Cambridge: Cambridge University Press.

Sibley, David Allen. 2009. *The Sibley Guide to Trees.* New York: Alfred A. Knopf.

Simo, Melanie Louise. 1988. *Loudon and the Landscape.* London and New Haven, Conn.: Yale University Press.

Smith, Ken. 2004. Lecture (November 3). Washington, D.C.: National Building Museum.

Sovinski, Rob. 1999. *Brick in the Landscape.* Hoboken, N.J.: John Wiley & Sons.

_____. 2009. *Materials and Their Applications in Landscape Design.* Hoboken, N.J.: John Wiley & Sons.

Stein, Carl. 2010. *Greening Modernism: Preservation, Sustainability, and the Modern Movement.* New York: W.W. Norton.

Steinberg, Saul. 2001. *Reflections and Shadows.* Translated by John Shepley. New York: Random House.

Strabo. 1923. *Geography.* Vol. II, Books 3–5. Translated by H.L. Jones. Cambridge, Mass.: Loeb Classical Library, Harvard University Press.

Thompson, J. William, and Kim Sorvig. 2008. *Sustainable Landscape Construction: A Guide to Green Building Outdoors.* 2nd ed. Washington, D.C.: Island Press.

Tilley, Christopher. 2004. *The Materiality of Stone.* Oxford and New York: Berg.

Toulmin, Stephen, and June Goodfield. 1982. *The Architecture of Matter.* Chicago and London: University of Chicago.

Treib, Marc, and Dorothée Imbert. 1997. *Garrett Eckbo: Modern Landscapes for Living.* Berkeley: University of California Press.

Ulm, Franz-Josef. 2006. "What's the Matter with Concrete?" In *Liquid Stone: New Architecture in Concrete,* edited by Jean-Louis Cohen and G. Martin Moeller, Jr. New York: Princeton Architectural Press.

Van Bruggen, Coosje. 1997. *Frank Gehry: Guggen-*

heim Museum Bilbao. New York: Guggenheim Museum Publications.

Van Hampton, Tudor. 2006. "Research and Design Is Changing the Shape of the Material World." *Engineering News-Record* 256, no. 14 (October 9): 22–25.

Van Hensbergen, Gijs. 2001. *Gaudí.* New York: HarperCollins.

Van Uffelen, Chris. 2008. *Pure Plastic: New Materials for Today's Architecture.* Berlin: Verlagshaus Braun.

Venkataraman, Bhawani. 2009. "The True Price of Water." In *Water*, edited by John Knechtel. Cambridge, Mass.: MIT Press.

Virgil. 1999. *Georgics*, translated by H.R. Fairclough, revised G.P. Goold. Cambridge, Mass.: Loeb Classical Library, Harvard University Press.

Vitruvius. 1960. *The Ten Books on Architecture.* Translated by M.H. Morgan. New York: Dover.

_____. 1985. *The Ten Books on Architecture*, translated by F. Granger. 2 Vol. Cambridge, Mass.: Loeb Classical Library, Harvard University Press.

Weilacher, Udo. 1999. *Between Landscape Architecture and Land Art.* Foreword by J.D. Hunt and S. Bann. Basel, Switzerland: Birkhäuser.

Weiler, Susan K., and Katrin Scholz-Barth. 2009. *Green Roof Systems: A Guide to the Planning,* *Design, and Construction of Landscapes over Structure.* Hoboken, N.J.: John Wiley & Sons.

Wels, Susan. 2008. *California Academy of Sciences: Architecture in Harmony with Nature.* Preface by G.C. Farrington. Foreword by R. Piano. Introduction by J.E. McCosker. San Francisco: Chronicle Books.

Williamson, Rebecca. 2010. "Al Fresco: When Air Became Fresh." In *Air*, edited by John Knechtel. Cambridge, Mass.: MIT Press.

Willis, Daniel. 1999. *The Emerald City and Other Essays on the Architectural Imagination.* New York: Princeton Architectural Press.

Winter, Irene J. 2005. "Mud Brick: Ur, Nineveh, Babylon, and the Aesthetics of Scale." A.W. Mellon Lectures in the Fine Arts (April 10). Washington, D.C.: National Gallery of Art.

Winterbottom, Daniel M. 2000. *Wood in the Landscape.* New York: John Wiley & Sons.

Yglesias, Caren. 2012a. *The Complete House and Grounds: Learning from Andrew Jackson Downing's Domestic Architecture.* Chicago: Center for American Places, Columbia College Chicago.

_____. 2012b. "Seeing Air." In *Visuality/Materiality: Images, Objects and Practices*, edited by Gillian Rose and Divya P. Tolia-Kelly. Surrey, UK: Ashgate.

Index

Numbers in **_bold italics_** indicate pages with photographs.

asphalt 84, 111, 114, 133, 139;
 recycling 114
Association of Postconsumer
 Plastic Recyclers 162
Atlantic Botanical Garden
 (Atlanta) *108*
atmosphere 7, 18, 25, 31, 64, 95,
 143, 146, 150, 156, 169, 179
atrium house design 92
attachment, sentiment of 172,
 175
automobile windshield glass 80
"Avoiding Wood from Endan-
 gered Forests" (Rainforest
 Relief Guidelines) 125
Axion International 162

Bachelard, Gaston 4, 34, 41, 93,
 137–138, 149–150; biography
 185
bacteria 17, 43, 72, 98, 122, 133,
 143, 146, 161, 169
Baekeland, Leo Henry 159–160
Bailey Plaza, Cornell University
 (Ithaca, N.Y.) *106*
Bakelite 159–160
bald cypress 123, 128
Baldwin, James 153
balsa wood 122
bamboo 8, 139
barium 81
Barragan, Luis 93
Barthes, Roland 160–161
basalt 103, 105
baseball bats 125
Baskin, Leonard 96
baths, public 92
beech 52, 119, 123
beer 121, 161
beeswax candles 30
Belgium 159
Bell and Rand 60
Benedictus, Edouard 80
beryllium 36, 39
Bessemer, Henry 40
Bethesda Terrace (Central Park,
 New York, N.Y.) 68
Big Dig 112
billiard balls 159
bioremediation 139, 142
BioTray 176
birch 122
bismuth 39
bituminous coating 56
black (color), associated with
 lead 45
black locust 123, *126*, 126
black walnut 123
blackboards 105

Blanc, Patrick 175
"Blankness as a Signifier"
 (Gilbert-Rolfe) 150
blast furnace slag 17
bluestone 104, 106
Blur Business Hotel and Cul-
 tural Facility (China) *164*
Böhme, Jakob 41
boric acid 81
borocilicate in glass 75, 81
Boston 145
Boston ivy (Japanese creeper)
 171
bottled water 90, 161
bower 172, 175
brain, associated with silver 43
Braque, Georges 79
brass 35–36, 39, 41, 44, 47
Brazil 104, 122
breccias (type of marble) 104
brick 49–62, 130, 133, 182,
 184; bonding names (based
 on orientation) 54; colors 51;
 crushed for backfill 61;
 downgrading 52, *53*; history
 57–58; joints 54; prefabri-
 cated panels 58; propertied
 49; relative density 90; seis-
 mic retrofitting 62; sizes 51–
 52; strength 61; structural
 applications 54; surface
 names 52; sustainability 60–
 62; terminology 49; thermal
 radiant heat 51, 54; types and
 sizes 51–52; used for art 57
brick mortar *see* mortar
bricklaying 49; dry-laid 50;
 herringbone pattern 54;
 joints 54, 56, 61; permeable
 paving installation 54, 61;
 repair 59; veneer 54, 58, 61;
 wall caps 54; wall types 54
brickmaking 49, 52, 57, 58;
 production embodied energy
 60
brine 91, 157
Brittany 105
bronze 34, 36–37, 39, 41, 44,
 47, 174
Bronze Age 39
Brookline, Massachusetts 145
Brown, Lancelot "Capability"
 94, 135
brown roofs 171
brownfields 139, 142
brownstone 104
Buffalo Bayou Promenade
 (Houston) *29*
building codes: acceptance of

alternate materials 123–124,
 136; combustibility of mate-
 rials 58; for repurposed stone
 109; for tempered glass 76;
 for wood 118
"Building, Dwelling, Thinking"
 (Heidegger) 137
building industry 180
building orientation 149, 152
building types 152, 182–183
Burnham, Daniel 58
Burton, Decimus 82–83

cadmium 139
calcium 134
calcium carbonate 104
calcium oxide 75
Calder, Alexander 43
Calera cement 18
California 144, 171
California Academy of Sciences,
 Golden Gate Park (San Fran-
 cisco) 175–176, *176*
Camana Bay (Grand Cayman,
 Cayman Islands) *C7*, *110*
Campbell, James 62
canals 92
cane 139
Canogar, Daniel *C2*
Cao | Perrot Studio *C4*
capillary action 134, 136, 150,
 167–168
Capitol (Washington, D.C.)
 146
carbon 36
carbon dioxide: absorbed by
 algae 177; in air 146, 169,
 179; byproduct of ceramic
 tile production 72; in com-
 bustion 25; of concrete and
 cement production 6, 7, 17, 18
carbon emissions 179–180
carbon footprint 34, 47; of
 brick 61; of ceramics 65; of
 earth 130; of glass 84
carbon monoxide 143, 149, 153
Carolinas 104
carpeting, wall-to-wall 139
Carrier, Willis 149
Cartesian tradition 137
Cascara Bridge (Madrid) *C2*
cassiterite 34
cast iron 41, 43, 47, 157, 172;
 historic façade ornamenta-
 tion *60*, 83
cave, original dwelling type 101,
 130–131
cedar 90, 119–120, 123, 125,
 162, 172